Early American Decorative Arts
1620–1860

Early American Decorative Arts
1620–1860

A Handbook for Interpreters

Revised and Enhanced

Rosemary Troy Krill

AltaMira
PRESS

A Division of
ROWMAN & LITTLEFIELD PUBLISHERS, INC.
Lanham • New York • Toronto • Plymouth, UK

Published by AltaMira Press
A division of Rowman & Littlefield Publishers, Inc.
A wholly owned subsidary of The Rowman & Littlefield Publishing Group, Inc.
4501 Forbes Boulevard, Suite 200, Lanham, Maryland 20706
http://www.altamirapress.com

Estover Road, Plymouth PL6 7PY, United Kingdom

British Library Cataloguing in Publication Information Available

Library of Congress Cataloging-in-Publication Data

Krill, Rosemary Troy, 1950–
 Early American decorative arts, 1620–1860 : a handbook for interpreters / Rosemary Troy Krill. — Rev. and enhanced.
 p. cm. — (American Association for State and Local History book series)
 Includes index.
 ISBN 978-0-7591-1944-4 (cloth : alk. paper) — ISBN 978-0-7591-1945-1 (pbk. : alk. paper) — ISBN 978-0-7591-1946-8 (electronic)
 1. Decorative arts, Early American—Handbooks, manuals, etc. 2. Decorative arts—United States—History—19th century—Handbooks, manuals, etc. 3. Henry Francis du Pont Winterthur Museum. I. Title.
 NK806.K75 2010
 745.0973—dc22
 2010000103

♾™ The paper used in this publication meets the minimum requirements of American National Standard for Information Sciences—Permanence of Paper for Printed Library Materials, ANSI/NISO Z39.48-1992.

Printed in the United States of America

Contents

Preface and Acknowledgments

VISITORS APPROACH WINTERTHUR ALONG A WINDING road that draws them into a rural landscape of rolling meadows, stone bridges, distant barns, and a naturalistic garden intersected by paths that invite exploration and lead ultimately to the museum. A large building whose size is masked by its secure placement in a hillside, the museum houses a unique collection of decorative arts.

Although the garden and the museum form the public face of Winterthur, which opened to the public in 1951, there is much more to be found. Winterthur boasts a research library with more than five hundred thousand manuscripts, books, drawings, prints, and photographs; graduate programs for advanced study in American material culture and art conservation; a bookstore; and shops that carry reproductions from Winterthur's collection. The estate is the former home of Henry Francis du Pont, a scion of the family whose industrial achievements hold an important place in American history and the man who created the decorative arts collection and garden.

Winterthur is perhaps best known for its dazzling array of more than eighty-five thousand objects, including furniture, textiles, ceramics, glass, silver and other metals, architectural elements, tools, needlework, prints, and paintings. No other collection of American antiques approaches the quality, variety, and depth represented at the museum. The focus is on the finest examples of objects made or used between 1620 and 1860 along the Atlantic coast. The scope is wide; high-style, vernacular, and ethnic objects are all represented, evoking the talents, visions, and aspirations from more than two hundred years of American life.

The collection is the legacy of Henry Francis du Pont. Beginning with a few modest purchases of early Americana in the 1920s, he rapidly became one of the leaders of the colonial revival movement of the early twentieth century. It was du Pont's aesthetic sense that shaped the period room concept still seen at Winterthur today. Those rooms, while evoking the past, do not duplicate it. Rather, the concept is modern, developed to provide sympathetic settings for the display of early American artifacts.

Museum guides interpret the period rooms for visitors. They combine knowledge about the collection and current scholarship with information about visitors, their expectations, and their learning styles. In doing so, they accomplish Winterthur's interpretive goals—providing visitors with the opportunity to look closely at objects and think about their meanings to people in the past as well as to themselves.

The first edition of this book, based on *The Handbook for Winterthur Interpreters*, was underwritten by a grant from the National Endowment for the Humanities and formed part of a long tradition of "collection guides" that reflect the commitment of both du Pont and the professional staff to education as a primary focus of museum activities.

The most gratifying aspect of working on this revised edition is knowing that the book is serving its intended purpose. It is an introductory volume for those charged with the public interpretation of collections in museums and historic sites that feature objects made or used in the North American colonies and young United States. The book also fulfills a need for students, serving as a text for university classes as well as specialized short-term courses. This new edition was prompted by a need to provide updated, current scholarship as well as the desire to enhance its usefulness through the addition of color images. The Winterthur Library made the goal of updating scholarship an attainable one. In the years since the first edition was completed, significant research has been published in the field. Thanks to Winterthur's collecting policies, much of that material is available in the library and has been integrated into the revised text and bibliography. Especially valuable as well has been the recent scholarship of Winterthur colleagues, the continued presentation of cutting-edge material in *Winterthur Portfolio*, and the updated information available in the collections management database at the museum.

All these resources have helped to strengthen this book. I trust that I have applied the findings well but consider any weak interpretations or factual errors my own. For their support of the project I thank not only our partners at AltaMira Press but many current and former members of the Winterthur staff: Gregory Landrey (division director, Library, Collections Management, & Academic Programs Division); J. Thomas Savage, (director, Museum Affairs Division); Jeff Groff (director, Public Programs Department); Pauline Eversmann (former director, Library, Collections Management & Academic Programs Division); Laszlo Bodo and James Schneck, photographers; Susan Newton, photo services coordinator; Alison Buchbinder, former McNeil Fellow; and Onie Rollins, senior editor. Finally, John Krill not only encouraged the project but helped me see that it could be real, with the gifts of his help and understanding.

Rosemary Troy Krill
Academic Programs Department
Winterthur Museum, Garden, & Library

Introduction

A MAHOGANY CHAIR, A COPPER KETTLE, A PORCELAIN plate with a pattern of tobacco leaves, a sampler stitched on linen . . . objects such as these are the decorative arts and household furnishings of the colonial past and the first century of the United States as a nation. They furnish numerous historic houses and museums where visitors go to seek information and renewal. For directions on their journey of discovery, visitors often rely on interpreters. This book is for them. It will help them understand their collections, whether they encounter visitors personally in galleries, write interpretive labels for exhibitions, or construct audio or video experiences. Interpreters, in turn, can help visitors achieve their goals.[1]

Excellent interpretation is built on a foundation of intense observation and a deep knowledge of collection objects. "What do you see when you look at these objects, either alone or with interested colleagues and visitors? What questions spring to mind?" This book is designed to help interpreters answer the questions that objects pose for them and their visitors.

This book is a guide. The focus is on providing information useful in interpreting objects and their contexts to interested, but not expert, museum visitors. Descriptive information—that is, specific information about specific objects—as well as the type of nuanced object study and interpretation that is the purview of curators and scholars is retrievable from museum registration records, curatorial guides, catalogues, and scholarly works. It is not the chief concern here. This book incorporates information within the framework of interpretive goals developed at Winterthur and refined through visitor research and guide training and evaluation.

The definition of interpretive goals for decorative arts collections is influenced by a basic tenet of material culture studies: Objects have meaning. They often have multiple layers of meaning, including the viewpoints of the maker, owner, and everyone who subsequently has interacted with the objects. And there are the varied viewpoints of the museum visitors, some of whom wish for descriptive material, the opportunity

to associate the object with a memory, the chance to evaluate or give an opinion, or the ability to categorize objects with those they already know.[2]

Each reader might start with the chapters that are of particular interest at the moment. This book may be used as a textbook, providing relevant chapters in a useful sequence, or as a reference book, offering bits of information as needed. But most important, it can be a starting point for further individualized study. It is not intended to contain detailed information on every object. And readers must remain aware of new publications in the rapidly changing field of material culture and decorative arts studies.[3] The purpose of this book is to stimulate interest, provide a basic bibliography, and encourage interpreters to seek out additional knowledge and to try new interpretive techniques.

ORGANIZATION

Part One of this book is a foundation for the chapters on different types of objects. The first chapter, "Interpreting Decorative Arts Objects," examines how messages can be conveyed to museum visitors. It discusses interpretive theory and describes the goals for the interpretation of decorative arts collections. Interpreters encourage visitors to look closely at objects, to think about meanings, and to relate these meanings to their own lives.

Next, background information pertinent to collection objects is explored in "Looking at Objects" and "Understanding Style." Using the interpretive goals as a framework, these chapters look at the ways in which objects may be approached and provide interpreters with a foundation in aesthetic analysis and a theoretical framework for the concept of "style."

In Part Two, eighteen chapters highlight categories of objects, taking their structure from the interpretive goals. They emphasize looking at objects and thinking about what they meant to their makers, buyers, sellers, owners, and users.

The disciplined study of the objects of other times and places can be richly rewarding. Today household

objects of all kinds abound. It is valuable to consider, individually and as a community, what these objects reveal to their users and to other observers. May this volume lead to knowledge and inspiration.

NOTES

1. Combs. For more on visitors' motivations for frequenting museums and historic houses, see Csikszentmihaly and Hermanson, Falk and Dierking, Hood, and Wilkening and Chung.
2. Eversmann et al., 144–51.
3. The bibliographies at the end of each chapter may guide further study. See also Ames and Ward; bibliographies and book reviews in issues of the journals *American Furniture* and *Ceramics in America*, published by the Chipstone Foundation, Milwaukee, Wisconsin; and *Winterthur Portfolio*, published for the museum by the University of Chicago Press.

BIBLIOGRAPHY

Ames, Kenneth L., and Gerald W. R. Ward, eds. *Decorative Arts and Household Furnishings in America, 1650–1920: An Annotated Bibliography*. Winterthur, Del.: Henry Francis du Pont Winterthur Museum, 1989.

Combs, Amber Auld. "Why Do They Come? Listening to Visitors at a Decorative Arts Museum." *Curator: The Museum Journal* 42, no. 3 (July 1999): 186–97.

Csikszentmihaly, Mihaly, and Kim Hermanson. "Intrinsic Motivation in Museums: What Makes Visitors Want to Learn?" *Museum News* 74, no. 3 (May/June 1995): 34–37, 59–61.

Eversmann, Pauline K., et al. "Material Culture as Text: Review and Reform of the Literacy Model for Interpretation." In *American Material Culture: The Shape of the Field*, edited by Ann Smart Martin and J. Ritchie Garrison, 135–67. Winterthur, Del.: Henry Francis du Pont Winterthur Museum, 1997.

Falk, John H., and Lynn D. Dierking, *Learning from Museums: Visitor Experiences and the Making of Meaning*. Walnut Creek, Calif.: AltaMira Press, 2000.

Hood, Marilyn G. "Staying Away: Why People Choose Not to Visit Museums." *Museum News* 61, no. 4 (April, 1983): 50–57.

Wilkening, Susie, and James Chung. *Life Stages of the Museum Visitor: Building Engagement Over a Lifetime*. Washington, D.C.: American Association of Museums, 2009.

Part One

Interpreting Decorative Arts Objects

PERSONAL MOTIVATIONS FOR VISITING HISTORIC houses or museums are varied. If the house once belonged to a famous person, visitors may hope to learn something about that person. If it has been preserved as a type of historic architecture, they may seek a better understanding of the subject. If the building is located in a garden or park, the focus might be on the landscape. Visitors may be there to share the experience with others, to leave everyday cares behind, to reflect and renew, or to experience beauty.[1] They may choose to take a guided tour, view an exhibition, or listen to recorded messages in order to deepen their experience with the objects in the collection. What should be the value of such an encounter? How can a collection of domestic objects and works of art—chairs, tables, dishes, needlework, portraits, glassware—provide experiences that will enhance the lives of visitors beyond their moments in the museum? By exploring rich and varied topics, they may associate the objects with personal or historical pasts; notice and describe characteristics; evaluate rarity, usefulness, or comfort; or categorize similar objects together.[2] The challenge for interpreters lies in understanding and, if possible, working with visitors as they see and think about objects and explore their meanings for the past and the present.

How is this interpretive challenge to be met? To serve museum visitors well takes a concerted effort. Interpretation has both a "general" and a "particular" presence. It is both an institution-wide program and a discrete activity; the two are interdependent.[3] On one hand, it is the program of an institution by which its leaders, staff, and stakeholders decide what it means to its community as a public institution. It is a process of planning and action. On the other hand, interpretation applies to the moments that occur every day as visitors engage with the museum's messages. Often this refers to personal interpretation, the time when a guide and visitor reach new understanding in a museum exhibition. But it is also part of those occasions when an exhibition curator chooses understandable words about just the right object on a label or themes for an audio tour that will interest visitors.

In this book, the focus is on the "particular meaning" of interpretation. Specifically, the focus is on those aspects of the experience that interpreters can influence. What will that interpreter, as the museum's representative, give back to visitors who have spent their time, money, and energy to visit? It is an important transaction and is the point at which the museum's overall interpretive program is realized. What special blend of knowledge, technique, and personality results in a satisfying experience for both guests and guides?

For years, interpretation was synonymous with knowledge. A guide's training consisted of extensive and intensive work in the collection absorbing facts: What is it? Who made it? When? Of what? Where? The answers to these questions and the ability to convey the information to visitors formed the basis of the reputation of museum guides as "knowledgeable." Up-to-date knowledge about objects and audiences is indeed a cornerstone of excellent interpretation; however, excellent interpretation is both knowledge based and visitor centered. Since the early 1980s, guide training at many sites has been expanded to include sessions in techniques and theories of interpretation as well as content. What is interpretation, anyway? There is much literature on the topic, and all authors begin with their own definition.

William Alderson and Shirley Low's *Interpretation of Historic Sites*, in its first edition, provides a working definition: "Interpretation is an attempt to create understanding."[4] The word *attempt* implies continual efforts to reach the visitor, to meet his or her needs, and to elicit a response and interest. It is not a static word suggesting an easily attainable goal. The word *understanding* is also crucial. Alderson and Low did not say that interpretation is an attempt to create knowledge; rather, they chose a word that indicates a step beyond facts—*understanding*.

The emphasis on understanding is one shared by Freeman Tilden. His classic *Interpreting Our Heritage* lists six principles, one of which states, "Information, as such, is not interpretation. Interpretation is revelation

based on information." Tilden elaborates this point in another of his principles: The chief aim of "interpretation is not information but provocation."[5] Another important source, William Lewis's *Interpreting for Park Visitors*, also addresses understanding. Lewis writes that interpretation should "help the visitor understand the interrelations among as many aspects of what is being observed as is possible."[6] The common denominator in these writings is the concept of understanding. It implies that through their experiences with interpreters, visitors have gained insight, not just knowledge.

Another important concept in these definitions is revelation. According to Tilden, interpretation is "revelation based on information." *Revelation* means something quite different from *telling*. Revelation occurs when a guide uses interpretive techniques that encourage guests to respond, to be aware of their own diverse associations with objects, and to form their own judgments and ideas about the objects seen.

Guiding in a historic house or decorative arts collection requires a skillful blend of knowledge and communication if understanding and revelation are to be achieved. The qualities distilled from these classic writings about interpretation, tested through years of experience, can provide a checklist. Excellent interpretation is knowledge based, visitor centered, coherent, and personal.[7]

Knowledge-based interpretation is about objects and about audiences. It is up-do-date, aware of new scholarship, and aware of cultural trends that affect visitors' interests. Visitor-centered interpretation succeeds in eliciting responses and interest from visitors. It meets the varied needs of visitors. Its tone is one of respect for visitors' diversity, including their learning strategies and associations with objects. It is comfortable for visitors and encourages them to be open to learning something new. It models various questions for object learning, so that visitors see and hear their own questions raised and addressed. Coherent interpretation weaves connections among objects. It is purposeful and organized. Personal interpretation is shaped by the interpreter's personality and interests.

Compare this list with the national standards on interpretation and education published by the American Association of Museums (AAM) in 2005. The AAM standards apply not only to the discrete activity of interpretation—one guide with several visitors in an exhibition at a particular moment—but also to an institution's interpretation program. In simple language, the AAM wants America's museums to be knowledgeable about their subject; to understand the audience and meet its needs; to be sure visitors enjoy their experience; and to change it if they don't.[8]

Excellent interpretation is satisfying for the visitor and the guide. Using interpretive techniques that promote understanding and revelation, a guide helps visitors find meaning in the material world.

NOTES

1. Combs; Alderson and Low (1976), 56–61.
2. Eversmann et al., 146–47.
3. Alderson and Low (1985), 3.
4. Alderson and Low (1976), 3.
5. Tilden, 9.
6. Lewis, 31.
7. This list was developed by members of Winterthur's Education Research Team (Tracey Rae Beck, Amber Auld Combs, Pauline K. Eversmann, Deborah V. R. Harper, Rosemary T. Krill, Edwina H. Michael, Beth A. Twiss-Garrity, chair) in concert with interpretation guide specialists. It has been used since 1994 in the Excellence in Interpretation seminar presented to all Winterthur museum interpreters.
8. American Association of Museums, *National Standards*, 19, 59–61.

BIBLIOGRAPHY

Standard Sources for the Study of Object Interpretation and Visitor Experiences in Museums

Alderson, William T., and Shirley Payne Low. *Interpretation of Historic Sites*. Nashville, Tenn.: American Association of State and Local History, 1976; 1985. (Subsequent editions published by AltaMira Press, http://www.altamirapress.com.)

American Association of Museums. *Excellence and Equity: Education and the Public Dimension of Museums*. Washington, D.C.: American Association of Museums, 1992.

Falk, John H., and Lynn D. Dierking. *Learning from Museums: Visitor Experiences and the Making of Meaning*. Walnut Creek, Calif.: AltaMira Press, 2000.

Lewis, William J. *Interpreting for Park Visitors*. Philadelphia: Eastern Acorn Press, 1980.

Tilden, Freeman. *Interpreting Our Heritage*. 3rd ed. Chapel Hill: University of North Carolina Press, 1977.

Additional Sources

American Association of Museums. *National Standards and Best Practices for U.S. Museums*. Commentary by Elizabeth E. Merritt. Washington, D.C.: American Association of Museums, 2008.

Ames, Kenneth L. "Why Things Matter." *The Material Culture of American Homes: American Decorative Arts in a Humanities Perspective*. Philadelphia: Media Shop, 1985. Slide tapes.

Borun, Minda, and Jennifer Dritsas. "Developing Family-Friendly Exhibits." *Curator: The Museum Journal* 40, no. 3 (September 1997): 178–96.

Combs, Amber Auld. "Why Do They Come?" *Curator: The Museum Journal* 42, no. 3 (July 1999): 186–97.

Eversmann, Pauline K., et al. "Material Culture as Text: Review and Reform of the Literacy Model for Interpretation." In *American Material Culture: The Shape of the Field*, edited by Ann Smart Martin and J. Ritchie Garrison, 135–68. Winterthur, Del.: Henry Francis du Pont Winterthur Museum, 1997.

Fleming, E. McClung. "Artifact Study: A Proposed Model." In *Winterthur Portfolio 9*, edited by Ian M. G. Quimby, 153–74. Winterthur, Del.: Henry Francis du Pont Winterthur Museum, 1974.

Gender, Allison, and E. Sue McCoy. *The Good Guide: A Sourcebook for Interpreters, Docents, and Tour Guides.* Scottsdale, Ariz.: Ironwood Publishing, 1985.

Roberts, Lisa. "Changing Practices of Interpretation." In *Reinventing the Museum: Historical and Contemporary Perspectives on the Paradigm Shift*, edited by Gail Anderson, 212–32. Walnut Creek, Calif.: Rowman & Littlefield, 2004.

Looking at Objects

HELPING VISITORS TO LOOK CLOSELY AT AN OBJECT is a fundamental interpretive goal. Interpreters can demonstrate and encourage visitors to use eyes as well as ears and minds. By looking actively and then thinking about objects, visitors can understand their many meanings. Active looking allows visitors to understand their own preferences and tastes as well as the subjective aesthetic judgments of others.

Art historians and critics codify and refer to this method of active looking as aesthetic analysis. As applied to decorative arts, it aids in understanding an object's visual appeal: the gleam of a silver tankard (material); the curved leg of a Queen Anne–style chair (line); the size of a glass teapot (scale); the air-twist stem in an English wineglass (ornament); the contrasting yarns in a crewelwork bed hanging (color); the dominance of a large looking glass hung between two windows (volume); and the balance among all parts of a brass andiron (proportion).

Material is the substance that composes an object or its parts. Depending on the material, it is more or less possible to manipulate line, color, scale, and texture. The wood of a high chest might be veneered, painted, or carved. The glass of a bottle may be colored, textured by being blown in a mold, or ornamented with cutting or engraving.

Color implies the name (hue), the relative lightness or darkness (value), and the relative vividness (saturation) of the shades we see. The names of colors are familiar; we learn them as the primary colors, secondary colors, and intermediate mixtures. Value implies the amount of white or black an artist mixes with pigments. We describe value when we call a color "light red" or "dark red." Saturation suggests how vivid or intense the color itself is. Imagine the red or blue of a new United States flag, fresh from its box. These colors would be more highly saturated than the red and blue of an older, well-used, faded flag. These terms offer a vocabulary to describe the colors we see. Color is a useful tool, since it often plays a relatively strong part in our reaction to objects. Similar colors, however, may be perceived differently by different people.

Texture indicates the relative roughness or smoothness of material as it presents itself to our eyes or our touch. We might be tempted to dismiss texture as inherent in the material. But compare in imagination the various textures of wood on a slat-back chair, smoothly worn in some places, revealing grain lines in others, with incised lines on its front and rear posts offering a decorative, textural element as well as a guideline for the chair maker.

Line describes the lines, angles, and curves of an object, both in outline and within the design. The straight lines and right angles of a chest made in the seventeenth century contrast with the curving lines of a Queen Anne–style joined chair.

Ornament refers to the decorative qualities of an object. The placement and motifs of ornamental devices can be noted and compared. The technique for achieving the ornamentation and the extent to which it is integral to or applied to the object can be observed. In a chair in the federal or early classical style, the straight legs and shield-shape back are ornamental, as are the inlay on the legs and carving on the back.

Scale describes the relationship of an object's size to some external standard such as a standard ruler or a full-grown human being. The scale of Independence Hall in Philadelphia, as impressive as it was to this country's founders, is now considered small compared to the twelve- and thirteen-story office buildings nearby.

Proportion describes how the various dimensions of an object and the size of its various parts relate to one another. In evaluating proportion, an object's dimensions within itself are more important than its comparison to an external standard. A stemmed wineglass, with its most obvious largest circumference near the top, appears tall and thin, drawing the eye upward. A glass decanter may be even taller, with a thin neck, but the largest circumference is toward the bottom. These proportions present a different visual impression.

Volume describes the way an object takes up space. Volume depends not only on how large an object is but on whether it is framed compactly or has extensions. It also depends on the relationship of solids and

voids. For example, compare an upholstered easy chair to a Windsor chair with a high back like a long-tooth comb. Regardless of the comparative dimensions, the upholstered chair gives an impression of volume different from the Windsor chair.

Although volume may be described objectively (the measurement of an object in cubic units), the concept of volume or mass in aesthetic analysis also has a subjective component. For example, space and its use in a Grecian temple are different from that in a Gothic cathedral, influenced by the different religious practices, values, and worldviews of people at the time.

Visual appeal may attract a viewer's attention, but other aspects of the object may sustain attention. Aesthetic analysis provides a starting point in an interpretive scheme that raises questions about why the object looks the way it does. What other visual choices were available? Why did the maker, owner, or user choose an object that looked the way it did?

BIBLIOGRAPHY

Taylor, Joshua. *Learning to Look: A Handbook for the Visual Arts*. Prepared with the Humanities Staff of the College at the University of Chicago. Chicago: University of Chicago Press, 1957.

Understanding Style

THINK ABOUT THE DIFFERENT WAYS PEOPLE USE THE word *style*. We might notice someone's individual style, talk about a person's lifestyle, or refer to the style of a novel. Entrées on a restaurant menu are prepared in the style of a particular cuisine. In the broadest sense, the word *style* may be applied to musical compositions, literary works, objects, events, or performances. *Style* can even be applied to the characteristic way in which some people think or behave.

In the decorative and fine arts, the word *style* describes a specific set of visual characteristics. In this vein, when we refer to a chair as being in the "Queen Anne or late baroque style," the words immediately bring to mind images of curved legs with little carved ornament. In the same way, describing a silver candlestick as "federal or early classical revival" will suggest an object shaped like a column with a decorated capital.

A DEFINITION OF STYLE

To confine the use of the word *style* to merely listing visual characteristics, however, is limiting. Understood in its fullest sense, style is more than an accumulation of design elements. Rather, style also refers to the choices people make within the limitations imposed by society and culture. In order to fully understand the concept of style, it is important to move beyond describing visual characteristics and include additional concepts such as relationships and choice. For the study of decorative arts, style is the repetition of identifiable visual characteristics that suggests relationships—object to object, object to people, object to its world—and results from choice. These three words—*characteristics, relationships,* and *choice*—need to be carefully defined to better understand the concept of style.

The characteristics that are easiest to see and understand are the visual characteristics of objects. A list of such elements includes (but is not limited to) material, color, texture, ornament, line, scale, volume, and proportion.[1] Some examples are the curve of a rococo teapot (line), the decoration of a delftware plate (color), and the size of a gold shoe buckle (scale).

Repeated design elements, taken together, categorize a style. In this book, the chapters about furniture include analyses of the most distinguishing characteristics of various styles.

Relationships imply connections between or among objects. One object might have a design element exactly like another object. Thus, there is a relationship between a chair and a silver tray when both have a ball-and-claw foot. Objects might be made in exactly the same way; two chests with identical construction details are certainly related. Second, relationships imply connections between objects and people. Things that were owned by the same person or made by the same workers often have similar visual characteristics. Third, relationships exist between or among objects and other aspects of the culture and society in which they exist. A federal or early classical revival desk-and-bookcase with inlaid eagles or an English earthenware plate with an eagle in the center are objects that mirror the values of the society in which they were used, the young United States.

The choice of certain design elements or combinations of elements may be consciously made at a particular time by an individual or group, as in the above examples; that is, the choice of the eagle as an inlay design on the desk-and-bookcase could have been a joint decision by the craftsman who made it and the person who ordered it. On the other hand, choice may be unconscious, the result of an accumulation of related design decisions. Choices generally are made within certain boundaries, often called conventions. Conventions may be general or they may be specific to a particular group of people in a particular time and place. One convention might be wealth. A buyer in the eighteenth century might have preferred a highly carved tea table, but his resources allowed only the purchase of a table without carving. Another convention can be religious affiliation. Quakers in eighteenth- and nineteenth-century Pennsylvania opted for less lavish textiles in their clothing, in keeping with their commitment to simplicity. Cultural values can also be classified as conventions. The Pennsylvania Germans

who lived in the outlying regions of Philadelphia and Lancaster chose to purchase objects similar to those they had known in their homeland rather than those of the predominant English culture.

CHANGES IN STYLE

Understanding characteristics, relationships, and choices is important in grasping the complex concept of style. Identifying and understanding a style often leads to a complex question: How and why does style change? Even experts disagree on the reasons; finding answers requires thinking about how and why ideas permeate a society and why people make certain choices.

In the decorative arts, influences from other regions or cultures often flow through objects and printed designs to the skilled maker or discriminating customer who chooses the new look. Objects imported from Europe or Asia influenced colonial artisans. Printed designs, sometimes in books, also spread new ideas about how things should look. Craftsmen who traveled to new areas seeking markets for their skills worked in new ways and trained others. If they were astute and lucky, they settled in a region where people's tastes and resources made them into good customers.

New styles develop when people stretch and change the limits of convention. Sometimes remarkable individuals, with their skills and vision, drive the change. They not only look for new ways to achieve the same ends but also work toward totally new goals. Many factors may cause such changes, including improvements in technology, availability of materials, changes in attitudes, and influences from other regions or cultures. Resulting changes may be accepted as part of an existing style or as an entirely new style.

Even when the forces for change overcome those for stability, change is seldom sudden. A single design element may change and then become part of a style because it is a "good" solution. The adoption of the curved back in the William and Mary, or early baroque-style, chairs is a case in point. This element was memorable, repeatable, and worked well within the existing conventions. It was accepted as part of the style. When the curved back was joined by crooked legs, a yoked crest rail, and a vase-shape splat, a new style was created, which we now call a later phase of the baroque, or Queen Anne.

DESIGN AND FASHION

The term *design* is not synonymous with the term *style*. A design is a plan for accomplishing a purpose. A person designs when he or she makes a plan (whether mental or physical), makes an object (like a chair), or arranges and manipulates things made by others (as in landscaping a garden or arranging an interior).[2] Sometimes it is possible to discern the designer's purpose by studying an object carefully. For example, one designer's problem may be the need for a warm, comfortable item of clothing. To solve the problem, he or she may design a particular weave for a fiber. Another designer, trying to duplicate oriental lacquerwork, may solve the problem by designing a new technique. If the resulting design—the particular way to achieve this particular end—is repeated in a number of objects, it may become part of an existing style or even lead to a new style.

Fashion, like design, is a term sometimes used interchangeably with style, but its meaning is different. A style may be in or out of fashion. A fashionable style is one that is dominant or popular among influential people and generally implies a particular time, place, or group. It also can mean change for change's sake, expenditures on objects for the sake of novelty, and competition among people trying to be "in fashion."

The styles described in the chapters on furniture continued in fashion among elite urban dwellers for limited, fairly well documented periods of time. Once in the design vocabulary, however, styles often survive or revive at different times and in different places. Examples of furniture with rococo or Chippendale characteristics were made long after the wealthy citizens were purchasing tables, chairs, and sideboards with classical revival elements. The curvilinear, naturalistic carved decoration on rococo furniture of the eighteenth century reappears in a slightly different way on rococo revival furniture in the nineteenth century. But fashion is not limited to the dominant culture. Other groups developed their own fashions. Dutch settlers of the Hudson River Valley, for example, continued to prefer the wardrobes reminiscent of their homeland long after they had adapted other aspects of the predominant English fashions. The Shakers, a religious group that emigrated from England in the late eighteenth century and grew rapidly in the early nineteenth century, produced furniture, textiles, and paintings that reflected their religious beliefs.[3] Non-Shakers were attracted to the objects because of the simplicity of their design, their functionality, and their superior construction. When they purchased and used these objects, they established a "fashion" for Shaker design.

NAMING STYLE CATEGORIES

For decorative arts interpreters, widely understood and accepted terminology for the various styles would be useful. Decorative arts scholars, however, have published various statements about style terminology. How can interpreters understand and use this scholarly work as they help visitors find meaning in objects?

Two common categories of terms in books and exhibitions in the United States are those called *art historical* and those called trade, collector, or *traditional* terms. Some decorative arts historians and museums are adopting the terms from art historical scholarship, which includes mannerist, baroque in its early and late phases, rococo, and classical revival in its early and late phases. The following section, a synopsis of art historical terms, as well as sections in the various chapters about furniture present background on these terms.

The newer, art historical terms appear at times to be simple substitutions for the older terms. *Jacobean* or *seventeenth-century* becomes *mannerist*.[4] *William and Mary* becomes *early baroque*, and *Queen Anne*, *late baroque*.[5] *Chippendale* is replaced with *rococo*, and *federal* and *empire* styles are called early and late classical revival.[6] However, a new name also emphasizes different aspects in an interesting way. For example, the term *late baroque* calls attention to the sculptural, dynamic, three-dimensional quality of the furniture, which it shares with the earlier baroque style, a visual relationship that is not as clear when we use the term *Queen Anne*.

People who are regular museum visitors or who read furniture history publications will be familiar with these terms. Many museum visitors who follow home furnishings magazines in the popular press, or the antiques or reproduction market, where the traditional terms are more widely used, may be less comfortable with art historical terms. Some scholars argue that art historical terms deflect attention from the people who actually used the objects, the words they understood, and the complexity of their lives and society. A piece of furniture that we might refer to as rococo was called, in the eighteenth century, "modern" or "stylish."[7]

The traditional terms for styles are a mix of references. Some identify historical epochs, like seventeenth-century for objects made at that time and federal for objects that were fashionable just after the United States was founded. These are problematic because style and chronology are not the same. The phrase "style period" is a misnomer. For example, furniture with particular style characteristics could have been made before or long after the historical era ended. Some traditional terms refer to monarchs, such as William and Mary or Queen Anne, or a famous designer, such as Chippendale. Some decorative arts scholars criticize these terms as tying American decorative arts to English scholarship. They point out that Queen Anne–style furniture was not made in this country until after the reign of Queen Anne.[8] In addition, some of these terms were coined by collectors in the late nineteenth and early twentieth centuries and, over the years, have referred to very different kinds of furniture. Too, museum visitors whose knowledge of furniture is rooted in English or French studies will use different monarchical names, like Georgian or Louis XV for furniture in the rococo style.

What are the best terms for an interpreter of decorative arts to use? They are those that the interpreter understands and that communicate most clearly to the visitors. Style terms are, in essence, a shorthand way of visualizing objects in the style. If the words *Queen Anne* bring a nod of recognition from a visitor while the term *late baroque* brings a confused frown, the interpreter's job is to use the more familiar term, confirm what it means, and suggest what *late baroque* means. It is important to communicate clearly and understandably before trying to enlarge the visitors' ideas or knowledge. It is also important to avoid using language as a barrier or suggesting that the visitor is not up-to-date or correct.

A good example of a popular interpretation that acknowledges scholarly concerns but tries to communicate the essence of style appears in the guidebook to the Governor's Palace at Williamsburg:

> Scholars of the decorative arts may quibble over terms like baroque and rococo, early and late Georgian, or William and Mary, Queen Anne, and Chippendale. And there are indeed significant differences between them. But all European and American art in the period 1700–1750 employed visual forms that were principally curvilinear and often were embellished with naturalistic ornaments, mainly foliage, flowers, and shells.[9]

A museum interpretation in this vein would acknowledge the words that are preferred by the interpreter and visitor alike. The interpretation would also communicate the visual essence implied by the terms. In this book, you will find both art historical and historical terms, and we have tried to be careful about using them correctly.

In the end, however, what we call an object is less important than understanding why it looks the way it does. Reaching this understanding requires a thorough knowledge of not only the visual characteristics but also the important cultural and social factors that influenced how the style developed and matured. It is not an easy task. One scholar's words about the early colonial period summarize this complexity: "Most of the stylistic movements present in early colonial America were complicated hybrids of European and English styles brought to the region by immigrant craftsmen or through trade."[10]

A SYNOPSIS OF THE ART HISTORICAL TERMS

Both traditional and art historical terms divide objects into categories, defined by clusters of visual characteristics and by a chronology of fashionable or influential styles. They locate an object in a series of like objects, often in an attempt to define its place and time of manufacture or use. As mentioned above, this process is a risky one and may work best for furniture and silver made in urban settings that was not strongly influenced by traditional or utilitarian needs. In addition, the terms may satisfy our modern need to categorize and identify but not our curiosity about the original users and their perceptions of the objects. Nevertheless, art historical terms are useful in interpretation. What are the meanings of these terms? How and why did preferences for certain visual characteristics develop at certain times?

As different as objects in the various styles may look to modern eyes, a unifying element was their reliance on a common source—the architecture, proportions, and motifs of the classical world. During the decades from 1620 to 1860, but especially in the 1700s, a classical education was essential to being considered "genteel." It meant learning the languages of ancient Greece and Rome, reading their great literature, and studying their history.

Classicism is the study of Greek and Roman civilizations as it evolved after the rediscovery of ancient civilizations in Italy during the Renaissance. The classical world itself extended from approximately the sixth or seventh century B.C. to the last years of the Roman Empire in the fourth century A.D. Extant architecture, including Greek and Roman temples as well as Roman military and civil architecture, forms the largest body of evidence about Greek and Roman civilizations. The ancient world also left behind abstract decoration based on the combination of geometry and naturalistic figures. Such decoration appeared as wall paintings

or frescoes and sculptural reliefs. Further evidence of the material culture of the classical world was found in drawings on Greek and Roman vases, stone seats in stadiums, and surviving bronze forms such as lamp stands and table and chair legs. The discovery of the decorations fueled an active fascination with classical civilizations, and this period was marked by a reappraisal of Greek and Roman civilizations.

From the Renaissance onward, the aesthetics of ancient Greece and especially Rome formed the basis for the development of style. As more was learned about ancient civilizations, changes in style occurred. Each variation attempted to change what had gone before, sometimes by establishing new rules that were perceived to be more correct and then applying those rules to new structures and spatial relationships. These ideas were put into printed books and engraved designs that circulated throughout Europe.

It was the mannerist version of classicism that the English colonists in North America adopted in the late seventeenth century. Mannerism, an artistic movement of the Renaissance, extended and played upon the classical conventions established during the fifteenth century in Italy. From Rome its influence traveled north through Europe. In the decorative arts, mannerism reached its fullest expression in the gold and silver objects favored by European royalty. Mannerism reached England in a much-altered form in the late sixteenth century. The important features of this style include monumental scale, massive architectural components, and the extensive use of strapwork (ornament consisting of twisted or intertwined bands) and geometric forms. Mannerism in the decorative arts and architecture favored an abundance of ornament.

By the beginning of the eighteenth century, a new variation on classicism had taken root in Europe. Once again the movement began in Italy, where early seventeenth-century architects and artists embellished the mannerist tradition, producing a lively and fanciful interpretation of classical design principles. This new style, today called baroque, is characterized by the reintroduction of the curved line, sculptural forms, painted decoration, and the use of architectural elements for ornament.

The visual effect of the baroque is to maximize the effects of light and shade, texture and form. The early baroque, fashionable among urban elites in the Anglo-American colonies between 1690 and 1730, makes extensive use of foliage and scrolls within a symmetrical context. Dramatically expanded trade

with Asia resulted in the incorporation of exotic motifs into European and English design. During the early eighteenth century, increased levels of prosperity as well as urban development led to the growth of groups of skilled colonial artisans and artists who were increasingly capable of providing high-quality versions of English goods in such objects as furniture and silver. Ceramics, textiles, metals, and glass continued to be imported, providing visual evidence of the new baroque aesthetic that was popular in Europe.

The later phase of the baroque, dating roughly between 1730 and 1760, is characterized by the ascendance of the curved line. Forms emphasize a pronounced mass and robust ornament with an interest in advancing and receding surfaces. Designs combine solids and voids as equally active visual elements. In England, in particular, architects rejected the more elaborate style of the early baroque associated with Christopher Wren in favor of the designs of Andrea Palladio and Inigo Jones that adhered more closely to a purer version of classicism. In the decorative arts, there was a blending of many elements: Chinese design known through ceramics; the continuation of the detailing of the early baroque; and components of a new, fanciful aesthetic emerging in France, later to be called the rococo.

Religious and political events on the European continent encouraged large-scale immigration to England and America, including skilled craftsmen. Some settled in urban centers, while others gathered in enclaves to continue their traditions; they responded to the conflicting design impulses in varied ways. Each colonial center and its dependent region developed a localized expression based on the continuity of shop traditions. At the same time, ethnic enclaves favored European Continental design traditions that resisted English influence.

The diversity of design sources continued as an impetus for the next major stylistic change, rococo, which became fashionable in the colonies by 1760. More so than any of the previous styles, the rococo departed from classical design principles, emphasizing asymmetry and a fanciful character using naturalistic and exotic motifs. The fully developed expressions of the style use convoluted surfaces and complex outlines wherein ornament ultimately becomes form. The play of light is consciously exploited as a compositional device. Like the later baroque, the rococo reflects many different sources: mannerist grotto ornament and architecture, the smooth rippling surfaces of Dutch auricular (that is, earlike) ornament developed for silver

in the late sixteenth and early seventeenth centuries, and baroque scrollwork and acanthus leafage.

The rococo style in France was championed in the early eighteenth century by architects who avoided the strict symmetry of classical form in interiors and replaced or overlaid it with representations of rocks, shells, leaves, and creatures that spread over the entire surface of a room. An increased use of looking glasses as paneling and an interest in shadowy, spectral light sources, combined with a softer pastel palette, made these rooms the most antistructural of any yet formulated since the Gothic. In the decorative arts, the rococo resulted in fancifully designed, lavishly decorated forms.

The rococo style was disseminated through printed design plates in which types of ornament and the formulas for applying it were clearly set down. As in the Renaissance, this was an era when decorative-arts design books intended for a specific medium—furniture, metals, or glass—set standards for all media. Thomas Chippendale's *Gentleman and Cabinetmaker's Director* (1754) was an example of the design books that found their way to the colonies.

American colonists did not wholeheartedly accept the rococo until after 1760; it then remained in fashion until the 1780s, well after a classical revival had swept Europe. Certain carvers were actively practicing the rococo in North America in the 1750s, but the style did not truly flourish until Chippendale's *Director* began to circulate and more English carvers immigrated. Like mannerism, the rococo was easily disseminated through the medium of prints but required experience to be executed with assurance.

A renewed interest in classicism is rooted in eighteenth-century archaeological activity in Italy and Asia Minor, including excavations at Pompeii and Herculaneum. The rediscovery of these antique cultures promoted the conscious use of Roman and later Greek forms, details, and coloring. The impetus for neoclassicism seems to have come in the 1750s from French and English designers who turned away from the rococo. The new discoveries in Rome and Greece, known through published designs and commentaries, excited interest in classical designs.

The continuing popularity in England of Palladianism abetted the interest in classicism. New designs swept the country beginning in the late 1750s, particularly the work of Robert Adam. New, more refined versions of classical grotesques were combined with urns, drapery, festoons, and animal motifs in an elegant and delicate manner that still retained something

of rococo aesthetic and coloring. All of the decorative arts followed architecture's lead in their simplified contour and plan, and complete squares, ovals, and arcs became the favored outline.

With a few exceptions, the classical revival was not transmitted to North America until after the Revolutionary War. Following European precedents, United States citizens experienced an earlier phase of the classical revival, also called federal, and a later phase, now called empire or late classical revival. The federal phase favored use of such decorative motifs as swags, urns, the eagle, fasces, and pictorial inlay. After 1815 a new form of neoclassicism emerged, derived from archaeological activity and the intellectual pursuit of accuracy. There was an awareness and identification of Greek, Roman, and Egyptian motifs. Architectural principles clearly influenced the design and detail of furniture and furnishings. Monumentality, a preference for vigorously sculpted motifs, and strong color contrasts characterize objects of this era.

This later classical revival (1815–1840 in North America) first appeared in France. The designers at Napoleon's court engaged in a deliberate propaganda effort by creating a heavier, Imperial Roman strain of the neoclassical design. Designers such as Charles Percier and Pierre F. L. Fontaine as well as popularizers like Pierre de La Mésangère produced engravings of their designs. In England designer Thomas Hope also produced designs. Increased emphasis was placed on luxurious materials and surface effects.

A second distinct phase of later classicism continued the purifying impulse of earlier theorists, although their conception of what was "pure Greek" often tended to be monolithic in scale. Coinciding with this was a nascent romanticism and exoticism that awakened interest in the medieval Gothic, the Egyptian, and the Middle Eastern. The interest in Egypt developed partly from Napoleon's expeditions, while the Gothic impulse, particularly in England, was linked to nostalgia for a romanticized medieval past. For the most part, exotic detail was merely grafted onto classical frameworks.

The stylistic trends that followed this period consisted of a reexploration of Renaissance design sources and a series of revivals. In the late nineteenth and twentieth centuries, the classical elements in design, particularly in architecture, witnessed a revival in the Beaux-Arts aestheticism that was paralleled by a series of experiments with form and function associated with the arts and crafts movement. Recently, with the development of postmodernism, explicit classical references have returned to the standard design vocabulary.

Even in classical antiquity, however, the rules of architecture and other artistic media were bent or violated for expressive or structural purposes. The range of possibilities available to artists between 1550 and 1850 was not inhibited by the rules of the antique, and artists experimented with a range of structural and expressive possibilities. However, although artists became increasingly aware of other architectural and decorative traditions, like those of China or the Romanesque and Gothic styles of medieval Europe, they never entirely lost interest in classical antiquity, and it continues to influence our artistic awareness today.

CONCLUSION

Style is a complex topic, yet it is useful in interpretation. Museum visitors often enjoy learning to identify style characteristics and testing themselves in categorizing objects. It gives them a way of thinking about what they see and what they like in museum settings. Style terms provide interpreters with a verbal shorthand to communicate clusters of design elements by emphasizing visual characteristics. It also gives interpreters a way to suggest the cultural and social contexts of style development by emphasizing relationships and choices. The concept of style reminds interpreters and visitors alike that they are studying objects made, used, and valued by people, in all their compelling variety.

NOTES

1. Taylor, 54–68.
2. Ames, 1.
3. Swank, 24–57.
4. Trent, 368.
5. Lindsey, 7–8.
6. Talbott, 6; Cooper.
7. Alexander, 1; Fitzgerald, 12–14.
8. Gusler, 248–51.
9. Carson, 33–36.
10. Lindsey, 5.

BIBLIOGRAPHY

Alexander, Forsyth, ed. "Hot Rococo." *The Luminary: Newsletter of the Museum of Early Southern Decorative Arts* 13, no. 2 (Fall 1992): 1–3.

Ames, Kenneth. "Why Things Matter." In *The Material Culture of American Homes, 1650–1920*, edited by Kenneth L. Ames, William Ayres, and Nancy L. Garrison.

Winterthur, Del.: Henry Francis du Pont Winterthur Museum, 1991.

Carson, Barbara. *The Governor's Palace: The Williamsburg Residence of Virginia's Royal Governor.* Williamsburg, Va.: Colonial Williamsburg Foundation, 1987.

Cooper, Wendy A. *Classical Taste in America.* New York: Abbeville Press, 1993.

Fitzgerald, Oscar P. "Book Review: *American Furniture 1998.*" *Newsletter of the Decorative Arts Society* 7, no. 1 (Spring 1999): 12–14.

Gusler, Wallace B. "Book Review: Nancy Richards and Nancy Goyne Evans, with Wendy A. Cooper and Michael S. Podmaniczky. *New England Furniture at Winterthur: Queen Anne and Chippendale Periods.*" In *American Furniture 1998,* edited by Luke Beckerdite, 248–51. Milwaukee, Wis.: Chipstone Foundation, 1998.

Heckscher, Morrison H., and Leslie Greene Bowman. *American Rococo, 1750–1775: Elegance in Ornament.* New York:

Metropolitan Museum of Art and Los Angeles County Museum of Art, 1992.

Lindsey, Jack L. *Worldly Goods: The Arts of Early Pennsylvania, 1680–1758.* Philadelphia: Philadelphia Museum of Art, 1999.

Swank, Scott. *Shaker Life, Art, and Architecture: Hands to Work, Hearts to God.* New York: Abbeville Press, 1997.

Talbott, Page. *Classical Savannah: Fine and Decorative Arts, 1800–1840.* Savannah, Ga.: Telfair Museum of Art, 1995.

Taylor, Joshua. *Learning to Look: A Handbook for the Visual Arts.* Prepared with the Humanities Staff of the College at the University of Chicago. Chicago: University of Chicago Press, 1957.

Trent, Robert F. "The Concept of Mannerism." In *New England Begins: The Seventeenth Century,* edited by Jonathan L. Fairbanks and Robert F. Trent, 3:368–79. Boston: Museum of Fine Arts, 1982.

Part Two

Introduction

THE FOLLOWING CHAPTERS FOCUS ON INTERPRETATION, on the attempt to create understanding.[1] They synthesize scholarship so that interpreters will find it relevant to interpreting their museum's collection. The chapters are like a traveler's guide that can lead the reader on a journey of discovery—a journey the interpreter and the visitor share. They will point in useful directions initially and continue to serve as ready references, but as the journey lengthens and intensifies, they will be replaced by more focused sources.

Each chapter begins with an introduction that considers a particular category of objects from the visitors' points of view. The introduction often describes the reactions museum guides notice when escorting visitors. In light of these first reactions, the chapter provides some general approaches that draw visitors into greater understanding and appreciation of the objects.

The four major sections of each chapter deal with looking at the object, thinking about style, making and marketing the object, and living with or owning the object. These sections were inspired by the interpretive goal that visitors have the opportunity to look at objects and think about their meanings to people in the past and in the present.

Each "Looking at" section lists several visual characteristics that are often most striking or important to notice. Sometimes it is a challenge to museum visitors and to interpretive staff simply to examine the object closely, in whatever way the visitor prefers and the museum makes possible. Close observation can often reveal interesting information or raise startling questions. This section encourages interpreters—and, through them, visitors—to look closely at objects, to see the characteristics of the object that are unique or that are repeated in like objects.

The "Thinking about Style" section suggests why objects came to look the way they did and why certain visual characteristics are repeated in many objects. This section reveals some of the relationships among objects, people, societies, and cultures that influenced people's choices about the objects.

The "Making and Marketing" and "Living with" sections elucidate some of the technological, economic, and social contexts in which the objects were chosen and used by the people who inspired, made, sold, bought, owned, used, passed on, saved, or admired them. These sections explore the meanings of the objects through the people who interacted with them and can help the interpreter move back and forth between the visually compelling object and the wonderfully complex stories of people, in the past and in the present.

The bibliography at the end of each chapter points the way to the road ahead on this journey of discovery about objects. It includes many sources considered to be standard in the study of the particular class of object as well as the sources used in the preparation of the chapter. Because this book began its useful life in 1992 as a training manual for Winterthur guides, many sources date prior to that year. Thanks to the help of many advisers, particularly Gerald W. R. Ward, and the unparalleled resources of the Winterthur Library, more recent important works have been added. The original 2001 edition was able to benefit from important research published by Winterthur's past and present curators and staff in the 1990s, including Arlene Palmer, *Glass in Early America* (1993); Ian M. G. Quimby, *American Silver at Winterthur* (1995); Nancy Goyne Evans, *American Windsor Chairs* (1996); Donald L. Fennimore, *Metalwork in Early America: Copper and Its Alloys from the Winterthur Collection* (1996); and Nancy E. Richards and Nancy Goyne Evans, *New England Furniture at Winterthur* (1997). This updated edition has culled from the more recent work of Winterthur's active publications program, including Pat Halfpenny and Donald L. Fennimore, *Campbell Collection of Soup Tureens at Winterthur* (2000); Donald L. Fennimore, *Iron at Winterthur* (2004); Linda Eaton, *Quilts in a Material World* (2007); Donald L. Fennimore and Ann K. Wagner, *Silversmiths to the Nation: Thomas Fletcher and Sidney Gardiner, 1808–1842* (2007); and Brock Jobe, *Harbor & Home: Furniture of Southeastern Massachusetts, 1710–1850* (2009).

Scholarship continually evolves, however. To pursue any of these topics further, an excellent annotated bibliography *Decorative Arts and Household Furnishings in America, 1650–1920*, edited by Kenneth L. Ames and Gerald W. R. Ward, is a good place to start. Several periodicals review newly published research. For the most recent scholarship, see the *Newsletter of the Decorative Arts Society* and the *Winterthur Portfolio*. The journal *American Furniture*, a publication about furniture made or used in the Americas from the seventeenth century to the present, has been published annually since 1993 by the Chipstone Foundation. It reviews new publications and offers a bibliography of recent works. Since 2001 Chipstone has provided the same service for ceramics scholars in the journal *Ceramics in America*. Digital versions of many articles are available at http://www.chipstone.org.

In the years between the first and revised publication of this volume, the Internet has become a useful research tool, and decorative arts Web sites are cited in the list below. Many major museums post excellent digital images and collections information electronically.

These chapters about objects are not definitive works of reference. Each chapter could contain numerous other categories of information and analysis. Rather, they are starting points for using a museum's objects as interpretive tools that can enhance the visitors' experience inside and outside the museum's walls.

NOTE

1. This is the definition of interpretation given in the first edition of William T. Alderson and Shirley Payne Low's classic *Interpretation of Historic Sites*; see especially the chapter "Interpretation of Historic Sites."

BIBLIOGRAPHY AND SUBSCRIPTION INFORMATION

Alderson, William T., and Shirley Payne Low. *Interpretation of Historic Sites*. Nashville, Tenn.: American Association of State and Local History, 1976. (Subsequent editions published by AltaMira Press, http://www.altamirapress.com)

American Furniture. Published by the Chipstone Foundation, Milwaukee, Wis. For subscriptions, see http://www.chipstone.org.

Ames, Kenneth L., and Gerald W. R. Ward, eds. *Decorative Arts and Household Furnishings in America, 1650–1920: An Annotated Bibliography*. Winterthur, Del.: Henry Francis du Pont Winterthur Museum, 1989.

Ceramics in America. Published by the Chipstone Foundation, Milwaukee, Wis. For subscriptions, see http://www.chipstone.org.

Ferguson, Eugene S. *Bibliography of the History of Technology*. Cambridge: MIT Press and the Society of the History of Technology, 1968.

Newsletter of the Decorative Arts Society. For updated information about subscriptions, see http://www.decartssociety.org.

Winterthur Portfolio: A Journal of American Material Culture. Published for Winterthur by the University of Chicago Press. For subscriptions, see http://www.journals.uchicago.edu/toc/wp.

Furniture in the Seventeenth-Century or Mannerist Style

INITIALLY, MANY MUSEUM VISITORS REACT TO seventeenth-century furniture with uncertainty. They call it "primitive" and "dark." Few examples survive, and modern reproductions are uncommon. Seventeenth-century (or mannerist) furniture is less familiar to visitors than objects in the Queen Anne (or late baroque) and Chippendale (or rococo) styles. Visitors may struggle to understand the formal, elaborately patterned, deliberately ordered world that produced this furniture. A guide's first step, then, may be to discuss why people chose to live with carved chests, turned chairs, and the elaborate joined cupboards, which we now call court cupboards.

Several facts about the seventeenth century are useful in interpreting its material culture. First, the early colonists transplanted their ideas about government, social hierarchies, and design from England and Europe. Second, the majority of early colonists in New England were members of the English middle class; they were not representative of the courtly or royal tradition. Third, immigrants regarded the natural environment of the New World as hostile, to be contained, controlled, and closely ordered. Finally, people's ideas about acceptable standards for housing and furnishings were different from modern ones. These factors affect the way seventeenth-century furniture looks and are important to its study and interpretation.

LOOKING AT SEVENTEENTH-CENTURY FURNITURE

Seventeenth-century furniture looked quite masterful and fashionable to an English Puritan settler in the Massachusetts Bay Colony. Its straight line and right angles and its massive quality give it an architectural look. Its ornament, whether carved or applied, is controlled and low-relief, sometimes emphasized by varying color in wood or in painted finishes. Imposing furniture with straight lines, right angles, and controlled, stylized ornament suggests the seventeenth-century style.

Architectural Qualities

Seventeenth-century furniture demonstrates architectural qualities in its proportions and in its ornament.

Designers and makers often produced furniture meant to look like small buildings. Using geometric formulas, the maker of a case piece designed it, in essence, as he would have designed a building's ground plan and elevations. First he decided the overall length and width; he then determined the height of the corner posts. Next he divided the four "walls" horizontally and vertically; finally, he applied decoration (fig. 4-1).[1]

Classical architectural elements inspired ornament, and the vocabulary used to describe classical architecture is often applied to the ornament on this furniture. Terms such as columns (base, shaft, capital), entablature (architrave, frieze, and cornice), dentils (small, toothlike rectangular wooden shapes), corbels, and glyphs describe details on case pieces and chairs.

Volume

Seventeenth-century furniture appears massive; it dominates space. Several design elements—line, proportion, and ornament—augment the furniture's solidity. Lines, both overall and within the piece, are straight and often join each other at angles. With the horizontal dimension frequently greater than the vertical, proportions present a short, broad appearance. Ornament, such as the carving on the front panels of a chest, is contained within such rectangular boundaries and rarely extends beyond the surrounding frames (fig. 4-2).

Color

Furnishings in the seventeenth century were vibrant with color, an effect of woods and paints. From very dark brown to light tan, shades of woods produced strong visual contrasts, not often visible to modern viewers. Furniture was often stained or painted. Black-painted maple reproduced the color of ebony. Other frequently used colors were verdigris (green copper acetate) and red (made from cinnabar, red lead, or iron oxides). White from white lead was a favorite that varied from pure white to stone gray. Blues were rarely available.[2] Specific combinations, most notably black with red and black with white, often appear together.

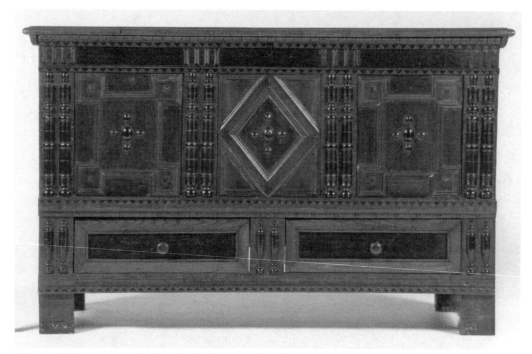

FIGURE 4-1. The applied ornaments (split spindles, bosses, or knoblike projections) on this architecturally inspired chest were painted black to simulate exotic woods like ebony, which were being used by English joiners and turners. Placed on the light-colored oak, these dark ornaments enhanced the geometric quality of the decoration. (Chest, Plymouth, Mass., 1680–1700. White pine, red oak, maple, cedar; H 33 in., W 53¾ in., D 20½ in. 1958.543 Winterthur Museum, gift of Henry Francis du Pont.)

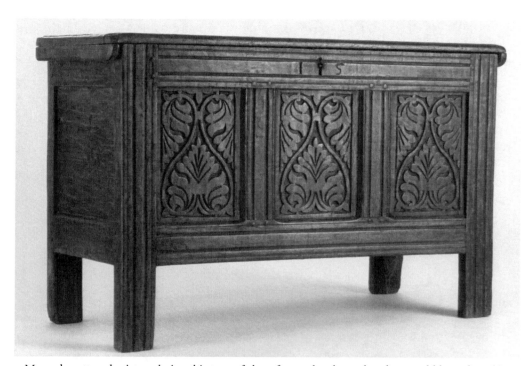

FIGURE 4-2. Massachusetts colonists ordering this type of chest from a local woodworker would have found its appearance familiar. The earliest immigrant craftsmen from England knew how to construct chests like this and to use a compass to lay out the carved design of opposing scrolls and abstract foliage. (Chest, John Houghton, Dedham, Lancaster, or Charlestown, Mass., 1630–1670. White and red oak, white pine; H 28⅓ in., W 44½ in., D 18¾ in. 1957.539 Winterthur Museum, gift of Henry Francis du Pont.)

Today, few objects retain their colorful appearance. Exposure to dirt and light, various surface treatments, or cleaning methods have altered surfaces dramatically.

Ornament

The decoration on seventeenth-century furniture—be it paint, low-relief carving, or wooden pieces applied to the surface—has similar visual qualities. Elements include curved lines or scrolls; abstract vines, leaves, and flowers; or passages of geometric designs such as repeated small triangles or sawtooth formations. The designs are complex, often covering much of the major surface, yet each unit is contained within the borders of the panel construction.[3] This type of ordered design works well with joinery that relies on green wood and mortise-and-tenon joints.

THINKING ABOUT STYLE

The distinct characteristics of volume, color, ornament, and architecture indicate definite choices made by the designers and users of the objects. The colonists brought ideas about how furniture should look and how their homes should be furnished. But what were the sources of these ideas? One important identifiable source is mannerism.

Mannerism, a northern European interpretation of late Italian Renaissance design, influenced seventeenth-century furniture. For today's art historians, mannerism, rooted in the Italian word *maniera*, describes aspects of sixteenth-century European fine arts. Its journey from the papal and princely courts of Michelangelo's Rome to the meetinghouses and homes of New England is long and complex.[4]

Current scholarship suggests that immigrants from the Low Countries, France, and Germany transported mannerism to England by 1600. From there, craftsmen and imported furniture carried it to New England. The usefulness of mannerism for the interpretation of seventeenth-century furniture in many modern public collections rests on two points: its identifiable set of design elements repeated in many objects and its concept of art and artistry.

Design Elements

New England furniture craftsmen employed the complex geometry and the stylized natural, animal, and human forms characteristic of mannerist decoration. Intricate, geometrically patterned bands, called strapwork, exemplify these elements (fig. 4-3). To enhance the impact of geometry, New England furniture makers used contrasting woods and applied paint (fig. 4-4). They also deliberately manipulated the rules of classical architecture to achieve an artistic end.[5] Architectural elements were often adapted for decorative effect.

The ornament on seventeenth-century or mannerist furniture made in the British colonies falls into two general groups: carved and applied. Paint was also used at times on carved objects, emphasizing the design by coloring certain areas or sometimes creating the design itself. Workers in the carved tradition decorated their objects with lozenges, diamond shapes, interlocking strapwork, flowers, fruit, C-scrolls, and anthropomorphic forms. Workers in the applied tradition emphasized geometry by applying half columns, heavy moldings, bosses, and diamonds.

Although the carved tradition reached northern Europe earlier than the applied tradition, some New England craftsmen used the two techniques simultaneously. A chest of drawers made for John and Margaret Staniford in 1678, for example, has carving in a geometric pattern on one drawer as well as applied moldings and split columns that divide surfaces into geometric patterns (fig. 4-5).[6] In its time, this chest would have been a new and expensive form. Colonists would have considered its ordered, geometric, stylized ornament to be graceful and sophisticated.

Mannerist Concepts about Art and Artistry

Artistic achievement emphasized an artist's refinement of—and abstraction from—nature.[7] The term *artifizioso* (with artifice) was considered to be complimentary because it suggested that the artist controlled his materials and techniques and surmounted all difficulties to achieve a polished, refined work.[8] To a New England craftsman, artificiality meant creating an object in a workmanlike way. In 1658, for example, Job Lane contracted to build a "good, strong, Artificial Meeting house" in Malden, Massachusetts.[9] Lane's clients expected him to produce a well-constructed building of good quality materials. They assumed that Lane and his fellow craftsmen were masters of the "art and mystery" of house carpentry that included a thorough knowledge of form and ornament according to an ideal English aesthetic. Small details like the chamfer (oblique cut on the edge of a board) and lamb's tongue along a ceiling beam in a seventeenth-century

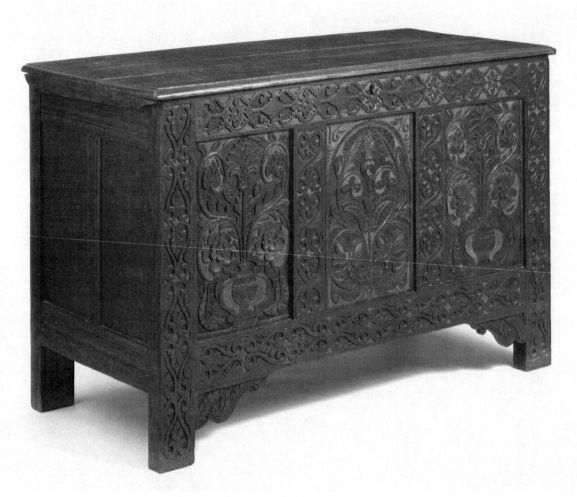

FIGURE 4-3. On a chest made in Ipswich, Massachusetts, probably by joiner Thomas Dennis, palmette designs on the stiles and lower rails and vases of flowers on the left and right panels ornament the front. New England craftsmen in the late seventeenth century often ornamented furniture with natural forms, but they were abstract, focusing on form rather than pictorial representation. (Chest, Thomas Dennis, Ipswich, Mass., 1676. Red and white oak; H 31½ in., W 49⅝ in., D 21¼ in. 1982.276 Winterthur Museum, funds for acquisition provided by the Honorable Walter H. Annenberg, Mr. and Mrs. George P. Bissell Jr., J. Bruce Bredin, Mrs. Donald F. Carpenter, Mrs. Lammot du Pont Copeland, John T. Dorrance Jr., Mr. and Mrs. Edward B. du Pont and Mrs. M. Lewis du Pont, Mrs. Henry Belin du Pont, Mrs. Reynolds du Pont, William K. du Pont, Mrs. George B. Foote Jr., Charles J. Harrington, Mr. and Mrs. George S. Harrington, Willis F. Harrington, Mr. and Mrs. Rodney M. Layton, Henry S. McNeil, Mrs. Henry S. McNeil, Mrs. G. Burton Pearson Jr., Stephen A Trentman, Mrs. Neal S. Wood.)

parlor may show a craftsman's desire to improve and refine wood, a natural element.

In his daily labor, a craftsman could reveal his understanding of God and his own role in God's world. Living in a society in which religious beliefs and pious practices among lay people were pervasive, the worker's vocation was part of a calling to honor God on earth and join His elect in heaven. The craftsman's work, therefore, had spiritual and moral value because it served God's will while filling some of society's needs. Written and printed records show that this attitude toward work was common through the 1600s and into the early 1700s.[10]

The idea of controlling and ordering the natural world was a comfortable one for seventeenth-century immigrants to New England. The yeomen not only studied and observed God's gift of nature to learn more about His plan, but also worked with, ordered, and improved nature by building homes, clearing and dividing land, and ordering society in familiar ways.[11]

These English mannerist qualities flourished in a New World environment that, in the immigrants' minds, was a vast emptiness, a void.[12] Between southern Maine and the Hudson River, however, that "void" was home to approximately seventy-two thousand Native Americans in 1615. The subjugation of

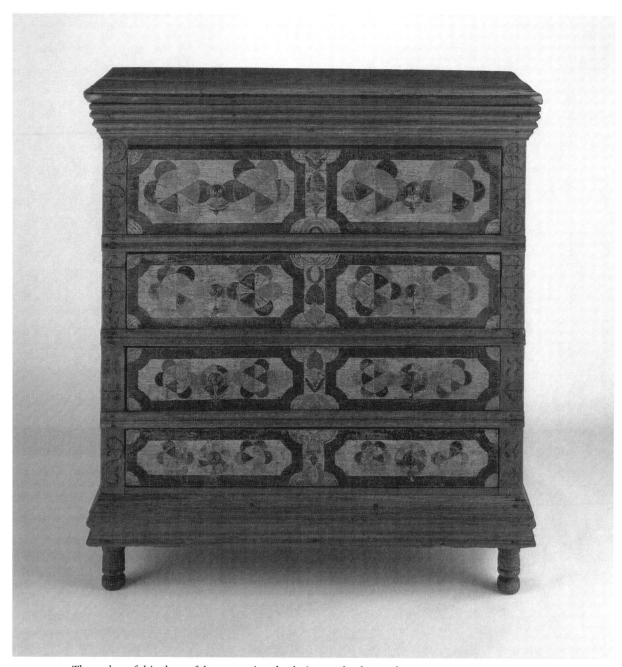

FIGURE 4-4. The maker of this chest of drawers painted a design on the drawer fronts to imitate paneling. Within each panel, paint imitated marquetry, or inlaid work of variously colored wood or other material. (Chest of drawers, Hadley, Mass., 1700–1720. Red and white oak, chestnut; H 45¼ in., W 43½ in., D 20¾ in. 1957.54 Winterthur Museum, gift of Henry Francis du Pont.)

the native population by 1690 and the elaborately patterned social, economic, and material life built by the colonists testify to the tenacity with which English colonists held to the English concepts of order and artifice. The mannerist ideal of orderly, improved, and artificial work connects design elements, visible in furniture today, to ideas about art, religion, and work in seventeenth-century New England culture.

MAKING AND MARKETING SEVENTEENTH-CENTURY FURNITURE

The repertoire of techniques, tools, and materials available to seventeenth-century workmen affected the appearance of their products. Woodworkers—both joiners and turners—and upholsterers were the craftsmen most involved in seventeenth-century furniture. Their use of specific materials and techniques to produce stylish

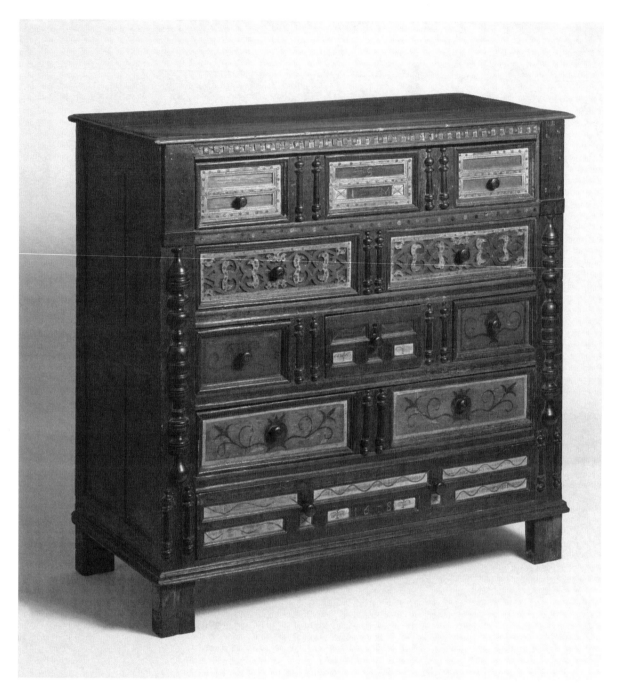

FIGURE 4-5. The hours of labor required to construct multiple drawers made this chest costly. One bank of drawers, the third in this photograph, is actually three separate drawers with recessed panels. Geometric and floral motifs are included in the decoration created with split spindles, applied moldings, carving, and paint on both carved and flat surfaces. The date, 1678, is painted on the top drawer and incised in panels on the lower drawer. (Chest of drawers, Ipswich or Newbury, Mass., 1678. Red and white oak, sycamore, maple, tulip poplar, black walnut; H 42 in., W 45 in., D 19⅞ in. 1957.541 Winterthur Museum, gift of Henry Francis du Pont.)

mannerist elements provides avenues for interpretation to modern-day museum visitors, helping them to understand the design elements.

Most woodworkers who came to New England brought with them both knowledge of regional English furniture styles and the technology necessary to re-create these styles.[13] They, in turn, trained others, developing local shop traditions. Early New England joiners used designs devised in England more than three generations earlier. Craftsmen, however, continued to immigrate throughout the seventeenth century and brought new ideas and technology with them.

Joiners, as their name implies, unite wooden parts with both board and mortise-and-tenon construction. In board construction, parts were simply nailed or pegged together to form, for example, a six-board chest; extensions of the end boards form feet. Most surviving seventeenth-century furniture was made with mortise-and-tenon construction (fig. 4-6). The tenon slipped into a mortise, and a wooden pin held it securely.[14] The joints connected vertical stiles and horizontal rails to form frames into which panels were set. Joiners not only made tables, chairs, cupboards, and chests but also built ships, houses, and churches using these techniques.

Turners, just as their name implies, turned wood on lathes to make chair posts, table legs, and ornaments applied to case furniture (fig. 4-7). To make rounded objects, they rotated rectangular blocks of wood on lathes, using carving tools on the turning wood to remove material and shape the piece. For chairs, they created front and rear posts, stretchers, and spindles for backs and sometimes under arms.[15] Chairs made by turners were slat-back or spindle-back. Slat-back chairs have horizontal slats between the rear posts; spindle-backs have vertical turned spindles. Slats normally bow backward to provide a more comfortable chair. Ash, hickory, black cherry, maple, and poplar were used to make turned chairs. Produced faster than

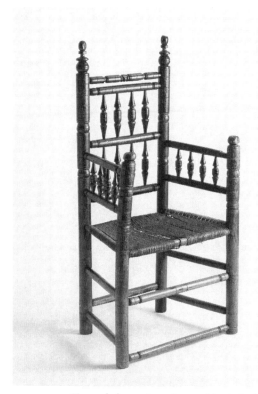

FIGURE 4-7. Turned elements make up this chair, including the spindles on the back and beneath the arms, which have a central design that looks like a spool and an urn. The back rails, the upright posts, and the stretchers between the posts are all turned. The seat is woven from flag or rush, narrow leaves of a plant, instead of the frequently used board bottom. The turner worked with green or uncured wood. Note the warp of the left leg. (Turned great chair, eastern Massachusetts, 1650–1675. Tulip poplar, soft maple, ash; H 46¼ in., W 24¼ in., D 18 in. 1958.681 Winterthur Museum, gift of Henry Francis du Pont.)

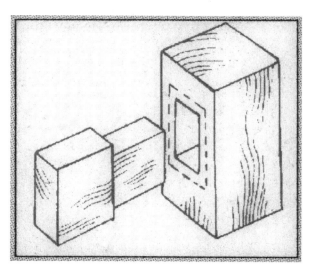

FIGURE 4-6. "The strongest, perhaps oldest, and most versatile of all joints is the mortise and tenon . . . one piece has a projection (the tenon) that fits into a corresponding recess (the mortise) chiseled out of the other piece" (Nancy A. Smith, *Old Furniture* [Boston: Little, Brown, 1975], p. 44). The major joint in chair construction, it is also important in table construction and is used for all kinds of framing. Sometimes it is pegged for greater strength. From *Furniture Study Glossary Card* (Winterthur, Del.: Henry Francis du Pont Winterthur Museum, 1992).

joined chairs, turned chairs were less expensive and more common.

Colonial woodworkers faced a welcome prospect— a generous supply of wood. New England's forests of oak, pine, cedar, poplar, maple, chestnut, and sycamore gave its craftsmen a distinct advantage over their English counterparts, who had a meager wood supply.[16] In 1660 Samuel Maverick recorded that Malden, Braintree, and Hingham, Massachusetts, provided Boston with timber for "many artificers."[17] New Hampshire and, later, Maine also supplied timber to furniture makers throughout New England.

With an ample supply, craftsmen were not restricted to techniques that conserved wood. Riving is an example of a process that allowed a colonial woodworker to work alone quickly without the necessity of conserving wood. Riving involved a maul (mallet) and froe (an edged tool, that resembled an ax with a short handle) to split a log vertically, much as one might

split firewood today. Green (undried or unseasoned) riven wood was easy to work and did not warp. As he tried to cut flat boards out of the cylindrical log, a river produced boards that were slightly wedge-shaped and therefore thicker on one edge than was necessary for construction. By examining the backboards of seventeenth-century furniture, it is sometimes possible to see the slight wedge shape to the boards. The bountiful supply of wood and effective use of labor benefited craftsmen in New England, where material was plentiful but labor was scarce.

Woodworkers used softwood like pine for inexpensive objects, but oak was the wood of choice for furniture. Exotic woods such as ebony and rosewood were also used, especially for applied ornament and inlays, as were native woods such as walnut, cedar, and poplar.

Craftsmen ornamented their objects by working wood in various ways and by painting. To produce carved decoration, the woodworker often preferred laying out the design with rule and compass rather than a template, which allowed him to adapt the scrolls, geometric shapes, or floral elements to the size of the panels.[18] He then removed material around the design, producing a slightly sunken background.[19] Sometimes he used punches to produce a textured surface. Most early furniture made in the colonies was stained or painted. Stains were made from vegetable coloring dissolved in oil. Pigments for paints were imported from England and ground in oil when needed. By the late 1600s, joiners in and around Boston were more commonly decorating furniture with paint, especially if the object was not the most expensive example.[20]

By the mid-seventeenth century, upholsterers working in Boston ordered frames from joiners to stuff and cover for customers (fig. 4-8). Upholsterers worked in large towns with expensive imported textiles or tanned animal hides. They commanded the most respect of any workmen in the furniture trades. A seventeenth-century interior lavishly furnished with upholstered objects visually transmitted a message to any visitor about the owner's wealth, cultural pretensions, and even status as one of God's elect.[21]

Working on stools, chairs, great chairs, and couches, upholsterers used quilted layers of linen webbing, linen sackcloth (a loosely woven linen cloth), marsh grass that was whipstitched to form rolls on edges and to stuff the form, and leather or fabric coverings.[22] They attached upholstery to frames with small iron tacks and then applied brass nails for decoration.

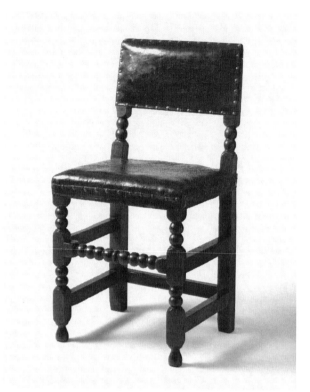

FIGURE 4-8. This chair is sometimes known as a low-back or leather chair. This example is stuffed with marsh grass stitched to prevent shifting. Turned ornament on the stiles, or upright members of the chair between the seat and the back, distinguish this form from wainscot chairs, which have backs like panels. (Leather chair, Boston, 1665–1695. Red maple, red oak, leather; H 36 in., W 18½ in., D 17⅕ in. 1958.694 Winterthur Museum, gift of Henry Francis du Pont.)

They advised clients about room furnishings, including lavishly hung bedsteads, and their products found a market in all English colonies of the New World.[23] Covering a wooden frame with textiles was another way an artisan demonstrated his artifice and his workmanlike attitude.

LIVING WITH SEVENTEENTH-CENTURY FURNITURE

An English immigrant who lived along the eastern seaboard in the late 1600s probably considered a house adequately furnished with some chests for storage, a table or two, and a few stools or chairs. Bedding might be rolled or stored when not in use. Many people, however, had considerably fewer objects. Wealthy settlers usually had a few more of each furniture form as well as hangings on a bedstead.

New England and the Chesapeake region, two well-studied areas of seventeenth-century European settlement, offer examples of furniture groupings. Inventoried in 1668, the Fairbanks House in Dedham,

Massachusetts, contained a bedstead, trundle bed, three storage pieces, and two chairs in the parlor. The hall, or main area for living and working, held two old tables, two pieces of seating furniture, and a box. Upstairs another bedstead, chest, and box furnished the parlor chamber. Nearly forty years later, a wealthy woman from Boston described a farmer's hut as containing a bed, table, and seating furniture, but the table was a board raised on sticks and the chairs were "a block or two in ye corner."[24] People in the Chesapeake also relied on a few pieces of movable, multifunction furniture such as chests, chairs, stools, tables, and beds.[25]

Over the decades and especially after the 1690s, the number of furnishings in households gradually increased in New England and in the Chesapeake, most often in the homes of the wealthy. In the Chesapeake region, however, it was more difficult than in the North to accumulate furnishings and ensure their survival through generations due to high rates of disease and death, difficult living conditions, and land and labor requirements, as well as the variable market price of tobacco (the cash crop). The seventeenth-century, or mannerist, furniture seen today in museum and historic house collections, therefore, most often descended from northern families at the upper end of the economic spectrum. In the seventeenth century, wealthy New Englanders often furnished their houses with formal, elaborately patterned furniture appropriate for the daily activities of the rooms. They chose furnishings that were available, functional, and affordable.

Availability

Some furniture was readily available to most New England property owners. In new settlements, ample opportunities and an abundant supply of wood meant that adequate quantities of furniture could be produced. In towns like Boston and possibly Salem, a large local and export market allowed a woodworker to depend completely on his trade for his livelihood. His products would have been more numerous and diverse than those of a woodworker in a rural area. Because there were fewer people and fewer needs, a rural artisan could fulfill his community's demands for furniture while farming and practicing other trades to make a living.[26]

Domestic Uses

Someone wealthy enough to own a variety of furniture forms could arrange it appropriately within an adequate living space. Organizing furnishings in a room meant that the social situations taking place in that room were organized as well.[27] Those who owned articles of furniture beyond bare necessity often set some pieces aside for specific uses and occasions. Family members or guests would have been impressed by the furniture, the importance of the event, and the status of the owner.

The amount and value of one's furnishings visually conveyed economic and social position. Information about how people used furniture stems from studies of wills, inventories, diaries, and account books. These documents indicate that the everyday living spaces, such as the hall, contained few pieces of furniture. If a house had an additional room that functioned as a parlor, more and costlier objects furnished that room, which was both public and private. In two houses in the last half of the seventeenth century, parlors contained bedsteads, tables, chairs, chests, cupboards, and boxes. Even in a society where land ownership was the basic index of wealth, some New Englanders displayed goods that revealed their social and economic status.[28]

Household objects for storage included chests and cupboards. At least one chest was a necessity to store textiles, and most were probably simply constructed board chests. Chests also functioned as seats, beds, and tables. Joined chests of drawers, which immigrant joiners from London began making in Boston by 1740, appeared only in the homes of the wealthy. Those few families who owned a cupboard used it to display silver, pewter, ceramics, or other objects for dining. A prized textile often covered the top, called the cupboard's head. As might be deduced from the items displayed on the cupboard, it often stood in the room where meals were served.[29]

Few families of English descent seemed to own a press—a large, two-door cupboard for storing linens and clothing. Dutch immigrants did, however, own such cupboards, which they called a *kas*. Made with panels set into mortise-and-tenoned frames, a *kas* contained shelves or pegs for folded or hung clothing and linens.[30]

In New England, chairs were the most numerous form of seating furniture. They were important because of the comfort they provided and the deference they symbolized. A turned great chair or wainscot chair conferred status on the person privileged to sit in it. Because they had arms, such chairs suggested thrones and postures of aristocratic leisure (fig. 4-9).

In the second half of the 1600s, the upholstered chair replaced the wainscot chair as the favored seating form

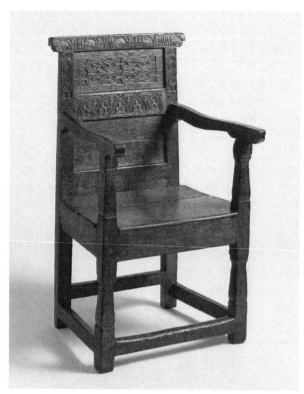

FIGURE 4-9. At least forty joiners lived and worked in Essex County, Massachusetts, in the seventeenth century. A joiner made this chair and decorated the central panel with an abstract floral design and the side framing members with a half-round lunette, carving of the sort often associated with East Anglia in England. A chair with a back formed by a solid panel is called a wainscot chair. (Joined great chair, Essex County, Mass., 1640–1700. Red and white oak; H 36¾ in., W 22⅜ in., D 20⅛ in. 1954.73 Winterthur Museum, gift of Henry Francis du Pont.)

for those who could afford it. Upholstery on the back and seat added comfort and cost, requiring extra, specialized labor and expensive materials such as leather or textiles. In fashion until the 1690s, straight-back upholstered chairs were sold in sets or multiples of six. A common grouping was six or twelve chairs and a great chair or couch that lined the walls of a room.[31] However, most of the chairs produced in seventeenth-century New England were probably less expensive turned chairs, such as spindle-back and slat-back chairs.[32]

Tables were less numerous than chairs. A joined table with six or twelve joint stools formed a common grouping in a parlor. Trestle tables that could be dismantled and stored and tables that could be converted to chairs were also seen. New table forms were occasionally seen by the 1670s. Oval-leaf tables and those with one drawer below the top and stretchers connecting the legs began to replace convertible furniture in halls and parlors (fig. 4-10).[33] The oval-leaf table, like a trestle table, conveniently folded for movement.[34]

Although no documented American seventeenth-century bedsteads survive, probate inventories suggest that the unornamented plain bedstead with four tall posts was the most common type. It was less expensive than other forms. The bedposts formed an armature for curtains and other textile fixtures of far greater value than the bedstead. Ropes threaded through holes in the rails or sacking on the bottom supported the bedding.[35] Benches that became beds and beds that folded against the walls when not in use also were common. It is thought that many people slept on pallets on the floor.[36]

CONCLUSION

By the end of the seventeenth century, one visitor to New England remarked that "a Gentleman from London would almost think of himself at home at Boston when he observes the Numbers of People, their Houses, their Furniture, their Tables, their Dress and Conversation, which perhaps is as splendid and showy, as that of the most considerable Tradesman in London."[37] With some modifications, most colonists transferred their cultures to the New World. For wealthy English settlers, furnishing their homes with objects made in the complex, colorful mannerist style re-created a familiar aesthetic in an unfamiliar locale. Such objects enhanced the immigrants' sense of security in an environment and with Native Americans they regarded as hostile. Colonial American furniture, however, was different in appearance from English prototypes because materials and conditions were different. With colonists from various European areas as neighbors, patrons and craftsmen collaborated to create suitable furniture that reflected the variety of experiences among immigrants to the New World.

NOTES

1. St. George, "Style and Structure," 20–22; Fairbanks and Trent, 3:504–505.
2. Fales, 12.
3. Gruber, 9, 196–98.
4. Fairbanks and Trent, 3:368–79.
5. Shearman, 71–73.
6. This chest and other furniture from the same Essex County group are analyzed and illustrated in Trent, Follansbee, and Miller, 1–64.
7. Shearman, 16–19.
8. St. George, "Style and Structure," 24; see also St. George, "Set Thine House in Order," 161–62.
9. St. George, "Style and Structure," 24.
10. Crowley, 53–60.

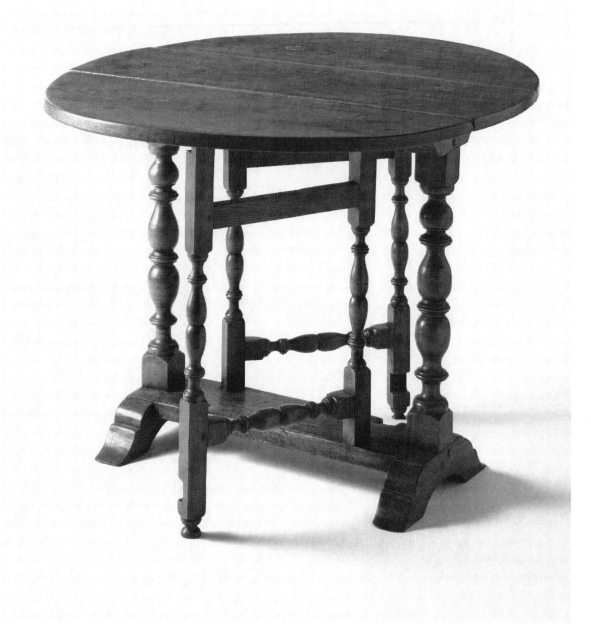

FIGURE 4-10. Although less numerous than chairs, tables were usually made by the same turners. Folding or falling-leaf tables could be folded and put aside and had many uses: dining, writing, game playing, and more. Based on English models, they were stylish from the late 1600s to 1740. (Table, New York, 1660–1700. Soft maple, butternut, cherry, maple; H 26⅛ in., W 13⅜ in., D 33 in. 1958.527 Winterthur Museum, gift of Henry Francis du Pont.)

11. Fairbanks and Trent, 1:xvii.
12. Allen, 1; Fairbanks and Trent, 1:66.
13. Fairbanks and Trent, 3:506.
14. Fairbanks and Trent, 3:507. A drawing of a mortise-and-tenon joint may be found in Fairbanks and Bates, 5.
15. Gronning, 92–103.
16. Fairbanks and Trent, 3:506.
17. Forman, 35.
18. Gruber, 180, 280.
19. See Gruber, 169 and 220, for a helpful description of laying out the design.
20. Gruber, 237.

21. See Craven, 101–11, for more about attitudes toward prosperity and godliness in late seventeenth-century New England.
22. Forman, xxiv.
23. Fairbanks and Trent, 2:288.
24. St. George, "Set Thine House in Order," 171–72.
25. Sweeney, 263–69; Carson et al., 142–43; Hurst and Prown, 13–17; Carr and Walsh, 62–63.
26. See Trent, Follansbee, and Miller, 63 n66, for a list of a skilled woodworker's opportunities in a seventeenth-century community, including activities from building houses, public buildings, ships, and mills to coopering and making fences.
27. St. George, "Set Thine House in Order," 172–73.
28. St. George, "Set Thine House in Order," 170–71.
29. Gruber, 195, 263, 279.
30. Gruber, 279, 280, 296.
31. Fairbanks and Trent, 2:288.
32. Forman, 85–86.
33. Fairbanks and Trent, 2:216.
34. Fairbanks and Trent, 2:214.
35. Fairbanks and Trent, 2:354–56.
36. Fairbanks and Trent, 2:221.
37. Fitzgerald, 19.

BIBLIOGRAPHY

Fairbanks, Jonathan L., and Elizabeth Bidwell Bates. *American Furniture 1620 to the Present*. New York: Richard Marek Publishers, 1981.

Fairbanks, Jonathan L., and Robert F. Trent, eds. *New England Begins: The Seventeenth Century*. 3 vols. Boston: Museum of Fine Arts, 1982.

Forman, Benno M. *American Seating Furniture, 1630–1730: An Interpretive Catalogue*. New York: W. W. Norton, 1988.

Gruber, Frances Safford. *American Furniture in the Metropolitan Museum of Art*. Vol. 1: *Early Colonial Period: The Seventeenth Century and William and Mary Styles*. New York: Metropolitan Museum of Art, 2007.

Jobe, Brock, and Myrna Kaye. *New England Furniture: The Colonial Era*. Boston: Houghton Mifflin, 1984.

Passeri, Andrew, and Robert F. Trent. "The Wheelwright and Maerklein Inventories and the History of the Upholstery Trade in America, 1750–1900." In *New England Furniture: Essays in Memory of Benno M. Forman*, edited by Brock W. Jobe, 312–52. Boston: Society for the Preservation of New England Antiquities, 1987.

Trent, Robert F. "Furniture in the New World: The Seventeenth Century." In *American Furniture with Related Decorative Arts, 1660–1830*, edited by Gerald W. R. Ward, 23–42. New York: Hudson Hills Press, 1992.

Additional Sources

Allen, David Grayson. "*Vacuum Domicilium*: The Social and Cultural Landscape of Seventeenth-Century New England." In *New England Begins: The Seventeenth Century*, edited by Jonathan L. Fairbanks and Robert F. Trent, 1:10. Boston: Museum of Fine Arts, 1982.

Carr, Lois Green, and Lorena S. Walsh. "Changing Lifestyles and Consumer Behavior in the Colonial Chesapeake." In *Of Consuming Interests: The Style of Life in the Eighteenth Century*, edited by Cary Carson, Ronald Hoffman, and Peter J. Albert, 59–166. Charlottesville: University Press of Virginia for the United States Capitol Historical Society, 1994.

Carson, Cary, et al. "Impermanent Architecture in the Southern American Colonies." In *Material Life in America, 1600–1860*, edited by Robert Blair St. George, 113–58. Boston: Northeastern University Press, 1988.

Chinnery, Victor. *Oak Furniture: The British Tradition. A History of Early Furniture in the British Isles and New England*. Woodbridge, Eng.: Antique Collectors' Club, 1979.

Craven, Wayne. *Colonial American Portraiture*. Cambridge: Cambridge University Press, 1986.

Crowley, J. E. *This Sheba, Self: The Conceptualization of Economic Life in Eighteenth-Century America*. Baltimore: Johns Hopkins University Press, 1974.

Fales, Dean A. Jr. *American Painted Furniture, 1660–1880*. New York: E. P. Dutton, 1979.

Fitzgerald, Oscar P. *Three Centuries of American Furniture*. Englewood Cliffs, N.J.: Prentice-Hall, 1982.

Forman, Benno M. "The Chest of Drawers in America, 1635–1730: The Origins of the Joined Chest of Drawers." *Winterthur Portfolio* 20, no. 1 (Spring 1985): 1–30.

Gronning, Erik. "Early New York Turned Chairs: A *Stoelen-draaiers's* Conceit." *American Furniture 2001*, edited by Luke Beckerdite, 89–119. Milwaukee, Wis.: Chipstone Foundation, 2001.

Hurst, Ronald L., and Jonathan Prown. *Southern Furniture, 1680–1830: The Colonial Williamsburg Collection*. Williamsburg, Va.: Harry N. Abrams in association with Colonial Williamsburg Foundation, 1997.

Kane, Patricia E. *Furniture of the New Haven Colony: The Seventeenth-Century Style*. New Haven, Conn.: New Haven Colony Historical Society, 1973.

Kirk, John T. *American Furniture and the British Tradition to 1830*. New York: Alfred A. Knopf, 1982.

Luther, Clair Franklin. *The Hadley Chest*. Hartford, Conn.: Case, Lockwood, and Brainard Company, 1935.

Nutting, Wallace. *Furniture of the Pilgrim Century, 1670–1720*. Boston: Marshall Jones Company, 1921.

Shearman, John. *Mannerism*. New York: Penguin Books, 1977.

St. George, Robert Blair. "Style and Structure in the Joinery of Dedham and Medfield, Massachusetts, 1635–1685." In *Winterthur Portfolio 13*, edited by Ian M. G. Quimby, 1–46. Winterthur, Del.: Henry Francis du Pont Winterthur Museum, 1979.

———. "'Set Thine House in Order': The Domestication of the Yeomanry in Seventeenth-Century New England." In *New England Begins: The Seventeenth Century*, edited

by Jonathan L. Fairbanks and Robert F. Trent, 2:159–88. Boston: Museum of Fine Arts, 1982.

Sweeney, Kevin M. "Furniture and the Domestic Environment in Wethersfield, Connecticut, 1639–1800." In *Material Life in America, 1600–1860*, edited by Robert Blair St. George, 261–90. Boston: Northeastern University Press, 1988.

Thornton, Peter. *Authentic Decor: The Domestic Interior, 1620–1920*. New York: Viking Press, 1984.

Trent, Robert F. "The Chest of Drawers in America, 1635–1730: A Postscript." *Winterthur Portfolio* 20, no. 1 (Spring 1985): 31–48.

———. "The Symonds Shops of Essex County." In *The American Craftsman and the European Tradition, 1620–1820*, edited by Francis J. Puig and Michael Conforti, 23–41. Hanover, N.H.: University Press of New England, 1989.

Trent, Robert F., Peter Follansbee, and Alan Miller. "First Flowers of the Wilderness." In *American Furniture 2000*, edited by Luke Beckerdite, 1–64. Milwaukee, Wis.: Chipstone Foundation, 2000.

Ward, Gerald W. R. "Some Thoughts on Connecticut Cupboards and Other Case Furniture." In *New England Furniture: Essays in Memory of Benno M. Forman*, edited by Brock W. Jobe, 66–87. Boston: Society for the Preservation of New England Antiquities, 1987.

Zea, Philip. "The Fruits of Oligarchy: Patronage and the Hadley Chest Tradition in Western Massachusetts." In *New England Furniture: Essays in Memory of Benno M. Forman*, edited by Brock W. Jobe, 1–65. Boston: Society for the Preservation of New England Antiquities, 1987.

Furniture in the William and Mary or Early Baroque Style

FURNITURE IN THE WILLIAM AND MARY (OR EARLY baroque) style has attracted significant scholarly attention in recent decades. *American Seating Furniture, 1630–1730* (1988); the exhibition and catalogue *Courts and Colonies: The William and Mary Style in Holland, England, and America* (1988), which coincided with the tricentennial of the accession of William and Mary to the English throne in 1688; and the exhibition and catalogue *Worldly Goods: The Arts of Early Pennsylvania, 1680–1758* (1999) have increased interest in this furniture. However, its place in furniture scholarship, the antiques market, and popular taste has not been as strong as furniture in the Queen Anne style or the Chippendale style. One source pointed out that this furniture was "little studied, seldom collected, and not much understood."[1] Thus, guides at museums and historic sites may find that their visitors have little familiarity with it.

The elaborate ornamentation, richly patterned surface treatments, and exotic materials that characterize this style suggest interesting interpretations. The impact of monarchs and courts in the movement of design ideas, global trading networks, and complex organization of trade and craft production all influenced furniture in this style.

LOOKING AT WILLIAM AND MARY FURNITURE

In looking at this furniture, pay special attention to the use of line, proportion, and surface ornament. The curved lines of decorative elements appear within structural lines that are straight and angular; the vertical dimension is emphasized; and surface ornament is lively. Furniture with straight, soaring lines and curving, patterned ornament suggests the William and Mary or early baroque style.

Line

Structural lines are predominantly straight. The stiles (vertical part of the frame), legs, and seat rails on chairs usually are straight. Typically, the top, sides, and legs of high chests are also straight, presenting a rectilinear outline. Curved lines appear often, however, in details such as the stretchers (rods between two legs) or skirts of chests and the crest rails and arms of chairs (fig. 5-1). Curved lines also appear in carved ornament, in which elaborate C-scrolls and reverse C-scrolls draw the viewer's eye over the object. The strong, rhythmic curves of the spiral form, turned in wood or worked in metal, exemplify this interest in a tightly curved line.[2]

Proportion

The emphasis is on vertical dimension in chairs and high chests (fig. 5-2). Chairs are tall in proportion to their width. Above the seat, which is placed at a comfortable height, the chair back extends upward to a crest rail decorated with tight, opposing curves. High chests, dressing tables, and tea tables stand on slim turned legs. The long, slim structural members (legs and backs) and the fact that the height often exceeds the width lend a lean appearance to furniture.

Ornament

William and Mary–style furniture has surfaces enlivened with patterns in inlays, veneers, lacquers, and paints. Surfaces are somewhat more elaborate than those of seventeenth-century furniture. On some high chests and dressing tables, swirling, patterned burled-wood veneers and herringbone banding produce the pattern. An artisan who worked along the Connecticut coast between Guilford and Saybrook substituted painted, scroll-like banding for inlay on a high chest. The central design includes a fleur-de-lis and scrolling vines that draw the eye over the curvilinear pattern (fig. 5-3).

Natural, exotic, and classical motifs often ornament William and Mary–style furniture. Natural forms include plumes as well as animal and floral symbols. Exotic influences of trade with Asian countries via Europe appear in caning and japanning, a type of surface finish that imitated lacquer. Classical elements include columns, urns, and C- and S-scrolls.

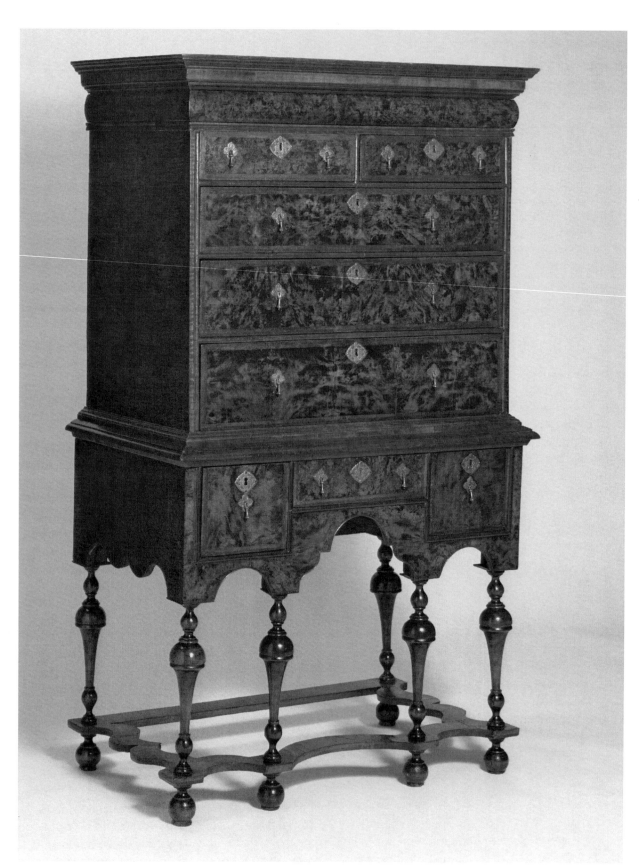

FIGURE 5-1. Curved and straight lines interplay on a high chest. Straight, veneered herringbone banding on the drawers of the high chest surround figured-burl veneer. The straight lines of the banding enclose the movement suggested by the swirls and curves of the burl. (High chest on frame, New England, 1700–1710. Maple, walnut; H 69½ in., W 41⅜ in., D 24¼ in. 1966.1306 Winterthur Museum, bequest of Henry Francis du Pont.)

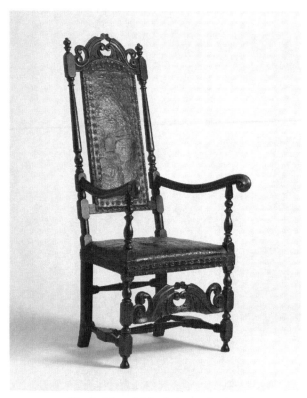

FIGURE 5-2. The height of this chair emphasizes the vertical dimension, but the heavily carved crest and front stretcher also give weight to the horizontal line and insert strong curved lines into the overall composition. Curved armrests also counterbalance the straight lines. This example is considered to be one of the highest style of William and Mary chairs produced in the colonies. (Armchair, Boston, 1695–1710. Sugar maple, red oak, Russia leather; H 53¼ in., W 24 in., D 27½ in. 1958.553 Winterthur Museum, gift of Henry Francis du Pont.)

The distinctive lines, proportions, and ornament identify William and Mary–style furniture. The very name, derived from monarchs of Holland and England, refers to the monarchs and the royal court traditions that influenced this style.

THINKING ABOUT STYLE

Around 1709 Pieter Schuyler received a looking glass (fig. 5-4) in appreciation for bringing five Iroquois sachems (chiefs) to the English court. As a traveler on two continents and a politician, Schuyler saw similar objects owned by rich and powerful people in England. His looking glass directly relates to new ideas about decoration spreading through European courts in the late seventeenth century. Two contexts are particularly useful for interpretation: the strong international courtly tradition and certain concepts of beauty that today are called baroque.

Courtly Tradition

In the age of absolutism, when kings were considered above the law, monarchs used patronage of the arts as one more sign of their unique, divinely sanctioned roles. Whether seeking wives in the noble families of France and Spain or traveling in exile, English monarchs and their courtiers observed, admired, and imitated other monarchs. Designs influenced by royal tastes are evident in objects brought to the colonies as well as those made in the colonies for a market that was not courtly but needed stylish, affordable goods.[3]

The international courtly tradition disseminated through diverse routes and changed through time and place. One important route, precipitated by civil war and royal marriages, connected Louis XIV of France through William and Mary of Holland to England. At Versailles, Louis XIV, the Sun King, enriched the palace and garden by enclosing and organizing vast spaces for the sumptuous ceremonies of daily court life. His ideas reverberated through noble Europe. Symbols of the sun and Apollo, the Sun God, suffused the design and ornament of the palace and garden and glorified the monarch who personified absolutism and divine right.[4]

Louis XIV influenced the new style by demanding and supporting great artistic production. In a flourishing workshop established in 1661 at Gobelins, near Paris, craftsmen produced luxurious furniture, marquetry, tapestry, and silver objects. But the artistic community in France was soon affected by religious and political decisions. In 1685 Louis XIV revoked the Edict of Nantes and ended eighty-seven years of religious freedom. Thousands of French Protestants (Huguenots) fled the country, taking their ideas and craft training with them.[5] One engraver and designer, Daniel Marot (1661–1752), who had trained in Paris under a court designer, fled to the Hague in 1684 or 1685 and worked for the Dutch *stadtholder* (viceroy), William of Orange. William and his wife, the English princess Mary Stuart, were called to rule England in the Glorious Revolution of 1688. Marot followed them. His fame rests on his work for William and Mary, both in Holland and in England, and on his more than two hundred influential prints of design ideas. Marot's concept of using objects, ornament, and textiles to unify great interior spaces is an essential characteristic of this style in interior design.[6]

Elements of French influence and of Marot's ideas in particular can be found in William and Mary–style furniture.[7] Examples include the high, arched skirts

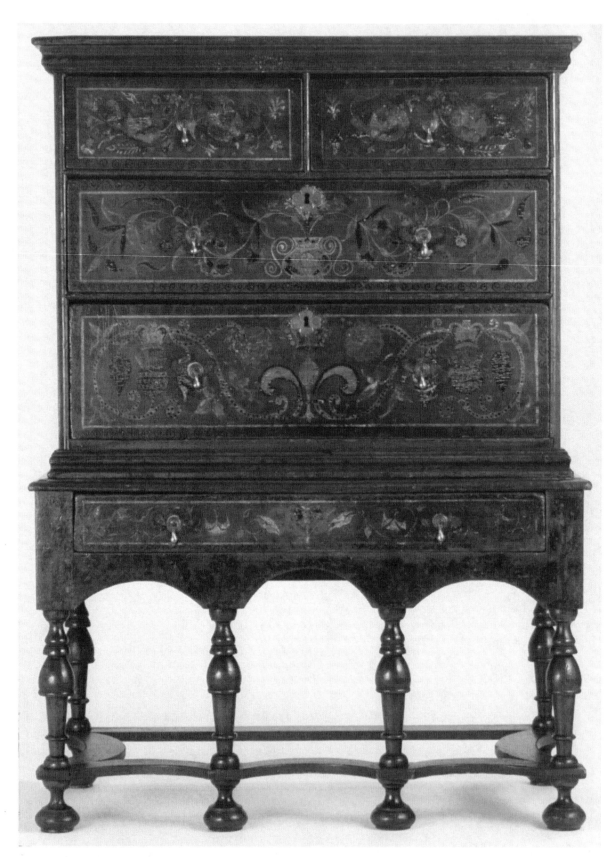

FIGURE 5-3. Painted decoration was often used over wood that did not have an attractive grain or color. The painted design might imitate fancy bandings or inlay work. The colors on this high chest include cream, red, black, and blue-green. (High chest, Saybrook, Conn., 1710–1727. White pine, tulip, ash; H 54¾ in., W 40⅛ in., D 21 in. 1957.1110 Winterthur Museum, bequest of Henry Francis du Pont.)

FIGURE 5-4. The frame of this looking glass is carved with the strapwork cross-hatching, flowers, and birds favored at the time. It also includes a motif considered exotic: the head of a Native American wearing feathers and a headdress. The surface is gilded. Both frame and the silvered glass reflected and enhanced the light, lending a grand appearance to a room. (Looking glass, England, 1705–1710. Spruce, glass; H 56¼ in., W 29½ in., D 1½ in. 1959.2516a Winterthur Museum, bequest of Henry Francis du Pont.)

jects should look. A courtly style took hold in colonial America just as political ties to the royal courts became stronger and more institutionalized. The Governor's Palace at Williamsburg was one of the "little courts of the royal governors."[9]

Colonial rulers displayed power through objects, buildings, and landscapes, mimicking the European monarchs. Their choices were influenced by ideas that were current in their culture as well as by an expanded knowledge of the shape and size of the world. Scientists, explorers, and scholars provided seventeenth-century artists with new, influential concepts. Ideas about space, exoticism, light, and antiquity can

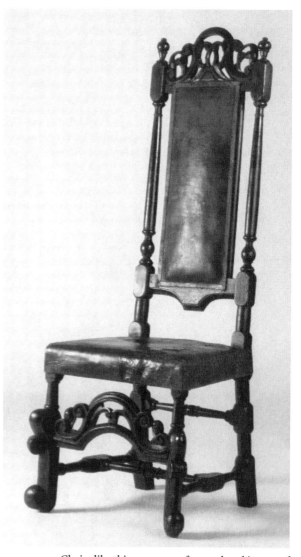

FIGURE 5-5. Chairs like this one were often ordered in sets of twelve. Although some colonists ordered directly from London, others found more reliable results by purchasing their goods through local importers or from local craftsmen. This Boston chair resembles those made in English cities. (Side chair, Boston, 1690–1710. Soft maple; H 52⅛ in., W 21⅜ in., D 22¼ in. 1959.28.2 Winterthur Museum.)

and trumpet-turned legs of veneered high chests made in New York and in New England between 1700 and 1730. The central shell motif, pendant lambrequins (short swag forms at corners, much like an upholstered decoration at the upper edge or a door or window), and mask of Schuyler's looking glass are elements typical of Marot's designs. A chair also shows elements characteristic of his designs in its height and the curve of its carved legs into turned-out scrolls on the front feet (fig. 5-5).[8]

Louis XIV centralized political power as well as artistic creation, and other European monarchs followed his example. The English colonies felt the tension of increased monarchical control as English officials arrived with ideas about how rulers should live and ob-

be used in interpreting a collection of William and Mary–style objects.

Space

Baroque artists lived in a world increasingly conscious of infinite space.[10] Copernicus's theory of a sun-centered universe, confirmed in the seventeenth century by Galileo and developed by Sir Isaac Newton, was seminal. Astronomy and physics attracted great minds and attention.

Painters and sculptors attempted to merge their concept of space with that of the viewer. For example, subjects in paintings gesture to the viewer's world or walk toward a seemingly infinite succession of compartmentalized spaces.[11] An expanded sense of space in domestic buildings also developed in the late seventeenth century. English country houses of the period often adopted rooms enfilade, a French practice of linking rooms by parallel doors. While no such sweeps of interior space were known to have existed in the English colonies, travelers to England and officials assigned to the colonies from England might have seen and admired them.

Large spaces could be organized visually by using textiles en suite, an idea promoted by Marot. A room in which identical textiles appear in the window hangings and the furnishing fabrics gave a unified, spacious impression to visitors and a newly important role to the upholsterer in creating stylish interiors.[12]

Exoticism

Voyages of discovery in the fifteenth and sixteenth centuries increased awareness of the earth's vastness. They introduced the knowledge of exotic cultures to Western Europeans. To Europeans, America was exotic; to all Westerners, Asia was exotic.[13] Mainly through images on imported ceramics and lacquerwork, China influenced furniture design in both form and ornament. The idea of a "crooked" or "bended" back on a chair and of one splat in the back derives from Chinese features. Chinoiserie is the word used to describe ornament influenced by Asian motifs but applied, often in small scale, to objects made in or based on European styles.[14]

Japanned furniture is an example of the interest in Asian-inspired ornament. Developed in the mid-1600s to satisfy the demand in Europe for oriental lacquerwork, japanned objects were known in London and Boston by the late 1600s. English and colonial craftsmen learned to make similar ornament to supply the demand.[15]

Japanners used tinted varnishes, paints, stains, and gesso to imitate oriental lacquerwork, and artisans with these skills were in Boston by 1712.[16] In a Boston japanned high chest (fig. 5-6), birds, flowers, and people offer an imaginative interpretation of oriental lacquerwork. In a recent study of japanned high chests, the ornament on drawer fronts is shown to be a continuous narrative painting emphasizing sea voyages and trade rather than a collection of similar but separate motifs. In addition to impressing guests, such high chests conveyed the story of international trade in which the fashion was rooted.[17]

Light

Light fascinated baroque artists. It could suggest the mind's radiance, define space, manifest the supernatural, and symbolize goodness and power.[18] The Sun King used these associations to his advantage. His Hall of Mirrors at Versailles shows how glass in windows and mirrors allowed architects to manipulate light and space. By the late seventeenth century, technological improvements in casting large sheets of glass led to the production of large pier glasses and window sashes.[19]

The baroque fascination with light traveled to the colonies. Although large glass pieces made little or no impact in the colonies, looking glasses were used in wealthy households and present an opportunity to interpret this fascination.[20] There was no colonial match for the gilded, silvered, or solid silver European furniture, but light-catching veneers and carvings link William and Mary–style furniture to the baroque interest in the play of light and shade.[21]

Antiquity

Seventeenth- and eighteenth-century scholars and noblemen studied classical painting, sculpture, and architecture, both for inspiration and as sources of artistic motifs. The stiles or vertical side rails of leather and caned chairs were conceived as classical columns. Baroque design ideas for domestic objects blossomed in an atmosphere of royal patronage. Elaborate objects and grand spaces were not part of the style in America, but they influenced the work of colonial artisans who produced objects with similar but distinctive ornament that included veneer, japanning, painting, C-scroll motifs, and classical and exotic designs. Such objects could be found in large, but not grand, rooms that were unified by matching textiles and furniture.

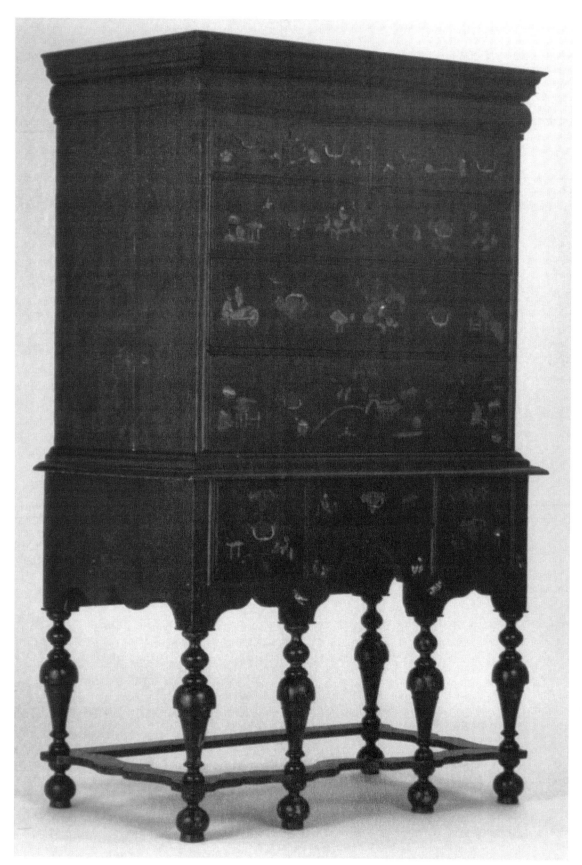

FIGURE 5-6. In this Boston japanned high chest, birds, flowers, and figures offer an imaginative interpretation of lacquerwork imported from China. (High chest of drawers, Boston, 1700–1720. Maple, hard pine; H 63⅝ in., W 40⅛ in., D 23 in. 1958.572 Winterthur Museum, gift of Henry Francis du Pont.)

Furniture in the William and Mary or Early Baroque Style 41

MAKING AND MARKETING WILLIAM AND MARY FURNITURE

Technical and commercial concerns affected furniture makers in England and America. Artisans found two skills, cabinetmaking and upholstering, to be important. For the most part, earlier woodworkers had been specialists in turning and joining, but different skills and techniques were needed to produce some of the new-style furniture. Furniture makers in commercial centers traded extensively in a complex international system, and evidence of these trading relationships can be seen in the objects they made.

Techniques

Furniture makers who constructed high chests with drawers needed to work with thinner pieces of wood than did the seventeenth-century joiner who made a board chest. They needed a type of joint that could hold thin wood as strongly as the mortise-and-tenon joint held thicker pieces. They solved these construction problems with techniques called cabinetmaking. Cabinetmakers used dovetail joints for the overall construction of fashionable high chests, dressing tables, and fall-front desks, which were often covered with hardwood veneer. In a dovetail joint, the tenon (which fits into the mortise) flares at its end, like a dove's tail. The flare can prevent the tenon from pulling out of the mortise when the tug on a drawer front pulls against the drawer sides.[22]

How did colonial woodworkers learn about the techniques of cabinetmaking? Scholars think immigrant craftsmen were probably responsible. One such cabinetmaker was John Brocas, who arrived in Boston in 1695 and worked there until his death in 1740.[23] He trained at least three native-born cabinetmakers in the new techniques. Immigrant craftsmen were probably also influential in Philadelphia, another urban center.[24]

Making easy chairs also required new skills of upholstery. The chair frames show similarities to cane or leather chairs with their medial stretchers, scalloped skirts, double-scroll arms, and rounded or scallop-shaped crest rails. Upholsterers attached padding to the wings and scrolled arms of chairs. They used marsh grass and curled horsehair held in place with twine and covered with linen, which protected sitters from the prickly horsehair.[25]

Craft Organization

Furniture makers in urban centers relied on workers in their own shops and increasingly on hired spe-cialists to complete furniture orders or to make parts for assembly into finished products. There is evidence that some workers served specialized apprenticeships in carving, caning, upholstering, and japanning.[26] The making of cane chairs exemplifies the industrialization of a craft through specialization, which could lead to economies of scale.[27] In the 1660s, chairs with cane seats and backs appeared in England. They were fashionable, yet they challenged furniture makers because the varied skills of turning, joining, carving, caning, and varnishing or staining were required to make them. If furniture makers were unable to acquire the necessary skills themselves or through shop workers, they found it cost effective to purchase parts from craftsmen such as turners and carvers. Artisans returned completed parts to the furniture maker's shop, where workers assembled and stained the finished products. The emergence of a new woodworking specialty, chair making, and the economies of large-scale production brought cane chairs within the reach of great numbers of people.[28] Responding both to the diffusion of design from the advanced artistic production of courtly circles and the demands of their customers, chair makers contrived a work process that allowed them to make fashionable furniture efficiently with various parts.[29] Between 1697 and 1704, an estimated 14,600 chairs were exported from England to the New World.[30] By 1700, colonial craftsmen manufactured chairs with cane that was imported, probably part of the vast international system of trade in raw materials and finished goods through Dutch and Portuguese merchants. The cane itself must have been purchased in places where the plant was native, such as China and India.[31]

Because of the variety of skills involved, chair making was chiefly an urban craft. Cities provided skills and markets for large-scale production, especially for the turned parts of case furniture and chairs. By the late seventeenth century, some city furniture craftsmen specialized in making inexpensive slat-back chairs with rush seats, caning, or upholstering. Furniture makers who worked in small towns were not as specialized. Without the demand to produce many objects in fashionable styles, they continued to practice woodworking crafts such as carpentry, coopering, and farm equipment production; many also farmed.[32] They also sometimes diversified into merchant activities. The impact of urban fashion on these artisans was tempered by local and personal construction techniques and designs.[33] The design impact of the William and Mary–style chair outlived its period of

highest demand, perhaps because of efficient production, which allowed chair makers to apply stylish details to chairs made for the middling sort.

Distribution

Specialization yielded an efficient use of resources. Chairs from a city could compete favorably in price with locally produced chairs. Consequently, many people could afford to purchase a stylish object or two. English cane chairs, which derived their design from Continental precedents, were exported throughout Europe and the colonies. Of the thousands sent from England to the New World between 1697 and 1704, 42 percent went to Virginia and Maryland, and 38 percent went to New England, even though chair making was a flourishing enterprise there. There are numerous examples of European cane chairs in New England museum collections.[34]

Surviving seventeenth-century chairs indicate that American craftsmen made more leather-covered chairs than cane forms.[35] Because of their carved frames and "Russian leather" upholstery, these chairs were more expensive than imported cane chairs.[36] So-called Russian leather was a high-quality, durable leather imported from northern Russia. It can be identified by the characteristic crosshatching created by hammering during production to increase absorbency and thus suppleness.[37] Boston chair makers, specializing in leather-upholstered chairs, supplied these chairs throughout New England, New York, Philadelphia, and the South.[38]

LIVING WITH WILLIAM AND MARY FURNITURE

From the 1630s to the 1680s, many colonists owned basic furniture: a chest, table, and bed, meaning the bedding and, less often, a bedstead. New Englanders also usually owned a form of seating furniture. By the 1680s, however, more domestic objects were available, at least to the wealthy.[39] The French set the standard for "civilized life indoors" and influenced the designs of those objects.[40] Louis XIV's complex ceremonies of daily court life necessitated specialized spaces and furnishings, which, in turn, influenced the furniture forms available to those who were wealthy but not noble. Wealthy householders at the turn of the eighteenth century in the English colonies could choose such new forms as looking glasses, desks, tea tables, easy chairs, and high chests with matching dressing tables for their best rooms.

Not only did the wealthy have more kinds of furniture, they also had more objects of each kind, such

as sets of six or twelve chairs. This trend toward sets of objects, allowing one for each individual, is also apparent with eating utensils. People of means in urban areas sought a unified approach to furnishing their rooms. A person who bought a high chest of drawers might also purchase a matching dressing table. Glass, ceramics, or other valued objects were displayed atop high chests. Chests of drawers provided stylish storage for clothing and linens. With arched skirts and stretchers set back to allow legroom, dressing tables served for grooming and for writing.[41] Few tables made in the colonies appear to have been specifically for serving tea. Many more such forms became available later, when the Queen Anne or late baroque and Chippendale or rococo styles were fashionable.[42]

Until about 1700, cane chairs were among the possessions of the wealthy. As they became more affordable, persons of the middling sort purchased them to replace stools and other forms. Cane chairs, after all, offered the advantages of "durableness, Lightness and cleanness from dust, worms and moths that inseparably attend Turkeywork, Serge, and other stuff-chairs and Couches to the spoiling of them and all Furniture near them."[43] They also provided a touch of the fashionable, with their imported cane, crest rails carved with C-scrolls, and tall backs.[44]

Oval tables with hinged leaves (called "falling leaves") replaced heavy joined tables or trestles with boards for dining.[45] Such tables were more easily movable. Several tables were used if many people needed serving. Tables were often placed in the hall, which began to evolve as a family sitting and dining room in houses with separate kitchens for meal preparation. Oval tables with falling leaves signify the move to informal dining in the late seventeenth century.[46]

Cabinetmakers in Boston, New York, and Philadelphia also provided their patrons with the latest in fall-front desks. Some examples show rich veneering contained within rectangular drawer fronts, characteristic of the style (fig. 5-7). Looking glasses brightened the rooms of those who could afford them. Hung high on the wall, a typical looking glass had a molded frame topped with a crown-shaped crest.

Some colonists associated power and status with furnishing one's home in the current English style. Chairs provided a relatively inexpensive means of responding to changes in fashion or economic status and could indirectly announce such a change to all.[47] In 1712, for example, James Logan, a Philadelphia merchant, paid £8 for a chest of drawers and £9 for three

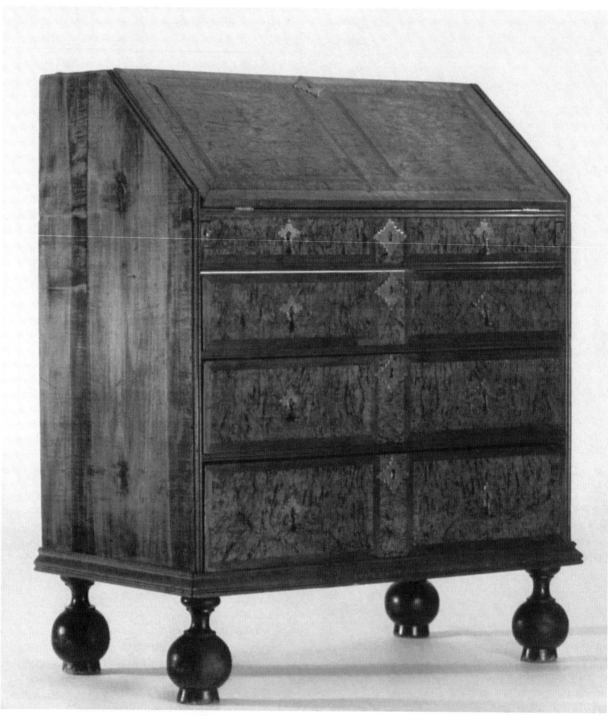

FIGURE 5-7. The large ball-shaped feet of this desk suggest an early style. In the early eighteenth century, decorative veneering carried no negative implications as it might today. The veneer is glued over solid wood. In this case both are walnut to assure compatibility. (Desk, Newport, R.I., 1700–1725. Burl maple veneer, walnut veneer, white pine, chestnut, soft maple; H 40½ in., W 35 in., D 19¼ in. 1958.1799 Winterthur Museum, bequest of Henry Francis du Pont.)

looking glasses, yet only £9 for eight chairs (including one armchair), a quilt, and a blanket.[48]

Matching sets of caned chairs, couches, and stools were first seen in London in the late seventeenth century. Considered the height of fashion, they were exported and appeared in inventories of prominent colonists from Boston to Charleston, South Carolina. Furnished with plump cushions, they expressed the taste for comfort, lightness, and elaborate ornament.

Easy chairs were the most costly seating furniture. The frame accounted for one-third of the cost, the outer cover and binding another third, while the pad-

ding, girt web, curled horsehair, feathers, ticking, and linen undercover accounted for the remainder. Upholstery added to the labor costs.[49] Exactly when the first easy chair was made in America is not known. A 1708 New York inventory lists an easy chair "lined with red," and four years later an easy chair was listed in a Boston inventory. Subsequently easy chairs appear with increasing frequency in the inventories of well-to-do colonists.[50]

Buying and selling furniture was one of many ways in which people in a community interacted with one another. Barter and credit were the primary means of exchange in an economy with little cash in circulation. Raw materials were traded for manufactured goods, or one kind of manufactured goods was exchanged for another. Craftsmen often carried credit and debits on their books for eventual settlement, sometimes for long terms. Such credit arrangements depended on trust. By handling this kind of commercial accounting and selling goods given them in trade, some craftsmen became successful merchants.

For colonists in British America, the royal governors set a style that some wealthy colonial families emulated as closely as possible. But many colonists could not furnish their homes in the newest style or chose not to do so. Levels of wealth, as well as ethnic, religious, and political allegiances, led colonists to different preferences. Some New Englanders, like those in the Connecticut River Valley of all economic levels, found traditional seventeenth-century furniture forms and room plans appropriate and comfortable well into the eighteenth century.[51] The Dutch in New York consciously expressed cultural preferences through their language and furniture into the early years of the nineteenth century. The *kas*, a large cupboard with doors, endured as a major storage form in the Dutch-influenced regions of Manhattan, the Hudson Valley, Long Island, and northern New Jersey.[52] The fat, full-turned rings on legs and stiles in New York leather upholstered chairs also reflect Dutch culture. A low back formed by three to five turned spindles, with stiles or side rails topped with a tall urn finial, was characteristic. Furniture historians who study these details of continental chair making corroborate the persistence of Dutch culture in the New York region long after the English took over that colony.[53]

CONCLUSION

From the 1690s until the 1720s, colonists who desired furniture in currently fashionable taste chose objects with bold forms and richly decorated surfaces—the

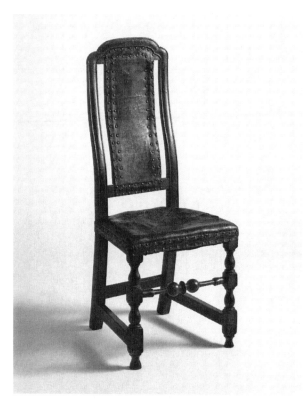

FIGURE 5-8. This side chair has its original webbing, marsh grass stuffing, and leather upholstery, attached by two rows of brass-headed nails on a leather strip around the rails. The curved back and the shaped stiles or back side rails may have been attempts by Boston chair makers to integrate newly fashionable characteristics into their efficient, piecework-based production. (Side chair, Boston, 1730–1740. Beech, leather, brass-headed iron nails, linen, marsh grass; H 43¼ in., W 18¾ in., D 18 in. 1981.46 Winterthur Museum.)

William and Mary or early baroque style. Through a developing international trading system, colonists adopted and adapted flourishing European intellectual and aesthetic trends. Colonial craftsmen understood the design elements and techniques and produced furniture similar in style and quality to that made in England and Europe.

By the 1720s, however, both patrons and craftsmen responded to changing ideas of fashion as characteristics of a new style began to appear (fig. 5-8). The curving lines so characteristic of ornament in the William and Mary style became much more important as structural elements. Called Queen Anne style by furniture historians, it has come to be seen as a later manifestation of baroque.

NOTES
1. Fairbanks and Bates, 43.
2. Murdoch, 56.
3. Adamson, 176.

4. Martin, 148–49; Snodin and Styles, chap. 3.

5. Baarsen, 15.

6. Baarsen, Jackson-Stops, Johnston, and Dee; Snodin and Styles, 59.

7. Johnston, 65.

8. Forman, cat. 61.

9. Baarsen, Jackson-Stops, Johnston, and Dee, 62–71.

10. Martin, 14, 155–57.

11. Martin, 161–63; Murdoch, 76.

12. Baarsen, Jackson-Stops, Johnston, and Dee, 176.

13. One decorative element on the lower edge of the Schuyler looking glass appears to be the head of a Native American, an example of an American motif used as an exotic reference. By the early seventeenth century, an American Indian woman was a symbol of the new continent for European artists.

14. Snodin and Styles, 61.

15. Lasser, 169.

16. Fales, 59.

17. Lasser, 169–76.

18. Martin, 223–48.

19. Thornton, *Seventeenth-Century Interior Decoration*, 75–83.

20. Jackson-Stops, 44, 53; Johnston, 74.

21. Baarsen, 15.

22. Trent, Follansbee, and Miller, 37, fig. 68.

23. Johnston, 66.

24. McElroy, 62.

25. See the description of easy chair production in Forman, 357.

26. Forman, 238.

27. Forman, 239.

28. Forman, 229.

29. Adamson, 176.

30. Forman, 239.

31. Adamson, 204 n9.

32. Zea, 55.

33. For a case study of the influence of William and Mary stylistic characteristics on local production, see Trent, *Hearts and Crowns*.

34. Forman, 239.

35. Adamson, 188; Forman, 243.

36. Johnston, 69.

37. Lindsey, 163.

38. For intracolonial trade in chairs, see Trent, *Hearts and Crowns*, 32.

39. St. George, 168–69; Carr and Walsh, 59–66.

40. Thornton, *Seventeenth-Century Interior Decoration*, 7.

41. Forman, 163.

42. Johnston, 74; Baarsen, Jackson-Stops, Johnston, and Dee, 206.

43. Forman, 238.

44. Adamson, 176.

45. Gruber, 121, 143.

46. Johnston, 74.

47. Forman, 299.

48. McElroy, 68.

49. Jobe, 79.

50. An upholsterer needed a substantial inventory of imported and domestic materials such as cloth, feathers, trimmings, leather, horsehair, web, and metal fittings, which increased his cost of doing business.

51. Ward and Hosley, 34.

52. Kenny, Gruber, and Vincent.

53. Gronning, 92–103.

BIBLIOGRAPHY

Baarsen, Reinier, Gervase Jackson-Stops, Philip M. Johnston, and Elaine Evans Dee. *Courts and Colonies: The William and Mary Style in Holland, England, and America.* New York: Cooper-Hewitt Museum, 1988.

Forman, Benno M. *American Seating Furniture, 1630–1730: An Interpretive Catalogue.* New York: W. W. Norton, 1988.

Kenny, Peter M., Frances Safford Gruber, and Gilbert T. Vincent. *American Kasten: The Dutch-Style Cupboards of New York and New Jersey, 1650–1800.* New York: Metropolitan Museum of Art, 1991.

Lasser, Ethan W. "Reading Japanned Furniture." In *American Furniture 2007*, edited by Luke Beckerdite, 169–90. Milwaukee, Wis.: Chipstone Foundation, 2007.

Lindsey, Jack L. *Worldly Goods: The Arts of Early Pennsylvania, 1680–1758.* Philadelphia: Philadelphia Museum of Art, 1999.

Thornton, Peter. *Seventeenth-Century Interior Decoration in England, France, and Holland.* New Haven, Conn.: Yale University Press, 1978.

Trent, Robert F. "The Early Baroque in Early America: The William and Mary Style." In *American Furniture with Related Decorative Arts, 1660–1830*, edited by Gerald W. R. Ward, 63–90. New York: Hudson Hills Press, 1992.

Additional Sources

Adamson, Glenn. "The Politics of the Caned Chair." In *American Furniture 2002*, edited by Luke Beckerdite, 174–206. Milwaukee, Wis.: Chipstone Foundation, 2002.

Baarsen, Reiner. "The Court Style in Holland." In *Courts and Colonies: The William and Mary Style in Holland, England, and America*, by Reiner Baarsen et al., 12–35. New York: Cooper-Hewitt Museum, 1988.

Bazin, Germain. *The Baroque.* London: Thames and Hudson, 1968.

Carr, Lois Green, and Lorena Walsh. "Changing Lifestyles and Consumer Behavior in the Colonial Chesapeake." In *Of Consuming Interests: The Style of Life in the Eighteenth Century*, edited by Cary Carson, Ronald Hoffman, and Peter J. Albert. Charlottesville: University Press of Virginia for the United States Capitol Historical Society, 1994.

Fairbanks, Jonathan L., and Elizabeth Bidwell Bates. *American Furniture 1620 to Present.* New York: Richard Marek Publishers, 1981.

Fales, Dean A. Jr. *American Painted Furniture.* New York: E. P. Dutton, 1979.

Fitzgerald, Oscar P. *Four Centuries of American Furniture.* Radnor, Pa.: Wallace-Homestead Book Co., 1995.

Gronning, Erik. "Early New York Turned Chairs: A Stoelen-draaier's Conceit." In *American Furniture 2001*, edited by Luke Beckerdite, 88–119. Milwaukee, Wis.: Chipstone Foundation, 2001.

Gruber, Frances Safford. *American Furniture in the Metropolitan Museum of Art.* Vol. 1: *Early Colonial Period: The Seventeenth Century and William and Mary Styles.* New York: Metropolitan Museum of Art, 2007.

Hook, Judith. *The Baroque Age in England.* London: Thames and Hudson, 1976.

Jackson-Stops, Gervase. "The Court Style in Britain." In *Courts and Colonies: The William and Mary Style in Holland, England, and America*, by Reiner Baarsen et al., 36–61. New York: Cooper-Hewitt Museum, 1988.

Jobe, Brock. "The Boston Upholstery Trade." In *Upholstery in America and Europe from the Seventeenth Century to World War I*, edited by Edward S. Cooke Jr., 65–89. New York: W. W. Norton, 1987.

Jobe, Brock, and Myrna Kaye. *New England Furniture: The Colonial Era.* Boston: Houghton Mifflin, 1984.

Johnston, Philip M. "The William and Mary Style in America." In *Courts and Colonies: The William and Mary Style in Holland, England, and America*, by Reiner Baarsen et al., 62–79. New York: Cooper-Hewitt Museum, 1988.

Martin, John Rupert. *Baroque.* New York: Harper and Row, 1977.

McElroy, Cathryn J. "Furniture in Philadelphia; The First Fifty Years." In *Winterthur Portfolio 13*, edited by Ian M. G. Quimby, 60–80. Winterthur, Del.: Henry Francis du Pont Winterthur Museum, 1979.

Murdoch, Tessa. "The Baroque in England." In *Design and the Decorative Arts, Britain, 1500–1900*, edited by Michael Snodin and John Styles, 56–57. London: V&A Publications, 2001.

Snodin, Michael, and John Styles, eds. *Design and the Decorative Arts, Britain, 1500–1900.* London: V&A Publications, 2001.

St. George, Robert Blair. "'Set Thine Own House in Order': The Domestication of the Yeomanry in Seventeenth-Century New England." In *New England Begins: The Seventeenth Century*, edited by Jonathan L. Fairbanks and Robert F. Trent, 2:159–88. Boston: Museum of Fine Arts, 1982.

Thornton, Peter. *Authentic Decor: The Domestic Interior, 1620–1920.* New York: Viking Press, 1984.

Trent, Robert F. *Hearts and Crowns: Folk Chairs of the Connecticut Coast, 1720–1840, As Viewed in the Light of Henri Focillion's Introduction to "Art Populaire."* New Haven, Conn.: New Haven Colony Historical Society, 1977.

Trent, Robert F., Peter Follansbee, and Alan Miller. "First Flowers of the Wilderness." In *American Furniture 2000*, edited by Luke Beckerdite, 1–64. Milwaukee, Wis.: Chipstone Foundation, 2000.

Ward, Gerald W. R., and William N. Hosley Jr., eds. *The Great River: Art and Society of the Connecticut Valley, 1635–1820.* Hartford, Conn.: Wadsworth Atheneum, 1985.

Zea, Philip. "Rural Craftsmen and Design." In *New England Furniture: The Colonial Era*, by Brock Jobe and Myrna Kaye, 47–72. Boston: Houghton Mifflin, 1984.

Furniture in the Queen Anne or Late Baroque Style

MUSEUM INTERPRETERS WHO SHOW VISITORS QUEEN Anne (or late baroque) furniture often notice their immediate pleasure and acceptance. Visitors are familiar with some elements of the Queen Anne style, which continues to be popular in furniture production today. To many people who visit museums and historic houses in the United States, furniture in this style is the essence of a colonial aesthetic. On one hand, familiarity obscures; the objects capture what we *think* colonials were all about. On the other hand, familiarity creates openness to the perspective of an eighteenth-century owner or user. The challenge is to elucidate present perspectives about the style by revealing those from the past.

Several considerations are important in the interpretation of this furniture: form, regional preferences, and comfort. Visually, the beauty of the style often derives more from sculptural form than from color or ornament, evidence of a continued interest in baroque qualities. Furniture scholars have worked for decades to understand where and how this furniture was made and used, researching long histories of ownership and studies of coastwise trade to discover both regional preferences and local and export markets. Lastly, increased attention was given to comfort and convenience during the time this furniture was fashionable in the colonies.[1]

LOOKING AT QUEEN ANNE FURNITURE

Furniture in the Queen Anne style is characterized above all by its line. Curved lines in the feet, legs, arms, crest rails, and pediments create forms that inspire the eye to move over the surface. Ornament, often shell shapes, is restrained and emphasizes the material, which, in urban style centers, was often walnut.[2]

Line

Lines that create curves abound. In contrast to William and Mary–style furniture, where curves appear as decoration, in Queen Anne furniture C-scrolls, S-scrolls, and ogee (S-)curves are incorporated into the structural members of the furniture. The shallow S-curve of a "crooked" back chair, for example, conforms to the similar S-curve of the human spine. The pronounced S-curve of the legs in a high chest contrasts with straight turned legs found in a William and Mary–style high chest. A Queen Anne–style chair made in Philadelphia has almost no straight lines, with the exception of the rear rail at the back of the seat (fig. 6-1).[3]

Volume

Objects in this style are sometimes termed sculptural, recalling how a sculptor forms a three-dimensional object from a solid and emphasizing form over ornament.[4] Pediments and facades, for example, especially of blockfront case furniture, rise and fall. Curved arms and legs of chairs continually carry the eye over the object. Cabinetmakers produced chair legs that flowed smoothly into the seats, then into the arms and backs, "repeating and reinforcing the major outlines."[5] The sense of movement and the sinuous quality of Queen Anne–style furniture contrasts with the rectilinearity of seventeenth-century and William and Mary–style objects.

Ornament

Curved line and restrained ornament create a highly three-dimensional form that characterizes the Queen Anne or late baroque style in America. In contrast to the inlay, figured veneers, paint, and carving of seventeenth-century and William and Mary–style furniture, applied ornament is, for the most part, absent from Queen Anne–style furniture. Curved lines and the limited use of relief-carved shells on chairs and case objects provide the principal ornament.

Japanning is the major exception to restrained ornament (fig. 6-2). A japanned and gilded high chest would have made an unforgettable impression on a visitor to a Boston home in the second quarter of the eighteenth century. Such an object continued the interest in baroque concepts of space, light, and exoticism.

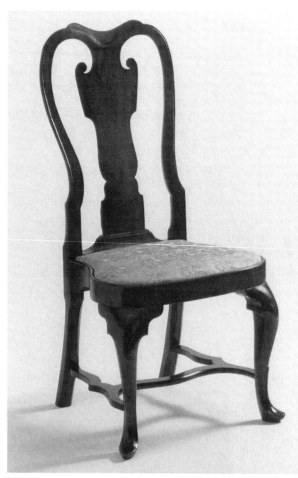

FIGURE 6-1. The predominantly curved lines of this chair are a key characteristic of the Queen Anne style. Even the stretchers, rarely used in Philadelphia chair construction, are curved. A Roman numeral, "VII", impressed in the front seat rail indicates that this chair was part of a set. (Side chair, Philadelphia, 1730–1750. Walnut; H 40 in., W 20 in., D. 19⅝ in. 1959.2504 Winterthur Museum, gift of Henry Francis du Pont.)

THINKING ABOUT STYLE

Queen Anne's reign (1702–1714) did not coincide with the taste for this style in the British colonies of North America; the name "Queen Anne" was first applied to the style more than a century after it was fashionable.[6] In England furniture historians and collectors called the style Georgian, after George I (reigned from 1714 to 1727) or George II (reigned from 1727 to 1760). Documentary sources suggest that people at the time named the furniture for its distinguishing characteristics rather than a style. In 1732, for example, a Boston upholsterer wrote a bill for "8 Leathr Chairs horsebone feet and banist[er] backs." "Horsebone" referred to cabriole, or S-curve, legs, and "banister back" refers to what is now called a baluster-shape splat at the back, or a flat, vase-shape splat. Many chairs combine these two characteristics (fig. 6-3).[7]

The period term "crooked back" refers to a chair with a curved back when viewed in profile, and "round backed" refers to a rounded crest rail.[8] Two important concepts suggest why this furniture looks the way it does: the continuation of the baroque approach to organizing space and the development of particular ways of producing furniture in shops or regions, whether for local sale or export.

Baroque Concepts

Hints of baroque ideas appear in this furniture often enough to justify the term "late baroque." Of particular note are baroque concepts about space and the play of light through projecting and receding surfaces. Baroque artists explored space, looked for depths and projections, and penetrated space with vistas and diagonals.[9] Vermeer and Rembrandt drew the viewers' eyes into the recesses of canvases and pulled imagi-

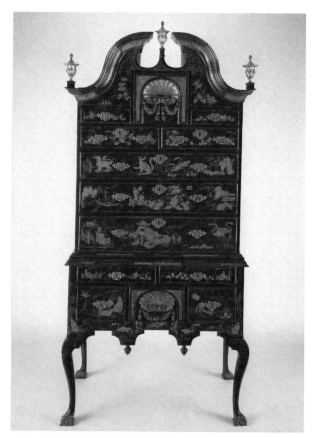

FIGURE 6-2. The broken arch pediment, cabriole legs, paw feet, and shell with swag in the center top and bottom of this high chest immediately suggest the Queen Anne style. The japanning was created by applying color to create a tortoise-shell-like finish, molding figures in gesso, and then gilding selected areas for emphasis. (High chest, Boston, 1740–1750. Soft maple, American black walnut, white pine, mahogany; H 85¼ in., W 42 in., D 24¼ in. 1957.1084 Winterthur Museum, gift of Henry Francis du Pont.)

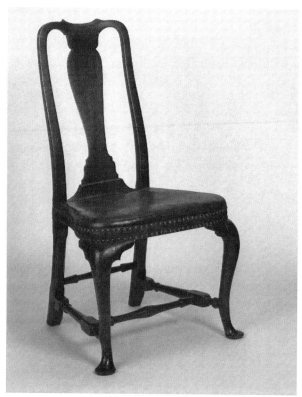

FIGURE 6-3. This chair is typical of what today is called a Queen Anne–style chair. Note the yoke-shape crest rail, solid vase-shape splat, horseshoe-style seat, and plain cabriole front legs. The eighteenth-century owner would have called it a chair with "banister back" or simply a "leather chair." The chair has original leather, which is upholstered over the seat rails. (Side chair, Boston, 1732–1745. Walnut, maple; H 39½ in., W 22 in., D 20¼ in. 1998.7 Winterthur Museum purchase with funds provided by Mr. and Mrs. George M. Kaufman, Mr. Martin Wunsch, and an anonymous donor.)

nations beyond the surfaces of paintings. Light and shadow fell across varying surfaces in both painting and architecture.

Architects and landscape designers controlled expanses of space. They designed not only buildings but also city plans, not only country houses but also sweeps of surrounding gardens and landscapes. Sir Christopher Wren covered the central space in London's St. Paul's Cathedral with a great dome, then divided the interior space to create vistas.[10] The vistas of major streets in Williamsburg, Virginia, followed the baroque formula of focusing on major public structures.

On a much smaller scale, Queen Anne–style furniture also shows an interest in space and light. The mirrored doors and the projecting and receding surface of a blockfront desk-and-bookcase made by Job Coit in 1738 is a good example (fig. 6-4).[11] The light reflec-

tions emphasize varying convex and concave surfaces. The curves of a Queen Anne–style chair probably would have pleased William Hogarth, who in 1753 proclaimed an S-curve the ultimate "line of beauty."[12] Fascination with curves is part of the excitement of movement in space, which some critics declare the essence of baroque design and culture.[13]

People influenced by baroque ideas were interested in spatial relationships in buildings and landscapes and were also inspired by unfamiliar or exotic spaces in their world. A fascination with Far Eastern cultures continued. Asian prototypes probably influenced the

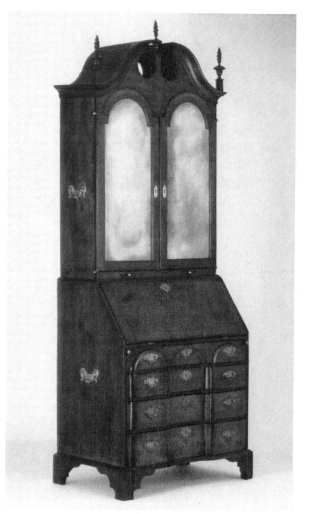

FIGURE 6-4. This desk-and-bookcase is signed "J Coit/1738" and "J Coit jr/1738" on drawers in the desk interior. Job Coit was forty-five years old that year. His second son, Job Jr. (like his two brothers), is identified as a joiner or cabinetmaker in legal documents. The elder Coit was not trained by English cabinetmakers, nor did he follow London designs or construction techniques. The inspiration for this early dated colonial example of the blockfront style is a mystery. (Desk-and-bookcase, Job Coit and Job Coit Jr., Boston, 1738. American black walnut, white pine; H 100⅛ in., W 39½ in., D 24½ in. 1962.87 Winterthur Museum.)

Furniture in the Queen Anne or Late Baroque Style 51

use of curved shapes in this furniture.[14] Other Far Eastern elements include the use of the ball-and-claw foot, a pattern that seems to have been copied from the highly imaginative dragons painted or embroidered on imported porcelains, textiles, and lacquerwork cabinets; the vase-shape splat that curved to conform to the human body; the increasing use of brass hardware on furniture to imitate Far Eastern cabinets; and japanning that imitated Asian lacquerwork.

Baroque ideas reached American trading centers filtered through the products and training of London craftsmen. The interpretation of those ideas varied from shop to shop and place to place. Regional characteristics developed, and furniture in the Queen Anne style was the first to be analyzed according to such categories.[15]

Regionalism

In modern studies of American colonial furniture, regionalism is a concept that groups objects on the basis of similar characteristics of design and construction. The similarity is explained by the furniture's origin in a specific geographic area. Regionalism is a useful interpretive tool because it encourages one to look carefully at specific elements of furniture and to question why they look the way they do.

Early twentieth-century furniture historians drew inspiration from work in the 1930s by historical geographers and linguists who used regional or sectional approaches in their studies of American culture. Current furniture scholars seek to define the products of specific regions by identifying both shop traditions and the geographical expanses over which their products found acceptance. A greater awareness of the reach of coastal trade in furniture has led to important regional studies in the last decades.[16]

In regional centers, artisans were influenced by those who trained them, those who worked at the next bench, and those who worked in nearby shops. They were also influenced by imported objects, as in the English chairs coming into Boston that were seen and adapted by Boston craftsmen.[17] Craftsmen chose to produce objects that were practical and successful in their market area; in other words, they prospered if they made things that pleased their local customers or sold readily in the export trade. Although an artisan's individuality persists in work habits and design, opportunities for change occur as new ideas, new objects, or new craftsmen enter the region. Local traditions face competition, and in this interplay between inherited practices and novel concepts, specific regional practices can appear.[18]

Regional characteristics were influenced not only by the artisan but also by the owners. Within each community, certain ideas about the way people ought to behave and the way furnishings ought to look prevailed. Community standards developed from varied sources, including shared religion, ethnic identification, status, and interest in current European fashions. In a close-knit community, these ideas could be accepted widely and persist for a long time. In the example of the furniture made in Rhode Island in the mid- to late eighteenth century, furniture scholars ask why the craftsmen adhered to baroque characteristics, like blockfront case pieces, when craftsmen in other cities were working with naturalistic motifs associated with Chippendale or rococo design. It may have been that the patronage of wealthy merchants and the success of far-flung trading ventures encouraged them to continue making furniture in the same ways.[19]

What features were important to a colonist when commissioning a chair or table? Did some see unfamiliar furniture as improper or simply different? As scholars study objects owned by identifiable individuals, they will answer these questions and refine our understanding of community standards of design and behavior.[20]

Queen Anne–style chairs, for example, lend themselves to regional comparison and contrast. Among the standard characteristics of New England chairs are a contoured or "crooked" back, a yoke-shape crest rail, a vase-shape back splat, a loose or slip seat, a scalloped front seat rail, side seat rails with low arches along the bottom edge, curved cabriole legs (sometimes with a squared front corner), turned front feet that often end in rounded pad shapes, back legs with chamfered corners, side stretchers that are partly turned and partly block shaped, and medial and rear stretchers that are turned with slight swells in the center.[21] In Boston, claw feet and rounded or "compass-shape" seats were more expensive modifications of this standard model. In Philadelphia, however, different characteristics prevailed.[22]

Regional interpretations not only describe shared characteristics but also suggest why a particular region was a cohesive community. What, for example, do we know about Boston and New England in the early 1700s that explains why a community produced regionally identifiable objects? Information about political and economic development can begin to answer this question. A further question about why the people of Boston or Newport or Providence chose certain furniture designs and not others is more difficult to

answer. With Boston as its major port, New England by the mid-1600s had developed an economy based on diverse exports (fish and whale products, wood products, foodstuffs) and commercial and shipping services. By the early 1700s, shipbuilding, commerce, and exports were well established in Boston, and its port was full of international and intracolonial shipping. A series of European conflicts, played out in the colonies, expanded the economy from 1689 until 1756. In this environment, Boston offered great opportunity to many artisans through access to local and export markets. Between 1725 and 1760, 224 furniture craftsmen worked there; no other American port in the period had more.[23] With these conditions, communication between and among craftsmen was easy, international ideas were available, and a regional pattern developed and flourished.

The well-developed furniture-making business in Boston gave the city's workers an advantage in exporting their wares. Studies of primary documents such as shipping and shop accounts as well as the objects themselves have shown the importance of the export trade to Boston's economy. Boston chairs traveled to port cities on the continent and in the West Indies.[24] Despite Boston's dominance, the furniture makers of Newport, Rhode Island, also shipped their products beyond the local market.

The furniture made in Newport in the mid-eighteenth century is a cohesive regional grouping. It was sold in Newport and Providence and exported to the south and the West Indies. Documents tell this story, which is also highlighted by the fact that a tea table made in Newport has a history of ownership in the Wright family of Wilmington, North Carolina.[25]

Well known and much studied, the most famous objects were made for the wealthy merchants of Newport and Providence.[26] For these merchants, the cabinetmakers fashioned so-called block- and shell-front case pieces, including desk-and-bookcases, chests of drawers, and desks. The craftsman "blocked" the drawer or door facades by creating alternating convex and concave panels, similar to the blocking seen in the desk-and-bookcase made by Job Coit in 1738 (fig. 6-4). Elaborating the design, the cabinetmakers capped or ended their panels with lobed shell carvings. On tea tables or side tables, John Goddard (1724–1785) and other Newport craftsmen used undulating curved skirts to produce the sculptural projecting-and-receding surface characteristic of the baroque.[27] Although their reasons for doing so are not entirely clear and may relate to the ready market, the cabinetmakers of

Newport worked in the baroque style long after their counterparts in other areas had stopped.

In the context of artisans working with known customers or producing standardized products for the export trade, regional characteristics provide interesting interpretations of some furniture made in the early and mid-1700s, but regional distinctions blur by the early 1800s. Nineteenth-century developments in communication and transportation, such as canals and railroads as well as coast-wide shipping, facilitated the extensive distribution of raw materials, finished products, and design ideas. The choices open to furniture makers and buyers, therefore, were less defined by geographic configurations.

No matter where they were made, "new fashion" Queen Anne–style chairs represented only a small percentage of chair production and ownership, but stylistically, their influence on design was significant. In the eighteenth century, New England chair makers used a combination of "new fashion" chair backs with the early baroque-style foot and stretcher design for inexpensive chairs (fig. 6-5).[28] In an effort to work efficiently and profitably, they might have found that a combination of the old and the new was useful. Craftsmen combined early Georgian, or Queen Anne, features like squared cabriole legs on chairs with rear back posts that were not curved, which they could make quickly.[29]

Turners working in New York, New Jersey, and Connecticut also adapted the Queen Anne style to their tradition and produced a chair called fiddleback, or York, after New York. On some fiddleback chairs, the turned cabriole legs meet the blocked corners of the front seat rail; on less expensive versions, the legs extend above the rush seat. Painted black or reddish brown, with rush seats, and probably of "middling" cost, these chairs were available to more people than the high-style joined chairs. Chair makers produced a variety of chairs at a range of prices with elements of a new style to suit customers' needs. Wealthy families probably used York chairs in lesser rooms; for other owners, York chairs ranked as best chairs for the parlor.[30]

MAKING AND MARKETING QUEEN ANNE FURNITURE

In each community, whether urban or rural, furniture makers favored certain woods, designs, and construction techniques that led to regional concepts of style.[31] Some communities could even support such specialized skills as gilding, ornamental carving, and some

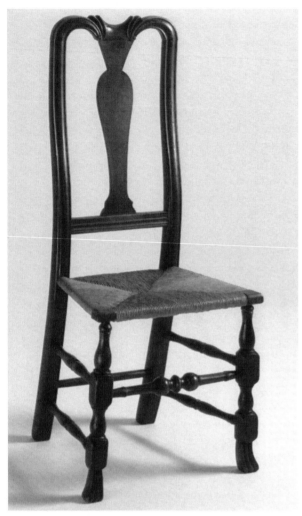

FIGURE 6-5. A chair maker used the Queen Anne–style back with a slight S-curve, called a "crook back," the yoke-shape crest rail, and a vase-shape splat to add fashionable touches to a chair with the turned legs and stretchers and brush-type feet suggestive of the William and Mary style. With its turned legs and rush seat, this chair was less expensive than a joined chair with an upholstered seat. (Side chair, Connecticut, 1720–1740. Maple, ash, tulip poplar; H 42⅛ in., W 19¾ in., D 17⅞ in. 1958.1576 Winterthur Museum, bequest of Henry Francis du Pont.)

kinds of upholstery.[32] Clients and patrons also affected a cabinetmaker's understanding of a style. Until 1740, Massachusetts, especially Boston, was an important chair-making center and style setter in the colonies. After 1740 Newport gained more prominence, but Philadelphia eventually became the preeminent center for furniture making.

Woodworking

Woodworking shops were small, with space enough for a few men, usually the master and his helpers and apprentices.[33] Custom work was usually a small portion of a shop's total output. Of necessity, shop owners supplemented their income; in rural areas they farmed, and in cities, some worked as carpenters or merchants. Commercial activities and investment were often the most financially successful diversifications. As one scholar notes, "Business acumen and a sensitivity to the fashion consciousness of the local elite characterized the best cabinetmakers."[34]

The cost of materials and labor and a profit for the master determined the price of objects. Because of the time involved, a desk-and-bookcase was the most expensive piece of eighteenth-century furniture. In addition to materials, form also helped determine the price of chairs and tables. In 1741 cabinetmaker Samuel Grant charged 32 shillings for a Boston leather chair, 43 shillings for a "leather-bottomed" maple chair with a trapezoidal seat, 65 shillings for the same chair in walnut, and 80 shillings for a chair with a compass seat. A patron who requested additional length for a table, with the necessary extra supporting legs, could expect to pay more. The forms of legs could be plain, cabriole, or Marlborough.[35] Corner, dining, and card tables had lathe-turned tapered legs with simply shaped pad feet. Such legs were less expensive to make than carved, curved legs (fig. 6-6).

Upholstering

Upholstery was an urban trade, since the necessary materials as well as supportive patrons could be found in cities. Successful upholsterers may have mass-produced leather-covered chairs for the Atlantic coast trade, but their custom work was seating furniture in the newest style for wealthy patrons. They took frames made by chair makers and stuffed and covered them with expensive textiles.

The finished appearance of an upholstered chair depended on the skill of the upholsterer (fig. 6-7). The upholsterer began with a layer of linen canvas on a wood frame. He then applied stuffing of curled horsehair, grass, or other resilient material that was affixed by another layer of canvas. The piece was then ready for the finish fabric. "As a rule, the outer covering cost about half the total price, the frame about a fifth, the labor even less, and the balance of the cost was for the stuffing materials which made the chair 'easie.'"[36] Sometimes a patron also ordered a slipcover—or several slipcovers for seasonal changes of color.

Another related task—the preparation and attachment of bed hangings—demonstrated the height of the upholsterer's art. A fully furnished bed, because of

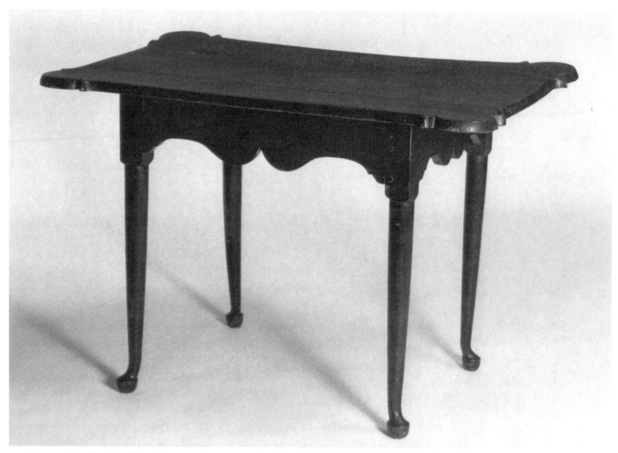

FIGURE 6-6. Small tables like this one, called "scallop'd" or "square tables" by their eighteenth-century owners, varied in cost and function, depending on the wood used and the need. People could eat meals, do business, or socialize at such tables. (Square table, Rhode Island, Connecticut, or Massachusetts, 1740–1790. Hard maple, soft maple; H 25½ in., W 38½ in., D 24½ in. 1959.1531 Winterthur Museum, bequest of Henry Francis du Pont.)

the quality and quantity of textiles involved, was often the most expensive possession in the home.

Japanning

The japanner was a specialist who applied his skill to the work of cabinetmakers. Applying dark base coats of red, brown, and black paint in addition to gesso, japanners created raised figures of exotic and fanciful flora and fauna that were then gilded and varnished.[37] Although japanned objects were often imported from England, twelve japanners are known to have worked in Boston in the first half of the eighteenth century.[38] The years between 1680 and 1740 saw the peak of fashion for japanned case pieces.[39] On some, the images on the drawer fronts tell a continuous story, sometimes of sea voyages, which would appeal to the families of the merchants whose wealth they displayed.[40]

LIVING WITH QUEEN ANNE FURNITURE

Those who owned Queen Anne–style furniture in the early 1700s lived in a society that was expanding rap-

idly. Although Virginia was the largest colony, Pennsylvania's population between 1720 and 1760 grew the most—from 30,000 to 180,000.[41]

Partly as a result of a series of European wars that fired English demand for colonial raw materials and brought hostilities to North American shores, the economy also expanded. New England merchants, for example, profited from Queen Anne's War (1702–1713, called the War of Spanish Succession in Europe) and relied on Boston furniture makers to satisfy orders resulting from lucrative naval supply commerce.[42] The European wars confronted English monarchs just as they overcame the challenges of the Civil War and Cromwellian Protectorate (1642–1658) and the Glorious Revolution of 1688.[43] Because strong colonies were assets, English monarchs and their ministers encouraged colonial development. England was not yet imposing taxes in the colonies to raise money for defense, so her ruling hand was gentle.

The vogue for Queen Anne–style furniture coincided with the ability and desire to spend for fashionable

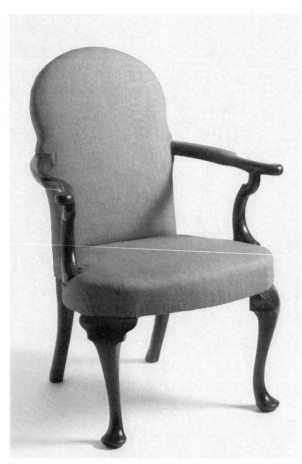

FIGURE 6-7. This armchair has a "stuffed back" in addition to a seat upholstered over the rails. Fully upholstered armchairs, or easy chairs, have been documented in the English colonies in the early 1700s and increasingly after 1750. (Armchair, New York, 1730–1750. Walnut, ash; H 35⅝ in., W 26⅛ in., D 23½ in. 1958.2596 Winterthur Museum, bequest of Henry Francis du Pont.)

goods. With European standards of interior decoration changing, upper classes improved the quality of goods owned and heightened the standards of comfort. The easy chair was developed for people who found it comfortable to recline on upholstery. A chest divided into drawers appealed to people who wanted specialized storage for many possessions.[44] Inventories show that people at most economic levels lived more comfortably than their seventeenth-century forebears.[45] Homes of the wealthy, in particular, became elegant.[46] Walls with raised panels suggest a conscious effort to construct more showy and permanent residences. Fireplaces were decorative as well as functional when faced with delft tiles or marble.

Inventories, however, also show that many people had sparsely furnished homes, and much of what they did have was not in the latest style. In rural areas, even well-to-do farmers chose to invest far more of their wealth in land, animals, and farm equipment than in household goods.[47] Most households had bedding in several rooms of the house, and the majority had cooking equipment and a minimal amount of tableware. In the eighteenth century, ownership of at least one table became common, and an increased number of people had six or twelve chairs.

By 1730 the price of tea dropped considerably, and more people developed a taste for tea drinking. Tea tables and implements became more common after 1725.[48] In the homes of the middling sort, the room with the most chairs often had two or three tables; this arrangement suggests a space for dining. Wealthy people had several tables in most of their rooms. For dining, a table with falling leaves and curved legs supplanted earlier turned-leg counterparts. Round and oval tops remained fashionable, and walnut and maple were common woods.

Tables and chairs at this time were aligned against the walls when not in use. Susanna Whatman in her *Housekeeping Book* offers the following advice: "One of the most useful directions [to a new servant] is that of putting away chairs, tables, and anything that goes next to the wall, with the hand behind it. For want of this trifling attention, great pieces are frequently knocked out of the stucco and [furnishings] leave a mark on the wall."[49]

Round tea tables, called "fly tea tables" at the time, had tops that pivoted into a vertical position when not in use, worked by a metal catch. The tripod legs were oriented to the stationary block holding the catch and supporting the table top, so that the table could easily fit either into a corner, with one leg at the corner's angle, or against a wall, with two legs touching the wall. The choice was up to the person ordering the table.[50] With marble or tile tops to withstand damage from spilled liquids, mixing tables were used to serve alcohol. Tables for cards are recorded in New England by 1725 but more regularly after 1750. Typically they had a leaf that folded over the top with often square or round projecting corners to hold candlesticks.[51]

Concern for comfort is evident, and those who could afford to do so ordered at least some upholstered seating furniture. The upholstered slip seat, which first appeared in France, was also found in the colonies.[52] Upholstered back stools, armchairs, easy chairs, and sofas were available, and armchairs were sometimes ordered in sets. Sofas in this style are rare. Upholsterers often used wool fabrics such as cheyney, harrateen, or moreen, which, after press-

ing between two calendar rollers, could acquire a subtle wavelike pattern with varying matte and shiny surfaces. Customers fancied bright blues, yellows, greens, and especially reds. Less expensive than wool, leather was also used to cover furniture. A particularly fine type was "Russian leather," named after its source in northern Russia. It was processed to a glossy, durable, supple surface.[53] The original leather covering is still evident on a Boston armchair (fig. 6-8), attesting to its durability.

High chests stood in rooms that also contained beds, and in inventories these were called "case of drawers," "chest of drawers," or simply "drawers." Bureau tables, dressing tables, chairs, tables, and tableware were also used in bedchambers.[54] The bedstead often displayed elegant textiles. For those who could afford it, matching chair upholstery and window hangings added richness to rooms.[55] Bedsteads in this style are rare survivals.

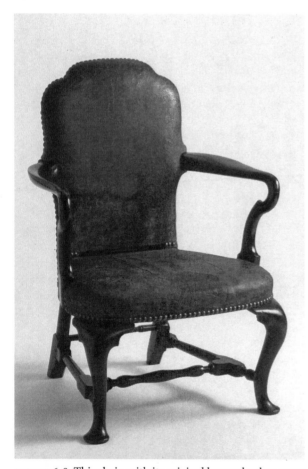

FIGURE 6-8. This chair, with its original brown leather cover and brass nails, is rare. Leather finish covers were more common on side chairs than on easy chairs. (Armchair, Boston, 1745–1765. Mahogany, soft maple; H 34¾ in., W 25¼ in., D 22¼ in. 1958.2597 Winterthur Museum, bequest of Henry Francis du Pont.)

CONCLUSION

In its design and regional diversity, furniture in the Queen Anne or late baroque style demonstrates the acceptance of metropolitan ideas in colonies that were consolidating a favorable position within a mercantile system. The persistence of Queen Anne design characteristics well into the 1800s, and their successful integration with traditional construction such as turned chairs, shows how well accepted a style it was. But even as mahogany chairs in this style were reaching their fashion pinnacle in the colonies, some English style setters were embracing "modern," French-influenced design characteristics, which would eventually lead to a fashion for the style we call rococo.

NOTES

1. Thornton, 60.
2. Lindsey, 112. In the essay "Pondering Balance: The Decorative Arts of the Delaware Valley, 1680–1756," Lindsey notes that black walnut was identified as the most common primary wood used, with yellow pine, white cedar, poplar, and sometimes chestnut and oak used as secondary woods.
3. Jobe and Kaye, 336; Hughes, 972–73.
4. Downs, xxi, wrote that these objects have "appropriate ornament subservient to form."
5. Gowans, 140.
6. Dates for the reigns of British monarchs are from Snodin and Styles, 461–62.
7. Jobe and Kaye, 347–48.
8. Trent, *Hearts and Crowns*, 60.
9. Hook, 11.
10. Fleming, 404–405.
11. Richards and Evans, 431–35.
12. *The Analysis of Beauty*, as quoted in Hummel, *Winterthur Guide*, 13.
13. Fairbanks and Bates, 85; Hook, 11; Fleming and Honour, 429–30, 432; Martin, 12–16.
14. Jobe and Kaye, 336.
15. Zimmerman, 17. See early examples of regionalism applied to Queen Anne–style furniture in Downs, xxiv–xxvii, and Comstock, 74–80.
16. See, for example, Keno, Freund, and Miller; Bivins, "Rhode Island Influence."
17. Keno, Freund, and Miller, 267. These furniture scholars found that Boston was the primary port of entry for British manufactured goods coming into the mainland colonies. Boston patrons and craftsmen set standards for fashionable goods inspired by imports.
18. Jobe and Kaye, 347–50.
19. Ward, "America's Contribution to Craftsmanship," 242.
20. Cooke, *Making Furniture*, 11, 92–117.
21. Richards and Evans, 3, 18–19.

22. Lindsey, 161–63.

23. Jobe, Whitehill, and Fairbanks, 3.

24. Summary of research by Keno, Freund, and Miller, 267–306, as quoted in Ward, "America's Contribution to Craftsmanship," 237.

25. Kane, 5.

26. Ward, "America's Contribution to Craftsmanship," 225.

27. Zea, 249–75.

28. Jobe and Kaye, 373–74.

29. Adamson, 201–3.

30. Cooke, *Making Furniture*, 96–99, 110–11, 126, fig. 8, 275. Cooke analyzes the inventories of two towns in southwest Connecticut. The documents date from 1760 to the 1820s. The chairs he calls "roundtop" or "York" have round-shoulder crest rails as well as dips, called saddles or yoke shapes, in the middle of the crest rail. These characteristics we recognize as coming from the Queen Anne style.

31. Jobe and Kaye, 23.

32. Zimmerman, 25.

33. Headley, 21.

34. Zea, 55; Jobe and Kaye, 14.

35. Richards and Evans, 216.

36. Jobe and Kaye, 366.

37. Jobe and Kaye, 197–98.

38. Jobe and Kaye, 197–98; Fales, 48, 60.

39. Lasser, 169.

40. Lasser, 177–82.

41. Nash and Jeffrey, 95.

42. Nash and Jeffrey, 95, 112; Sellers, McMillen, and May, 23; Whitehill, Jobe, and Fairbanks, 5. The dates for the War of Spanish Succession come from Snodin and Styles, 461.

43. Dates from Snodin and Styles, 461.

44. Thornton, 60.

45. Carr et al., 126, 137–38.

46. Bushman, 352.

47. Carr et al., 166.

48. Kane, 1.

49. Jobe and Kaye, 290.

50. Kane, 1.

51. Richards and Evans, 217; Comstock, 73.

52. Fitzgerald, 39.

53. Trent, "17th-Century," 46–49. Russia leather is discussed in Lindsey, 163.

54. Cummings, 162; Jobe, Whitehill, and Fairbanks, 194.

55. Jobe, Whitehill, and Fairbanks, 42.

BIBLIOGRAPHY

Downs, Joseph. *American Furniture: Queen Anne and Chippendale Periods in the Henry Francis du Pont Winterthur Museum*. New York: Macmillan, 1952.

Heckscher, Morrison H. *American Furniture in the Metropolitan Museum of Art*. Vol. 2. *Late Colonial Period: The Queen Anne and Chippendale Styles*. New York: Random House for the Metropolitan Museum of Art, 1985.

Jobe, Brock W. "The Late Baroque in Colonial America: The Queen Anne Style." In *American Furniture with Related Decorative Arts, 1660–1830: The Milwaukee Art Museum and the Layton Art Collection*, edited by Gerald W. R. Ward, 105–37. New York: Hudson Hills Press, 1991.

———. *Portsmouth Furniture: Masterpieces from the New Hampshire Seacoast*. Boston: Society of the Preservation of New England Antiquities, 1993.

———, ed. *New England Furniture: Essays in Memory of Benno M. Forman*. Boston: Society for the Preservation of New England Antiquities, 1987.

Jobe, Brock W., and Myrna Kaye. *New England Furniture: The Colonial Era*. Boston: Houghton Mifflin, 1984.

Keno, Leigh, Joan Barzilay Freund, and Alan Miller. "The Very Pink of the Mode: Boston Georgian Chairs, Their Export, and Their Influence." In *American Furniture 1996*, edited by Luke Beckerdite, 266–306. Milwaukee, Wis.: Chipstone Foundation, 1996.

Lindsey, Jack L. *Worldly Goods: The Arts of Early Pennsylvania, 1680–1758*. Philadelphia: Philadelphia Museum of Art, 1999.

Monkhouse, Christopher P., and Thomas S. Michie. *American Furniture in Pendleton House*. Providence: Museum of Art, Rhode Island School of Design, 1986.

Richards, Nancy E., and Nancy Goyne Evans. *New England Furniture at Winterthur: Queen Anne and Chippendale Periods*. Winterthur, Del.: Henry Francis du Pont Winterthur Museum, 1997.

Snodin, Michael, and John Styles. *Design & the Decorative Arts: Britain 1500–1900*. London: V&A Publications, 2001.

Trent, Robert F. *Hearts and Crowns: Folk Chairs of the Connecticut Coast, 1720–1840*. New Haven, Conn.: New Haven Colony Historical Society, 1977.

———. "17th-Century Furniture Upholstery in Massachusetts." In *Upholstery in America & Europe from the Seventeenth Century to World War I*, edited by Edward S. Cooke Jr., 46–49. New York: W. W. Norton, 1987.

Ward, Gerald W. R., ed. *American Furniture with Related Decorative Arts, 1660–1830: The Milwaukee Art Museum and the Layton Art Collection*. New York: Hudson Hills Press, 1991.

Whitehill, Walter Muir, Brock W. Jobe, and Jonathan L. Fairbanks, eds. *Boston Furniture of the Eighteenth Century*. Boston: Colonial Society of Massachusetts, 1974.

Zimmerman, Philip D. "Regionalism in American Furniture Studies." In *Perspectives on American Furniture*, edited by Gerald W. Ward, 11–38. New York: W. W. Norton, 1988.

Additional Sources

Adamson, Glenn. "The Politics of the Caned Chair." In *American Furniture 2002*, edited by Luke Beckerdite, 174–206. Milwaukee, Wis.: Chipstone Foundation, 2002.

Bivins, John. "Rhode Island Influence in the Work of Two North Carolina Cabinetmakers." In *American Furniture 1999*, edited by Luke Beckerdite, 79–108. Milwaukee, Wis.: Chipstone Foundation, 1999.

Bushman, Richard. "American High Style and Vernacular Cultures." In *Colonial British America: Essays in the New History of the Early Modern Era*, edited by Jack P. Green and J. R. Pole, 345–83. Baltimore: Johns Hopkins University Press, 1984.

Carr, Lois Green, et al. "Forum: Toward a History of the Standard of Living in British North America." *William and Mary Quarterly*, 3rd ser., 45, no. 1 (January 1988): 116–70.

Comstock, Helen. *American Furniture: Seventeenth-, Eighteenth-, and Nineteenth-Century Styles*. New York: Viking Press, 1962.

Cooke, Edward Strong Jr. *Making Furniture in Preindustrial America: The Social Economy of Newton and Woodbury, Connecticut*. Baltimore: Johns Hopkins University Press, 1996.

———, ed. *Upholstery in America & Europe from the Seventeenth Century to World War I*. New York: W. W. Norton, 1987.

Cummings, Abbott Lowell. *Rural Household Inventories*. Boston: Society for the Preservation of New England Antiquities, 1964.

Fairbanks, Jonathan L., and Elizabeth Bidwell Bates. *American Furniture: 1620 to the Present*. New York: Richard Marek Publishers, 1981.

Fales, Dean A. Jr. "Boston Japanned Furniture." In *Boston Furniture of the Eighteenth Century*, edited by Walter Muir Whitehill, Brock W. Jobe, and Jonathan L. Fairbanks, 49–70. Boston: Colonial Society of Massachusetts, 1974.

Fitzgerald, Oscar. *Four Centuries of American Furniture*. Radnor, Pa.: Wallace-Homestead Book Co., 1995.

Fleming, John, and Hugh Honour. *The Penguin Dictionary of Decorative Arts*. London: Viking, 1989.

Fleming, William. *Art and Ideas*. 3rd ed. New York: Holt, Rinehart and Winston, 1991.

Garrett, Elizabeth. *At Home: The American Family, 1750–1870*. New York: Harry N. Abrams, 1990.

Gowans, Alan. *Images of American Living: Four Centuries of Architecture and Furniture as Cultural Expression*. New York: Harper and Row, 1976.

Headley, Mack. "Eighteenth-Century Cabinet Shops and the Furniture-Making Trades in Newport, Rhode Island." In *American Furniture 1999*, edited by Luke Beckerdite, 17–37. Milwaukee, Wis.: Chipstone Foundation, 1999.

Hook, Judith. *The Baroque Age in England*. London: Thames and Hudson, 1976.

Hughes, G. Bernard. "'Hogarth Chiars' in Georgian England." *Country Life* 140 no. 3633 (October 20, 1966): 972–73.

Hummel, Charles F. *A Winterthur Guide to American Chippendale Furniture: Middle Atlantic and Southern Colonies*. New York: Crown Publishers, 1976.

———. *With Hammer in Hand: The Dominy Craftsmen of East Hampton, New York*. Charlottesville: University Press of Virginia for the Henry Francis du Pont Winterthur Museum, 1968.

Kane, Patricia E. "The Palladian Style in Rhode Island Furniture: Fly Tea Tables." In *American Furniture 1999*, edited by Luke Beckerdite, 1–16. Milwaukee, Wis.: Chipstone Foundation, 1999.

Kirk, John T. *American Chairs: Queen Anne and Chippendale*. New York: Alfred A. Knopf, 1972.

Lasser, Ethan W. "Reading Japanned Furniture." In *American Furniture 2007*, edited by Luke Beckerdite, 169–90. Milwaukee, Wis.: Chipstone Foundation, 2007.

Martin, John Rupert. *Baroque*. New York: Harper and Row, 1977.

Miller, Henry M. "Baroque Cities in the Wilderness: Archaeology and Urban Development in the Colonial Chesapeake." *Historical Archaeology* 22, no. 2 (1988): 57–73.

Nash, Gary B., and Julie Roy Jeffrey, eds. *The American People: Creating a Nation and a Society*. New York: Harper and Row, 1982.

Sellers, Charles, Neil R. McMillen, and Henry May. *A Synopsis of American History*. Vol. 1: *Through Reconstruction*. 3rd ed. Chicago: Rand McNally College Publishing, 1974.

Thornton, Peter. *Authentic Decor: The Domestic Interior, 1620–1920*. New York: Viking Press, 1984.

Ward, Gerald W. R. "America's Contribution to Craftsmanship: The Exaltation and Interpretation of Newport Furniture." In *American Furniture 1999*, edited by Luke Beckerdite, 225–48. Milwaukee, Wis.: Chipstone Foundation, 1999.

Zea, Philip. "The Serpentine Furniture of Colonial Newport." In *American Furniture 1999*, edited by Luke Beckerdite, 249–75. Milwaukee, Wis.: Chipstone Foundation, 1999.

Furniture in the Chippendale or Rococo Style

FURNITURE IN THE STYLE WE CALL CHIPPENDALE (OR rococo) conjures images of genteel colonials, conversing and drinking tea, seated in carved mahogany chairs in rooms with classical pediments inspired by English examples. Such settings are also associated with the founding of the United States. In the meeting chamber of Independence Hall in Philadelphia, the Constitutional Convention's presiding officer, George Washington, sat in a chair made in 1779.[1] The chair, the only documented relic of the convention, has a curving crest rail with central carved ornament and a splat with Gothic arches in the Chippendale style.

Twentieth-century collectors usually call this furniture "Chippendale"; furniture scholars use the term rococo. The former name celebrates London cabinetmaker Thomas Chippendale and his influential pattern book, *The Gentleman & Cabinet-maker's Director*, first published in 1754.[2] Since the publication of William Hornor's *Blue Book, Philadelphia Furniture* in 1935, many scholars have identified and attributed furniture based on designs printed in Chippendale's book. They have also researched furniture makers and wood carvers.

Furniture historians study these objects closely, looking at the design, material, and construction. They examine the printed design sources and learn who owned and possibly imitated these influential styles. Tool collections, craftsmen's record books, and buyers' accounts also survive, which help to connect the furniture to makers, owners, and users—past and present.

LOOKING AT CHIPPENDALE FURNITURE

A profusion of ornament often appears to be the most dramatic design element of Chippendale-style furniture. Additionally, distinctive lines and material, especially mahogany, characterize the style in eighteenth-century North America. When you see mahogany furniture with a combination of curved and straight structural lines and possibly an abundance of carved ornament, think of the Chippendale or rococo style.

Ornament

Carving accounts for the ornament on most Chippendale furniture. On some examples it nearly covers the object, as seen in a bracket made between 1760 and 1785 (fig. 7-1). On others, it highlights specific areas such as legs, arms, splats, and crest rails of chairs; skirts, pediments, and legs of high chests; or skirts, legs, and edges of tables. Some examples, however, are not carved, indicating an owner's preference for a plainer or less expensive object.

Carved motifs on Chippendale furniture cluster loosely into four categories. One group includes flora, shells, and animals derived from recognizable natural forms. In the second group are stylized natural forms such as gadrooning, volutes, and scrolls as well as geometric forms such as C-scrolls and quatrefoils. Architectural elements—columns, pagodas, arches, and moldings—inspired a third group. A fourth group includes designs such as tassels and swags that appear similar to those in textiles.

Line

Curved lines in Chippendale- or rococo-style furniture often carry a viewer's eyes beyond the object. The quintessential Chippendale-style flared crest rail on a chair is a clear example (fig. 7-2). Similar lines extend pediment ends on clock cases, high chests, and chest-on-chests. Curves elongate the feet of tripod bases on tables, stands, and fire screens, suggesting more movement and extension than the contained curves of the Queen Anne or late baroque style.

Tempering the curved lines, however, are straight lines. On an armchair, for example, curves may appear in arms, legs, splat, and crest rail, but straight lines delineate stiles and seat rails. Some desks, desk-and-bookcases, and chests of drawers are basically rectilinear forms with added carving and ball-and-claw or curved bracket feet (fig. 7-3).

Material

Urban furniture makers working in this style most often chose mahogany for the parts that customers

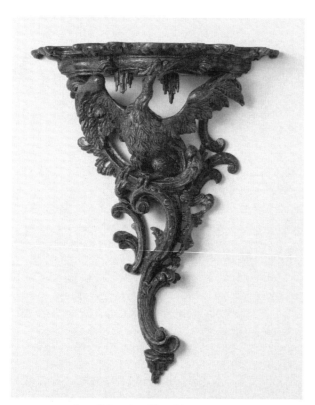

FIGURE 7-1. A wall bracket like this rare example made in Philadelphia between 1760 and 1785 constituted specialized work for the wood carving trade, which was so important to the ornamentation of Chippendale-style furniture. The C-scrolls, leafy foliage, and suggestions of stalactites above the bird's head exemplify rococo carving motifs. (Wall bracket, Philadelphia, 1760–1785. Pine; H 16¼ in., W 12⅞ in., D 5½ in. 1958.2242 Winterthur Museum, gift of Henry Francis du Pont.)

would see. Carvers found its dense grain conducive to their best work, and the grain patterns, enhanced with appropriate finishes, added to an object's beauty.[3] For example, a Philadelphia furniture maker centered swirling grain on the swelled front of the chest in figure 7-3, where it would attract the most attention. The combination of the curved grain and the serpentine structure of the drawer fronts reinforces the overall design.

Such characteristic ornament, line, and material help identify the Chippendale or rococo style, which became fashionable in the colonies of British North America before the Revolutionary War. The story of the style's development is closely connected to design influences from France and England and their accessibility through printed sources.

THINKING ABOUT STYLE

The fact that modern collectors named this style of furniture after a book, Chippendale's *Gentleman & Cabinet-maker's Director*, suggests the importance of printed materials to craftsmen and their patrons.

Increasingly available during the eighteenth century, printed materials influenced politics, manners, and religion. Pattern books existed for the crafts of furniture making and house building, which was closely related and often had a great influence on furniture. Books disseminated metropolitan designs both in England and the colonies.

Knowledge and the ownership of books denoted good breeding and gentle manners. A well-stocked and well-chosen library more often graced the home of a wealthy, prominent family in the late eighteenth century than in earlier years.[4] In England and other countries, architects, house builders, and their patrons read and used architectural and pattern books. Then they built and crafted buildings and furniture with similar motifs. Andrea Palladio's *Quattro libri dell' architettura*, or the famous *Four Books of Architecture*, were the most influential.[5]

Palladio was born in Padua, Italy, in 1508 and died seventy-two years later in Vicenza. His popularity in

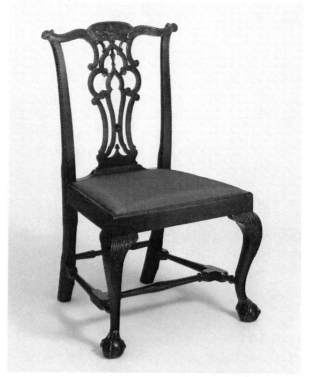

FIGURE 7-2. This side chair shows the traditional stretcher construction and chamfered rear legs of New England manufacture with the flared crest rail and ornamental pierced back splat of the Chippendale style. The splat has a large trefoil above a pointed lancet in the center. Both designs are illustrated in Chippendale's *Gentleman & Cabinet-maker's Director* (1754), but the splat design is not common in English or colonial chairs. (Side chair, Boston, 1760–1775. Mahogany, birch; H 38 in., W 23⅝ in., D 22⅞ in. 1961.140.1 Winterthur Museum, gift of Henry Francis du Pont.)

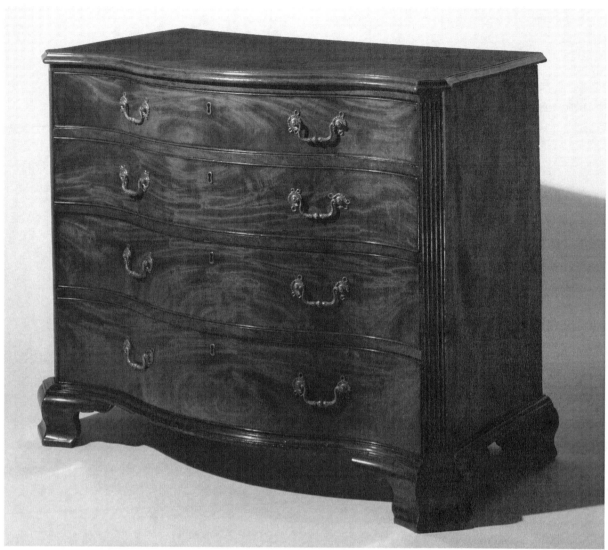

FIGURE 7-3. The curved lines in the serpentine front and top of this chest as well as the ogee bracket feet are balanced by the straight lines of the fluting and chamfering at the case corners and the horizontal drawer fronts. Mahogany, which decorates these drawer fronts with swirls and curves, was the favored wood for furniture in the rococo style. (Chest of drawers, Philadelphia, 1775–1793. Mahogany, tulip, pine; H 36 in., W 47¼ in., D 26⅝ in. 1959.631 Winterthur Museum, bequest of Henry Francis du Pont.)

England and her colonies rests on two foundations: Patrons and builders found his work practical and applicable, and the prevailing artistic and political climates encouraged designs based on classical sources. Palladio addressed a significant architectural problem, defining the proportions of a building's parts to form a pleasing whole.

Following a Renaissance tradition of using a column's diameter as a unit, Palladio and others of his time drew up proportional systems to guide builders. Chippendale adapted this system in the *Director*. With illustrations and descriptions of Roman ruins and the five classical orders, Palladio's books nurtured the fascination with Roman art and architecture. His success

in combining aesthetics and utility and in transferring his designs to the easily transported printed page resulted in Palladian-inspired villas as far from Italy as Monticello in Virginia.

Palladio's *Four Books* were published in 1570. The first complete English translation appeared in 1715 as Britain's ruling classes struggled for equilibrium after the politically chaotic seventeenth century. Palladio's followers in England included Giacomo Leoni, who published the 1715 edition; Colin Campbell, who published his own *Vitruvius Britannicus* in three volumes between 1715 and 1725; and Richard Boyle, the third earl of Burlington, who became the dominant figure in the new Palladian movement. Campbell's volumes

contained Palladio's work as well as designs by the great English architect Inigo Jones. Already schooled in classical designs through grand tours on the European continent, English noblemen relied on such books in building their great houses. These aristocrats found Campbell's English Palladianism, grounded in Roman antiquity, a fitting symbol for the new spirit of English liberty and the Whig political party as it emerged in contrast to the monarchism of the Tories.[6] In this commitment to classicism, the English diverged from their traditional reliance on French and Dutch design influences. At the time, rococo influences were strong in France and the rest of Europe.[7]

Many pattern book compilers followed the lead of Palladio's and Campbell's work.[8] One was Chippendale, who wrote that to excel as a cabinetmaker one must carefully study the five classical orders, "since they are the very Soul and Basis of his Art."[9] Chippendale's designs, however, also reflect the free and fanciful taste of the 1740s and 1750s. Chippendale employed three kinds of ornament: Gothic, Chinese, and Modern. Gothic pillars, arches, and quatrefoils recalled English medieval architecture, and Chinese motifs grew from a continued fascination with the ancient, distant civilization of the Far East. In some side chairs, it is possible to see a pointed Gothic arch in the pierced back splat or a quatrefoil at the base. Both the Gothic and Chinese motifs were open to imaginative interpretations and therefore fit neatly with what Chippendale called Modern, which was the influence of rococo design from France.[10]

Rococo is ornament that is complex but light in touch and often asymmetrical in detail.[11] The natural forms of shells, leaves, branches, flowers, and clouds lend themselves to rococo interpretations. The flowers, cartouches, and leaves on the looking glass frame carved for John Cadwalader by James Reynolds are examples (fig. 7-4).

American craftsmen knew of Chippendale's *Director*. At least seven owned their own copy, and others could have referred to one in a shop, the private library of a patron, or, in the late 1760s, at the Library Company of Philadelphia. The traceable influence of the *Director* varies by region. In New England, John Goddard of Newport owned a copy, but his surviving furniture shows no use of the designs. Copies were in the libraries of William Buckland, an Annapolis architect; Thomas Jefferson, at Monticello; and Edmund Dickenson, a cabinetmaker in Williamsburg, Virginia.[12] There was a copy in Charleston, North Carolina, and a bookcase survives there that is clearly

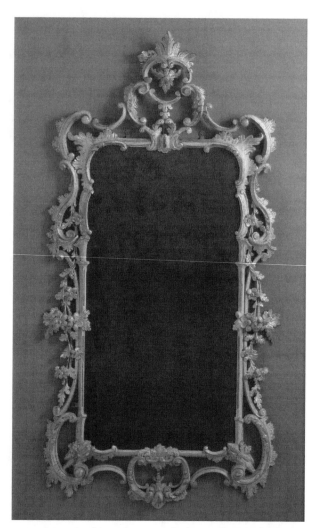

FIGURE 7-4. Looking glasses and picture frames, both imported from England and locally made, were decorated in the French-influenced style replete with shells, scrolls, foliage, and rocaille. James Reynolds of Philadelphia made this looking glass frame but also advertised imported looking glasses for sale. (Looking glass, Philadelphia, 1769–1770. Pine, tulip, glass; H 55½ in., W 28½ in., D 2¼ in. 1952.261 Winterthur Museum, gift of Henry Francis du Pont.)

based on Chippendale's designs. Philadelphia's furniture shows great influence of the *Director*. Thomas Affleck, trained in London and known for his fashionable furniture, owned a copy. Philadelphia furniture maker John Folwell proposed the publication of an edition of the *Director* in June 1775, but the Revolution caused a change in plans.[13]

Designs stored in the minds and executed in the work of craftsmen were also important sources of influence. As the colonies developed in the second half of the eighteenth century, the number of furniture makers increased. They worked particularly in urban areas, and scholars have identified shop traditions and regional patterns more clearly delineated than before 1750.

Chairs offer visible examples of regional preferences in design and construction. New England chairs combine Chippendale design elements on the back with traditional construction in seats and stretchers. The traditional chamfered rear legs and stretcher configuration join "new" flaring crest rails, pierced back splats, straight seat skirts, and ball-and-claw feet with unwebbed, long, thin talons.[14] New York furniture makers used different proportions for their chair design, which appears wide and heavy. The carving on New York furniture is shallow and controlled when compared to Philadelphia work, which exhibits sculptural carving. Philadelphia furniture characteristics are rear legs with rounded or chamfered edges, crest rails with definite ears, and side rails often tenoned through the rear legs. The back splat designs include illusions of interlaced or pierced and carved straps and a Gothic arch with quatrefoils (fig. 7-5).[15]

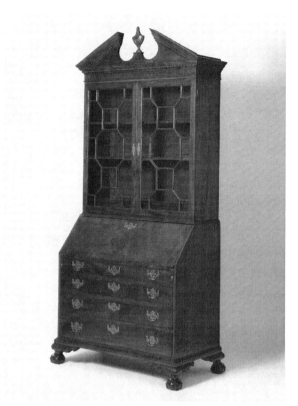

FIGURE 7-6. This desk-and-bookcase is attributed to the shop of New York cabinetmaker Samuel Prince because of its similarity to a labeled example. Such an acquisition, especially with rare glass doors, was a major investment for its owner in the late eighteenth century. (Desk-and-bookcase, Samuel Prince, New York, N.Y., 1770–1775. Mahogany, tulip, white paint; H 98½ in., W 47¾ in., D 25⅝ in. 1951.31 Winterthur Museum, gift of Henry Francis du Pont.)

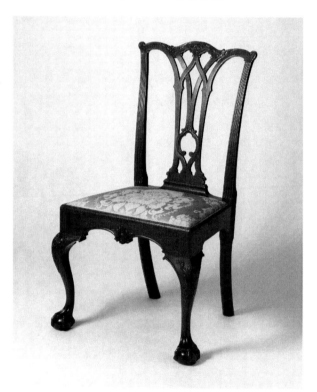

FIGURE 7-5. This chair has a back splat design that relates to Plate X in the 1762 edition of Chippendale's *Director*. The design was used by Philadelphia furniture makers. On the back of the chair, an interlaced strap culminates in a Gothic arch just under the crest rail. At the base of the splat is a trefoil. A paper label is pasted inside the rear seat rail: "MADE and SOLD by THOMAS TUFFT, Cabinet and Chair-Maker, FOUR Doors from the Corner of Walnut-Street in Second Street, Philadelphia." (Side chair, Thomas Tufft, Philadelphia, 1760–1780. Mahogany, white cedar; H 38¾ in., W 23¾ in., D 20⅞ in. 1957.514 Winterthur Museum, gift of Henry Francis du Pont.)

A desk-and-bookcase made in New York just before the Revolution illustrates several aspects of the origin and spread of Chippendale's designs (fig. 7-6). A similar design was published in *Household Furniture in Genteel Taste for the Year 1760*, a book produced in London by Robert Sayer, a printseller, to which Chippendale contributed some works.[16] The pierced fretwork on the cornice, doors, and brasses; its acanthus leaf-carved bracket above the ball-and-claw feet; and its broken pediment identify this desk-and-bookcase as being in the Chippendale style. In giving this piece a prominent place in his home, the owner displayed his status as an educated reader and owner of books.

MAKING AND MARKETING CHIPPENDALE FURNITURE

Extensive documentation of furniture-making practices survives for the second half of the eighteenth century, enhancing our understanding of how this furniture was made and sold. What construction

techniques, raw materials, tools, and selling practices did woodworkers know and use? Surviving furniture, tools, and records all tell the story.

The furniture maker who filled an order for a chair or chest of drawers relied on successful construction techniques that were honed through apprenticeship and years of use. He employed a system of proportion derived from architecture for laying out an object's overall size and the relationship of various parts.[17] To work efficiently and satisfy customers, he used templates, patterns, and measuring sticks or gauges to ensure the fit of furniture parts.[18] To incorporate new designs, he studied actual objects, learned from other craftsmen, or looked at pattern books.

Carving, the hallmark of elaborate furniture in the mid- to late 1700s, depended more on freehand work than did turning chair parts. Although a carver often used a drawing or pattern to lay out a design, he worked freehand to cut away the background and outline the design. His rough and then final modeling with various gouges completed the work. Like the precise cutting of tight-fitting dovetails in cabinetmaking, carving required meticulous, often specialized, work that increased the price of a product.[19] If a customer wanted something new, the woodworker had to push beyond the boundaries of his skill and habits as well as the patterns and templates available in the shop. He had to consider the potential return on his labor. These choices were important as he created a new form and thus influenced the development of the style.

Woodworkers used both imported and domestic woods. Sabicu, or horseflesh mahogany, was imported from the Bahamas. It can be identified by modern analytical methods. Mahogany from the West Indies entered colonial ports in exchange for grain and other foodstuffs. It appears in furniture made in Philadelphia after 1720. By 1750 it became more common as larger quantities entered the port of Philadelphia.[20]

Mahogany was also available to woodworkers who lived a distance from coastal ports. The Dominy family on the eastern tip of Long Island worked with it, as did at least one worker in the western Connecticut market town of Woodbury.[21] If a woodworker used mahogany frequently, it probably meant he had affluent purchasers and close contact with trading routes and new design ideas.[22] Native local woods were, of course, more readily available and affected the price of furniture. The Dominys, for example, charged 10 shillings for a maple stand, 12 shillings for a cherry stand, and 18 shillings for a mahogany table made in their shop in 1796.[23]

Furniture shops were small by modern standards. They were usually situated close to the worker's home, and, if a town supported several furniture makers, were often in the same neighborhood. Nathaniel Dominy III worked in a shop attached to his home in East Hampton, Long Island. The space contained three workbenches (fig. 7-7). Smaller than the shop of a major London designer such as Thomas Chippendale, who employed about seventy workers in his three-story building with various rooms for specialties such as upholstery, the Dominy shop was typical for a mid-eighteenth-century North American woodworker.[24] The largest number of workbenches found in inventories of New England furniture makers was seven.[25] The number of benches in a shop indicates only an estimate of the number of people employed there.

Furniture makers might learn their trade from a family member or by apprenticing to a master outside

FIGURE 7-7. This workbench from the shop of the Dominy family, East Hampton, Long Island, is shown in the reconstructed Dominy Shop at Winterthur. (Workbench, East Hampton, Long Island, 1750–1775. Red oak; H 28¾ in., L 82⅛ in. 1957.26.369 Winterthur Museum purchase with funds provided by Henry Belin du Pont.)

the family. In the course of everyday work, a shop owner taught his helpers efficient and accurate methods for laying out, measuring, and finishing an object and instructed them in the community's acceptable standards of workmanship and style preferences. To satisfy their customers on Long Island, the three generations of Dominy craftsmen were masters of both wood- and metalwork. After adequately training a son to take over shop responsibilities, a father usually specialized in his favorite crafts.[26] Such specialization was common in New England.[27]

Tradition dictated the responsibilities of the master and apprentice. Hercules Courtenay, who learned to carve in a large London shop, probably came to Philadelphia under the sponsorship of Benjamin Randolph, a furniture maker. Randolph paid for Courtenay's clothing in 1767, which was expected of a master.[28] Courtenay, in turn, became master of a shop by 1769 and apparently trained others.

Furniture makers made and sold their work in the community, which influenced how a craftsman earned his living, how much he depended on the seasons and outside work, and how he was paid by his customers.[29] Seasonality most strongly affected those who lived in rural areas, farmed, or derived income from repair work related to agriculture. John Dunlap of rural New Hampshire, for example, produced furniture from December to March, when he turned to plowing. From May through October, his woodworking was predominantly house joinery, which required good weather. June and July were the best months for selling furniture, as his farmer neighbors estimated their harvests and incomes.[30]

Many furniture makers diversified, and surviving accounts indicate that artisans often derived income from several sources—with furniture making not necessarily the most lucrative. In a rural setting, an artisan could do general woodworking and repair; lease his animals, equipment, and land; and do agricultural work for himself and others. In August 1765, for example, Nathaniel Dominy IV of Long Island cradled and banded oats—an income supplement for a twenty-eight-year-old whose father still controlled the family business.[31] Nathaniel IV and his son also worked at house building and millwrighting.[32] In a port town, woodworking skills were also needed to adorn and fit out ships.[33] James Reynolds, a London-trained carver, advertised his availability for "Ship Work in general" upon his arrival in Philadelphia in 1766.[34]

Merchant activities were another diversification. An upholsterer dealing with imported materials, an affluent clientele, and the market opportunities of a city found the move to merchant a natural progression.[35] Within two years of arriving from London, Reynolds, known today for his carving, offered "a very large and genteel Assortment" of imported looking glasses, wallpaper, painting brushes, pencils, and other supplies for sale in Philadelphia.[36] If furniture making provided a comfortable income, diversification into merchant activities often accounted for an affluent one.[37] A furniture maker in a port town, for example, could invest in a ship that carried his goods, or a Philadelphia carver could invest in an iron furnace that used his carved forms for casting stove parts or chimney firebacks.[38]

Living in an economy made cash-poor by the mercantile regulations of English rulers, eighteenth-century artisans in British North America dealt with credit. Thomas Affleck, for example, billed John Cadwalader £37 for carving by James Reynolds, done between October 1771 and January 1772.[39] Although stated in cash terms, this debt was probably not settled with money in a timely fashion. A furniture maker often carried a debit against a yearly reckoning or used it as a credit to purchase other goods and services. In small towns, the same account system existed. In 1782, for example, John Dunlap sold a desk for twenty-seven bushels of corn or the equivalent value in fish, eels, or money. The debt remained on Dunlap's books for five years until full payment of more than 450 eels was made.[40] And in 1770 and 1775, the Dominy family noted several loads of wood on the credit side of the ledger.[41] John Cahoone, a cabinetmaker in Newport, Rhode Island, in the 1750s, paid wages in cash, goods, and future orders.[42]

Most successful craftsmen had to travel to market their goods, learn new skills, or acquire better working or living conditions. From the eastern tip of Long Island, the Dominys served customers as far north as Hartford, Connecticut. In 1795 Nathaniel Dominy IV rented a mare to take a "Clock-Tour" of eastern Long Island to repair clocks and watches for customers.[43] Nicholas Bernard and Martin Jugiez, London-trained carvers in Philadelphia, conducted business in Boston, New York, and Charleston. In 1765 Bernard visited Charleston to sell wares. He advertised "that he is just arrived in this Town, and has for sale, at a Back Store in Gadsden's Alley . . . GILT and painted glasses . . . mahogany desks, china tables, tea tables & tea chests."[44]

In the second half of the eighteenth century, most colonial furniture makers relied on habit, standard

techniques, and measurements to ensure efficient work. They crafted objects with imported and local woods; worked with a few others in small shops; supplemented craft income with agricultural, woodworking, or mercantile activities; used credit; and bartered. The end of the colonial era brought gradual changes to all of these activities, most notably in extending marketing networks and an increasing availability of cash.

LIVING WITH CHIPPENDALE FURNITURE

The extent of furniture ownership changed during the mid- to late 1700s, although not for everyone and not everywhere. Some people began to judge as inadequate the kind and quality of furnishings that their parents or grandparents would have thought sufficient. People of the middling sort as well as substantial property owners began to value gentility. Their interest in a genteel lifestyle is manifest through such evidence as the popularity of tea tables and chests of drawers. But the extent of this interest is more difficult to document. Only a few people in the colonies owned furniture similar to designs in Chippendale's *Director* or other pattern books, and many people still owned only a few pieces of furniture.

Furniture makers in large and small towns worked for whoever would buy their wares, making goods to suit their own work habits and their client's needs. In Philadelphia, William Savery, who was locally born and trained, produced a walnut chair sometime between 1755 and 1765. It had a flaring crest rail and pierced splat but not the sculptural carving done by London-trained workers. His furniture was purchased by John Cadwalader, a man of nearly unlimited means, who paid more than £61 for at least twenty-nine pieces of walnut furniture: twenty-four chairs, two chamber tables, and three pieces of storage furniture, including a chest of drawers with fluted columns. The furniture was mostly for Cadwalader's second-floor rooms.[45] In less pretentious homes, Savery furniture probably would have been found in the best rooms.

High-style Chippendale furniture was available to only a few wealthy patrons such as Cadwalader. Their large landholdings included fashionable Philadelphia houses in the 1760s and 1770s. They purchased furniture and architectural woodwork decorated by London-trained carvers for their main reception rooms. Cadwalader paid £119.8.0 in one invoice (there were apparently others) to Thomas Affleck and carvers James Reynolds, Nicholas Bernard, and Martin Jugiez for furniture including three sofas, an easy chair, two card tables, and four fire screens. Various upholsterers' bills suggest that Cadwalader purchased thirty-two chairs, twenty for his front parlor. Although Affleck's bill lists no chairs, the furniture was probably similar in quality to other side chairs associated with the family (fig. 7-8).[46]

On the other hand, through the end of the eighteenth century most families owned little "moveable wealth." In the Chesapeake, 40 percent of landowners still owned less than £50 worth of consumer goods, and the designation "landowners" excluded significant portions of the population—women, tenants, and bound laborers, both black and white.[47]

Although ownership of expensive, fashionable, substantial pieces of furniture was limited, knowledge of fashion was not. Inventory studies show that even small landowners occasionally owned a fork or packet of tea, indicating awareness of new manners and social ceremonies. Those who had table cutlery, tea, earthenware, linen, spices, books, wigs, watches, pictures, and silver were aware of a trend toward gentility, which emphasized personal refinement in deportment, conversation, and education.[48] In material life, it emphasized social ceremony and fashion. Objects for each individual became important, whether an in-

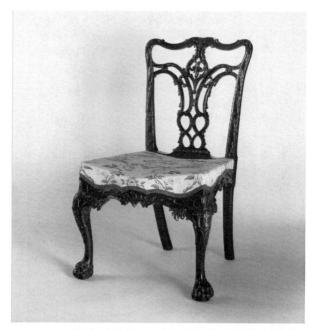

FIGURE 7-8. This chair is associated with the Cadwalader family. The carving on the front seat rail resembles that on a card table made for John Cadwalader, and a similar chair appears in the Charles Willson Peale portrait of John's brother Lambert Cadwalader. (Side chair, Philadelphia, 1769–1770. Mahogany, cedar; H 36¾ in., W 23¾ in., D 23¾ in. 1958.2290 Winterthur Museum, gift of Henry Francis du Pont.)

dividual fork or a teacup. Social customs became more ritualized, which required the correct accoutrements. For example, tables for playing cards were different from tables for drinking tea or eating breakfast. Furniture forms with drawers or pigeonholes offered more and specialized storage for linen, cutlery, and books. Where a chest might have served in the past, a chest with drawers or a desk-and-bookcase with drawers, shelves, and pigeonholes became preferable.[49]

Studying inventories, which were listings of someone's assets at the time of death, allows some generalizations about the kinds of furniture people owned and the rooms in which they used it. Sofas were relatively rare and symbols of status. When an upholstered sofa was owned, the upholstery on the chair seat coverings and window hangings in a room were often en suite.[50]

Chairs in sets of six, eight, or ten furnished both parlors and second-floor chambers if a house had such rooms. When the Honorable Andrew Belcher died in rural Suffolk County, Massachusetts, in 1771, he owned fifteen chairs in his parlor and ten leather-bottom mahogany chairs (including two armchairs

in a second downstairs reception room labeled a dining room, a room designation that was used only in great houses in the 1770s).[51] Each of Belcher's three chambers (the word "chamber" usually meant an upstairs room) also contained chairs; in one, a set of eight walnut chairs included two armchairs. Dining paraphernalia appeared in other chamber inventories in Suffolk County, and the presence of chair sets in chambers suggests that eating and visiting occurred in these rooms that were not yet private retreats.[52]

Chairs lined the walls when not in use.[53] As noted in one period document, "When a person comes into his chamber, and finds the chairs all standing in the middle of a room, he is angry with his servant, and rather than see them continue in that disorder, perhaps takes the trouble himself to set them all in their place with their backs to the wall. The whole propriety . . . arises from its superior conveniency in leaving the floor free and disengaged."[54]

Although some tables can be distinguished as tea tables and some as card tables, large and small tables often served varying purposes (fig. 7-9). George Washington ordered a table that would have at least two

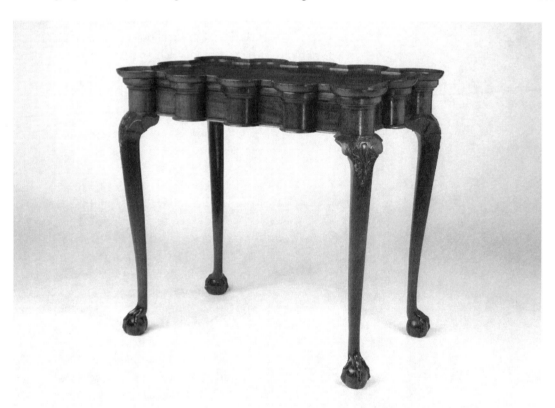

FIGURE 7-9. This tea table, called "turret-top" by twentieth-century collectors, is one of six known examples that were apparently made and used only in the Boston area. The form relates to round-corner card tables and scallop-top tea tables, both examples of specialized forms that were increasingly favored by the wealthy in the 1790s. (Tea table, Boston, 1745–1765. Mahogany, white pine; H 27½ in., W 30 in., D 19⅜ in. 1958.2774 Winterthur Museum, bequest of Henry Francis du Pont.)

uses: "To the things wrote for in my last add . . . a neat maho'y card table w'ch may serve for a dress'g one."[55]

Game and tea tables were the two most common specialized forms. During the late 1700s, card tables appeared in many fashionable houses, and a 1753 inventory from Woodbury, a rural Connecticut town, included a tea table.[56] A tea set was often displayed on a stationary table.[57] The round-top tea table, new in the second half of the eighteenth century, lent itself to such a practice. The popularity of the tilt-top table in Philadelphia suggests that space flexibility was more important than tea set display.[58]

Tables appear in inventories of first-floor parlors; first-floor halls or common rooms, whether they were work spaces, dining spaces, or informal reception rooms; and in second-floor chambers.[59] Chambers were the usual sites of storage furniture like high chests of drawers, clothes presses, and dressing tables. Placed in a parlor setting today, they show a colonial revival furnishing plan rather than a colonial one (fig. 7-10).[60]

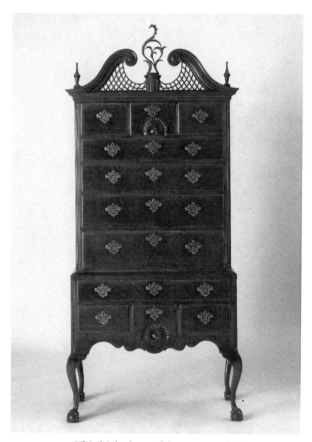

FIGURE 7-10. This high chest of drawers, made in Connecticut, is attributed to Eliphalet Chapin. The carved cartouche, which is original, illustrates the asymmetry of the Chippendale or rococo style. (High chest of drawers, Eliphalet Chapin, East Windsor, Conn., 1775–1790. Cherry, white pine; H 87⅛ in., W 40¼ in., D 20⅛ in. 1993.55 Winterthur Museum purchase.)

Other storage forms used in chambers and listed in inventories as chests were chest-on-chests (which New Yorkers apparently preferred), the blockfront chests of New England, and various chests from the Philadelphia area.

The desk was an exception to the custom of placing storage furniture in a chamber. In Delaware the desk sometimes stood in a parlor; in Massachusetts, it was more often in a back parlor, if there was one, or in the common room or hall.[61] First made in London in the 1720s, the desk-and-bookcase gave its owner status by indicating participation in business affairs that required correspondence, filing, and ownership of books.

Looking glasses became increasingly important in elegant parlors when Chippendale's designs were fashionable. They were often displayed between two windows in the front parlor.[62] In the late eighteenth century, people who had looking glasses, tea tables, desks, or other expensive objects in parlors clearly devoted financial resources to consumer goods to ornament their homes rather than spending on land, animals, and equipment. Many other people had neither the means to buy nor the need for fashionable furnishings; yet, their objects were sometimes influenced by Chippendale- or rococo-style designs long after their vogue in London.

CONCLUSION

Well documented and widely recognized, furniture in the style we call Chippendale or rococo offers numerous interpretation opportunities for guides. Visitors may notice design motifs that lead to discussions of design sources, furniture makers' techniques, and use in the eighteenth century. Printed books and drawings helped to disseminate new ideas about furniture design. Thomas Chippendale was one of several who published such books, and twentieth-century furniture historians and collectors chose his name to document the designs they identified. In the British colonies on the verge of a war for independence, those who owned Chippendale-style furniture ranged from a wealthy man who possessed an expensive pair of upholstered sofas to a rural farmer who purchased a traditional chair form with a flared crest rail. In varying degrees, colonial men and women adopted modes of polite, genteel behavior associated with the furniture forms—be they social rituals like serving tea at tea tables or ownership of individual chairs, cutlery, and dishes for each family member and guest.[63]

NOTES

1. Considered an accurate contemporary depiction of the interior of Independence Hall, *Congress Voting Independence* by Edward Savage hangs at the National Portrait Gallery, Smithsonian Institution, and is reproduced in Miller et al.
2. Hummel, *Winterthur Guide*, 13.
3. Hummel, *Winterthur Guide*, 8.
4. Jones, 5–6; Hook, 80, 131.
5. Harris, 101; Lewis and Darley, 225; see also Bushman, "American High Style," 348, 365–66.
6. Hook, 46–50.
7. Thornton, 88.
8. Harris, 104.
9. Chippendale, preface.
10. Jones, 31, 64.
11. Jones, 10–16.
12. Heckscher and Bowman, 178; Gusler, 113 n59, 182.
13. Heckscher, "Philadelphia Chippendale," 283–95.
14. Jobe and Kaye, 380.
15. Hummel, *Winterthur Guide*, 17–24, 47–77.
16. Gilbert, 1:89.
17. Zea, "Construction Methods," 73.
18. Cooke, 237–38.
19. Hummel, *With Hammer in Hand*, 235.
20. Alden, 7–8; Lindsey, 117–19.
21. Hummel, *With Hammer in Hand*, 343; Cooke, 62.
22. Hummel, *With Hammer in Hand*, 235; Cooke, 62.
23. Hummel, *With Hammer in Hand*, 235.
24. Headley, 21.
25. Hummel, *With Hammer in Hand*, 10; Jobe and Kaye, 7; Cooke, 28–29.
26. Hummel, *With Hammer in Hand*, 220.
27. See also Zea, "Rural Craftsmanship and Design," 67.
28. Beckerdite, "Part III," 1045.
29. Cooke, Introduction.
30. Cooke, n. 31.
31. Hummel, *With Hammer in Hand*, 215.
32. Hummel, *With Hammer in Hand*, 235–36.
33. Jobe and Kaye, 12–13.
34. Beckerdite, "Part I," 1120.
35. Jobe and Kaye, 10.
36. Beckerdite, "Part I," 1121, 1124.
37. Jobe and Kaye, 14.
38. Jobe and Kaye, 13–14; Beckerdite, "Part II," 512.
39. Beckerdite, "Part I," 1126.
40. Andrews, 3.
41. Hummel, *With Hammer in Hand*, 353–58; see also Cooke, 71, for use of local wood.
42. Headley, 22.
43. Hummel, *With Hammer in Hand*, 217.
44. Beckerdite, "Part II," 512.
45. Wainwright, 39; also see Bushman, "American High Style," 351, for more information on first-floor public rooms versus second-floor private spaces.
46. Heckscher and Bowman, 214–17; Wainwright, 126, for Dickinson family connection; Zimmerman, "A Methodological Study,"197–98.
47. Carr et al., 140.
48. Carr and Walsh, 60, 65.
49. See also Bushman, "American High Style," 352, for uses of chairs and storage furniture.
50. Wainwright, 39; Golovin and Roth, 78, 93; Fitzgerald, 68.
51. Cummings, 242–44.
52. Cummings, xxxi.
53. Fitzgerald, 68.
54. Smith, "The Theory of Moral Sentiments," 1759, as quoted in Thornton, 102.
55. As quoted in Golovin and Roth, 23.
56. Cooke, 157.
57. Cummings, xxix.
58. Fitzgerald, 71; Heckscher, "Philadelphia Furniture," 100.
59. Wainwright, 45, 72; Cummings, 154–244; Twiss-Garrity, 19–20.
60. Cummings, xxxi.
61. Twiss-Garrity, 19; Cummings, xxx.
62. Wainwright, 45–47; Thornton, 103.
63. Carr et al., 137.

BIBLIOGRAPHY

Downs, Joseph. *American Furniture: Queen Anne and Chippendale Periods in the Henry Francis du Pont Winterthur Museum*. New York: Macmillan, 1952.

Heckscher, Morrison H., and Leslie Greene Bowman. *American Rococo, 1750–1775: Elegance in Ornament*. New York: Metropolitan Museum of Art and Los Angeles County Museum of Art, 1992.

Jobe, Brock, and Myrna Kaye. *New England Furniture: The Colonial Era*. Boston: Houghton Mifflin, 1984.

Puig, Francis J., and Michael Comforti, eds. *The American Craftsman and the European Tradition, 1620–1820*. Minneapolis: Minneapolis Institute of Arts, 1989.

Richards, Nancy E., and Nancy Goyne Evans. *New England Furniture at Winterthur: Queen Anne and Chippendale Periods*. Winterthur, Del.: Henry Francis du Pont Winterthur Museum, 1997.

Additional Sources

Alden, Harry A. "Wood You Believe: Horseflesh Mahogany in Early American Furniture." *Guidelines* (Newsletter of the Education, Public Programs, and Visitor Service Division, Winterthur, Del.) 4, no. 2 (April–May 1989): 7–8.

Andrews, Jan. "The Dunlaps and Their New Hampshire." *Guidelines* 2, no. 5 (October–November 1987): 1–6.

Beckerdite, Luke. "Philadelphia Carving Shops: Part I: James Reynolds." *The Magazine Antiques* 125, no. 5 (May 1984): 1120–21, 1124, 1126.

———. "Philadelphia Carving Shops: Part II: Bernard and Jugiez." *The Magazine Antiques* 128, no. 3 (September 1985): 512.

———. "Philadelphia Carving Shops: Part III: Hercules Courtenay and His School." *The Magazine Antiques* 131, no. 5 (May 1987): 1045.

Bushman, Richard L. "American High Style and Vernacular Cultures." In *Colonial British America: Essays in the New History of the Early Modern Era*, edited by Jack P. Greene and J. R. Pole, 345–83. Baltimore: Johns Hopkins University Press, 1984.

———. *The Refinement of America: Persons, Houses, Cities.* New York: Alfred A. Knopf, 1992.

Carr, Lois Green, Gloria L. Main, Jackson T. Main, John J. McCusker, and Billy G. Smith. "Forum: Toward a History of the Standard of Living in British North America." *William and Mary Quarterly*, 3rd ser., 45, no. 1 (January 1988): 116–70.

Carr, Lois Green, and Lorena S. Walsh. "Changing Lifestyles and Consumer Behavior." In *Of Consuming Interests: The Style of Life in the Eighteenth Century*, edited by Cary Carson, Ronald Hoffman, and Peter J. Albert, 59–166. Charlottesville: University Press of Virginia for the United States Capitol Historical Society, 1994.

Carson, Barbara. *Ambitious Appetites: Dining, Behavior, and Patterns of Consumption in Federal Washington.* Washington, D.C.: American Institute of Architects Press, 1990.

Chippendale, Thomas. *The Gentleman & Cabinet-maker's Director.* Reprint. New York: Dover Publications, 1966.

Cooke, Edward Strong Jr. *Rural Artisanal Culture: The Pre-Industrial Joiners of Newton and Woodbury, Connecticut, 1760–1820.* Ann Arbor, Mich.: University Microfilms International, 1984.

Cox, Warren J. "Four Men, the *Four Books*, and the Five-Part House." In *Palladian Studies in America I: Building by the Book 2*, edited by Mario di Valmarana, 117–46. Charlottesville: University Press of Virginia for the Center for Palladian Studies in America, 1986.

Cummings, Abbott Lowell. *Rural Household Inventories.* Boston: Society for the Preservation of New England Antiquities, 1964.

Fitzgerald, Oscar. *Four Centuries of American Furniture.* Radnor, Pa.: Wallace-Homestead Book Co., 1995.

Fleming, William. *Art and Ideas.* 3rd ed. New York: Holt, Rinehart and Winston, 1991.

The Framing of the Federal Constitution. Handbook 103. Washington, D.C.: U.S. Department of the Interior, 1979.

Gilbert, Christopher. *The Life and Works of Thomas Chippendale.* 2 vols. New York: Macmillan, 1978.

Golovin, Ann, and Rodris Roth. *New and Different.* Unpublished exhibition script. Washington, D.C.: National Museum of American History, 1988.

The Great River: Art and Society of the Connecticut Valley, 1635–1820. Exhibition catalogue. Hartford, Conn.: Wadsworth Atheneum, 1985.

Gusler, Wallace B. *Furniture of Williamsburg and Eastern Virginia, 1710–1790.* Richmond: Virginia Museum of Fine Arts, 1971.

Harris, John. "The Pattern Book Phenomenon." In *Palladian Studies in America I: Building by the Book 2*, edited by Mario di Valmarana, 101–16. Charlottesville: University Press of Virginia for the Center for Palladian Studies in America, 1986.

Headley, Mack. "Eighteenth-Century Cabinet Shops and the Furniture-Making Trades in Newport, Rhode Island." In *American Furniture 1999*, edited by Luke Beckerdite, 17–47. Milwaukee, Wis.: Chipstone Foundation, 1999.

Heckscher, Morrison H. *American Furniture at the Metropolitan Museum of Art.* Vol. 2. *Late Colonial Period: The Queen Anne and Chippendale Styles.* New York: Random House for the Metropolitan Museum of Art, 1985.

———. "Philadelphia Chippendale: The Influence of the *Director* in America." *Furniture History* 21 (1985): 283–95.

———. "Philadelphia Furniture, 1760–1790: Native-Born and London-Trained Craftsmen." In *The American Craftsmen and the European Tradition, 1620–1820*, edited by Francis J. Puig and Michael Conforti, 92–111. Hanover, N.H.: University Press of New England, 1989.

Hook, Judith. *The Baroque Age in England.* London: Thames and Hudson, 1976.

Hornor, William Macpherson Jr. *Blue Book, Philadelphia Furniture: William Penn to George Washington, with Special Reference to the Philadelphia-Chippendale School.* Philadelphia, 1935.

Hummel, Charles F. *A Winterthur Guide to American Chippendale Furniture: Middle Atlantic and Southern Colonies.* New York: Rutledge Books, Crown Publishers, 1976.

———. *With Hammer in Hand: The Dominy Craftsmen of East Hampton, New York.* Charlottesville: University Press of Virginia for the Henry Francis du Pont Winterthur Museum, 1968.

Hurst, Ronald L., and Jonathan Prown. *Southern Furniture, 1680–1830: The Colonial Williamsburg Collection.* Williamsburg, Va.: Harry N. Abrams for the Colonial Williamsburg Foundation, 1997.

Jobe, Brock W., ed. *New England Furniture: Essays in Memory of Benno M. Forman.* Boston: Society for the Preservation of New England Antiquities, 1987.

Jones, Stephen. *The Eighteenth Century: Cambridge Introduction to the History of Art.* Cambridge: Cambridge University Press, 1985.

Kasson, John. *Rudeness and Civility: Manners in Nineteenth-Century Urban America.* New York: Hill and Wang, 1990.

Lewis, Philippa, and Gillian Darley. *Dictionary of Ornament.* New York: Pantheon Books, 1986.

Lindsey, Jack L. *Worldly Goods: The Arts of Early Pennsylvania, 1680–1758.* Philadelphia: Philadelphia Museum of Art, 1999.

Mackiewicz, Susan. "Property Is the Great Idol of Mankind, However They May Profess Their Regard for Liberty and Religion." In *The Material Lives of Philadelphia Elites, 1700–1775.* Unpublished typescript, 1985.

Miller, Lillian B., et al. *The Dye Is Now Cast: The Road to America Independence, 1774–1776*. Washington, D.C.: Smithsonian Institution Press, 1975.

Milley, John C., ed. *Treasures of Independence: Independence National Historical Park and Its Collections*. New York: Mayflower Books, 1980.

Monkhouse, Christopher P., and Thomas S. Michie. *American Furniture in Pendleton House*. Providence: Museum of Art, Rhode Island School of Design, 1986.

Nichols, Frederick Doveton. *Palladio in America*. New York: Rizzoli, 1978.

Nivelon, François. *The Rudiments of Genteel Behavior*. London, 1737.

Park, Helen. *A List of Architectural Books Available in America before the Revolution*. Los Angeles: Hennessey and Ingalls, 1973.

Pye, David. *The Nature and Art of Workmanship*. London: Studio Vista Limited, 1971.

Richardson, Edgar P. *American Paintings and Related Pictures in the Henry Francis du Pont Winterthur Museum*. Charlottesville: University Press of Virginia for the Henry Francis du Pont Winterthur Museum, 1986.

Scott, Ernest. *Working in Wood: The Illustrated Manual of Tools, Methods, Materials, and Classic Construction*. New York: G. P. Putnam's Sons, 1980.

Shepherd, Raymond V. Jr. "Cliveden and Its Philadelphia-Chippendale Furniture: A Documented History." *American Art Journal* 3, no. 2 (November 1976): 2–16.

Thornton, Peter. *Authentic Decor: The Domestic Interior, 1620–1920*. New York: Viking Press, 1984.

Trent, Robert F. *Hearts and Crowns: Folk Chairs of the Connecticut Coast, 1770–1840*. New Haven, Conn.: New Haven Colony Historical Society, 1977.

Twiss-Garrity, Beth Ann. "Getting the Comfortable Fit: House Forms and Furnishings in Rural Delaware, 1780–1820." Master's thesis, University of Delaware, 1983.

Vibert, Jeanne. "The Market Economy and Furniture Trade of Newport, Rhode Island: The Career of John Cahoone, Cabinetmaker, 1745–1751." Master's thesis, University of Delaware, 1981.

Wainwright, Nicholas B. *Colonial Grandeur in Philadelphia: The House and Furniture of General John Cadwalader*. Philadelphia: Historical Society of Pennsylvania, 1964.

Zea, Philip. "Construction Methods and Materials." In *New England Furniture: The Colonial Era*, by Brock Jobe and Myrna Kaye, 73–100. Boston: Houghton Mifflin, 1984.

———. "Rural Craftsmanship and Design." In *New England Furniture: The Colonial Era*, by Brock Jobe and Myrna Kaye, 47–72. Boston: Houghton Mifflin, 1984.

———. *Useful Improvements, Innumerable Temptations: Pursuing Refinement in Rural New England, 1750–1850*. Deerfield, Mass.: Historic Deerfield, 1998.

Zimmerman, Philip D. "Change and Persistence in Revolutionary America: American Chippendale." In *American Furniture with Related Decorative Arts, 1660–1830*, edited by Gerald W. R. Ward, 153–87. New York: Hudson Hills Press, 1992.

———. "A Methodological Study in the Identification of Some Important Philadelphia Chippendale Furniture." In *Winterthur Portfolio* 13, edited by Ian M. G. Quimby, 193–208. Winterthur, Del.: Henry Francis du Pont Winterthur Museum, 1979.

———. "Workmanship as Evidence: A Model for Object Study." *Winterthur Portfolio* 16, no. 4 (Winter 1981): 283–308.

Furniture in the Federal or Early Classical-Revival Style

VISITORS TO MUSEUMS AND HISTORIC HOUSES USE various names to identify the furniture style called federal in the United States: early classical revival, Louis XVI, Adam, Sheraton, and Hepplewhite. The names define several important aspects of the style. International in scope, it was inspired by Roman archaeological excavations in the mid-eighteenth century. Each country adopted the style in accordance with its own most recent past.[1] In France, neoclassical motifs were added to earlier furniture and architectural forms that were firmly French in spirit.[2] Robert Adam, a Scottish architect and designer, studied the ruins of Roman antiquity and contributed to interest in antique material culture by wedding it to the popular Palladian style and a refined, delicate taste.[3] Thomas Sheraton and George Hepplewhite published design books in England that popularized Adam's work. In the United States, the style became aligned with the spirit of the new republic; hence the name federal. These three elements—international neoclassicism, design books, and nationalism—are all important in understanding federal-style furniture. Its classical yet delicate look appeals to modern tastes. The challenge is to help visitors appreciate the diversity and complexity of the furniture. Guides can use the variations of chair forms, worktables, card tables, and sideboards to address increased specialization in furniture forms.

LOOKING AT FEDERAL FURNITURE

Furniture in this style looks strikingly different from the Queen Anne or Chippendale styles. The proportions and lines are slender and graceful, and the ornament emphasizes color through the use of inlays and relief carving.

Volume

Light and delicate are words frequently used to describe federal furniture (fig. 8-1). The lightness becomes particularly evident when the furniture is compared to styles that immediately preceded or followed it. The fragile, almost insubstantial look of many chairs, tables, and case pieces derives from the frequent emphasis of voids as well as long, thin proportions. Craftsmen sought to translate their understanding of the ancient system of proportion to the design of the furniture, and this contributes to its refined appearance. Based on the diameter of a column, the classical proportional system dictated that height, width, and depth should be related.

Line

The federal or early classical-revival style emphasizes rectilinear relationships that result in crisp edges (fig. 8-2). Furniture makers sought unity in composition and used smooth, continuous lines to define forms and shapes. Curved lines, so essential to the baroque and rococo styles, do not disappear in this style; they become less dominant and shallower. On a worktable from Boston made early in the 1800s, a rectangular workbox with canted or slanted corners sits atop slim, curved, tapered legs and curved stretchers, showing how line and geometry emphasize the light, delicate look (fig. 8-3). Cabinetmakers employed inlay and veneers to enhance the smooth, two-dimensional look and integrate structure and decoration.

The emphasis on line gives this furniture a sharply geometric look, not only in forms but also in decoration. Circles, rectangles, squares, and ovals are integrated into the design of an object. For example, on a sideboard from New York made at the turn of the nineteenth century, the motif of an oval or a circle within a rectangle unifies the design of the facade (fig. 8-4).

Ornament

Federal ornament is rich with contrasting veneers and inlays in exotic woods, pictorial inlays, paint, gilt and gesso, fine carving, and classical motifs: urns, swags, paterae, volutes, acanthus leaves, and husks. The golden grain of satinwood and birch made it an ideal choice for both veneers and inlays. Decoration

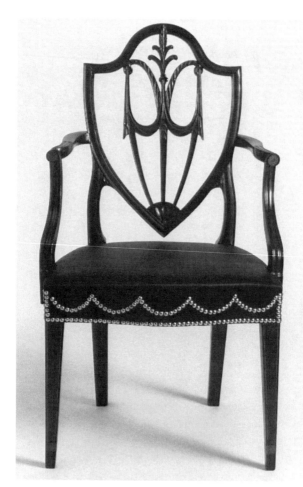

FIGURE 8-1. This chair is distinguished by crisply carved swags, leaves, and plumes. It is related to the design shown in plate 28 in the appendix of Thomas Sheraton's *Cabinet-Maker and Upholsterer's Drawing Book: in Three Parts* (1793). However, it combines elements from several designs, resulting in a coherent whole that is a tribute to the skill of the maker. (Side chair, New York, N.Y., 1795–1800. Mahogany, ash, cherry, tulip poplar; H 38⅕ in., W 23 in., D 21 in. 1957.673 Winterthur Museum, bequest of Henry Francis du Pont.)

often is abstract. Inlay takes the form of thin, meandering lines that are reminiscent of Roman grotesques; classical motifs are reduced to an outline as opposed to a completed form. In vase-back chairs from New York in about 1800, for example, the urn in the splat was abstracted to an outline. Unlike the Chippendale style or the empire style, the federal style emphasizes color as much as form or relief carving. The eagle and shield, an American motif that symbolized a new nation, was often integrated as inlaid or carved ornament.

THINKING ABOUT STYLE

In the mid-eighteenth century, archaeological excavations as well as a reaction against the excesses of the rococo resulted in a renewed interest in the classical

world. Classicism—the study of early Greek, Roman, and sometimes Egyptian civilizations—represents a continuum in the tradition of Western art. From the fifteenth century onward, classicism as a way of thinking about and organizing design dominated artistic endeavors.

Thus, the fascination with classical antiquity was not new. What was new, however, was both the increased ability and desire to study the ancient civilizations through primary sources. Excavations, especially at the Roman sites of Herculaneum (1738) and Pompeii (1748), provided the impetus for the development of an international style that is now called neoclassicism. The rapid and wholehearted embrace of neoclassicism also represented a reaction against the rococo.[4]

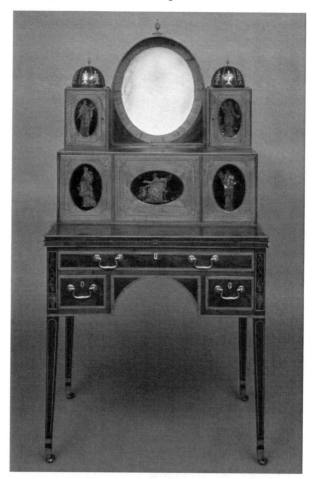

FIGURE 8-2. In addition to emphasizing rectilinear relationships, this lady's desk uses stepping of the three sections to visually lighten what is a very substantial form. Like sideboards, writing desks for ladies were a new form in the late eighteenth century. They reflect an increasing specialization of furniture and may have stimulated buying among growing numbers of consumers. (Lady's cabinet and writing table, Baltimore, 1795–1810. Mahogany, satinwood, red cedar; H 62⅛ in., W 30⅞ in., D 22¼ in. 1957.68 Winterthur Museum.)

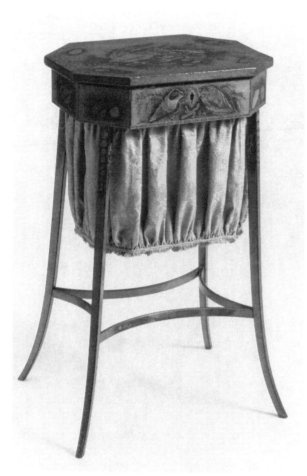

FIGURE 8-3. Worktables or sewing tables join sideboards and lady's writing desks as innovative forms made in the federal style. In this example, the hinged lid opens to reveal a compartmented tray. Beneath the tray is the fabric storage pouch. Fancy painted furniture had gained popularity at the time federal furniture was fashionable. Seashells painted on this worktable were also executed in inlays using exotic woods in unpainted examples. The table is signed "Vose & Coates" in script on the underside of the tray. (Worktable, Vose & Coates, Boston, 1808–18. Maple, tulip poplar, basswood, aspen, paint; H 28¹⁵⁄₁₆ in., W 19⅛ in., D 15¼ in. 1957.983 Winterthur Museum, bequest of Henry Francis du Pont.)

Neoclassicism included decorative elements from ancient Greece and Rome. Its proponents were scholars, architects, and dilettantes who flocked to Rome in the second and third quarter of the eighteenth century. Not content with the work of their Renaissance predecessors, these students pursued the antique world with new zeal. In addition to studying at seats of classical learning, they visited archaeological digs and made detailed drawings of buildings, ornament, and architectural elements. Students from England, France, Germany, and Denmark as well as many other countries took the Grand Tour and returned to their homelands eager to promulgate a new style based on what they had seen.[5]

A leading proponent of the new style was Robert Adam, a Scottish architect who traveled in Europe between 1754 and 1758. In addition to studying at the French Academy in Rome, he made detailed drawings of the ruins of Diocletian's palace at Spalato on the Dalmatian Coast as well as other ancient sites near Rome. Returning to England, Adam, along with William Chambers and James Stewart, precipitated a stylistic revolution. As architect to George III, Adam became one of the premier architects and interior decorators of the great English country houses: Kedleston, Syon Park, Osterley Park, Luton Hoo, Moor Park, and Culzean Castle among others.[6] Style, politics, and power often mix, and the return of Adam to England represents such a blending of circumstances: a political climate that encouraged the tasteful demonstration of wealth and power as architects and designers, armed with a new style, needed to make a living.

Adam was the consummate designer. Roman, Greek, and Etruscan features; holdovers from Palladianism; and the contemporary influence of Piranesi and French neoclassicism all figure in his work. With elements seeming to advance and recede, Adam exteriors exhibit a strong sense of movement.[7] Unlike many architects who concentrated on exterior design, however, Adam focused on interior decoration.[8] His hallmark was a unified approach; he coordinated not only wall decoration but also floors, curtain treatments, hardware, furniture, paint colors, upholstery fabrics, and furniture. Relying on refined, stylized ornament and vibrant pastel colors, Adam created interiors that were based loosely on classical prototypes.

Originally embraced by the English nobility and the landed gentry, the Adam style filtered to others through Robert and James Adam's *Works in Architecture* and other popular books of furniture and ornament design. *Works* provides an encyclopedia of motifs, which George Hepplewhite and Thomas Sheraton popularized.[9] Hepplewhite's *The Cabinet-maker and Upholsterer's Guide* was published posthumously in 1788 by A. Hepplewhite & Co., led by his wife, Alice. The book simplified and condensed Adam's furniture style and made it available to cabinetmakers, particularly those working far from the style center of London.

Adam also influenced Thomas Sheraton's *Cabinet-Maker and Upholsterer's Drawing Book*. Sheraton, originally a journeyman cabinetmaker who turned to designing and drafting, published his book in four

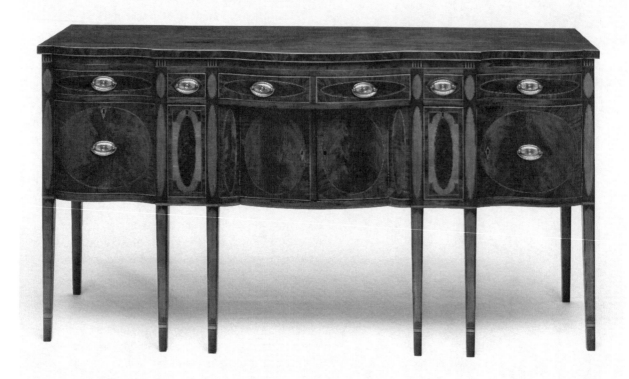

FIGURE 8-4. The pattern created by the shaped front of this sideboard, made more complex through the use of light against dark veneers that delineate geometric forms, makes it exceptional. Its length exceeds the more usual six feet, and it is among the few surviving sideboards with eight legs. (Sideboard, New York, N.Y., 1795–1805. Mahogany, mahogany veneer, satinwood veneer, white pine, tulip poplar, ash; H 41¼ in., W 79½ in., D 28⅝ in. 1957.850 Winterthur Museum, bequest of Henry Francis du Pont.)

parts between 1791 and 1794. Each section dealt with a specific aspect of drawing: geometry, perspective, furniture design, and ornamentation. Unlike Hepplewhite, Sheraton geared his book to a specific audience of cabinetmakers and upholsterers and urged them to know and use classical architectural proportions.[10]

Specific style characteristics are frequently attributed to Hepplewhite or Sheraton and lead to the identification of vase-back chairs as "Hepplewhite" or square-back chairs with reeded legs as "Sheraton." In practice, these categories are general at best and frequently deceptive, particularly when applied to American furniture. The basic difference is that Hepplewhite's designs tend to be curvilinear and have carved ornament; Sheraton favored a predominant rectilinear line, painted surfaces, and generously applied inlays.[11] Both are more correctly seen as part of the neoclassical tradition rather than as creators of distinct schools of design.

If the work of Robert Adam and others in creating the English country house tradition represents a successful blending of circumstances, the same might

be said of the arrival of the neoclassical or classical-revival style in America after the Revolutionary War. Americans were involved in building a new nation, an ideal republic in the tradition of Rome. The close identification of the style with the Roman republic was a powerful draw for the new country.

The federal or early classical-revival style in the young United States is therefore one aspect of international neoclassicism. Traces of the new style were in the colonies prior to the Revolutionary War in such objects as a writing desk made for Thomas Jefferson by Benjamin Randolph, a Philadelphia cabinetmaker, and a silver tea urn crafted by Richard Humphreys and given in 1774 by grateful members of the Continental Congress to Charles Thomson, secretary of the Congress. However, the full flowering of neoclassicism occurred after the cessation of hostilities between the new nation and Great Britain. Through pattern books, the importation of European furniture by merchants and diplomats, and an influx of European immigrants (both patrons and craftsmen), residents rapidly accepted the new style after 1784.

The importation of English and French furniture gained acceptance for the new style. When ports opened to foreign goods before the signing of the Treaty of Paris in 1783, English merchants in particular shipped loads of furniture and accessories to sell in the former colonies. In addition, statesmen and merchants returned to the United States from their war years abroad with not only the consciousness of the European classical style but also tangible evidence in fine French furniture and marble mantels from Italy.[12] Helping feed an already active demand for the new style, such men as Thomas Jefferson, Benjamin Franklin, James Monroe, and Boston merchants Harrison Gray Otis and James Swan shipped home crates full of household goods.

The continued immigration of foreign cabinetmakers also contributed to the rapid acceptance of the new style. In New York, two of the most active cabinetmakers were a Scotsman, Duncan Phyfe, and a Frenchman, Charles-Honoré Lannuier. In New England, English immigrant John Seymour and his son Thomas, who first settled in Maine and then in Boston, were leading practitioners. The Finlay brothers, Irish immigrants who trained in London before moving to Baltimore, promoted the vogue for fancy furniture in that growing port town. In Charleston, South Carolina, a group of German immigrant cabinetmakers were important in introducing the new style.[13]

Despite the radical departure of international neoclassicism from the design principles of the rococo, the style in the young United States represents a less abrupt break with the past than its European counterparts. At least until the end of the 1700s, cabinetmakers continued to combine elements of the old and new. A chair made in Philadelphia shows evidence of the Chippendale or rococo style, with some elements that suggest federal or early classical-revival style in its design (fig. 8-5). Even when the design is in the classical taste, traces of the old ways remain. In Philadelphia, for example, cabinetmakers and patrons continued to prefer solid wood construction without veneers and to use the skills of the celebrated Philadelphia carvers.

Immigrant and native-trained cabinetmakers, assisted by carvers, inlay makers, painters, and gilders, produced furniture in the federal style in many cities and regions of the young United States. In Salem and Boston, Massachusetts; New York City; Philadelphia; Baltimore; and Charleston, South Carolina, among others, furniture makers developed shops and relationships with merchants supplying lumber and spe-

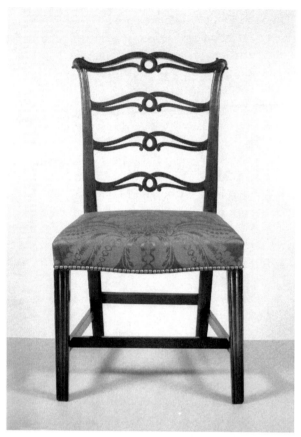

FIGURE 8-5. Stiles that flare outward ending in ears where the stiles meet the crest rail suggest the profile of a Chippendale chair. The front legs, called Marlborough legs, suggest the rectilinearity (straight lines and right angles) of the federal style. This chair is probably similar to one with "scroll'd splatts" described, according to Charles Montgomery, in Philadelphia price books of the 1790s and made through the early years of the 1800s. (Side chair, Philadelphia, 1785–1800. Mahogany, white pine, tulip poplar, white oak, hickory, walnut; H 37½ in., W 21¼ in., D 21¾ in. 1959.1487 Winterthur Museum, bequest of Henry Francis du Pont.)

cialists supplying decorative skills. In identifying the work of a particular shop or school, scholars study the economy and trade patterns of a city or region in addition to documented furniture from various hands. In urban centers, craftsmen were able to specialize and work for a cabinetmaker or subcontract work to his shop. The manuscript account books of Joseph True, a turner from Salem, Massachusetts, for example, indicate that he worked for nearly all the cabinetmakers of Salem and nearby Beverly. Some scholars regard a slender turned leg with an attenuated, bulbous foot as a regional characteristic of the area north of Boston.[14] The availability of design books and transportation for both workers and objects, however, aided the creation of furniture that is not assigned to a specific region.

The reemergence of a preference for painted furniture marks a significant aspect of style at the turn of the nineteenth century. The revival may be linked to the painted forms in sophisticated English furniture as well as the simple, flat surface preferred in federal furniture.[15] Hepplewhite referred to painted furniture as "japanned" and remarked that paint gave "a rich and splendid appearance."[16] Likewise, Sheraton devoted a special section of his *Cabinet Dictionary* to painted furniture.[17] The flat surfaces and emphasis on two-dimensional decoration in the early classical-revival style provided an ideal form for painted decoration.[18] By the 1820s, most regions in the United States produced painted or "fancy furniture." Elias Haskett Derby of Salem, a self-proclaimed arbiter of taste in federal New England, had several sets of painted chairs made for his family. Two with Derby family history, made about 1801, have white and brown grounds and feature peacock feathers and bows as well as floral designs on the legs. Boston is represented by a delicate sewing table, made between 1808 and 1818, which is labeled by the cabinetmaking firm of Vose & Coates (see fig. 8-3). In addition to shells on the top and sides, the table legs have the whimsical dependent cockleshells that imitate bellflower inlay.

In the early 1800s, Governor Joseph C. Yates of New York ordered a large set of painted furniture that included a settee, bed, and several chairs. With a typical background color of white for high-style painted furniture of the federal style, the set is highlighted with gold.[19] The popularity of gilded furniture accelerated when leaders such as Jefferson, Monroe, and John Adams returned from abroad with French examples.

Artisans in Baltimore produced some of the finest painted furniture. Fanciful in design and superb in craftsmanship, examples are as sophisticated as any made at the time and represent that city's significant contribution to the decorative arts.[20] Two Irish craftsmen who trained in England before immigrating to Baltimore, Hugh and John Finlay, set the standard as they served the needs of the growing city's newly prosperous merchant class. In 1804 they advertised: "Varnished, gilt and ornamented in a style not equaled on the continent—with real views, fancy landscapes, flowers, trophies of music, war, husbandry, love, etc. etc."[21]

Although some painted furniture represents the epitome of sophistication, the vernacular tradition of furniture painting thrived at the same time. Windsor chairs, Pennsylvania German chests, and worktables decorated by schoolgirls for graduation pieces are just some examples of painted forms that are removed from the fancy furniture tradition. However, they all testify to the popularity of painted wood surfaces at the turn of the nineteenth century.

The federal or early classical-revival style was fashionable for a relatively brief period in the United States. By 1815 greater adherence to classical forms created the style we know today as empire or late classical revival.[22]

MAKING AND MARKETING FEDERAL FURNITURE

Furniture makers and buyers at the turn of the nineteenth century witnessed the beginning of a transition from a craft to an industry.[23] Shop organization and the relationship between craftsman and customers changed significantly. Cabinetmaking techniques, however, altered slightly but often had different emphases. Cabinetmakers still used mortise-and-tenon and dovetail joints, which were more precise and refined than in earlier furniture. Veneering, used in William and Mary or early baroque–style furniture, reappeared to achieve the smooth, gleaming surfaces highly valued in this furniture. Steamed or bent wood in fancy chairs and lamination to construct the curves on federal-style furniture were two new techniques.

In evolving from a craft to an industry, the significant reorganization of furniture-making shops is one of the most exciting aspects of post–Revolutionary War cabinetmaking. In the colonial period, a master craftsman with one or two journeymen and apprentices kept a small stock of ready-made furniture parts and perhaps even completed furniture on hand. The extent to which most eighteenth-century furniture represented a specific agreement between a craftsman and his customer is open to question. What is more certain, however, is that after the Revolutionary War, the demands of a widening market in an expanding economy led to a need for more efficient means of production.[24]

More and more craftsmen maintained inventories, and large enterprises geared to cost-effectiveness and quantity production replaced small workshops. In general, an owner chose a furniture design, supervised the work, contracted specialty work, and, if required, sent items to upholsterers for finishing. To increase efficiency, owners employed workers who performed specific tasks. Journeymen rarely stayed long with a master and moved from shop to shop.[25]

The work situations of John Seymour and his son Thomas offer an example. After emigrating from the area of Devon, England, in 1784, and spending some

time in Portland, Maine, Seymour and his family moved to Boston by 1793. John was fifty-five, and his son Thomas was twenty-two. During the first years in Boston, they worked in a "1/2 House & Shop," according to tax records, probably the typical small workshop with a few workers.[26]

In 1804, when he was thirty-three, Thomas Seymour announced the opening of the Boston Furniture Warehouse. He developed a diversified business until the economic decline after the War of 1812 caused him to close his business and return to working for other cabinetmakers. At the Boston Furniture Warehouse, he advertised an inventory of "every article necessary to furnish a house complete."[27] He offered cartage services, rented space to other artisans, and hired specialized workers as subcontractors to carve, produce ivory inlays, and upholster. The scale of business required capital, and Seymour found revenue sources in investment partners as well as his increasing reputation as a purveyor of elegant, well-made furniture. He coordinated all of the work; he let out work to painters, finishers, carvers, and inlay makers, and ordered hardware and brasses from London. Much of his furniture, therefore, is collaborative. Recent research has succeeded in identifying construction techniques and markings on the furniture and its pieces that appear to indicate the Seymour hand. Thomas Seymour represents a new breed of cabinetmaker who, when times were good, turned entrepreneur.[28] The Philadelphia shops of Daniel Trotter and Ephraim Haines as well as the New York ventures of Duncan Phyfe and Michael Allison provide similar examples.

The eighteenth-century production system of master, journeyman, and apprentice evolved into new relationships between employer/owner and employee or between entrepreneur and contractor. Federal furniture became the work of numerous hands. In many shops, owners did not work alongside their journeymen; rather, many apprentices were trained in parts of the process. This division of labor signifies a fundamental change in the economy, and it may be argued that this separation of craftsmen from end products is truer evidence of an industrial revolution than the introduction of any machine or machine processes.

The increase in task differentiation coincides with another development—the publication of price books. Originally compiled because of wage disputes between journeymen and masters, price books listed retail prices of finished objects and wages to be paid for each task associated with cabinet- and chair making. Although based on *The London Cabinet Book of Prices*

of 1788, which codified earlier agreements that existed only in manuscript, the books in the United States did not separate the two crafts.[29] The first American price book appeared in 1794 in Philadelphia, with a second edition appearing in 1795. New York followed suit in 1802 and 1803, with less reliance on the London book as American craftsmen began to document their own practices.

Evidence indicates that price books were widely owned and used.[30] A library bookcase made between 1794 and 1800, possibly attributed to John and Thomas Seymour, is similar to a design for a "Library Book-Case" in George Shearer's *Cabinet-Makers' London Book of Prices*, published in 1788.[31] The friction between master and journeymen that led to price books was based on economics. With fortunes possible from the new organization of production, each participating group wanted the largest piece of the economic pie.[32] Price books, then, are evidence of changes in the furniture trade and testify to the unionization of crafts as well as the separation of craftsmen from final products.

An additional influence on the furniture trade in the early 1800s is the increase in consumption, but scholars debate the cause. Some support a demand-led theory that the increase was partly fueled by wartime deprivation, growth of population, and democratization of spending that resulted in members of the middle class choosing to spend more of their disposable incomes on consumer goods.[33] Other scholars advocate a supply-led theory, postulating that manufacturers overproduced and then created and manipulated new markets to dispose of their surplus.[34] Whatever the reasons, large-scale furniture sales at auction and well-stocked warehouses developed in the early 1800s, representing a break with traditional methods of marketing goods. Instead of the personal bond between maker and buyer, which resulted in the "bespoke" furniture of the eighteenth century, customers visited an auction or warehouse, saw what they wanted, and purchased what was already made.[35]

The American Revolution brought not only political but also economic freedom as it ended the control exercised by the British mercantile system. Many cabinetmakers seized the opportunity and began to produce furniture for export to regions in the United States and abroad. Auctions and venture cargo are two aspects of this new method of marketing furniture. Auctions led to the production of furniture designed more to attract a purchaser's eye on the auction block than for sturdy construction or fine detail. Faced with

renewed competition from imported goods and the prospects of increased export markets, the cabinetmaker began to recognize the value of identifying himself with the designs of his furniture and furniture designs with his business.[36] The need for labels had not been a factor when the maker and the buyer knew each other, but new marketing methods spurred makers to label and mark their goods.

Venture cargo or consigning merchandise to a ship's captain for sale abroad also contributed to the increase in labeling. A gentleman's secretary made between 1790 and 1804 is an example (fig. 8-6). Labeled by Nehemiah Adams of Salem, Massachusetts, the secretary was found and purchased in Capetown, South Africa, in the twentieth century. Adams was one of a group of Salem cabinetmakers who participated in the active sea trade after the Revolutionary War, and the Sanderson brothers, Jacob and Elijah, formed a cooperative venture that was heavily involved in the export trade. Among the Sanderson papers is a directive from Elijah to the captain of the brigantine *John* to take nine cases of mahogany furniture and sell them "to the best advantage you Can on your Voyage out, Either at the Cape of Good Hope or Isle of France or Else Where in the East Indies as you may find best for my advantage." Furniture left ports like Salem, New York, and Philadelphia in large numbers for foreign and domestic ports.[37]

Thus, the personal relationship between craftsman and customer altered, as did the relationship between master and journeymen. These changes signal another important shift—from the importance of the individual artisan in the furniture trade to the importance of manufactories, eventually leading to the factories and mass-production techniques of the second half of the nineteenth century.

LIVING WITH FEDERAL FURNITURE

Furniture is primarily a domestic object that functions to make life easier, better, and more comfortable. New forms were designed to accommodate demands created by more leisure time, increased wealth, more diverse social activities, and entertainment.[38] Many new forms, with specific functions, appear in the decade immediately following the Revolutionary War: sideboards, sewing tables, pier tables, bottle cases, lady's worktables and secretaries or writing tables, and secretary-and-bookcases. In addition, some forms, such as sideboards and writing tables, were themselves divided into specific components. This style of furniture, therefore, signifies not only changes in aesthetics but also dramatic changes in domestic environments and lifestyles.

A study of inventories at the turn of the nineteenth century, however, reveals that new and specific forms were not always used in the same type of room. In 1805, for example, the contents of the house of William Bingham, one of Philadelphia's wealthiest citizens, were offered at auction, with articles listed by room. Dining tables were noted in the "Front Room South" and the "Front Parlor South," as well as the "Dining Room" and "Ball Room."[39] A study of Salem inventories reveals the same information: First-floor rooms do not seem to have been set aside exclusively for such specific functions as dining and entertaining, and several first-floor rooms probably were used interchangeably for either function while also housing furnishings associated with other activities.[40] Inventories in Newport, Rhode Island, however, reveal a different story. There, the placement of furniture in rooms indicated that certain functions were assigned to certain spaces; dining tables were found in the "keeping room," the second-best parlor.[41]

Prior to the American Revolution, dining occurred in various spaces in houses—parlor, bedchamber, and hall. Although the name "dining room" sometimes appears on architectural drawings of Virginia houses in the colonial period, these rooms may be small holding rooms where prepared food was kept before serving or to spaces where family or servants might dine informally.[42] After the Revolutionary War, dining rooms—or, in the case of Mount Vernon, a banqueting hall—became important spaces in the homes of the wealthy for the rituals of dining.

This was certainly the case in the Bingham house in Philadelphia. Bingham's auction list demonstrates that he accepted the stylish belief that eating rooms were considered apartments of conversation and should be furnished with elegance and splendor. Looking glasses, chandeliers, knife urns, sideboards, wine cooler, chairs, many sets of china, glassware of all sorts, platters, trays, silverware, and plateaus are listed, suggesting a room for eating and conversation.[43]

The importance of conversation also influenced the configuration of drawing rooms. Like the dining room, a drawing room seems to have been used for entertaining, as compared to the more diverse uses associated with parlors. The Bingham's drawing room is the only room to list a carpet ("1 elegant carpet"); the other furnishings included fourteen chairs, two sofas, a variety of looking glasses, and fine textiles at the windows. No card tables, worktables, or musical

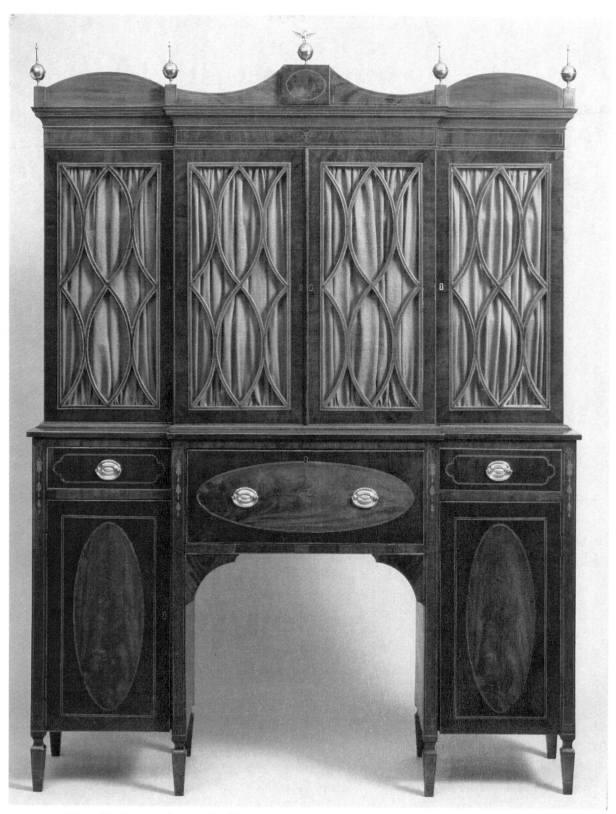

FIGURE 8-6. The voids that contribute to the delicate quality of federal furniture can be actual open spaces or the appearance of openings created by the use of light-color veneers against dark woods, as in the ovals on the lower doors of this desk. The windows in the doors are outlined in an unusual painted oval design. The large center secretary drawer, which pulls out to reveal a writing surface, is a major innovation in desks of the late eighteenth century. (Secretary-and-bookcase or gentleman's secretary, Nehemiah Adams, Salem, Mass., 1795–1798. Mahogany, mahogany veneer, satinwood, white pine; H 89¼ in., W 67¾ in., D 17⅞ in. 1957.796 Winterthur Museum, bequest of Henry Francis du Pont.)

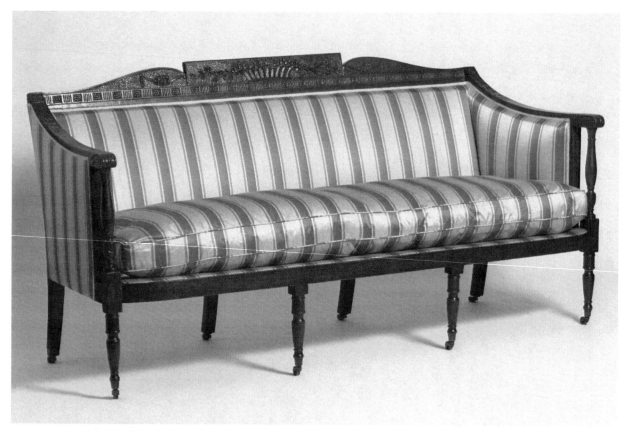

FIGURE 8-7. Sofas were a relatively uncommon form in this period. The carved crest rail shows a basket of fruit and trailing vines in a central frame called a tablet. The design of this sofa relates to images in Thomas Sheraton's *Cabinet-Maker and Upholsterer's Drawing Book*. (Sofa, Salem, Mass., 1800–1810. Mahogany, birch, white pine; H 37 in., W 75 in., D 29½ in. 1957.863 Winterthur Museum, bequest of Henry Francis du Pont.)

instruments were in the drawing room—these were in the parlors and upstairs rooms.

Although upholstered sofas remained expensive before 1820, those who could afford them outfitted them with imported textiles and elaborate carving and veneers (fig. 8-7). Sofas invited two people to sit intimately and engage in a dialogue. Settees and even Grecian couches also encouraged this verbal interaction.

Card playing, a popular pastime in the mid-1700s, became a passion at the end of the century. Most well-outfitted parlors featured a pair of card tables. Surviving numbers indicate that many houses had them in various rooms, attesting to their versatility. They could be used as side or pier tables, and their lightweight, portable nature made them useful in composing symmetrical room arrangements.[44] Another change in the late eighteenth century was the physical removal of business functions of prosperous individuals from homes to offices. When the men left to "go to the office," the ladies moved in, as it were, and created "morning rooms," which were spaces that promoted and eventually enshrined that particularly

nineteenth-century phenomenon, the cult of domesticity.[45] A morning room, with sewing table, desk, card table, piano, and canterbury, codified the increasingly feminine nature of the domestic environment.

Even bedrooms acquired more specific forms. Bureaus with mirrors and commodes replaced the high chest of drawers in bedrooms of the well-to-do. Salem inventories show a difference between the master bedroom and others, with the former possessing more furniture made of mahogany in up-to-date forms, sets of chairs, looking glasses, and expensive textiles.[46] The Binghams' bedroom exhibited the same lavishness, with a looking glass, eight arm chairs, and "1 State bedstead with damask satin curtains."[47] The bedroom of Elizabeth Derby West from Oak Hill in Danvers, Massachusetts, has been reinstalled in the Museum of Fine Arts, Boston, and affords an idea of how master bedrooms of the wealthiest Americans were furnished.[48]

There is evidence that more people were investing more money in consumer goods. Paintings and watercolors provide intriguing glimpses into the material life of Americans of more modest means than

the federal elite. In 1814 John Lewis Krimmel depicted the interior of a Pennsylvania German home, a scene filled with consumer goods: Silhouettes and paintings hang above the fireplace, and ceramics line cupboard shelves (fig. 8-8). Although sparse, the furniture includes a Windsor chair and a tall-case clock (a favorite status symbol of the Pennsylvania Germans). In addition to pictorial evidence, the relatively high survival rate of such forms as painted chairs and card tables attests to their availability among the middle classes.

At its highest level of development, an interior in the federal or early classical-revival style captured the spirit of the age: "A Federal interior was a complex and well-planned composition meant to be studied over time and enjoyed. Architecture and furniture together contributed to a harmonious whole that engaged and entertained the eye."[49]

CONCLUSION

Furniture in the federal or early classical-revival style recalls an intensely nationalistic time that expressed its values in the wholehearted embrace of classical prototypes, including furniture forms and decorative motifs. There was also an increasing diversity of life in gender roles, economic expansion, technology, and worldview. This close association of a style with history makes federal furniture especially exciting to interpret. Using objects, a guide can help visitors link the eighteenth and nineteenth centuries as well as glimpse the future. The eighteenth century witnessed a rapid growth in population, the beginnings of a sophisticated economic system, and the development of an independent government. Ahead lay dramatic changes in production, transportation, domestic life, manufacturing, and in the boundaries of the new nation.

FIGURE 8-8. This genre painting is intended to give the viewer insight into daily life. The artist shows furnishings widely popular in the early years of the nineteenth century: a picture of George Washington, images of naval battles, a birdcage, and blue-decorated ceramics that may be creamware or pearlware from England. Perhaps more important, he shows people: arriving guests, a woman startled by their arrival before she has finished tidying up, a girl with a tea tray, and a little boy taking advantage of the confusion to fill his pockets with food from the party table. (*The Quilting Frolic*, John Lewis Krimmel, Philadelphia, 1813. Oil on canvas; H 16⅞ in., W 22⅜ in. 1953.178.2 Winterthur Museum.)

NOTES

1. Stillman, 49.
2. Hawley, 11.
3. Hawley, 10.
4. Hawley, 3.
5. Cooper, *Classical Taste*, 26; Talbott, 6–10.
6. Hawley, 11.
7. Beard, 5; Stillman, 2–3.
8. Fitzgerald, 86.
9. Tracy, *Classical America*, 12.
10. Kane, 42.
11. Tracy, *Nineteenth-Century American Furniture*, xi.
12. Tracy, *Classical America*, 17.
13. Bivins, "Convergence and Divergence," 49–51; Savage, 106–13.
14. Clunie, 1007.
15. Cooper, *Classical Taste*; Flanigan, 99; Mussey, 90.
16. Hepplewhite, 2.
17. Montgomery, 445.
18. Montgomery, 446.
19. Fales, 102.
20. Elder and Bartlett, 46; Humphries, 139–212.
21. Pilling, 128.
22. Tracy, *Classical America*, 17.
23. Kane, 39.
24. Montgomery, 14.
25. For a complete discussion of the organization of furniture making, see Montgomery, *American Furniture*, and Kane, "Design Books."
26. Tax record as quoted in Mussey, 33.
27. Advertisment in the Boston newspaper *Columbian Centinel*, December 8, 1804, as quoted in Mussey, 52.
28. Mussey, 28–72.
29. Montgomery, 19.
30. Kane, 40.
31. Mussey, 170–71, 57.
32. Fairbanks and Bates, 197.
33. Carson, 483–87.
34. McKendrick, Brewer, and Plumb, 15.
35. Mussey, 34, 48, 52.
36. B. Ward, 12.
37. B. Ward, 8; Bivins, "Rhode Island Influence," 70–75.
38. Cooper, *Classical Taste*, 215–22, 252–68; Flanigan, 99.
39. Alberts, 470.
40. Cooke, 250.
41. Garrett, 25.
42. Wenger, 155.
43. Alberts, 468.
44. Hewitt, Kane, and Ward, 16–17.
45. Garvan, 42.
46. Cooke, 253–54.
47. Alberts, 470.
48. Cooper, *Classical Taste*, 38.
49. Dunbar, 5.

BIBLIOGRAPHY

Conger, Clement, Mary K. Itsell, and Alexandra W. Rollins, eds. *Treasures of State: Fine and Decorative Arts in the Diplomatic Reception Rooms of the U.S. Department of State.* New York: Harry N. Abrams, 1991.

Cooper, Wendy A. *Classical Taste in America 1800–1840.* New York: Abbeville Press, 1993.

Hepplewhite, George. *The Cabinet-Maker and Upholsterer's Guide.* London, 1788, 1789, 1794. Reprint. New York: Dover Publications, 1969.

Hewitt, Benjamin A., Patricia E. Kane, and Gerald W. R. Ward. *The Work of Many Hands: Card Tables in Federal America, 1790–1820.* New Haven, Conn.: Yale University Art Gallery, 1982.

Jobe, Brock W. *Portsmouth Furniture: Masterworks from the New Hampshire Seacoast.* Boston: Society for the Preservation of New England Antiquities, 1993.

Kenny, Peter M. *Honoré Lannuier: Cabinetmaking from Paris: The Life and Work of a French Ébéniste in Federal New York.* New York: Metropolitan Museum of Art, 1998.

Montgomery, Charles F. *American Furniture: The Federal Period, 1788–1825.* New York: Viking Press, 1966.

Mussey, Robert D. Jr. *The Furniture Masterworks of John & Thomas Seymour.* Hanover, N.H.: University Press of New England for the Peabody Essex Museum, 2003.

Sheraton, Thomas. *The Cabinet-Maker and Upholsterer's Drawing Book.* London: 1793, 1794, 1801. Reprint. New York: Praeger Publishers, 1970.

Ward, Gerald W. R., ed. *American Furniture with Related Decorative Arts, 1660–1830: The Milwaukee Art Museum and the Layton Art Collection.* New York: Hudson Hills Press, 1991.

Weidman, Gregory R., and Jennifer F. Goldsborough. *Classical Maryland, 1815–1845: Fine and Decorative Arts from the Golden Age.* Baltimore: Maryland Historical Society, 1993.

Additional Sources

Alberts, Robert C. *The Golden Voyage.* Boston: Houghton Mifflin, 1969.

Beard, Geoffrey. *The Work of Robert Adam.* New York: ARCO Publishing Co., 1978.

Bivins, John. "The Convergence and Divergence of Three Stylistic Traditions in Charleston Neoclassical Case Furniture, 1785–1800." In *American Furniture 1997*, edited by Luke Beckerdite, 47–105. Milwaukee, Wis.: Chipstone Foundation, 1997.

———. "Rhode Island Influence in the Work of Two North Carolina Cabinetmakers." In *American Furniture 1999*, edited by Luke Beckerdite, 79–108. Milwaukee, Wis.: Chipstone Foundation, 1999.

Carson, Cary. "The Consumer Revolution in Colonial British America: Why Demand?" In *Of Consuming Inter-*

ests: *The Style of Life in the Eighteenth Century*, edited by Cary Carson, Ronald Hoffman, and Peter J. Albert, 483–697. Charlottesville: University Press of Virginia for the United States Capitol Historical Society, 1994.

Clunie, Margaret Burke. "Joseph True and the Piecework System in Salem." *The Magazine Antiques* 111, no. 5 (May 1977): 1006–13.

Cooke, Edward S. Jr. "Domestic Spaces in the Federal Period Inventories." *Essex Institute Historical Collections* 116, no. 4 (October 1980): 245–64.

Cooper, Wendy A. "The Furniture and Furnishings of the Farm at Danvers." *Bulletin of the Museum of Fine Arts, Boston* 81 (1983): 38, 99.

Dunbar, Michael. *Federal Furniture.* Newtown, Conn.: Taunton Press, 1986.

Elder, William Voss III, and Lu Bartlett. *John Shaw: Cabinetmaker of Annapolis.* Baltimore: Baltimore Museum of Art, 1983.

Fairbanks, Jonathan, and Elizabeth Bidwell Bates. *American Furniture: 1620 to the Present.* New York: Richard Marek Publishers, 1981.

Fales, Dean A. Jr. *American Painted Furniture, 1660–1880.* New York: E. P. Dutton, 1972.

Fitzgerald, Oscar. *Four Centuries of American Furniture.* Radnor, Pa.: Wallace-Homestead Book Co., 1995.

Flanigan, J. Michael. *American Furniture in the Kaufman Collection.* Washington, D.C.: National Gallery of Art, 1986.

Forman, Benno M. *American Seating Furniture, 1630–1730: An Interpretive Catalogue.* New York: W. W. Norton, 1988.

Garrett, Elisabeth Donaghy. *At Home: The American Family, 1750–1870.* New York: Abrams, 1989.

Garvan, Beatrice. *Federal Philadelphia: The Athens of the Western World.* Philadelphia: Philadelphia Museum of Art, 1987.

Hawley, Henry. *Neo-Classicism: Style and Motif.* Cleveland: Cleveland Museum of Art, 1964.

Humphries, Lance. "Provenance, Patronage, and Perception: The Morris Suite of Baltimore Painted Furniture." In *American Furniture 2002*, edited by Luke Beckerdite, 139–212. Milwaukee, Wis.: Chipstone Foundation, 2002.

Kane, Patricia E. "Design Books and Price Books for American Federal-Period Card Tables." In *The Work of Many Hands: Card Tables in Federal America, 1790–1820*, by Benjamin A. Hewitt, Patricia E. Kane, and Gerald W. R. Ward, 39–54. New Haven, Conn.: Yale University Art Gallery, 1982.

McKendrick, Neil, John Brewer, and J. H. Plumb. *The Birth of a Consumer Society: The Commercialization of Eighteenth-Century England.* Bloomington: Indiana University Press, 1982.

Pilling, Ronald. "Baltimore Fanch Furniture." In *Early American Furniture*, edited by Mary Jean Madigan and Susan Colgen, 124–33. New York: Billboard Publications, 1983.

Savage, J. Thomas. "The Holmes-Edwards Library Bookcase and the Origins of the German School in Pre-Revolutionary Charleston." In *American Furniture 1997*, edited by Luke Beckerdite, 106–25. Milwaukee, Wis.: Chipstone Foundation, 1997.

Stillman, Damie. *English Neoclassical Architecture.* 2 vols. London: Zwemman, 1988.

Talbott, Page. *Classical Savannah: Fine and Decorative Arts, 1800–1840.* Savannah, Ga.: Telfair Museum of Art, 1995.

Tracy, Berry B. *Classical America, 1815–1845.* Newark, N.J.: Newark Museum, 1963.

———. *Nineteenth-Century American Furniture and Other Decorative Arts.* New York: Metropolitan Museum of Art, Graphic Society, Ltd., 1970.

Ward, Barbara McLean. "Marketing and Competitive Innovation: A Case Study of the Brands, Marks, and Labels Found on Federal Period Furniture." In *Everyday Life in the Early Republic*, edited by Catherine E. Hutchins, 201–18. Winterthur, Del.: Henry Francis du Pont Winterthur Museum, 1994.

Ward, Gerald W. R. "Silver and Society in Salem, Massachusetts, 1630–1820: A Case Study of the Consumer and the Craft." Ph.D. dissertation, Boston University, 1984.

Weidman, Gregory. "Baltimore Furniture in the English Tradition." In *The American Craftsman and the European Tradition, 1620–1820*, edited by Francis J. Puig and Michael Conforti, 256–81. Minneapolis: Minneapolis Institute of the Arts, 1989.

Wenger, Mark. "The Dining Room in Early Virginia." In *Perspectives in Vernacular Architecture III*, edited by Thomas Carter and Bernard L. Herman, 149–59. Columbia: University of Missouri Press, 1989.

Furniture in the Empire or Late Classical-Revival Style

THE TRADITIONAL NAME FOR THIS STYLE OF furniture—empire—recalls Napoleon, his identification with classical civilization, and his optimistic dreams of an extensive empire. At the beginning of the 1800s, the empire (or late classical-revival) style originated as part of an ongoing and pervasive interest in classicism that suffused Western design. The continued popularity of this furniture into the mid-1800s, despite competition from other revival styles, indicates how well the style captured contemporary tastes.

The interest in empire-style furniture did not persist into the twentieth century. Until recently, the imposing proportions and elaborate decoration of urban empire furniture rarely appeared as a collecting interest or in reproductions. Although visitors might not have an interest in this furniture, guides should invite them to admire the high quality of craftsmanship, the bold classical designs, and the rich veneers that demonstrate technical skills and sophisticated tastes.

Furniture in the empire or late classical-revival style was popular during a time of change that was as sweeping as any period in this country's history. As stylistic influences flowed from France and England, furniture making, like other industries, was affected by changes in the marketplace and in the organization of production. Wide transportation networks, steam power applications, increased cash availability, and formal, impersonal labor relations all had an effect on the making and selling of furniture.

LOOKING AT EMPIRE FURNITURE

Furniture in the empire style displays large volume, both in overall dimensions and in its parts; varied materials; and ornament derived from classical sources. Even the individual ornamental motifs seem large and sculptural in comparison with furniture in the federal style. Architectural elements such as columns and friezes can be seen in the furniture. Gilding, metal mounts, and glass highlight many objects. The word *monumental* seems appropriate.

Volume

Empire furniture fills space in a compelling manner. Individual structural members appear large in comparison with the more delicate components of federal furniture. The saber legs on a klismos chair (fig. 9-1), for example, appear larger than the legs of a federal- or early classical-revival-style shield-back chair. Mirrors, which serve as backs for some pier tables, make the table appear larger and reflect and emphasize the front legs, which are often very sculptural and three-dimensional. Emphasis on the horizontal dimension enhances the sense of the furniture's solidity. Furniture also appears heavy and firmly fixed on the ground. Wide crest rails on chairs as well as wide horizontal surfaces supported by columns on pier tables and some wardrobes and beds strengthen this look (fig. 9-2).

Materials

Makers who crafted empire furniture used diverse, often valuable, materials to create colorful and ornate objects. They added metal, glass, and stone to their traditional material, wood. Metal mounts or inlay, as decorative elements, can be seen on chairs, pier tables, and looking glasses. Gilding, the application of thin sheets of gold to wooden parts, gave the impression of costly metal on tables and looking glasses. Often applied in veneers that accentuated strong grain lines, showy, exotic woods were used. As exemplified in a collector's cabinet with dark eagle supports, the colors of these various materials allowed furniture makers to work with contrasts of light and dark (fig. 9-3). Light reflecting on polished wood, shiny mirrors and metal, and smooth marble all create colorful, striking objects.

Ornament

Objects fashioned in the empire or late classical-revival style clearly alluded to classical forms and motifs. Some furniture, especially klismos and curule

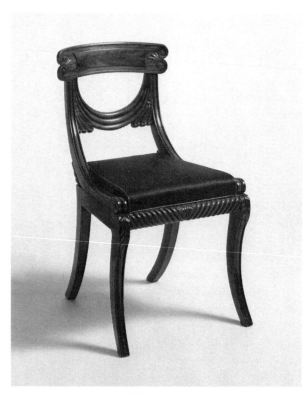

FIGURE 9-1. Designers of high-style empire chairs sometimes selected the classical klismos form with saber or "sweep" legs, a molded upper frame that sweeps upward to form the stiles, and a curved horizontal crest rail. (Side chair, Boston, 1815–1825. Mahogany, birch, cloth, horsehair, leather; H 33 in., W 19 in., D 22½ in. 1982.99.1 Winterthur Museum.)

chairs, were attempts at a direct reproduction of classical forms. More often, however, objects adapted classical ideas. Architectural elements in the antique taste ornamented furniture. Where the ancient Greeks and Romans used caryatids and columns to support roofs, furniture makers in America used them to support tabletops or nonstructural ornaments. Urns and lyres served a similar function. The saber leg, or "sweep" leg, as it might have been called at the time, was one that curved outward, a widely used motif inspired by English Regency designs.[1] Extensive carving that incorporated classical elements within a balanced, symmetrical framework is characteristic of this furniture.

A pier table with curving dolphin supports illustrates elements of the empire style (fig. 9-4). Substantial volume is suggested by the large, sculptural dolphins, and the horizontal plane is emphasized by the thick bottom shelf. Marble, glass, gilding, and bronzing join carved mahogany to produce a resplendent object. The dolphin motif recalls Neptune, the Roman god of the sea, whose trident, or three-pronged spear, was sometimes entwined with a dolphin.

THINKING ABOUT STYLE

The civilizations that flourished around the Mediterranean in the seven centuries before and the four centuries after Christ's birth were the inspiration for the style called empire or late classical revival. The artists, architects, and artisans of Egypt, Greece, and Rome created objects that became widely known and copied at the turn of the nineteenth century. Spreading through Europe to the young United States, the influence of the ancients merged with French and English political and artistic developments. In 1804 Napoleon proclaimed the French Empire, and his act gave a name to the French manifestation of the antiquities-based style.[2]

Through the late eighteenth and nineteenth centuries, knowledge about Egyptian and Greco-Roman life increased. After seeing antiquities in person or in publications, designers copied the forms more precisely than before. A Roman magistrate's folding chair, for example, inspired the curule shape for the legs of chairs (fig. 9-5). Called a "Grecian cross" in price books, the front and back legs appear on each side like two half circles meeting at the top of the lobe. A stretcher connects the meeting points of the half circles, from side to side beneath the seat of the chair.[3]

The style reached American furniture makers in diverse ways, and their products exhibit French and English influences drawn from printed sources, active craftsmen, and imported furniture. Craftsmen marketed their products beyond local boundaries and without the constraints of local credit. Although some furniture makers developed recognizable regional traits, their expansive markets often carried these characteristics far beyond local consumers.

Influential in furniture design since the 1750s, publications increased in number and diversity in the first half of the 1800s. With sometimes convoluted relationships, designers and printed sources provided reciprocal inspiration.[4] Publishing a design book in 1798, Pierre Fontaine and his partner, Charles Percier, encouraged Napoleon to commission interior decoration for several important buildings. Thomas Hope, a wealthy English collector and art patron, developed a friendship with Percier and demonstrated his commitment to the archaeological manner in his own house in London. In 1807 Hope published *Household Furniture and Decoration*, which documented the work on his own home. In 1808 George Smith based some of his designs on Hope's book, and they, in turn, appeared in Rudolph

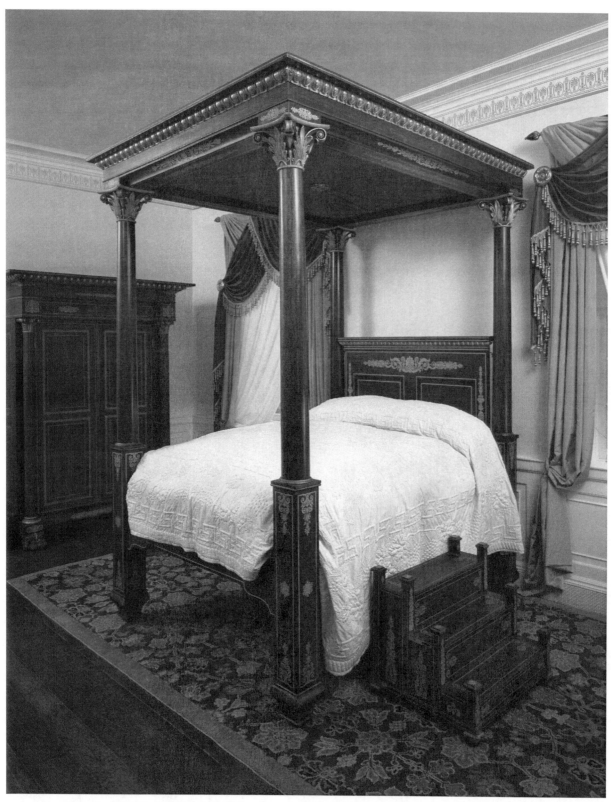

FIGURE 9-2. Isaac Jones created a large suite of furniture, including this massive bed, for a wealthy Philadelphia merchant. Note the addition of stylized floral stenciled gilt ornamentation. The four tall columns with ornate capitals, which have carved palmettes and volutes, support the classical cornice. (Bed, Isaac Jones, Philadelphia, 1825–1840. Rosewood veneer, mahogany, rosewood, copper, zinc, lead, silk, gilt; H 111½ in., W 73¾ in., D 90 in. 1989.12.1 Winterthur Museum.)

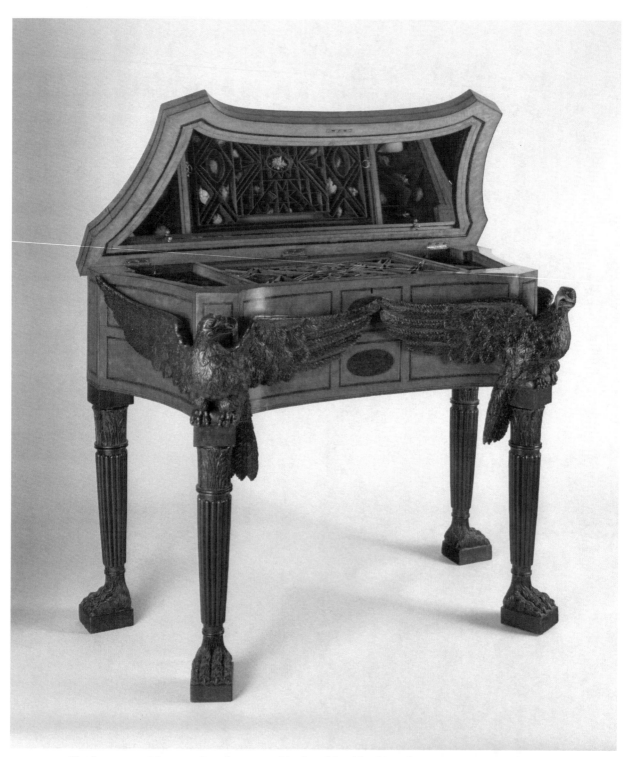

FIGURE 9-3. The finest materials were selected to create this pier table with a hinged mirror top, made in the shop of Joseph B. Barry in Philadelphia. The interior is elaborately fitted with trays for organizing the owner's collection of objects. (Pier table, Joseph B. Barry, Philadelphia, 1810–1820. Mahogany, mahogany veneer, satinwood veneer, tulip poplar, white pine, ebony, rosewood, brass; H 39 in., W 49 in., D 26 in. 1957.945 Winterthur Museum, bequest of Henry Francis du Pont.)

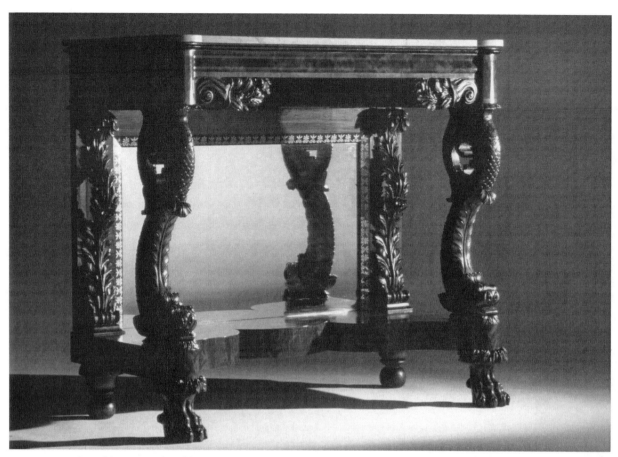

FIGURE 9-4. Pier tables were placed between two windows and routinely displayed silver, glassware, and other treasured objects. Only a few are as ornate as this Philadelphia example. (Pier table, Philadelphia, 1825–1840. Mahogany, mahogany veneer, rosewood veneer, gilt, paint, vert, marble, glass; H 44 in., W 50 in., D 24 in. 1975.191 Winterthur Museum purchase with additional funds provided by the Claneil Foundation.)

Ackermann's *Repository of the Arts*, a London periodical published between 1809 and 1828. Americans read Ackermann's publication as well as Pierre de La Mésangère's *Meubles et Objects de Goût*, which also popularized designs by Percier and Fontaine.

French designers focused on ancient Greco-Roman designs, especially those found on vases and sarcophagi, and they copied some chair forms directly. Sofas and settees also reflected antique forms, notably the "Grecian couch," which is often associated with a well-known portrait of Madame Recamier painted by Jacques-Louis David in 1800. The artist portrayed the young woman reclining on a backless couch. Other designs adapted classical motifs to forms less directly copied from the antique. Such characteristics include veneered columns with ormolu (gilded brass or bronze) mounts, veneered surfaces, and flattened ball feet with bands of ormolu.[5]

Designs from France inspired English furniture of the early 1800s. Called the Regency style because of its popularity during the regency of George IV (1811–

1820), the furniture was massive, strongly sculptural, and lavishly ornamented with gilt. English and French influences came to the East Coast of the United States not only through design books but also through immigrant craftsmen, imported furniture, and details published in cabinetmakers' price books. The movements of these people, objects, and books were complex and are sometimes difficult to trace. The interpretations of this style made by craftsmen in the United States indicate that they knew about the motifs and techniques needed to produce fashionable objects.[6]

The American classical style embodies characteristics of both the French Empire and English Regency. Because English and French designers copied freely from each other, it is often difficult to discern which characteristics of an object are English and which are French. Generally speaking, furniture with a plain, almost severe look is often identified as French-inspired; a pier table labeled by Michael Allison and a worktable labeled by Honoré Lannuier, both of New York, are examples (figs. 9-6, 9-7). The pier tabletop

Furniture in the Empire or Late Classical-Revival Style 93

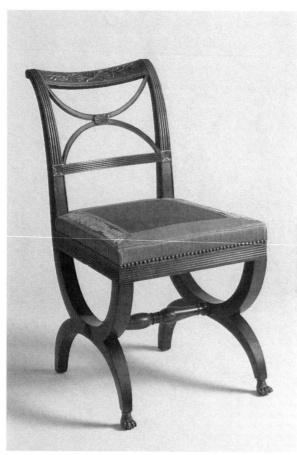

FIGURE 9-5. Customers were charged for additional embellishments on furniture such as the front brass feet, carved foliage, and bold reeding along the rails of this chair. The form of the legs, with the distinctive semicircles meeting at the top of the lobe, gives this chair the name curule. (Chair, New York, N.Y., 1810–1815. Mahogany, maple, birch, white pine; H 33 in., W 18 in., D 24¼ in. 1964.24.1 Winterthur Museum purchase with funds provided by the Charles K. Davis Fund.)

is a plain rectangular frame with ormolu mounts, and the sculptural elements are limited to plain columns and paw feet. Furniture with varied colors and materials is identified often as English-inspired.

In the 1820s, ornament on American furniture included carved acanthus and lotus leaves, anthemia (lobed, floral forms, in radiating clusters), pineapples, and twisted reeding. Cabinetmakers sometimes substituted stenciled and painted designs in gilt and bronze powder for more expensive metal mounts. By the 1830s, furniture became increasingly heavy as broad expanses of veneer replaced carved elements. Turned and carved capitals and bases on pillars replaced metal bands. Massive scrolls, sometimes embellished with applied wooden rosettes, beaded detail, or carved anthemia, supported sofas and tabletops.

By the 1830s, regional differences were not as obvious. Furniture historians have identified some characteristics specific to furniture made in Boston, New York, and Philadelphia.[7] For example, beginning in 1816, "Grecian" tables with central pedestals, mahogany veneers, scrolled feet and apron rails, and large-scale carving were favored by several Boston makers (fig. 9-8). Craftsmen clustered in neighborhoods and were mutually influential, making attribution difficult.[8] However, these craftsmen's products did not necessarily remain close to home. Philadelphia, for example, supported an extensive export market that made its furniture available to consumers in Washington, D.C., and farther south.[9]

Some characteristics of Boston-made furniture are wide, bold reeding on chair arms and seat rails; a small, flat panel of horizontal reeding above chair legs and card table legs; and ebonized turnings with inlay and bold concave tablet tops with carved anthemia.[10] On klismos chairs, a middle rail carved to resemble fabric swags suggests a Boston origin (see fig. 9-1). Furniture scholar Peter Kenny described some characteristics of New York furniture at the time when Duncan Phyfe and Honoré Lannuier were supplying their wealthy patrons: a reeded leg and a New York method of producing water-leaf carving, the long, slim-lobed leaves with central vein often seen on the splayed saber legs of card tables and on chair legs.[11]

MAKING AND MARKETING EMPIRE FURNITURE

The world of the craftsman changed markedly in the early national period. The characteristic ways of working and selling in a colonial mercantile economy and a deferential society gradually disappeared. Trends scholars call modern formed a national economy with diverse trade in a democratic society. In this period after independence and the Napoleonic wars, domestic and foreign trade generally increased the demand for products. Master craftsmen sometimes developed businesses that emphasized efficiency, volume production and sales, plus low wages. Squeezed out by less-skilled workers, skilled journeymen organized themselves politically and agitated for better wages. Owners of businesses and their workers found their purposes and interests diverging as new ways of making and selling furniture developed. An industrial revolution conjures images of large-scale mechanization, and some did occur in the woodworking trades. For furniture makers and their workers in the early 1800s, however, changes in their markets and working relationships appear to have been more important.

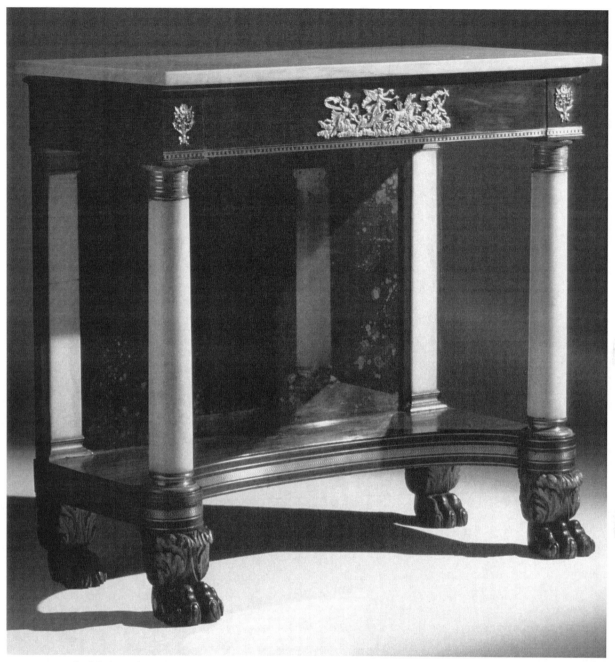

FIGURE 9-6. The label on this pier table states that its maker, Michael Allison, chose only the "best materials." (Pier table, Michael Allison, New York, N.Y., 1816–1835. Rosewood, tulip poplar, brass, ormolu, marble, glass; H 37 in., W 40 in., D 19¾ in. 1974.2 Winterthur Museum purchase.)

Three topics in particular offer interpretive opportunities emphasizing the change from eighteenth-century ways of making and marketing furniture: the development of centralized sales, auctions, and warehouses; the master craftsman's development as an entrepreneur and the journeyman's as a wage laborer; and the application of powered machinery.[12]

By 1835 a typical cabinetmaker on the East Coast saw the sales of his product move away from the shop floor. The time-honored method of "bespoke" work—filling an order for a customer—was, except for specialty work, disappearing.[13] In its place came "shop work," making a quantity of furniture for sale at auction or in the maker's wareroom (showroom), if he had one, or in the warehouse of a furniture dealer.[14] After the Revolution, warerooms began to appear, and by 1810 they were important to commerce in many cities.[15] By the 1820s they had an effect on furniture sales

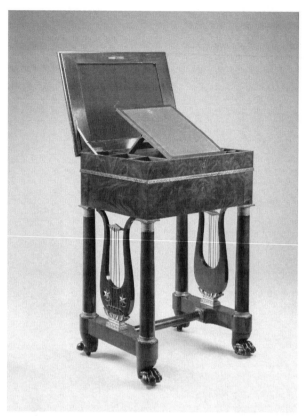

FIGURE 9-7. Young women desired worktables to store their sewing equipment and needlework projects. Certainly the owner of this elaborate example would have been delighted by the brass inlay and lyre-shaped supports. A printed paper label marks this table as the work of Charles-Honoré Lannuier. (Worktable, New York, N.Y., 1810–1819. Mahogany, walnut, rosewood, white pine, tulip poplar, brass; H 31¾ in., W 22 in., D 17¾ in. 1960.6 Winterthur Museum purchase with funds provided by Henry Francis du Pont.)

in outlying districts as well.[16] In 1825 the wareroom operated by Isaac Vose and Son in Boston was described as "a warehouse in front, three stories high, commodiously arranged for exhibiting furniture; three story wooden dwellinghouse adjoining, in thorough repair, and very convenient, ... in the rear very extensive workshops with suitable fixtures and a large space protected from the sun for seasoning mahogany."[17]

A newspaper advertisement that a cabinetmaker had furniture "constantly on hand" for perusal and sale was a clue that the new marketing method was in place.[18] Making furniture for display meant that the cabinetmaker expected customers to look at and judge his goods before buying, that he needed space (either his own or an agent's) to arrange finished goods, and that he had capital invested in his completed inventory. Some craftsmen had the money to become merchants; many did not and could compete only by working with agents or other craftsmen.

An agent, either a commission merchant or an auctioneer, often provided wareroom space for cabinetmakers. In Boston, for example, merchants explicitly identified as furniture dealers increased from one in 1810 to fifteen in 1821 to thirty-two in 1833. Labels in furniture made during these years in Boston often identify the seller rather than the maker.[19]

Auctioneers served several purposes. They gathered and sold furniture made by several makers; they sold furniture shipped from makers in far-off cities; and they sold goods for cabinetmakers who found themselves with surplus. Auctions were plentiful in Boston, where most furniture sold was locally made, and in Washington, D.C., where furniture from Philadelphia, New York, Baltimore, and Boston was common.[20] The records of New York makers show that they used auctions both in their city and in cities in the South that received their shipments.[21] Auctions, by their nature, emphasized competitive pricing and separated makers from customers. For the cabinetmaker, they were an effective, affordable marketing tool. Furniture scholar Robert Mussey found that a 1.5 to 5 percent commission was usual for auctioneers in Boston during the time that father and son John and Thomas Seymour worked there (1793–1826).[22] Auctions also developed a reputation for presenting less-than-fine-quality goods. Thus, in 1835, Yarnall Baily, a cabinetmaker in Chester County, Pennsylvania, advertised that "he attends to every branch of the business personally, and makes NO AUCTION WORK."[23]

Dissatisfaction with agents and auctions led cabinetmakers to cooperate in their own sales and auctions. Organized in Philadelphia in 1806, the Society of Journeymen Cabinetmakers, a benevolent association, established its own successful wareroom in 1834.[24] Tradesmen, mechanics, and manufacturers in and around Boston banded together in 1795 in the Massachusetts Charitable Mechanics Association. By 1837 the association was exhibiting and awarding prizes for furniture to encourage good local work. In many cities, such sales offered makers an alternative to commission merchants and control over the sales of their products.

Cabinetmakers who produced wholesale or order work could consign their work to merchants, agents, or ship captains for sale beyond the local market.[25] Although the local market was significant for Philadelphia cabinetmakers, they also produced goods that traveled to western Pennsylvania, cities south of Washington, D.C., and the West Indies and South America. The appearance of New York objects in Boston and

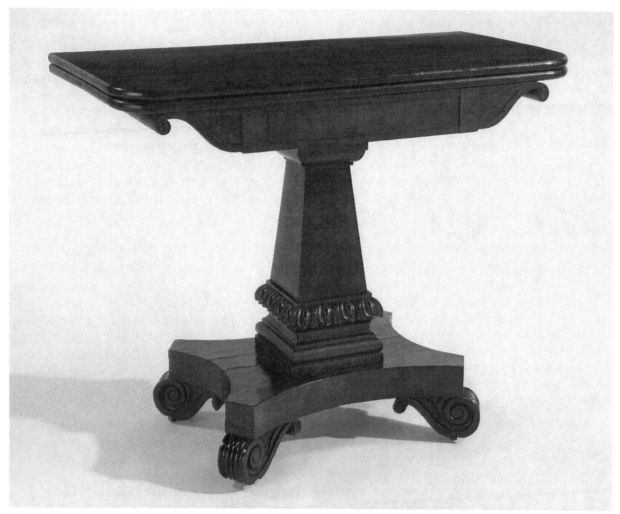

FIGURE 9-8. This mahogany empire-style card table has a top that pivots and then rests on the pedestal base when opened to play cards or games. Notice the brass casters that would have allowed the owner or servants to move this table easily. (Card table, Boston, 1815–1830. Mahogany, brass; H 29¾ in., W 36½ in., D 18⅛ in. 2003.26 Winterthur Museum, gift of Wendy and Michael Crowley.)

Washington sales suggests that New York probably had a significant export trade. Although most of his patrons were New Yorkers, Honoré Lannuier shipped furniture south to Savannah and the Caribbean.[26] Bostonians, on the other hand, imported little furniture from beyond their own outlying areas, and in 1832, Boston chair makers and cabinetmakers reported that most of their work was sold in Boston.[27]

Because of warerooms, auctions, expanding markets, and the entrepreneurial role of the shop master, the kind and number of workers in furniture shops changed. There were two major changes: an enlarged work force in each shop and a decreased use of skilled labor. The number of workbenches in shops increased, and the number of people working together probably increased as well. In comparison with the two benches in Brewster Dayton's shop in 1796, Thomas Emmons,

who purchased the Isaac Vose and Son property described above, owned eleven benches when he died in 1825.[28] At the same time, Thomas Ogden, who introduced the wareroom to Chester County, Pennsylvania, employed nine or ten workers, and in Washington, D.C., Thomas Adams employed ten "hands" in 1820.[29]

Both dissatisfied shop owners and furniture workers complained about declining number of skilled workers in shops. In 1828 the *Mechanics' Free Press* of Philadelphia reported: "There are men in this city who have from 15 to 20 apprentices, who never or very seldom have a journeyman in their shops."[30] In 1835, Philadelphia journeymen advertised in the *Gazette* that "we merely wish to appraise the public of the fact that they may be enabled to judge whether . . . it [furniture] can be as well manufactured by an

inexperienced boy as by an experienced man, who had spent his youth in acquiring a knowledge of the rudiment."[31]

Hiring fewer skilled workers allowed a craftsman to pay lower wages than he would for skilled labor, and apprenticeship became a source of inexpensive labor rather than a route to craft mastery.[32] Skilled workers responded to reduced opportunity by banding together. Furniture makers' societies, which often began as organizations for mutual aid and insurance, existed in Philadelphia by 1806, in Washington by 1831, and in Boston by 1825. These societies probably included successful manufacturers as well as mechanics, but their projects suggest efforts to keep market control in the hands of furniture makers. In Boston and Washington, such societies sponsored their own sales, and groups in Washington and Philadelphia published price books that, invaluable today as documents of the variety and prices of furniture forms, were actually efforts to establish just wages.[33] Journeymen cabinetmakers usually were paid by the piece. Price books, then, were labor negotiation documents that often resulted from journeymen banding together to oppose further wage reductions.[34]

In the first half of the nineteenth century, machines powered by other than human muscle appeared in woodworking trades. Reliable documentation about the extent of their use is scarce, however, and scholars conclude that steam- or water-powered machines were probably not in common use in furniture shops until at least midcentury.[35] Furniture makers in New Castle County, Delaware, for example, had no power machinery in 1850.[36] In Boston, furniture was mostly handmade in the early 1800s, and in Philadelphia, woodworking machinery was not in general use until after 1840.[37]

The expense of installing power machinery was most easily borne by a large operator who used the machinery to prepare stock rather than to finish it. To introduce power machines, he needed to purchase water rights or fuel; construct necessary gears, shafting, and belts; build or buy a machine; and pay workers to maintain it—all significant investments. Owners of large sawmills and furniture factories were able to invest more easily than small operators.[38] The recollections of New York cabinetmaker Ernest Hagen confirm that machinery was most important in preparing stock. He wrote that in the late 1840s, "The work was all done by hand, but the scroll sawing of course was done at the nearest sawmill. The Employers having no Machinery at all, all the Mouldings were

bought at the Moulding Mill and turning done at the Turning Mill."[39]

Philadelphia cabinetmaker Michael Bouvier exported tools and veneers as well as cabinetware. He may have operated a shop large enough to use a powered veneer cutter, which, with steam saws, were the only machines generally used by large operators in Philadelphia before 1840.[40] Thus, although components made with machines may have affected the price, manufacture, and appearance of furniture before midcentury, working in a powered manufactory was not the typical experience of cabinetmakers before then.

In the early 1800s, the kind and source of lumber was more similar to earlier periods than other aspects of work. Mahogany was still the principal primary wood, and local woods, including tulip (yellow poplar), ash, and pine were important secondary woods. Zebrawood was an exotic mentioned by a Washington, D.C., craftsman.[41] New York cabinetmakers in the first quarter of the nineteenth century relied on mahogany from Santo Domingo but also used satinwood from East India or rosewood from Brazil.[42] Despite the similarity in materials, the business of furniture making changed in selling practices, market size, and labor needs. These issues foreshadowed the future for nineteenth-century cabinetmakers.

LIVING WITH FURNITURE IN THE EMPIRE STYLE

Empire-style furniture stood in the parlors and dining rooms of wealthy citizens of the new United States. Surviving paintings and prints suggest that the mahogany furniture was ornamented with metal mounts, marble, and glass.[43] Supported by improved transportation systems and national systems of money and banking, extensive trading routes carried fashionable furniture far from the place of manufacture.

Chairs, especially painted and stenciled fancy chairs, were widely available and inexpensive. Examples of painted and grained Windsor, Hitchcock-type, or klismos-type chairs survive from many areas, including Maine, New York, Philadelphia, and Baltimore.[44] As in earlier years, chairs were the most numerous product of furniture makers' shops. In Washington, D.C., in 1820 Thomas Adams and his ten workers produced 156 dozen chairs.[45] An elegantly furnished parlor or dining room in the second quarter of the nineteenth century was different from its pre-Revolutionary counterpart. Center tables and sofas became more common, as did relatively new forms such as pier tables and pianofortes. Looking

glasses and sideboards, which had become increasingly popular in the 1790s, remained stylish.

A round table, in the center of a room or near a window for light or a hearth for warmth, symbolized a less formal, more private, more family-oriented room that was becoming acceptable in England. Family members could gather at the table to sew, draw, or read. A round center table worked well with an argand lamp or solar lamp, new lighting techniques in the late eighteenth and early nineteenth centuries. The movement of furniture away from the walls marked an irreversible departure from eighteenth-century practices.[46] Pier tables, however, remained against walls. Used as serving and hall tables, they often stood between two windows against a pier, a masonry term meaning the solid support between two openings.[47]

Upholstered furniture, including sofas, "Grecian couches," and settees or window seats, furnished parlors. Less expensive than a Grecian couch, a sofa frame had scroll arms of equal length, solid front and plain veneered back, two winged paw feet at front, and two turned feet at back; carving and extra veneering increased the cost.[48] Settees sometimes filled a window enclosure or flanked a door, as they do in an important document of furniture use, Henry Sargent's *The Tea Party*, painted in Boston about 1823.[49] Firm, squared edges, forming a boxy shape, appear commonly on upholstered empire furniture. Available in England since the mid-eighteenth century, the straight-edge look resulted from efforts to increase the comfort of upholstery by making it more firm, resilient, and inclined to stay in place.[50]

Pianoforte production became a specialized branch of furniture making in the early 1800s, and instrument cases reflect the neoclassical taste. The pianoforte's name suggests its advantage over earlier harpsichords and spinets; it had a dynamic range that allowed both soft and loud playing.[51] Another new furniture form, the canterbury, could often be found nearby, holding sheet music (fig. 9-9). The popularity of the pianoforte after 1800 encouraged the development of the upright

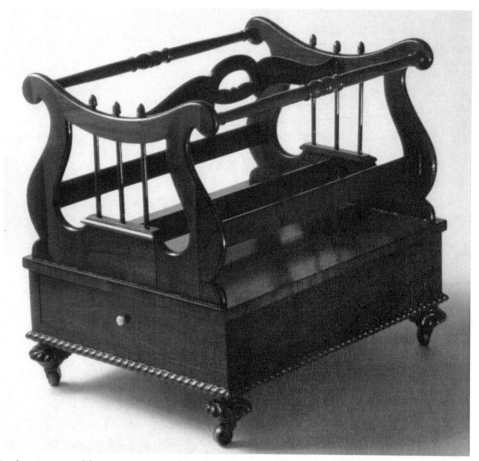

FIGURE 9-9. By the 1800s, wealthy consumers could order elegant pianofortes as well as a new form, called a canterbury, for holding sheet music. This fashionable example, with lyre-shape supports, wooden "strings," and gadrooned borders, would have been placed near the piano. (Canterbury, New York, N.Y., or Philadelphia, 1825–1840. Rosewood, pine, tulip poplar, brass, ivory; H 16⅜ in., W 14¾ in., L 18 in. 1977.126 Winterthur Museum purchase.)

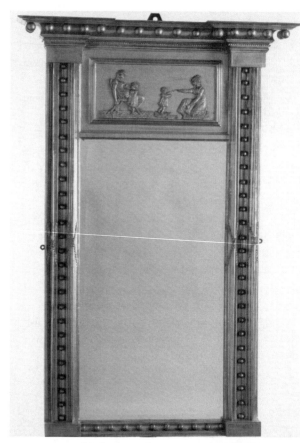

FIGURE 9-10. This looking glass is one of a pair made from pine with gesso to support the gilt layer. The overhanging cornice with pilasters on the sides gives this stylish mirror an architectural emphasis. At the top, the rectangular plaque depicts a woman sitting in a klismos chair while playing with children. (Looking glass, probably Boston, 1815–1825. White pine, gesso, gilt, glass; H 49⅜ in., W 33¾ in. 1960.192.2 Winterthur Museum purchase with funds provided by Henry Francis du Pont.)

piano, in which vertical strings use much less space than the horizontally stringed grand piano.[52] Upright pianos found their place in parlors, decorated with such fashionable elements of late classical-revival taste as lyres and scrolls, acanthus leaf carving, stenciling and metallic mounts, and columns, pilasters, and capitals.[53] The prices of pianos, however, prevented widespread ownership until later. In England in the early 1800s, for example, the cost of a piano equaled a clerk's or schoolteacher's annual income.[54]

Mirrors underline the fascination with shiny, reflective surfaces that late classical-revival decoration emphasizes. In the late 1700s, large mirrors, extending almost to the ceiling, began to cover wall surfaces between two windows. Smaller mirrors, both rectangular and round, often decorated walls or rooms containing empire furniture (fig. 9-10).[55] As specialized rooms for dining became fashionable in large houses, sideboards for the storage and display of dining accoutrements gained importance.[56] "Vases" for knives, so called by George Hepplewhite, often stood on each end.

CONCLUSION

The acceptance of designs inspired by the classical Mediterranean world pervaded fine and decorative arts in Europe and America as the eighteenth century gave way to the nineteenth. Recalling the civic virtues of the Greek and Roman states, classical designs strongly appealed to post-Revolutionary France and the young United States. Thomas Jefferson, during his ministry to France (1784–1789), purchased eighty-six cases of furniture. He recognized the usefulness of Greco-Roman designs to his political program, for extending democracy in the United States and extending his country's reputation in the Atlantic community of nations.

NOTES

1. Mussey, 105.
2. Fennimore, "Fine Points," 45.
3. Tracy, fig. 17.
4. Fennimore, "American Neoclassical Furniture," 50.
5. Cooper, *In Praise of America*, 249.
6. Fennimore, "American Neoclassical Furniture," 49–65; "Searching for Roots," 14–15.
7. Talbott, "Part II," 1004; Catalano, "Empire Style," 10; Kenny, *Honoré Lannuier*, 75–78.
8. Mussey, 360–61; Zimmerman and Jorgensen, 146–51.
9. Golovin, 899.
10. Tracy, figs. 28, 29.
11. Kenny, *Honoré Lannuier*, 75–78.
12. The opportunities and tribulations of masters, journeymen, and apprentices in an increasingly republican society and international market have spawned significant research. For more on these issues and for documentation of the broad generalizations, see Lewis; Ridgway; Rock, chaps. 2, 5, conclusion; Steffen, intro., chap. 9, conclusion.
13. Kessler, 36; Catalano, "Cabinetmaking," 6.
14. Catalano, "Cabinetmaking," 34–37.
15. Talbott, "Furniture Industry," vi.
16. Kessler, vi, 34–39.
17. As quoted in Talbott, "Part I," 879.
18. Kessler, 39; Catalano, "Cabinetmaking," 101.
19. Talbott, "Furniture Industry," 104; Catalano, "Cabinetmaking," 35.
20. Golovin, 899; Talbott, "Furniture Industry," 23.
21. Kenny, *Honoré Lannuier*, 62.
22. Mussey, 28, 34–36, 76.

23. As quoted in Kessler, 43.
24. Catalano, "Cabinetmaking," 44–46.
25. Catalano, "Cabinetmaking," 33.
26. Kenny, *Honoré Lannuier*, 133–37; Kenny, "Opulence Abroad," 240.
27. Talbott, "Furniture Industry," 10–13.
28. Talbott, "Part I," 879.
29. Kessler, 44; Golovin, 899.
30. As quoted in Catalano, "Cabinetmaking," 23.
31. As quoted in Catalano, "Cabinetmaking," 37.
32. Catalano, "Cabinetmaking," 36; Garrett, 888; Golovin, 899; Ridgway, 547.
33. Catalano, "Cabinetmaking," 13.
34. Rock, 249.
35. Earl, 315; Ettema, 24.
36. Earl, 315.
37. Talbott, "Part I," 878; Catalano, "Cabinetmaking," 27–31.
38. Ettema, 24–25.
39. As quoted in Ettema, 30.
40. Catalano, "Cabinetmaking," 27.
41. Eversmann, 14; Golovin, 902.
42. Kenny, *Honoré Lannuier*, 154–56.
43. See Cooper, *In Praise of America*, pl. 46, 249.
44. Churchill, 84–90; Weidman, *Furniture in Maryland*, 108, 116–18.
45. Golovin, 899.
46. Thornton, 210.
47. *Oxford English Dictionary*; Fitzgerald, 120.
48. Garrett, 895; Cooper, *Classical Taste*, 124–25.
49. Cooper, *In Praise of America*, pl. 46.
50. Thornton, 156.
51. Hollis, 3.
52. Hollis, 22.
53. Libin, cats. 16, 25.
54. Ehrlich, 10.
55. Fitzgerald, 122–23.
56. Fennimore, "Searching for Roots," 14.

BIBLIOGRAPHY

Cooper, Wendy A. *Classical Taste in America*. New York: Abbeville Press, 1993.

———. *In Praise of America: American Decorative Arts, 1650–1830*. New York: Alfred A. Knopf, 1980.

Fairbanks, Jonathan L., and Elizabeth Bidwell Bates. *American Furniture 1620 to the Present*. New York: Richard Marek Publishers, 1981.

Fennimore, Donald L. "American Neoclassical Furniture and Its European Antecedents." *American Art Journal* 13, no. 4 (Autumn 1981): 49–65.

———. "Fine Points of Furniture, American Empire: Late, Later, Latest." In *Victorian Furniture: Essays from a Victorian Society Autumn Symposium*, edited by Kenneth Ames, 45–54. Philadelphia: Victorian Society in America, 1983.

———. "Searching for Roots: The Genealogy of a Philadelphia Sideboard." In *Western Reserve Antiques Show Catalogue*. Cleveland, 1990.

Kenny, Peter M. *Honoré Lannuier, Cabinetmaker from Paris: The Life and Work of a French Ébéniste in Federal New York*. New York: Metropolitan Museum of Art, 1998.

Mussey, Robert D. Jr. *The Furniture Masterworks of John & Thomas Seymour*. Hanover, N.H.: University Press of New England for Peabody Essex Museum, 2003.

Talbott, Page. *Classical Savannah: Fine and Decorative Arts, 1800–1840*. Savannah, Ga.: Telfair Museum of Art, 1995.

Additional Sources

Catalano, Kathleen M. "Cabinetmaking in Philadelphia 1820–1840." Master's thesis, University of Delaware, 1972.

———. "The Empire Style: Philadelphia." In *Nineteenth-Century Furniture: Innovation, Revival, and Reform*, edited by Art and Antiques, 10–17. New York: Billboard Publications, 1982.

Churchill, Edwin A. *Simple Forms and Vivid Colors*. Augusta: Maine State Museum, 1983.

Earl, Polly Anne. "Craftsmen and Machines: The Nineteenth-Century Furniture Industry." In *Technological Innovation and the Decorative Arts*, edited by Ian M. G. Quimby and Polly Anne Earl, 307–29. Charlottesville: University Press of Virginia for the Henry Francis du Pont Winterthur Museum, 1974.

Ehrlich, Cyril. *The Piano: A History*. London: J. M. Dent and Sons, 1976.

Elder, William V. *Baltimore Painted Furniture, 1800–1840*. Baltimore: Baltimore Museum of Art, 1972.

Ettema, Michael John. "Technological Innovation and Design: Economics in American Furniture Manufacture of the Nineteenth Century." Master's thesis, University of Delaware, 1981.

Eversmann, Pauline K. "Workshop on Empire Furniture with Don Fennimore, November 7, 1985." *Winterthur Guidelines* (December 1985–January 1986): 14–19.

Fitzgerald, Oscar. *Three Centuries of American Furniture*. Englewood Cliffs, N.J.: Prentice-Hall, 1982.

Garrett, Wendell, ed. "The Price Book of the District of Columbia Cabinetmakers, 1831." *The Magazine Antiques* 107, no. 5 (May 1975): 888–97.

Golovin, Anne Castrodale. "Cabinetmakers and Chairmakers of Washington, D.C., 1791–1840." *The Magazine Antiques* 107, no. 5 (May 1975): 898–922.

Hollis, Helen R. *Pianos in the Smithsonian Institution*. Smithsonian Studies in History and Technology 27. Washington, D.C.: Smithsonian Institution Press, 1973.

Hounshell, David N. *From the American System to Mass Production, 1800–1932: The Development of Manufacturing Technology in the United States*. Baltimore: Johns Hopkins University Press, 1984.

Kenny, Peter M. "Opulence Abroad: Charles-Honoré Lannuier's Gilded Furniture in Trinidad de Cuba." In *American Furniture 2004*, edited by Luke Beckerdite, 239–64. Milwaukee, Wis.: Chipstone Foundation, 2004.

Kessler, Barry Allen. "Of Workshops and Warerooms: The Economic and Geographic Transformation of Furniture Making in Chester County, Pennsylvania 1780–1850." Master's thesis, University of Delaware, 1986.

Lewis, Jan. *The Pursuit of Happiness: Family and Values in Jefferson's Virginia*. Cambridge: Cambridge University Press, 1983.

Libin, Laurence. *Keynotes: Two Centuries of Piano Design*. New York: Metropolitan Museum of Art, 1985.

Loesser, Arthur. *Men, Women, and Pianos: A Social History*. New York: Simon & Schuster, 1954.

Ridgway, Whitman H. *Community Leadership in Maryland, 1790–1840: Comparative Analysis of Power in Society*. Chapel Hill: University of North Carolina Press, 1979.

Rock, Howard B. *Artisans of the New Republic: The Tradesmen of New York City in the Age of Jefferson*. New York: New York University Press, 1979.

Steffen, Charles G. *The Mechanics of Baltimore: Workers and Politics in the Age of Revolution, 1763–1823*. Urbana: University of Illinois Press, 1984.

Stoneman, Vernon C. *John and Thomas Seymour: Cabinetmakers in Boston, 1794–1816*. Boston: Special Publications, 1959.

Talbott, E. Page. "Boston Empire Furniture: Part I." *The Magazine Antiques* 107, no. 5 (May 1975): 878–87.

———. "Boston Empire Furniture: Part II." *The Magazine Antiques* 109, no. 5 (May 1976): 1004–13.

———. "The Furniture Industry in Boston, 1810–1855." Master's thesis, University of Delaware, 1974.

———. "Seating Furniture in Boston, 1810–1835." *The Magazine Antiques* 139, no. 5 (May 1991): 956–69.

Thornton, Peter. *Authentic Decor: The Domestic Interior, 1620–1920*. New York: Viking Press, 1984.

Tracy, Berry B. "Introduction." In *Nineteenth-Century America: Furniture and Other Decorative Arts*, edited by Marilynn Johnson, Marvin D. Schwartz, and Suzanne Boorsch, xi–xxxii. New York: Metropolitan Museum of Art, 1970.

Weidman, Gregory R. "Baltimore Federal Furniture in the English Tradition." In *The American Craftsman and the European Tradition, 1620–1820*, edited by Francis J. Puig and Michael Conforti, 256–81. Minneapolis: Minneapolis Institute of Arts, 1989.

———. *Furniture in Maryland, 1740–1790*. Baltimore: Maryland Historical Society, 1984.

Zimmerman, Philip D., and David Jorgensen. "A Grecian Card Table by William Fisk and Thomas Wightman of Boston." *The Magazine Antiques* 166, no. 5 (May 2006): 146–51.

Windsor Furniture

Windsor furniture appears in many historic displays, from parlors, chambers, and storage rooms to exterior settings such as gardens or piazzas. The varied settings for the furniture mirror its varied uses throughout the eighteenth and nineteenth centuries. Visitors often are interested in Windsor furniture. They recognize the basic forms and understand the furniture's comfort and convenience, which suggests an important interpretive point. Unlike high-style objects, Windsor furniture was part of the material lives of many people in the colonies and new republic. It represents a design tradition successfully filling diverse needs over a long period of time.

Windsor chairs probably evolved between 1710 and 1720 in England and were imported to North America by the late 1720s. Examples are documented in Philadelphia and Charleston, South Carolina, in the mid-1730s. The most significant differences between Windsor chairs and other chairs are that the seat is made of a single plank of wood and that the stiles, or uprights, of the back and the back legs are separate members attached to the seat, not continuous pieces of wood. The bottom of a Windsor chair seat has four drilled holes for the legs. The top of the seat has holes that support the back structure. This is called stick-and-socket construction.[1]

LOOKING AT WINDSOR FURNITURE

Visitors often admire the light, delicate proportions of Windsor furniture, emphasized through repetition of the vertical lines in the spindles and legs. Color and ornament, especially painted decoration, may also catch a visitor's eye.

Proportion

The construction of Windsor furniture, with delicate turned elements socketed into a solid seat, presents an image of voids bounded by thin lines. The solid plank seat does not detract from this impression, since it is often modeled on the top surface, to form a more comfortable seat, and chamfered (beveled) around the sides to leave a narrow edge. The spindles, thin bow back, and thin front edge of the seat on a bow-back chair made between 1775 and 1800 highlight the delicate proportions (fig. 10-1).

Some Windsor chairs, especially those dating after 1800, have crest rails, slats, or spindles with larger dimensions. The medallion or tablet between the cross rods—called a "double bow" at the time—as well as the seat with flat edges and the turned bamboo-style legs emphasize the solid rather than voided space on a side chair made between 1802 and 1812 (fig. 10-2). The chair appears heavier in proportion than the bow-back chair. The shift in focus from the sculptural quality of the eighteenth-century Windsor to the heavier proportions and broad, flat surfaces of the nineteenth-century Windsor was influenced by an emphasis on painted ornament.

Line

The distinctive lines of the various back structures and splayed legs often attract attention to Windsor chairs. These strong vertical members effectively balance the curves and horizontal lines of the crest, seat, and arm rails. The bow-back armchair has a narrow rail that extends from one rear side of the seat to the other, containing the back spindles and leading the eye in a continuous arch over the chair back. The continuous-bow Windsor, with its back arch ending in delicate arms, is perhaps the best example of trim proportions and contrast of vertical and curved lines (fig. 10-3). The splayed effect of the leg and stretcher construction produces not only a stable chair but also an impression of verticality, leading upward toward the spindles.

Curved and horizontal lines balance the sense of verticality. They appear in the swelled or vase-shape turnings on the legs or arm supports, as seen in figure 10-1. The chair in figure 10-2 exemplifies the balance of horizontal and vertical lines. The flat-edge seat with little surface modeling and the double-bow crest interrupts the vertical legs and spindles. The continuous back and arm rail of bow-back and continuous-bow

the lines of the crest rail or seat to various elaborate pictorial decorations. In 1804, for his new, fashionable federal-style house in Kennebunk, Maine, George Washington Wallingford had "1 dozen black windsor chairs, ½ doz. yellow windsor chairs, and 3 black yellow-striped windsor chairs."[3] Tablets between the stiles of some chairs provided surfaces for decoration, with compositions of flowers and fruit, especially grapes, being popular.

Ornament

The ornament on unpainted Windsor furniture derives from the shape of turned and shaved spindles, stretchers, crest rails, and arms. The ornament on painted examples often includes gilt and accents in

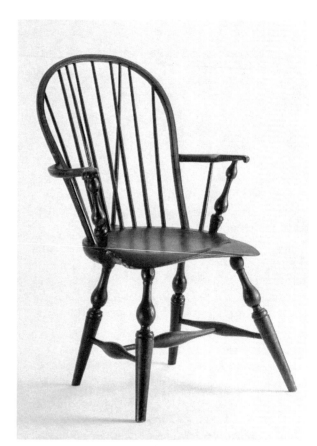

FIGURE 10-1. In order to construct this bow-back Windsor, the craftsman needed to understand the properties of the different woods that would best serve his needs in producing robust turnings and the curves in the seat. Two bracing spindles strengthen the back. (Bow-back Windsor armchair, attributed to Samuel Hemenway, Shoreham, Vt., 1790–1800. Soft maple, oak, hickory, black cherry; H 36½ in., W 22¾ in., D 24⅓ in. 1959.1632 Winterthur Museum, bequest of Henry Francis du Pont.)

examples also draw the eye away from verticality, as does the modeling of the plank seats to form D shapes, shield shapes, or ovals.

Color

Today many Windsor chairs show the grain and "natural" color of the wood, which appeals to modern eyes but was not the original intent. Finishes covered any color differences in the various woods in seats, spindles, and legs. The child's chair retains some of its original straw-color paint with dark paint highlighting the grooves in the bamboo turning (see fig. 10-2).

Customers ordered their chairs painted yellow, black, blue, white, red, brown, or the traditional green, and some were covered completely. Green was so common a color that in the eighteenth century, Windsors were known as "green chairs."[2] Painted decoration ranges from simple stripes emphasizing

FIGURE 10-2. This square-back chair with a medallion or tablet decoration still has some of its original straw-color surface paint. Some parts of the decorative painting also appear to be original, particularly the dark paint in the grooves of the bamboo turning. This child's chair, like others made at the time, was based on chairs made for adults. (Square-back Windsor side chair, Delaware River Valley, 1802–1812. Yellow poplar, maple, oak, hickory; H 28 in., W 13 9⁄16 in., D 12¾ in. 1958.120.5 Winterthur Museum.)

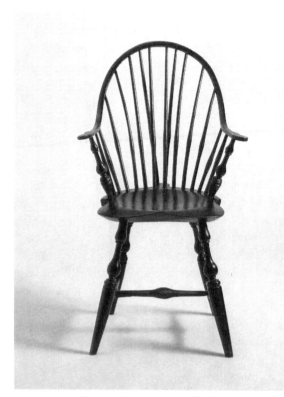

FIGURE 10-3. The continuous-bow Windsor armchair was a popular design in Rhode Island, New York City, and Connecticut. Craftsmen in the Tracy family of Connecticut developed graceful chair forms that demonstrate their skills in turning elaborate spools, rings, and baluster spindles. Note the tab seat projection with the added spindles supporting the back. (Continuous-bow Windsor armchair, Ebenezer Tracy Sr., Lisbon Township, New London County, Conn., 1790–1795. White oak, chestnut, soft maple; H 38¼ in., W 23⅓ in., D 21¼ in. 1961.502 Winterthur Museum, bequest of Henry Francis du Pont.)

bright hues. Swells, decorative turnings, and carved crest and arm ends decorate many eighteenth-century Windsor chairs. Swells in side stretchers served not only a decorative but also a utilitarian purpose by providing space for socketing the cross stretcher into the side stretchers (see fig. 10-1). Turnings on legs, stretchers, and arm supports often include vase and ring shapes. Legs have various turned ends, including balls, tapers, and other shapes, such as the tapered cylinders on the feet of a high-back armchair made in Philadelphia (fig. 10-4). This chair also shows how some Windsors gave chair makers an opportunity to include volutes, or spiral shapes, and carving on the crest rails and arms.

The variation in proportion, line, color, and decoration of Windsor furniture reflects the different forms that were fashionable at different times. Windsor chair designs changed over the years, and it is

possible to determine when various styles went in and out of fashion.

THINKING ABOUT STYLE

Windsor chair makers developed visually pleasing products. The earliest examples made in the English colonies were tall, bulky, and painted green in the English fashion. By the 1750s, chair makers produced both high-back and low-back versions. The high-back chair has a tall, comb-like back; the horizontal crest is supported by spindles that rise from the seat through a curved rail that extends to form the armrests and matches the edge curve of the shaped seat. Low-back Windsors were probably introduced a few years after the high-back chair (fig. 10-5).[4] The usual one-piece, steam-curved rail was not strong enough to support the weight of the user of a low-backed chair, however, so a U-shaped rail, combining a backrest and arms, was often made of three pieces of sawn wood.

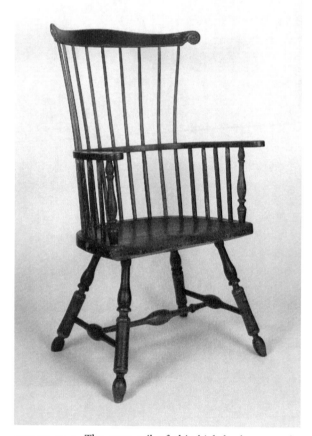

FIGURE 10-4. The crest rail of this high-back or comb-back Windsor armchair is ornamented with carved volutes. Traces of reddish-brown and black paint remain, providing evidence of the original appearance of the chair. (High-back Windsor armchair, Philadelphia, 1765–1770. Hickory, oak, poplar, maple; H 43 in., W 25¼ in., D 26 in. 1959.1612 Winterthur Museum, bequest of Henry Francis du Pont.)

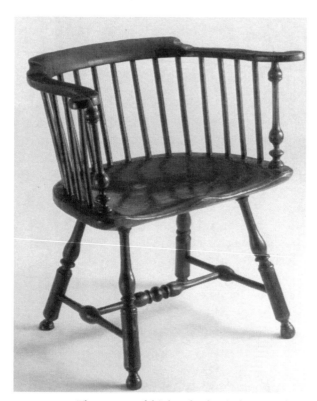

FIGURE 10-5. The turners of this low-back Windsor armchair created dramatic arm supports with a shaft-bulb-and-spool design. Also adding drama are the flat, ogee-curved arms that flare out. They were cut from three pieces of wood. (Low-back Windsor armchair, Philadelphia, 1758–1765. Oak, red maple, poplar; H 27¾ in., W 28⅓ in., D 17 in. 1964.1526 Winterthur Museum, bequest of Henry Francis du Pont.)

Although English Windsor furniture was an important influence on the design of Philadelphia Windsor chairs, elements of American-made joined and turned chairs are also evident. Like their English prototypes, early American Windsor chairs have D-shape seats with blunt edges, bent arm rails, and turned front arm supports. The seats are chamfered at the bottom edge, which visually reduces the bulk of the seat while retaining necessary thickness for the drilled leg holes. The leg and stretcher plan, however, was adapted from chairs with a rush seat and lathe-turned front and rear posts that were popular in the Delaware Valley. Early American Windsors have ball feet, and H-plan stretchers unite the legs. The serpentine cresting rail with carved scrolls at the ends was inspired by joined Queen Anne and Chippendale-style chairs.[5]

In the 1760s, Philadelphia chair makers introduced changes in their high-back Windsors that reflected changes in English Windsor design at midcentury. Although the tall back was retained, the proportions were slimmed and the seat became shield-shape rather than O-shape. By the late 1760s, tapered feet replaced

ball feet, a change that increased structural strength and shortened production time.[6] Some models have curved arm supports, an English influence.

Introduced before the Revolutionary War, the sack-back armchair was the next model to appear (fig. 10-6). This chair featured an oval seat and a round back with long spindles of different lengths above the arm rail and enclosed within the arch of a bent bow.[7] Chair makers produced this chair type in many regions of the new nation. Chairs from Philadelphia have a solid stance without much splay to the legs. Robust turnings are characteristic of New York chairs (fig. 10-7). Legs made in Boston often have a bulge where the stretchers enter the legs. Pennsylvania Germans sometimes introduced a deep, narrow curve in the bow, a long overhang to the arms, different turning patterns at the termination of front and back legs, and a thicker seat.

By the 1780s Philadelphia Windsor chair makers had introduced yet another design, the fan-back side

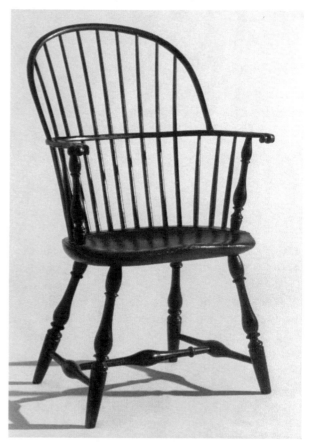

FIGURE 10-6. Joseph Henzey developed his own distinctive style by turning slightly bulging rings, large flaring spools, and elongated baluster elements. He branded "I. HENZEY" on the bottom of the seat of this chair. (Windsor sack-back armchair, Joseph Henzey, Philadelphia, 1770–1785. Oak, poplar, hickory; H 39¹⁄₁₆ in., W 25¼ in., D 16½ in. 1987.19 Winterthur Museum purchase with funds provided by Collectors Circle and Russell Ward Nadeau.)

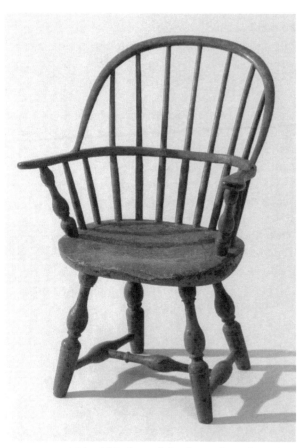

FIGURE 10-7. This child-size sack-back armchair shows evidence of several paint layers, including red, black or dark green, yellow, and cream. Note the deep, robust curves of the baluster turnings on the legs, a New York feature. (Windsor sack-back armchair, New York, 1785–1795. Tulip poplar, maple, paint; H 25 in., W 17⅞ in., D 16¾ in. 1986.3 Winterthur Museum.)

chair. They began to call Windsor side chairs "dining chairs," and their small size compared to Windsor armchairs fit well around a dining table. Chair makers throughout New England copied this style.[8] The bow-back pattern, introduced in Philadelphia about 1785, was the first Windsor model to be produced as both an armchair and a side chair. Legs and stretchers were often turned to simulate bamboo. In the late 1790s, a square, shield-shape seat with a central depression and usually a beaded edge replaced the contoured seat with a pommel (a raised area at center front). Sometimes these bow-back chairs were painted a pale straw color to further imitate bamboo, with grooves accented in a different color.[9]

The 1790s were years of innovation in Windsor seating design. Boston craftsmen, for example, offered a curved stretcher as an option on a bow-back Windsor. A tall-crested, canted-back chair was produced in New England, especially in southeastern Massachu-

setts; the chair was designed for relaxation and would not have been comfortable for use at a desk or table.

In New York City, chair makers developed the continuous-bow Windsor chair. The design of the curved back probably was influenced by an upholstered chair with curved arm and back construction called a bergère. At least eleven New York City chair makers have left documented examples of this design, which was also made in Connecticut and Rhode Island (see fig. 10-3).[10]

In the late 1790s, some Philadelphia craftsmen made Windsor chairs with pierced slats reminiscent of a joined mahogany chair made at about the same time. At extra cost, mahogany arms replaced painted armrests. A stuffed or upholstered seat was another option. The most favored seat coverings for Windsors were leather and wool moreen, a strong fabric with a glossy or moiré finish in colors that complemented the paint color on the chair. Some Windsors with stuffed seats cost as much as fashionable mahogany federal-style chairs.[11]

As the nineteenth century began, the demand for painted seating furniture continued to increase. American chair makers responded with new models and expanded production in volume and scope. Philadelphia chair makers introduced a square-back Windsor, which "dominated design until the mid nineteenth century." The first ones had a single-rod crest across the back (fig. 10-8); a double-rod crest followed (see fig. 10-2). Sometimes a decorated tablet stood between the posts. Within months, the new square-back style had become popular throughout the Delaware Valley and was introduced at other chair-making centers along the eastern seaboard.[12]

The double chair was first made in America in the mid-eighteenth century. In 1754 Philadelphia chair maker Jedidiah Snowden billed a customer for "2 double Windsor chairs with 6 feet & stretchers answerable."[13] His double Windsor chair would be called a settee today. After the War of 1812, chair makers outside of Philadelphia challenged the city's primacy as the center of Windsor design and began to use a variety of design sources. Design books and price lists became available, and chair makers also drew inspiration from stylish joined chairs. About 1812, New York chair makers introduced the arrow spindle, then known as the flat stick. The arrow design related to the urn shape so ubiquitous in federal furniture design. In another innovation, chair makers attached front, back, and side stretchers directly to the chair legs, forming a boxlike undercarriage

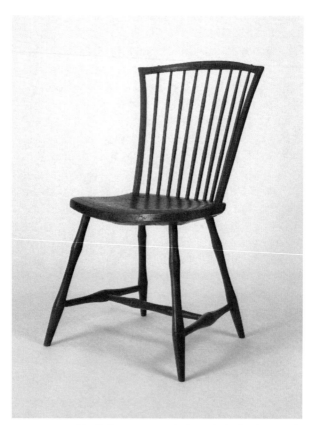

FIGURE 10-8. Until about 1800, Windsor chairs had a round-back design. Then a new-fashioned square back with a four-part bamboo leg design quickly became more popular. This chair combines the new back with the older, three-part leg design. (Square-back Windsor side chair, Philadelphia, 1798–1802. Yellow poplar, maple, hickory; H 34½ in., W 20½ in., D 15⅞ in. 1970.1359 Winterthur Museum, bequest of Henry Francis du Pont.)

(compare the stretcher construction in fig. 10-1 with the boxlike structure in fig. 10-2).[14]

By about 1815, the broad-slat crest rail was most popular because it provided space for decoration. About the mid-1820s, the roll-top chair was introduced, and soon after, chairs with scroll-front seats were available.[15] During the 1840s the crest with rounded ends became typical (fig. 10-9). As revival styles became fashionable, some chair makers returned to round-back Windsor styles.[16] Urban chair makers also occasionally produced eccentric designs. However, demand encouraged standard designs. Windsor design and construction techniques were used to make such forms as three-leg stools, cradles, and chairs with writing arms.

MAKING AND MARKETING WINDSOR FURNITURE

Makers of Windsor chairs were proficient in such woodworking techniques as turning, shaving, steam-ing, and bending. To make a Windsor chair, a crafts-

man first produced the turned and shaved parts, such as the legs or spindles. This was followed by shaping a seat from a thick plank of wood. He drilled holes in the top and bottom of the seat to receive the back structure and the turned legs. He was then ready to assemble the chair, using the legs, arms, and parts of the back, which he had either made or purchased from another craftsman.

Craftsmen used several different woods in making Windsor chairs. In the Mid-Atlantic region, yellow poplar often formed the seat. In New England white pine was common, but chair makers in Rhode Island and Connecticut also used basswood, chestnut, walnut, and butternut. Legs and stretchers were usually turned from maple, although in northern New England, birch was common. Spindles were shaved from billets of hickory, oak, or ash.

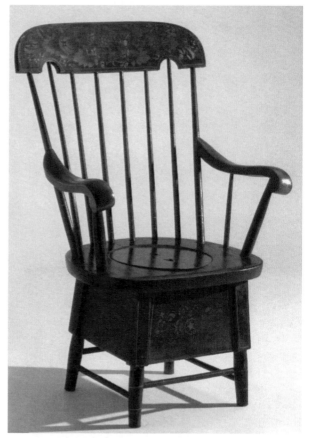

FIGURE 10-9. The owner of this armchair would have been pleased with its stylish graining patterns created by using red and black paint to imitate tortoiseshell on the crest rail with rounded ends. The rectangular box below the seat conceals the chamber pot, and the hinged door at the back allows the user not to be disturbed during its removal. (Commode Windsor armchair, New England, 1850–1865. Pine, maple; H 37¾ in., W 23¾ in., D 21⅓ in. 1979.70a,b Winterthur Museum, gift of Mrs. Wilmer E. Hansen.)

Paint covered these different woods. Until after the Revolutionary War, green was the most common color. Yellow hues, especially a pale straw color, began to gain popularity after 1806 (see fig. 10-2).[17] Many Windsor chairs in museums today no longer show original paint colors, which has been removed or covered with another color, often black or brown.

Inspired by imported Windsors, by the mid-1740s, chair makers in Philadelphia began to produce the chairs. By the late 1750s, craftsmen in Newport, Rhode Island, were making them, and New York City merchants had introduced a brisk trade in Philadelphia Windsors. By the Revolution, Philadelphia chair makers had begun to produce Windsor chair parts in substantial quantities and were shipping them as "knocked down" or "shaken chairs" to agents in other areas, particularly the coastal South and the islands of the Caribbean.[18] Standardization allowed chair makers to fill orders quickly and with modest expense. By the early 1780s, Windsor chair makers in Philadelphia had developed a side chair, priced considerably lower than the armchair. By the end of the 1790s, Americans bought more Windsor chairs than all other forms combined.[19] The bow-back side chair became the basic product of the trade at the end of the century because the simplicity of its design was suitable for mass production.[20] Fan-back side chairs usually sold in sets of six. In Philadelphia Windsor chairs were so common that their current prices regularly were reported on commodity market sheets.[21]

By the end of the eighteenth century, the Windsor chair was the choice of the American consumer, although price was of some consequence. Before the Revolutionary War, when a journeyman made about 4 or 5 shillings a day, a Windsor chair cost between 10 and 18 shillings. By comparison, a plain rush-bottom chair cost from 4 to 6 shillings, and a plain walnut joined mahogany chair cost about twice as much as a Windsor, at the top end of the price scale.[22] In the 1780s and 1790s, when the economy was on the rise, a set of six Windsor chairs cost about 9 dollars, the equivalent of nine days' pay for an average urban worker.

Well before the 1800s, Windsor furniture makers were using the same marketing techniques as other furniture craftsmen. Although direct, face-to-face transactions were most common until the 1840s, a chair maker could also consign his work to a ware-room, which was sometimes owned by an entrepreneur rather than a manufacturer. He could send his goods to an auction, storekeeper, agent, or merchant middleman, who would then sell them locally or ship them to foreign markets.[23]

LIVING WITH WINDSOR FURNITURE

Before the Revolutionary War, customers purchased high-back Windsor armchairs for restful seating, sometimes substituting them for easy chairs, and low-back Windsors for use at desks and writing tables. Many householders had Windsor chairs in nearly every room. At his death in 1736, Lieutenant Governor Patrick Gordon of Philadelphia owned five Windsor chairs, and during the 1740s an increasing number of English Windsors appeared in the probate records of other prosperous Philadelphians.[24]

Although old forms continued to be made and used, new models became popular after the Revolution. Buyers generally purchased the chairs in sets of six. With their rounded backs and lack of arms, the chairs were useful around dining tables. When Joseph Barrell, a Boston merchant, placed an order for chairs from New York in 1795, he wanted "18 of the handsomest windsor chairs fit for Dining and my Hall. I would have them with arms, rather less in the seat … than common, as they will thereby accommodate more at table. I would have them painted of light blue gray color, the same as my summer dining room. Let them be strong and neat."[25]

Men of the professions often owned writing-arm Windsors. Clergymen are the largest group of identified original owners, followed by physicians, public servants, and political figures. The writing arm was often covered with leather for a smooth surface.[26] One made between 1790 and 1803 that once belonged to George Thacher, a lawyer and judge of Biddeford, Maine, has a drawer under the arm. It is divided into three compartments, for inkwell and pens. A shelf below the bottom of the drawer slides out to expand the working space, and a second drawer is under the seat (fig 10-10).

CONCLUSION

Windsor furniture, together with rush-seat turned chairs, formed a basic category of seating furniture for many people during the colonial and early national period. Wealthy people placed Windsor chairs in halls, chambers, and gardens; people of the middling sort used them in halls and parlors. The typical stick-and-socket construction is still used today.

Windsor furniture offers an opportunity to interpret the material culture of larger numbers of people than, for instance, joined mahogany seating furniture, fine imported ceramics, or silver. Unlike many decorative arts objects on display in museums that symbolize the social distances people established between

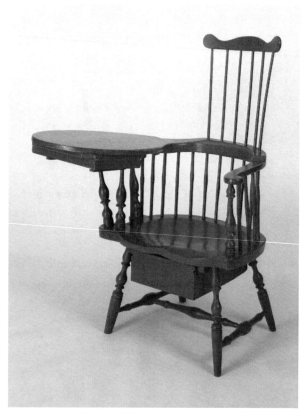

FIGURE 10-10. This comb-back writing armchair offers both comfort and convenience to its user. The maker turned several woods on a lathe for the construction; however, for the drawer he used dovetails to join the pieces of wood. (Writing Windsor armchair, Maine, 1790–1803. Oak, birch, pine; H 46⅓ in., W 37 in., D 32 in. 1955.15.2 Winterthur Museum, gift of Henry Francis du Pont.)

each other, Windsor chairs are objects that symbolize a shared material experience and the continuity of successful design.

NOTES

1. Evans, "Design Sources, Part I," 282; Evans, *American Windsor Chairs*, 13, 65.
2. Fitzgerald, 48.
3. Sprague, 118.
4. Evans, *American Windsor Chairs*, 81.
5. Evans, "Design Sources, Part I," 283, and fig. 5; *American Windsor Chairs*, 66, 81.
6. Evans, "Expert Opinion," 12.
7. Evans, *American Windsor Chairs*, 95.
8. Evans, "Design Sources, Part I," 284–88; *American Windsor Chairs*, 99.
9. Evans, *American Windsor Chairs*, 105.
10. Evans, "Design Sources, Part II," 293.
11. Evans, "Design Sources, Part I," 290.
12. Evans, "Design Sources, Part II," 1129; *American Windsor Chairs*, 135–36.
13. As quoted in Evans, "Design Sources, Part I," 284.
14. Evans, Design Sources, Part II," 1130–31; *American Windsor Chairs*, 146.
15. Evans, "Design Sources, Part II," 1133.
16. Evans, "Design Sources, Part II," 1142.
17. Evans, *American Windsor Chairs*, 201, 424.
18. Fitzgerald, 104.
19. Evans, *American Windsor Chairs*, 71.
20. Evans, "Expert Opinion," 12.
21. Evans, *American Windsor Chairs*, 71.
22. Evans, *American Windsor Furniture*, 68.
23. Evans, "Painted Seating Furniture," 56–157.
24. Evans, "Design Sources, Part I," 283; *American Windsor Chairs*, 65.
25. Fales, 90.
26. Evans, *American Windsor Furniture*, 45–52.

BIBLIOGRAPHY

Evans, Nancy Goyne. "The Aberrant Windsor." *Maine Antiques Digest* (February 1990).
———. "American Painted Seating Furniture: Marketing the Produce, 1750–1840." In *Perspectives on American Furniture*, edited by Gerald W. R. Ward, 153–68. New York: W. W. Norton in association with the Henry Francis du Pont Winterthur Museum, 1988.
———. *American Windsor Chairs*. New York: Hudson Hills Press in association with the Henry Francis du Pont Winterthur Museum, 1996.
———. "American Windsor Chairs: A Style Survey." *The Magazine Antiques* 95, no. 4 (April 1969): 538–41.
———. *American Windsor Furniture: Specialized Forms.* New York: Hudson Hills Press in association with the Henry Francis du Pont Winterthur Museum, 1997.
———. "Design Sources for Windsor Furniture. Part I: The Eighteenth Century." *The Magazine Antiques* 133, no. 1 (January 1988): 282–97.
———. "Design Sources for Windsor Furniture. Part II: The Early Nineteenth Century." *The Magazine Antiques* 133, no. 5 (May 1988): 1128–43.
Kassay, John. *The Book of American Windsor Furniture: Styles and Technologies.* Amherst: University of Massachusetts Press, 1998.

Additional Sources

Denker, Ellen Paul, and Bert Denker. *The Rocking Chair Book.* New York: Mayflower Books, 1979.
Evans, Nancy Goyne. "Expert Opinion: Nancy Goyne Evans on Philadelphia Windsor Chairs." *Auction Forum U.S.A.* (February 1990).
———. "The Genesis of the Boston Rocking Chair." *The Magazine Antiques* 123, no. 1 (January 1983): 246–53.

———. "A History and Background of English Windsor Furniture." *Furniture History* 15 (1979): 24–53.

Fales, Dean A. Jr. *American Painted Furniture.* New York: E. P. Dutton, 1979.

Fitzgerald, Oscar P. *Four Centuries of American Furniture.* Radnor, Pa.: Wallace-Homestead Book Co., 1995.

Santore, Charles. *The Windsor Style in America.* Philadelphia: Running Press, 1981.

———. *The Windsor Style in America.* Vol. 2. Philadelphia: Running Press, 1987.

Sprague, Laura Fecych, ed. *Agreeable Situations: Society, Commerce, and Art in Southern Maine, 1780–1830.* Kennebunk, Me.: Brick Store Museum, 1987.

Trent, Robert F. "Presidential Windsors!" *Winterthur Magazine* 38, no. 1 (Winter 1991–92): 17.

Clocks

THE TICKING OF A TALL-CASE CLOCK IN A MUSEUM provides a familiar sound. Because clocks supply the means of dividing days into measurable parts and synchronizing activities, visitors may assume that people of the past depended on clock time as we do today. Guides can use this familiarity and this fascination to explore how clocks and concepts of time affected behavior.

In colonial times, clocks were a luxury. They were the most complex mechanical devices some consumers could purchase. They were not as ubiquitous as they are in modern interiors or in some period displays. Visitors who wear watches with digital displays of hours, minutes, and seconds have different time perspectives than did eighteenth-century town dwellers, who heard the hourly bells of a public clock or saw a clock only in the home of a wealthy neighbor. Their rural counterparts may rarely have seen a clock.

Statistics on clock and watch ownership and value have not been thoroughly researched, but scholars estimate that one white adult in fifty owned a clock by 1700 and one in thirty-two owned a watch. Owners tended to be merchants, professionals, and others engaged in commerce. A study of four Connecticut towns where, in the 1790s, clocks and watches were taxed indicates that even by the end of the century perhaps only one or two people in one hundred owned more than one timepiece.[1] The tax indicates that assessors considered the objects to be assets.[2]

This chapter suggests ways to look at clocks as evidence of attitudes toward time, which is a complex topic. Two sections, "Looking at Clocks" and "Thinking about Style," concentrate on tall clocks. The information will help visitors become familiar with clocks, their designs, and workings. For someone who measured time's passing by looking at such an imposing piece of furniture, what did time mean? Generally accepted ideas about time in Western Europe and North America changed dramatically during the colonial and new republican periods.

LOOKING AT CLOCKS

The case and dial are two parts of a clock that are most easily seen in museum displays, and visitors most often notice their scale, proportion, material, and ornament. Looking at similarities and differences can lead to an appreciation of the skill and labor required to make a clock as well as the costs and rewards of owning one. Clockworks are less visible than cases and dials and are discussed in "Making and Marketing."[3]

Scale

The size of a tall clock may surprise visitors accustomed to today's miniaturized electronic clocks, but height has a distinct purpose (fig. 11-1). The clockworks in a case are regulated by the pendulum, which is approximately three feet long. The weights need room to descend their allotted length to keep the clock running for eight days, which was standard, or one day (thirty hours).[4] The clocks had to be tall. The scale of a tall clock contrasts with that of a wall clock, such as the "banjo clock" attributed to Simon Willard (fig. 11-2).

Proportion

The proportion of each section of a tall clock's case often resulted from a standard layout, with the hood section balancing the base. The extension of the cornices beneath the scrolled pediment visually increases the width of the hood to balance the width of the waist. A japanned tall clock with movement by Gawen Brown exemplifies a different proportional system (fig. 11-3). That clock has a broad waist with emphasis on the hood; the stepped sarcophagus top appears larger than the base. In a tall clock case by John Paul Jr. from Lebanon County, Pennsylvania, the center panel of the case is small in proportion to its broad, structural stiles and rails and indicates strong construction (see fig. 11-1). Revealing its decorative function, the proportions of the face of a French shelf clock are small in comparison to the statue of George

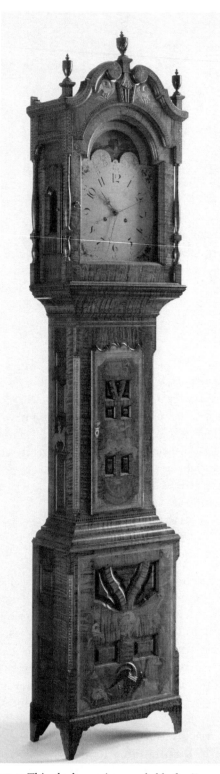

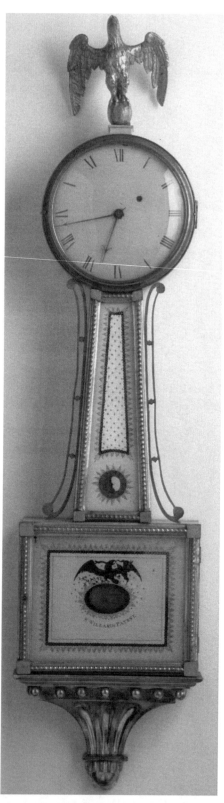

FIGURE 11-1. This clock case is remarkable for its ornamentation, which is executed in both inlay and carving. The figures include the date "1815" and the motto "Liberty." Men on horseback, an approximation of the state seal of Pennsylvania, and eagles are also major ornaments. (Tall clock, John Paul Jr., Elizabethville, Pa., 1815. Maple, walnut, tulip poplar, pine, ash, iron, paint, ivory, brass; H 98 in., W 20¾ in., D 10¼ in. 1958.2874 Winterthur Museum, bequest of Henry Francis du Pont.)

FIGURE 11-2. Simon Willard was granted a patent for the smaller-size movement in this clock in 1802. It took less labor and less brass and so was half the cost of a tall-case clock. (Clock, Simon Willard, Roxbury, Mass., 1805–1810. White pine, mahogany, brass, glass, gilt, paint; H 41½ in., W 10⅜ in., D 3¾ in. 1957.952 Winterthur Museum, bequest of Henry Francis du Pont.)

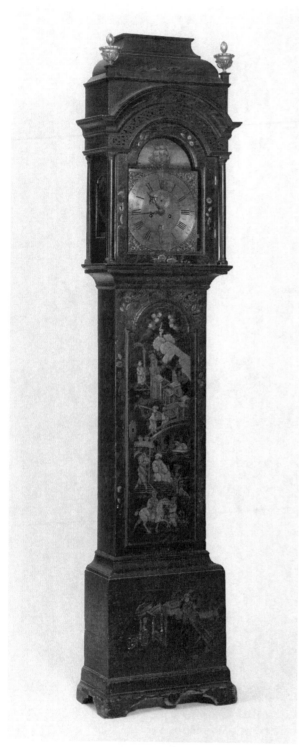

FIGURE 11-3. This clock has a stepped or "sarcophagus" top, in contrast to the scrolled top more familiar to modern viewers. In the first two decades of the 1700s, some furniture had stepped arrangements on the top for the display of fine china. The words "Brown Boston" are engraved on the chapter ring, which is the ring on the face on which hour and minute divisions are engraved. (Tall clock, Gawen Brown, Boston, 1745–1755. Pine, paint, gesso, gilt, brass; H 94½ in., W 22⅛ in., D 10⅝ in. 1955.96.3 Winterthur Museum.)

Washington and other sculpted symbols of America on either side of the face (fig. 11-4).

Material

Clock and case makers used metal, wood, and glass to construct clocks and cases. The dial on a clock by Edward Duffield includes steel hands, a silvered brass chapter ring (the ring on which the numbers are engraved), and cast-brass spandrels (the decoration at the four corners of the clock face). The metal components indicate the range of metalworking demanded of a clockmaker (fig. 11-5). Wood encases many clocks in this period. The well-designed use of figured wood, as in John Paul Jr.'s elaborate case, can enhance visual appeal. Glass protects the dial and the works from dust that could prevent accurate timekeeping. On some wall and shelf clocks, painted glass is decorative as well as functional.

Ornament

The natural, abstract, and figured motifs ornamenting clock dials and cases are often similar to those found on case furniture, silver, and other objects (see individual furniture and metalwork chapters). For example, the case on the Gawen Brown clock is decorated with a japanned motif, as on numerous furniture pieces from the period. The tulips, vases, birds, and horse and rider seen on the clock by John Paul Jr. were inspired by his German American heritage as well as the eagles, banding, and sections of patera (fluted circular forms) on furniture in the federal style. Comparing and contrasting the techniques and motifs on clocks and furniture encourages close observation and offers interpretive opportunities.

Engraving, applied cast-metal decoration, and paint often ornament metal dials. The flowers, foliage, and rocaille (forms derived from artificial rockwork and shellwork in eighteenth-century fountains and grottoes) on a clock face made by Duncan Beard compares with rococo ornament on furniture and silver (fig. 11-6). Spandrels, which are cast-metal decorations, can also be seen in the corner of the Beard clock face. Paint eventually replaced metalwork as dial decoration, as can be seen in the painted dial that ornaments a tall clock made by Daniel Oyster in Reading, Pennsylvania (fig. 11-7). Figures of the four seasons fill the corners of the face, where cast and applied leafy spandrels might have decorated an earlier clock. A spread-wing eagle can be seen in the space between the moon faces; a more traditional choice would have been gold stars on a blue background. Ornament can lead to interpretive

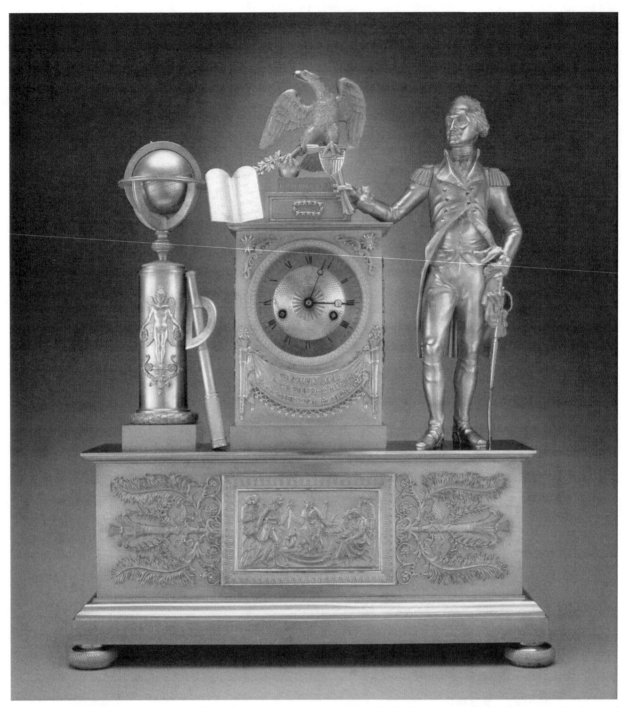

FIGURE 11-4. The engraving on this clock appeals to American patriotism. We find the words "July 4th 1776 the Birthday of Liberty" on the book; "America, the Asylum of the oppressed" on the sides; and "Washington First in War, First in Peace, First in the Hearts of his Countrymen" on the swag. The Marquis de Lafayette is reputed to have purchased one hundred of these clocks to give to fellow officers. (Shelf clock, Jacques Nicolas Pierre François Dubuc, Paris, 1815–1819. Brass, iron, glass, gilt brass; H 20¼ in., W 18⅓ in., D 6 in. 1957.744 Winterthur Museum, bequest of Henry Francis du Pont.)

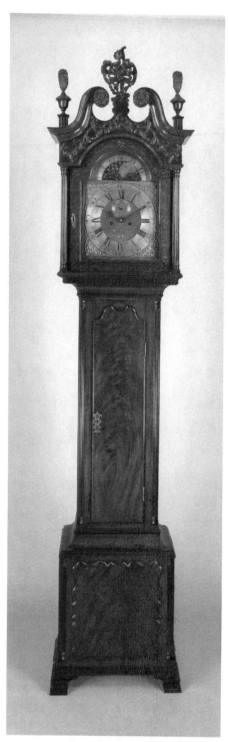

FIGURE 11-5. Benjamin Franklin requested that Edward Duffield make a clock for the public, which hung outside Duffield's shop from the 1740s until the Revolutionary War. From 1762 to 1775 Duffield was appointed Keeper of the Clock in Philadelphia, in recognition of his skills as a clockmaker. This was indeed an honor in a city well respected for its men of letters and sciences as well as its artisans. (Tall clock, Edward Duffield, Philadelphia, 1765–1775. Mahogany, chestnut, oak, pine; H 122½ in., W 24¼ in., D 12 in. 1952.247 Winterthur Museum, gift of Henry Francis du Pont.)

discussions by illustrating the diverse skills needed to create a fine, functional clock.

THINKING ABOUT STYLE

The relatively few clocks that existed in American homes between 1640 and 1860 represent four broad style categories, each hinting at varying ideas of time and acceptance of mechanically measured time: the clocks in which the works may be seen; tall-case, weight-driven clocks; shelf and wall clocks; and small, decorative, spring-powered French clocks. As mentioned above, design elements connect clocks to other objects, especially furniture and metals, and to the concepts of style developed in the furniture chapters in this volume.

Before about 1700, a clock might have had a visible, complex mechanism that was regulated by a pendulum and driven by a weight. A clockworks without a case or a clock with glass panes revealed how wheels and pinions moved the hands and measured time. Europeans found clocks extraordinary and fascinating, and they became a metaphor for the world that functioned harmoniously, overseen by a powerful authority: a "clockmaker" God. In the centuries just before and during colonization, clocks demonstrated the new world of rationality as they taught that unfamiliar effects could be traced to concrete, observable causes.[5] The English philosopher Robert Boyle demonstrated this attitude in the early 1650s:

> When . . . I see in a curious clock, how orderly every wheel and other parts perform its own motions . . . , I do not imagine, that any of the wheels, etc. or the engine itself is endowed with reasons, but commend that of the workman, who framed it so artificially. So when I contemplate the action of those several creatures, that make up the world I do not conclude . . . the vast engine itself to act with reason or design, but admire and praise the most wise Author.[6]

Some works, originally uncased, were later installed in cases with glass panes on the sides and doors to reveal the workings. A bracket or table clock usually had glass on three sides to allow an observer to study the spring-driven works.[7]

The introduction of the pendulum in the late 1600s allowed for more accurate timepieces. Having noticed the equal amount of time spent by swings of a pendulum, Galileo Galilei began work on a pendulum clock. Christaan Huygens, a Dutch mathematician, published a treatise on the pendulum in 1648 and is credited as the inventor of the pendulum clock. A

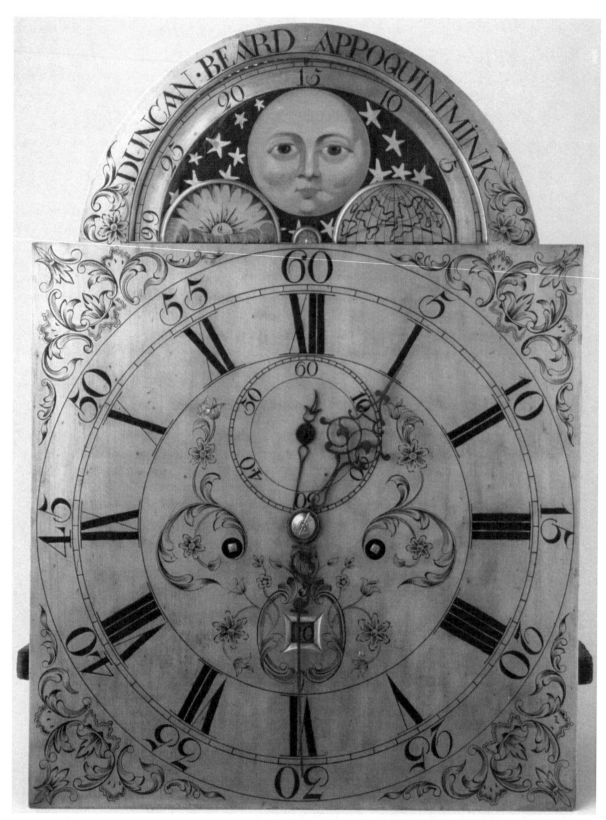

FIGURE 11-6. The name on this clock dial refers to the maker, Duncan Beard, not the owner, William Corbit of Odessa, Delaware. The clock still stands in the Corbit-Sharp House, owned by the Historic Odessa Foundation. The works include a gear that turns a wheel to show the date of the month. The dial also features the decoration of the starry firmament in the arch, a favored design. (Clock face, Duncan Beard, Delaware, 1770–1785. Brass, silver, gold; H 17⅜ in., W 12½ in. Clock case, Delaware Valley, 1770–1785. Mahogany, pine, glass, tulip poplar, pine; H 106¼ in., W 21½ in., D 11¼ in. 1973.119 Winterthur Museum, gift of Mrs. Earle R. Crowe.)

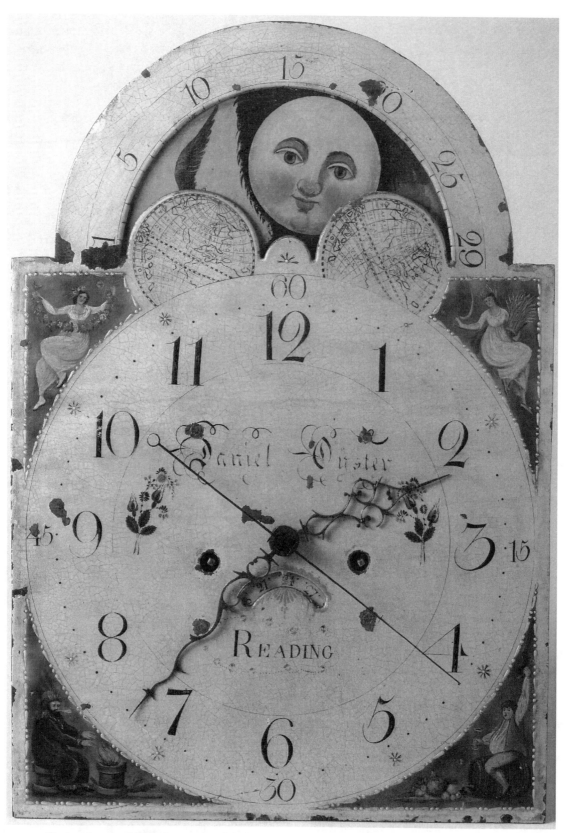

FIGURE 11-7. Clockmakers could purchase painted dials, made of sheet iron and decorated by an ornamental painter, from a supplier in a city. The dials could be made locally or imported from Birmingham, England. The name Daniel Oyster, the clockmaker, is painted on this dial. (Clock face, possibly Birmingham, Eng., 1790–1800. Iron, paint, brass; H 18⅝ in., W 13¼ in. Clock case, Pennsylvania, 1790–1800. Walnut, pine; H 97⅜ in., W 21⅝ in., D 10⅝ in. 1959.2807a,b Winterthur Museum, bequest of Henry Francis du Pont.)

similar development, the balance spring, brought accuracy to watches.[8]

Clocks then became large pieces of furniture, a second general stylistic grouping. Wooden cases enclosed and protected the works and pendulums.[9] Although tall clocks appear ornate to modern eyes, the wooden cases were simple compared to Renaissance clocks made for the nobility, works of art in themselves. Wooden-case clocks displayed hours and minutes, necessary information in the centralized, commercial activities of governments of late seventeenth-century England, Holland, and France. Especially in England, people began to perceive a clock as a timepiece rather than a mechanical representation of universal movement.[10]

As the seventeenth century unfolded, clocks became more accurate and less complex; they also became less expensive but remained out of the reach of most people. With the possible exception of prosperous urban artisans, clocks were owned mainly by merchants, professionals, and civic leaders.[11] These were the people whose work required schedules and synchronization before private ownership of clocks was widespread.[12]

Dating from the early 1800s, American-made shelf and wall clocks constitute a third group and represent shifts in the look of clocks and in attitudes toward time. Smaller in scale and more portable than tall-case clocks, these newer versions expanded the market in America. They could be produced in quantity at reasonable costs. The "banjo clock" manufactured by Simon Willard represents this group (see fig. 11-2).

Mantel clocks made in France form a fourth group of clocks used during the time of the colonies and young republic. With elaborate, sculptural cases of stone (especially marble), gilded brass, and sometimes enamel, they revealed French preferences for clocks with nonwooden cases and neat, unobtrusive movements that integrated well with interior decoration. Clocks with figures were dominant in France by the 1790s and continued to be fashionable through the 1820s. Cast, chased, and gilded, the figures and other ornament were the most costly part of the object (see fig. 11-4).[13] French clocks did not focus attention on the face; they emphasized the object as a work of art as well as an example of regular, harmonious cooperation in a complex system. Through the early 1800s, the world-as-clockwork metaphor was used by French politicians and intellectuals to express their general concept of social order that insisted on a central authority to regulate political and economic activities. The philosopher Voltaire wrote: "All things are machines merely; everything in the universe is subjected to eternal laws. . . . [W]e are only wheels to the machine of the world."[14] In contrast, other rulers and philosophers, especially in England, found the clock metaphor less applicable to their developing ideas of freedom in the marketplace and liberty in political order.[15]

In addition to representing attitudes toward time, clock styles often relate to current fashionable and regional furniture styles and design preferences. For example, clockworks made by Edward Duffield are housed in cases that rival the decoration and workmanship on other examples of Chippendale or rococo-style case furniture (see fig. 11-5). Duffield's case has carving on the hood and a well-placed figure in the mahogany grain of the door. A cartouche similar to those on high chests probably ornamented the pediment center. The hood and its base molding are typical of Philadelphia work in this style.[16] Some Philadelphia-made cases had scrolled pediments that ended in rosettes, flame finials, and quarter columns flanking the waist and base—all elements found on Philadelphia-made high chests of the same period.

Federal or early classical-revival-style cabinetwork encases movements attributed to George Hoff Jr. of Lancaster, Pennsylvania (fig. 11-8). Hoff used zebrawood, ebony, and satinwood for federal-style line inlays and crosshatched string inlay.[17] Such work is characteristic of Baltimore, a center of fine furniture making at the turn of the century.[18] Hoff made his clocks in an area of Germanic settlement, but the works are set in a case that rivals the best work of English-influenced craftsmen. Other Germanic clockmakers or their customers chose to make or use cases that integrated both German and English traditions. One was John Paul Jr. in Dauphin County, Pennsylvania. He made a clock case that is an impressively skilled combination of color, decorative woodworking techniques, and figured wood (see fig. 11-2). Strong construction created heavy proportions on clock cases influenced by Pennsylvania German techniques, as evident in the raised, shaped panels.[19] The masterful use of inlay on Paul's clock exemplifies the high-quality work of Germanic artisans.[20]

Clock dials show stylistic progression through the 1700s. The composite dial, made up of several parts, was used into the 1780s.[21] A clock made by Edward Duffield is an example (see fig. 11-5). The dial plate was cast and beaten brass, with the hour numbers engraved on a separate, silvered-brass circle called a

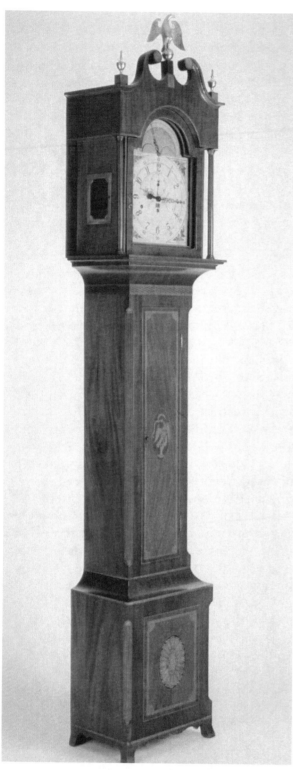

FIGURE 11-8. In addition to striking the hour and quarter hour, this clock has a set of eleven musical bells that play seven tunes. In the early history of timekeeping, town clocks would strike, informing all of the time. This clock crosses into the realm of sound purely for pleasure. (Tall clock, George Hoff Jr., Lancaster, Pa., 1800–1816. Mahogany, mahogany veneer, pine, zebrawood, satinwood; H 107 in., W 20¾ in., D 15½ in. 1957.1026 Winterthur Museum, bequest of Henry Francis du Pont.)

chapter ring. Cast-metal spandrels often decorated the four corners of the dial. Characteristic of the 1720s and 1730s, the center was often engraved to impart a matte appearance.[22] Duncan Beard of Appoquinimink, Delaware, engraved his dial a half century later on a single sheet of silvered brass (see fig. 11-6). Appearing between about 1760 and 1770 and disappearing about 1800, such dials had a short life in the Philadelphia area.[23] Especially after 1800, painted iron dials, many imported from England, competed with engraved dials of either the composite or single-sheet type.[24] Until about 1800, all of these dial types marked the hours with Roman numerals.[25]

Clock styles varied, but they all exhibited the diverse skills of brazier, engraver, pewterer, iron founder, ornamental painter, cabinetmaker, and mathematician. Sometimes these skills resided in one person. At other times, the work of several artisans appears in one clock.[26]

MAKING AND MARKETING CLOCKS
American clockmakers in the eighteenth and early nineteenth centuries faced challenges that ranged from applying mathematical theory to casting metal parts and working with wood. They were masters of some skills but usually depended on others to supply talent or parts. Influenced by the prospect of expanding their markets, some clockmakers in the early 1800s adopted new manufacturing techniques and methods that emphasized mechanical prowess, cooperation, marketing, and modernization.

Clockwork Mechanisms

An understanding of the wheels, gears, and pulleys that measure time is best developed by studying working movements. At most museums, however, visitors must admire the clockworks from a distance, often with an incomplete appreciation.

Clockworks vary from a simple recording of hours and minutes to complex varieties such as the Hoff works that record hours, minutes, seconds, days of months, and stages of moons as well as striking quarter hours and even playing one of seven tunes every hour. Because a clockwork had to move in a controlled, measurable way, a tall clock had weights, pendulum, and an escapement that regulated a release of energy or power to move the hands. Even a complex clock depended on these components.

The falling of a weight provided energy to move the works. Gravity, therefore, powered tall clocks. The uncoiling of tightly wound springs released energy

to power other clocks and watches. Released energy, however, had to be controlled. Working together, a pendulum and escapement rationed the energy, transmitted it to the gears that ran the clock, and turned it into regular, countable beats that allowed the clock to measure time. Exactly how the pendulum and escapement worked together is best understood by direct observation. As a weight fell, it moved the toothed clock wheel. Above the wheel was a small metal piece that looked like two barbed ends (flukes) of an anchor; one fluke and then the other regularly engaged and disengaged a tooth of the wheel. The rotary pressure exerted by the teeth of the escape wheel kept the anchor oscillating. The length of the pendulum governed its oscillation and, thus, the clock's speed.[27]

The easiest evidence of an escapement for a visitor to see is often a second hand on a tall clock. The movement of the hand, often forward, then slightly back, then forward, demonstrates the movement of the anchor-recoil escapement, as the fluke, engaging with a tooth on the wheel, not only stops the wheel but causes it to move backward slightly; hence the name "anchor-recoil." Some tall clocks ran by a variant escapement, a "dead beat." The dead beat, using a crown wheel escapement, eliminated the slight backward movement of an anchor-recoil escapement.

Through arrangements of gears, called "trains," the regular movement of an escapement measured time on a clock face. A train connected wheels (gears with sixteen or more teeth) and pinions (gears with fewer than sixteen teeth) to perform a specific function. The timekeeping train of wheels and pinions, a "going train," transmitted driving power to the escapement of a clock. The wheels and pinions of a "striking train" controlled the striking of a clock.[28]

The clockmaker's challenge was to devise gear trains to make regular movements perform different operations.[29] A clock face, for example, may have had three hands: hour, minute, and second. In addition, it may have shown the day of the month, the phases of the moon, and, sometimes, tidal movement. Each of these operations required a gear train that usually operated from the main, "going" train. In addition, a clockwork that included sounds, regular striking, or sometimes music required additional trains. By looking at a clock face and counting the functions, an observer can determine the complexity of the works.

Making Clocks

The term *clockmaker* can identify a person with well-developed skills in both woodworking and met-

alworking. Nathaniel Dominy IV of Long Island was a rural clockmaker who relied on artisans in his own shop to produce both case and works. Daniel Burnap of East Windsor, Connecticut, was a skilled engraver and probably specialized in metalwork. Records indicate that Burnap made clock dials for less-skilled clockmakers, and although he hired journeymen to do his woodworking and purchased cases made by cabinetmakers, he owned a box of joiner's tools himself and may have known how to use them.[30]

Clockmakers often depended on fellow artisans or manufacturers to supply parts. One New York clock, an excellent example of the cooperative business arrangements possible in an urban artisan neighborhood, was signed by four artisans.[31] In 1789 Thomas Pearsall and Effingham Embree made and sold the clock with a engraved dial signed by James Berry, another New York clockmaker, who did the engraving. The clock also has a cast-brass bell that is signed by John Youle, a brass founder in the neighborhood. In southeastern Massachusetts in the late 1700s and early 1800s, members of the Bailey family made clockworks but could have purchased dials from a supplier who sold Boston-made or British painted sheet-iron dials, contracted with a cabinetmaker for cases, purchased inlay from one urban supplier and metal hardware from another, and sought still other skills if the case needed decorative painting.[32] Clockmaking and selling involved an intricate set of transactions. Many clockmakers sought works and parts from far afield. Metal hardware, for example, was a standard category of goods imported from England, both before and after the Revolutionary War. Simon Willard used dials made by James Wilson of Birmingham, England, for tall clocks.[33] He also bought metal disks from Boston brass founder William Hunneman; from these he cut his own gears.

Partly because of the complexity of the work, a clockmaker's output was limited. A typical clockmaker in about 1760 made twelve to twenty tall clocks a year. By 1860 a New England manufacturer produced about 150,000 shelf clocks a year.[34] To increase output so dramatically, clock entrepreneurs took several important steps. They designed small, inexpensive, more transportable clocks that rivaled tall clocks in popularity. Simon Willard's fame derives from this accomplishment. They also experimented with applying machines and waterpower to clock manufacture, an achievement connected with Eli Terry and his clocks with wooden works.

Simon Willard and his brother Aaron were prolific, successful clockmakers from the late 1700s through

the first half of the 1800s in Roxbury, near Boston. Their major contribution was the design of small, functional clocks that used short pendulums. Simon's most memorable contribution was patenting his "improved timepiece," popularly called a "banjo clock," in 1802. His redesigned pendulum and weight arrangement allowed the pendulum to be secured when the clock was moved, the dials were clearly readable, and cases ranged from simple to elaborate. The banjo clock became popular immediately.[35] An example attributed to Willard is decorated with white paint over mahogany and reverse painting on glass done by Aaron and his brother-in-law, Spencer Nolen, who were partners in Boston from about 1805 until 1809 (see fig. 11-2).

Affordability contributed to the popularity of the Willard-type clock. The rare purchaser of a tall clock in southeastern Massachusetts in the early 1800s paid as much as 35 dollars for a clock movement and dial. Encasing the clock added extra expense for a total of 60 dollars, which was out of reach for most people. Willard's timepiece, patented in 1802 and selling for 45 to 55 dollars, cost just 35 dollars within eleven years and 20 dollars ten years after that.[36] Economies of scale and efficiency may have accounted for these reductions, in addition to the general lowering of prices after the Panic of 1819. The sluggish economy may have prevented some consumers from taking advantage of the falling prices, but the Willard timepiece changed the market for the traditional cased clock.

Eli Terry and other Connecticut clockmakers changed the market for clocks again by the mid-1820s.[37] Terry's best-known product is a shelf clock, popularly called "pillar-and-scroll" and patented in 1816. His entrepreneurial success rests on his astute grasp of two related developments: powered machines that produced reliable, inexpensive parts and an existing market for dramatically increased clock production.[38] For Terry's clocks, water-powered machines cut wooden gears and dials in multiples. The dials were painted, sometimes by young girls who completed them as piecework at home, and the case was simple but strongly nailed and glued.[39] Terry's apprentice, Seth Thomas—another familiar name in clock manufacture in the United States—made clocks with movements and designs similar to Terry's.

Marketing Clocks

Eli Terry's generation greatly expanded the market for clocks in the United States. Before their era, clockmakers made and sold their products within their local communities, often for bartered goods, such as sawn lumber.[40] They also tapped into international trade routes for English clockworks, with materials arriving by way of the same import routes that brought textiles, other metal goods, prints, and ceramics to American ports.

Producing clocks at low cost and in quantity, Terry needed the rural markets beyond his Connecticut locale. Terry reported in the 1820 United States Census that with ten men and two women working, his company produced eleven hundred clocks annually. Peddlers provided Terry and other producers of small consumer goods with quantity marketing. Even if a peddler paid 10 dollars for a small wooden-cased clock and doubled his price to consumers, his price was still less than uncased tall-clock movements.[41]

In the early 1800s, more people owned more clocks than before and became familiar with dividing time into abstract, equal portions rather than depending on the less precise, natural divisions of time. With clocks, people synchronized and organized their activities and those of others by clock time. These were momentous changes with wide-ranging effects.

LIVING WITH CLOCKS

During the first hundred years of European settlement on North America's East Coast, few people lived with clocks. Although clock ownership increased after 1750, one study of owners in Connecticut in the 1790s and another of southeastern Massachusetts found that the objects were still not common.[42] Many, however, lived with the concept of measuring time and of using it to good advantage. In the late 1600s, diarist Samuel Sewall noted that he left Boston "Abt an Hour by Sun."[43] Public time in New England towns was measured by the ringing of bells, the beating of drums, the sounding of conch shell horns, or the call of watchkeepers.[44]

Clocks were major consumer expenditures, like fully furnished beds, looking glasses, large pieces of case furniture, and silver objects. One study of urban and rural Maryland and Virginia found timepieces to be luxuries, like pictures and silver.[45] Tax lists for four Connecticut towns in the 1790s showed that timepiece owners also owned silver, had fireplaces or large houses, or owned vehicles.[46] Owners were primarily affluent dwellers in towns or cities.

Other eighteenth-century inventories, however, show that nearly every Pennsylvania German home contained a clock.[47] Clock ownership was not reserved for the wealthy. But why was this so? German settlers came from an area where the art of clockmaking

was well established, and their ancestors, like other Europeans, found clocks fascinating representations of a well-regulated world. In the early 1700s, the English rejected the clockwork metaphor as they struggled with the idea and practice of political liberty and a checked-and-balanced government.[48] For the Germans, however, the idea of a "clockwork" state persisted into the early 1800s, when the French Revolution and the domination of Prussia by Napoleon I shook their confidence. Perhaps these contrasting associations influenced ownership in the two groups.

In general, clock ownership increased after 1750, but a clock remained a significant expenditure. Although late eighteenth-century families, eager to demonstrate their status, desired clocks, they could more easily acquire such smaller consumer goods as teacups, packets of tea, or prints.[49] By 1800, clock ownership increased further as members of the middle and lower economic groups could afford them, most of the wooden-gear variety.[50]

Wooden-movement clocks occupy one end of the spectrum available to consumers; French-made sculptural clocks are at the other end. As objects of significance, clocks received special treatment. For example, Simon Willard's banjo clocks, especially with white painted cases, were sometimes used for weddings gifts.[51] Prizing clocks for both sentimental and monetary value, owners usually displayed them in the public rooms with the major case furniture, the bedsteads, or the silver-plated objects. In an interior painted by John Lewis Krimmel in southeastern Pennsylvania in 1813, a tall-case clock graces the corner of the parlor, although stylistic evidence suggests that it might have been thirty or forty years old. Even the more widespread ownership of clocks did not immediately diminish their status as important household objects.

Owning or using a new kind of object can affect behavior, and clocks are excellent examples. Although people in Western European cities might have been accustomed to public clocks ringing the hours as early as the 1300s, not until the first half of the 1800s did widespread, private ownership of clocks allow many individuals to synchronize their activities.[52] The technical design of mass-produced clocks limited error to one minute per week; many today accept a similar margin of error.[53]

As factory owners regulated the work of their employees by the clock, they increased control of their workers' pace. A timetable for a Lowell, Massachusetts, textile mill scheduled morning, evening, and meal bells and stated that "the Standard time being that of the meridian of Lowell, as shown by the regulator clock of Joseph Raynes, 43 Central Street." To avoid question, the timetable states that "in all cases, the first stroke of the bell is considered as marking time."[54]

The Lowell Timetable suggests the next step required to synchronize activities: agreement on a standard time. As workplaces and commercial activities expanded in the 1800s and as railroads and telegraphic systems reduced the time necessary for travel and communication, efforts to agree on time increased. Railroads and steamship lines published schedules by 1840. After midcentury, celestial observations and time signals telegraphed from observatories allowed regions to operate on one time standard. In 1918 standard time was mandated by federal law. In this move toward greater dependence on the clock, scholars see a major change in Western attitudes toward time and work. As factory clocks tolled, work time and pay defined by a clock replaced work time and pay defined by task.[55]

CONCLUSION

Between the seventeenth and nineteenth centuries, the making, selling, and owning of clocks changed significantly. People who lived and worked along North America's eastern seaboard encountered three pivotal and interrelated changes: They became more aware of and attuned to clock-measured time; their work habits were governed more by clock time than by tasks; and they found clocks increasingly available and affordable. Although they are probably connected, no precise cause-and-effect relationship can be stated for such complex developments.

Clocks, whether in a museum or a historic house, offer outstanding interpretive opportunities. The clock dials and cases illustrate style choices made by early Americans who were influenced by their concepts of time, their knowledge of metropolitan tastes, and their traditions of workmanship and design. The diverse origins of some clock parts indicate the complexity of business and trade, even for an artisan in the era of handcrafted clocks. Clocks show the industrialization of consumer goods manufacturing, which affected not only ownership but also behavior.

NOTES

1. O'Malley, 23.
2. Soltow, 115.
3. Between 1690 and 1720, Joseph Lawrence adapted the works from an English twelve-hour clock for a thirty-

hour clock. The works were originally uncased, and the case we see today was made in the early 1700s. Lawrence's clock is now displayed at Winterthur (1963.625). This example highlights a potential source of confusion in studying clocks. The clockmaker's name often identifies these clocks, but that craftsman may not have worked on or ordered the case. In this essay, the clock and case will be referred to as one object made within the given date range. If specific information about the works and the case is available and important for interpretation, it is included.

4. Hohmann, 65.
5. Mayr, 26–27.
6. Boyle as quoted in Mayr, 232 n184.
7. La Fond, no. 9; no. 36.
8. Mayr, 14; Doggett, 77.
9. Doggett, 77.
10. Mayr, 13–15, 115–17.
11. Thompson, 67.
12. Hensley, 18–19.
13. Smith, 228–33; Edey, 63, 83.
14. Voltaire, as quoted in Mayr, 130.
15. Mayr, 14, 115–21, 122–40.
16. La Fond, no. 18.
17. La Fond, no. 22.
18. Montgomery, 200.
19. La Fond, no. 26.
20. La Fond, no. 22.
21. Bailey, 25.
22. La Fond, no. 10.
23. Bailey, 20.
24. Sullivan, 40; Bailey, 20, 53.
25. Bailey, 25.
26. Hummel, 220.
27. Landes, 365.
28. Mayr and Stephens, 47–49.
29. Bailey, 19.
30. Hoopes, 53–56.
31. La Fond, no. 10.
32. Sullivan, 40; Bailey, 53.
33. La Fond, no. 2.
34. Bailey, 27.
35. Foley, 2–9.
36. Sullivan, 40–41.
37. Sullivan, 41–42.
38. Hounshell, 51–57.
39. La Fond, no. 57.
40. Sullivan, 39–40.
41. Murphy, 174–84.
42. Soltow, 115–20; Sullivan, 39.
43. Hensley, 14.
44. Hensley, 11–12.
45. Golovin and Roth, 78–87.
46. Soltow, 115–17.
47. Garvan and Hummel, 91; Forman 148.
48. Mayr, 128–35.
49. Carr and Walsh, table 1, 80, 81.
50. Soltow, 116–21.
51. La Fond, no. 63.
52. Landes, 7, 73.
53. Smith, 316; Landes, 2.
54. "Timetable of the Lowell Mills, To take effect on or after October 21st, 1851," as quoted in O'Malley, 53.
55. Thompson, 58–60.

BIBLIOGRAPHY

Battison, Edwin A., and Patricia E. Kane. *The American Clock, 1725–1865: The Mabel Brady Garvan and Other Collections at Yale University.* Greenwich, Conn.: New York Graphic Society, 1973.

Fennimore, Donald L. *Metalwork in Early America: Copper and Its Alloys from the Winterthur Collection.* Winterthur, Del.: Henry Francis du Pont Winterthur Museum, 1996.

Hummel, Charles. *With Hammer in Hand: The Dominy Craftsmen of East Hampton.* Charlottesville: University Press of Virginia for the Henry Francis du Pont Winterthur Museum, 1968.

Landes, David S. *Revolution in Time: Clocks and the Making of the Modern World.* Cambridge, Mass.: Harvard University Press, Belknap Press, 1983.

Mayr, Otto. *Authority, Liberty, and Automatic Machinery in Early Modern Europe.* Baltimore: Johns Hopkins University Press, 1986.

Mayr, Otto, and Carlene Stephens. *American Clocks: Highlights from the Collection.* Washington, D.C.: Smithsonian Institution, 1990.

Additional Sources

Bailey, Chris H. *Two Hundred Years of American Clocks and Watches.* Englewood Cliffs, N.J.: Prentice-Hall, 1975.

Carr, Lois Green, and Lorena S. Walsh. "Changing Lifestyles and Consumer Behavior in the Colonial Chesapeake." In *Of Consuming Interests: The Style of Life in the Eighteenth Century*, edited by Cary Carson, Ronald Hoffman, and Peter J. Albright, 59–166. Charlottesville: University Press of Virginia for the United States Capitol Historical Society, 1994.

Doggett, Rachel. *Time, the Greatest Innovator: Timekeeping and Time Consciousness in Early Modern Europe.* Washington, D.C.: Folger Shakespeare Library, 1986.

Edey, Winthrop. *French Clocks: Collectors' Blue Books.* New York: Walker and Company, 1967.

Foley, Paul J. *Willard's Patent Time Pieces.* Norwell, Mass.: Roxbury Village Publishing, 2002.

Forman, Benno M. "German Influences in Pennsylvania Furniture." In *Arts of the Pennsylvania Germans*, by Scott T. Swank et al., 102–70. New York: W. W. Norton for the Henry Francis du Pont Winterthur Museum, 1983.

Garvan, Beatrice B., and Charles F. Hummel. *The Pennsylvania Germans: A Celebration of Their Arts, 1683–1850*. Philadelphia: Philadelphia Museum of Art, 1982.

Golovin, Ann, and Rodris Roth. "New and Different." Unpublished exhibition script. Washington, D.C.: National Museum of American History, August 27, 1988.

Hensley, Paul B. "Time, Work, and Social Context in New England." *New England Quarterly* 65, no. 4 (December 1992): 531–59.

Hohmann, Frank, III. *Timeless: Masterpiece American Brass Dial Clocks*. New York: Hohmann Holdings LLC, 2009.

Hoopes, Penrose R. *Shop Records of Daniel Burnap, Clockmaker*. Hartford: Connecticut Historical Society, 1958.

Hounshell, David A. *From the American System to Mass Production*. Baltimore: Johns Hopkins University Press, 1984.

Jobe, Brock, and Myrna Kaye. *New England Furniture: The Colonial Era*. Boston: Houghton Mifflin, 1984.

La Fond, Edward. "Catalog of Clocks in the Winterthur Collection." Unpublished manuscript, Joseph Downs Collection of Manuscripts and Printed Ephemera, Winterthur Library.

La Fond, Edward F., and J. Carter Harris. *Pennsylvania Shelf and Bracket Clocks*. Columbia, Pa.: National Association of Watch and Clock Collectors, 2008.

Machmer, Richard S., and Rosemarie B Machmer. *Berks County Tall-Case Clocks*. Reading, Pa.: Historical Society Press of Berks Country, 1995.

Montgomery, Charles F. *American Furniture: The Federal Period, 1788–1825*. New York: Viking Press, 1966.

Murphy, John Joseph. "Entrepreneurship in the Establishment of the American Clock Industry." *Journal of Economic History* 26, no. 2 (June 1966): 169–86.

O'Malley, Michael. *Keeping Watch: A History of American Time*. New York: Viking Penguin, 1990.

Smith, Alan, ed. *The Country Life International Dictionary of Clocks*. New York: G. P. Putnam's Sons, 1979.

Soltow, Lee. "Watches and Clocks in Connecticut, 1800: A Symbol of Socioeconomic Status." *Connecticut Historical Society Bulletin* 45, no. 4 (October 1980): 115–22.

Sullivan, Gary R. "Clockmaking in Southeastern Massachusetts: The Bailey Family of Hanover." In *Harbor & Home: Furniture of Southeastern Massachusetts, 1710–1850*, by Brock Jobe, Gary R. Sullivan, and Jack O'Brien, 39–44. Hanover, N.H.: University Press of New England, 2009.

Thomas, Keith. "Work and Leisure in Pre-Industrial Society." *Past and Present* 29 (December 1964): 50–66.

Thompson, E. P. "Time, Work, Discipline, and Industrial Capitalism." *Past and Present* 38 (December 1967): 56–97.

Zimmerman, Philip D. *Delaware Clocks*. Dover, Del.: Biggs Museums of American Art, 2006.

Ceramics

VISITORS TO HISTORIC HOUSES AND MUSEUMS ALL USE ceramics daily, and plates, teacups, saucers, bowls, and storage containers are easily recognizable. Nevertheless, those same visitors may find the ceramics in a museum setting unfamiliar in both form and decoration.

By looking carefully at ceramics and thinking about the meanings of objects in the past and present, visitors and interpreters realize both the needs and attitudes they share with past generations as well as the customs and ideas that have changed dramatically. Knowledge of ceramic manufacturing processes, output, distribution, and use is constantly increasing, and recent archaeological studies of English and North American pottery and residential sites have led to new understandings about ceramics in colonial America.[1]

This chapter discusses connections among all types of ceramics available at a specific time, connections between the variety of ceramics and extensive international trading systems, and connections between ceramics and other materials. This information can be applied to interpreting displays organized by body content (earthenware, stoneware, and porcelain), by country or continent of origin, and by ownership and use.

LOOKING AT CERAMICS

What lures a visitor to look at a ceramic object? Sometimes the form itself, especially the line and scale, is compelling; sometimes texture, color, or ornament draws the eye.

Material

Clay is the product of weathered rock that, when wet, reveals its most important property: the capacity to be shaped and to hold that shape in changing conditions. The three basic ceramic bodies are earthenware, stoneware, and porcelain. It is easiest to distinguish these bodies by their firing temperature and porosity, but differences among these bodies are not easy to distinguish visually. Ceramics of different body types were often used and decorated differently.

Earthenware clays occur widely and would have been available to nearly any colonial potter. Earthenware becomes hard when fired between 800 and 1100 degrees Celsius. It is not vitrified; that is, it is not fired at a temperature high enough to make it glassy and impermeable. It is porous even after firing, allowing liquids to leach through, and it must be glazed to become nonporous. Evident in the numerous chips around the edges of delftware, for example, glaze remains a separate layer from an earthenware body. Utilitarian redware used for food preparation is most often earthenware (figs. 12-1 to 12-5).

Stoneware clays do not occur as widely as earthenware clays. Stoneware must be fired between 1200 and 1300 degrees Celsius and so required a larger investment for fuel than earthenware. Although stoneware is nonporous after firing, potters often glazed it with salt and sometimes lead. Salt glazing during firing reduced both the time necessary to complete an object as well as the chance of breakage. In the kiln, chlorine as a toxic gas escaped from the salt, and sodium combined with alumina and silica in the clay to create a glassy but pitted surface (fig. 12-6).

Porcelain is fired at more than 1280 degrees Celsius. It is nonporous, or vitreous (glasslike), after firing (figs. 12-7 to 12-11). True, or hard-paste, porcelain is composed of two ingredients: kaolin (china clay, a fine white clay) and petuntse (china stone, which lowers the melting temperature of kaolin and increases its plasticity). Porcelain is white and usually somewhat translucent, two favored qualities in the 1600s and 1700s; its fracture is clean and smooth. Until about 1700, the ingredients of true porcelain were not found in Europe. In the mid-1700s, deposits of kaolin and petuntse were discovered in Cornwall, and some English potteries began to make hard-paste porcelain.

English potters, however, concentrated on soft-paste (artificial) porcelain. They achieved whiteness and translucency by making a hybrid of glass and ceramic. Recipes combined white clay with glassy frit (partially fused glass), soapstone, or bone ash (see fig.

pitchers that are about the same size and were made about the same time in England of the same materials show the importance of line (see figs. 12-1, 12-2). One pitcher has curved lines in the bowl, spout, and handle; the other is angular in outline, especially in the shoulder and handle. They present design options for the purchaser.

Texture

The shape and organization of visual or tactile variations on the surface of an object impart texture. Many ceramic objects display the expected smooth surface, a result of the potter's work in clay preparation and the smoothing and pulling of the walls of an object. But subtle or obvious texture can result from manufacture, decoration, or modeling. Manufacturing processes produced a slightly rough, mottled overall texture in two kinds of ceramics: some Chinese export porcelain of the late 1700s and early 1800s, and salt-glazed stoneware. Painted decoration that is applied after produc-

FIGURE 12-1. On this pitcher, the British potters printed an image of the surrender of the British army at Yorktown, Virginia, October 19, 1781, marking the end of the Revolutionary War. Apparently the need to create a product they could easily market in the United States overcame any hesitancy to commemorate this event. On the reverse is an image of Lafayette, who participated in the Battle of Yorktown as part of General George Washington's staff. The date of the pitcher coincides with the timing of Lafayette's triumphal visit to the United States. (Pitcher, Staffordshire, Eng., 1824–1830. Earthenware [lusterware], lead glaze; H 7¼ in., L 9½ in., Diam 6 in. 1966.67 Winterthur Museum, gift of Mr. B. Thatcher Feustman.)

12-8). Glazes on soft-paste do not always fit the object as tightly as hard-paste glazes and show some shrinking from the body at the foot ring.

Line

Focusing on the outlines of an object may help visitors to analyze its appeal. Some shapes are standard and recognizable. Redware plates clearly show the basic dish or plate shape: a disk with slightly upturned sides (see fig. 12-3). The lines of many ceramic objects, however, vary widely and indicate one advantage of clay as a material—its plasticity, which allows an almost infinite variety of shapes to be formed from throwing, turning, modeling, or molding.

The variation in line often gives a ceramic object ornamentation beyond its function. For example, two

FIGURE 12-2. Many British factories were making lusterware with patriotic images. Andrew Jackson is identified here as a general and the hero of the Battle of New Orleans in the War of 1812, a marketable image during his terms as president, from 1829 to 1837. (Pitcher, Staffordshire, Eng.; 1824–1830. Earthenware [lusterware], lead glaze; H 8¼ in., L 9 in., Diam 6⅕ in. 1966.69 Winterthur Museum, gift of Mr. B. Thatcher Feustman.)

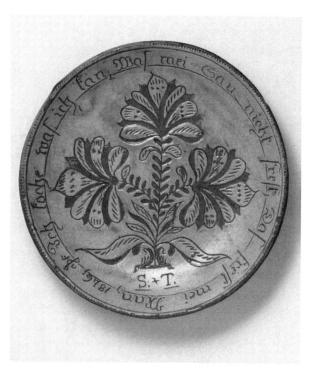

FIGURE 12-3. The sgraffito (incised) decoration on plates made by Pennsylvania Germans often included humorous comments. A translation of the message on this plate is: "I only cook what I can cook still; what the pig won't eat my husband will." (Plate, Samuel Troxel, Montgomery County, Pa., 1846. Redware or earthenware; H 1½ in., Diam 9⅜ in. 1960.626 Winterthur Museum, bequest of Henry F. du Pont.)

tion stands out slightly from the surface of an object and adds texture as well as color. In the two pitchers (figs. 12-1, 12-2), texture adds interest in the beaded decoration around the rims and in the reeding or series of parallel ribs at the neck of one pitcher.

Color

The clay body itself, the glaze, and the color applied to either the body or the glaze all impart color to a ceramic object. Earthenware, for example, is often the familiar red of bricks, or it may be buff-colored. American stoneware clays produced gray products. True porcelain is made with clays that give a very white appearance. Sometimes, overall surface color does not occur naturally; it may be added to the clay or the glaze. If the color is matte-finished, it usually is in the clay; if it appears to be part of a glassy layer on top of the clay, the color is in the glaze.[2]

Colorants on the surface of an object can be applied at various stages in the production process. The point when a potter applies color influences the final appearance by affecting both hue and dispersion. Although the range of colors applied to ceramics objects is broad, some are more common than others. Blue, often derived from cobalt, appears in stoneware, porcelain, and refined earthenware, perhaps a result of the pigment's stability in the production process, which made it cost effective.[3] Potters experimented and developed expertise with colors that were stable. This knowledge, as well as their customers' preferences, influenced color choices.

Ornament

Potters used clay's plasticity to produce decorative forms. In the two pitchers (see figs. 12-1, 12-2), the different treatment of the handles—angular on one, curved on the other—emphasizes how molding could produce different ornamental forms. The

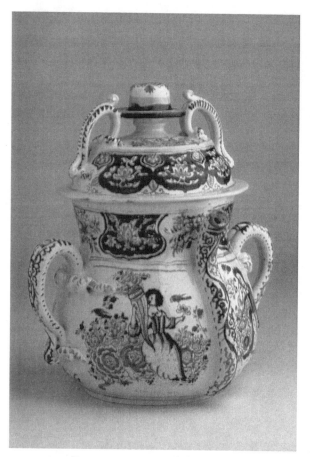

FIGURE 12-4. Posset pots were vessels for drinking a beverage of the same name made of cream or milk curdled with ale or wine. Posset was often served warm, thickened with cake or cookie crumbs, and was supposed to have a medicinal effect. The pot was customarily a communal vessel, with each person sipping a portion from the spout. Although the colors on this example are Chinese in inspiration, the form and the images in the decoration are European. (Posset pot, probably Lambeth, Eng., 1709. Earthenware, tin glaze; H 10½ in., W 10¼ in., Diam 7½ in. 1959.1894 Winterthur Museum, bequest of Henry Francis du Pont.)

only an introduction to the long and complex development of style in ceramics.

Decoration

Decoration for its own sake or for its symbolic meaning often increases an interest in objects among collectors and museum visitors. Plain redware or creamware, however, was probably much more common in colonial households than it is in museum displays.[4]

A potter made a choice of decoration by balancing the urge to decorate with the realities of efficient production. Scratching or coloring had the advantage that either could be done before the firing and would, if the colors were stable, look acceptable after an object came out of the kiln. Pennsylvania German sgraffito plates are excellent examples of decoration influenced by a particular culture—the Germanic settlements of eastern Pennsylvania. Potters first applied color to

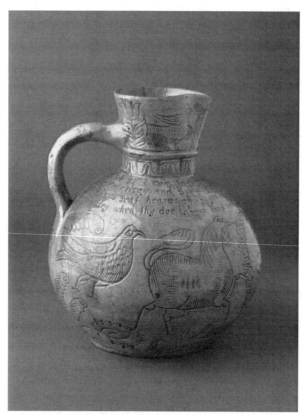

FIGURE 12-5. This pitcher has a history of ownership in Delaware. The sgraffito decoration includes the date "1698," a woman flanked by two unicorns, and, on the neck, a man's head flanked by birds. The message reads, in modern English, "Kind sir I came to gratify your kindness love and courtesy and serve your table with strong beer for this intent I was sent here; or if you please I will supply your workmen when in harvest dry they do labor hard and sweat good drink is better far than meat." (Jug, North Devon, Eng., 1698. Earthenware, lead glaze; H 11 in., Diam 10 in. 1964.25 Winterthur Museum.)

beaded decoration near the rim was also part of the molding process. Color varies in amount of detail and surfaced covered. Sometimes it appears to have been applied spontaneously; other times it appears in carefully painted or printed designs.

THINKING ABOUT STYLE

Ceramics are made primarily from water and clay, the residue of weathering and erosion that is neither precious nor fine. They serve basic human needs, can be visually appealing, and sometimes have subtle meanings for makers, owners, or viewers. Why did potters elaborate the form and decoration of such an unpretentious material in almost limitless ways? Answering this question leads to a discussion of aesthetics, culture, politics, technology, and economics. Several influences on style are discussed below: decoration, Eastern/Western influences, and marketing. This is

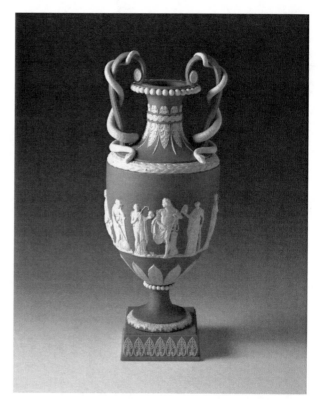

FIGURE 12-6. This elaborate vase, made at the Etruria Factory of Josiah Wedgwood and Thomas Bentley, shows blue and white colors that have come to be associated with the Wedgwood name. The blue matte body is stoneware. The white relief decoration of Greek mythological figures and the urn shape clearly demonstrate the European fascination with classical design sources. (Flower container, Wedgwood Etruria Factory, Staffordshire, Eng., 1790–1800. Stoneware [jasperware]; H 14 in., Diam 6 in. 1997.14 Winterthur Museum purchase with funds provided by Collectors Circle and the Winterthur Centenary Fund.)

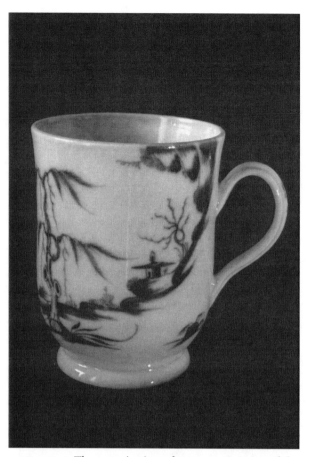

FIGURE 12-7. The organization of space, asymmetry of design, shape of the trees, and pagoda-like building are features of Chinese design on this English mug. It was made at the Plymouth Porcelain Works by William Cooksworthy, who first patented porcelain manufacture in England in 1768. (Mug, Plymouth, Eng., 1768–1777. Porcelain [hard-paste]; H 4 in., L 4⅓ in., Diam 3¼ in. 1977.90 Winterthur Museum, gift of Mr. and Mrs. John Mayer.)

redware plates, then scratched the design with a stylus and perhaps added other colorants. Although Germans settled other areas in North America and developed strong pottery industries, the sgraffito technique was used, for the most part, only in Pennsylvania (see fig. 12-3).[5]

The designs chosen by these potters are similar to those used by Pennsylvania German fraktur and furniture makers. Their sources are varied. The tulip may spring from Persian influences, the eagle from European heraldic devices, and the three spreading flowers from religious symbolism. Specifically American motifs are less common. Transfer-printed designs on English earthenware made for the American market were apparently seen and adapted by some Pennsylvania German potters, an example of the impact of aggressive English marketing.[6]

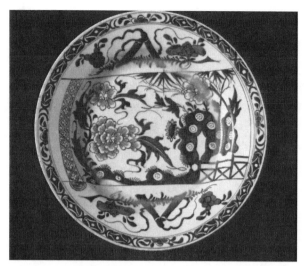

FIGURE 12-8. This plate, made at the Bow Porcelain Works near London, features Asian images, including a scroll with a naturalistic design of peonies, bamboo, rocks, and a fence. Plates made in China have similar central scroll designs and possibly served as the inspiration for Western potters. (Plate, Bow Porcelain Works, London, 1760. Porcelain [soft-paste]; H 1⅓ in., Diam 9⅓ in. 1978.75 Winterthur Museum.)

Many sgraffito plates date from the period between 1780 and 1840, although the wares continued to be made throughout the nineteenth and twentieth centuries. Little stylistic change occurred. Perhaps an apprenticeship system or the community's continued acceptance of designs having religious and cultural meaning discouraged change.[7]

Eastern/Western Influences

A major contribution of Chinese aesthetics and technology to ceramics was the development of porcelain.

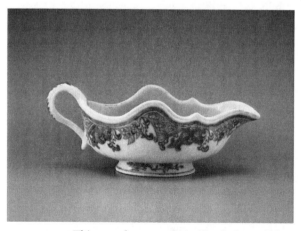

FIGURE 12-9. This sauceboat, made in Jingdezhen, China, was recovered from a Dutch East India Company ship that sank in 1752. It was probably part of a dinner service, and the design is based on the shape of single-handled silver sauceboats. (Sauceboat, China, 1750–1752. Porcelain [hard-paste]; L 8¼ in. 2000.61.43 Winterthur Museum.)

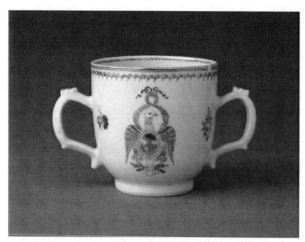

FIGURE 12-10. The Order of the Cincinnati was a fraternal organization formed by George Washington's officers after the Revolutionary War. Its name comes from the mythical Lucius Quintus Cincinnatus, a Roman general and statesman. Pierre l'Enfant, who designed the plan of Washington, D.C., also designed the emblem for the Order of the Cincinnati. (Cup, Jingdezhen, China, 1786–1793. Porcelain [hard-paste]; H 2½ in., W 2⅗ in., L 4⅜ in. 1953.166.1 Winterthur Museum, gift of Henry Francis du Pont.)

European ceramicists eventually perfected the medium but also developed an earthenware body that rivaled porcelain in whiteness as well as desirability, allowing many people to own and use fine ceramics. How Europeans achieved the white body is an important story in ceramic manufacture, but why it was so important is a crucial element in the development of style.

As important as the fine white color of porcelain were the influences of form and design. Westerners eagerly imitated the look of Eastern wares; however, even centuries after contact, Asian peoples successfully minimized Western cultural influences, including the importation of Western goods. Eastern potters imitated Western goods mainly to sell beyond their own shores.

Between the seventh and ninth centuries, Chinese potters perfected porcelain—a hard, translucent, ceramic body made of kaolin and petuntse.[8] By the mid-1500s, the Portuguese had established trade with China and established a permanent settlement at Maçao. They discovered that fine, white decorated porcelain was lucrative cargo for Europe.[9] In the early 1600s, investors interested in Far Eastern trade established the Dutch East India Company, and the Dutch came to dominate the China trade. A plate that was recovered from the Dutch East India Company's *Witte Leeuws* (*White Lion*), which sank in 1613, carries decoration that is characteristically Chinese in its eight-panel design and floral motifs. It is typical of porcelain made

for sale in foreign markets, but the designs had Chinese meanings as well as Western appeal (fig. 12-11).[10]

Throughout the 1600s, challenge, conflict, and accommodation characterized political and economic developments as well as object design. The Dutch soon found that giving Chinese potters wooden models or metal or ceramic objects to copy helped them produce saleable objects. During the late 1600s, the Holland-China trade was interrupted by internal wars in China; foreigners were expelled and the kilns were burned. This unsettled twenty-five years had lasting effects on ceramic design, as Japanese porcelain replaced Chinese in ships bound for Europe. Most favored were the deep red and dark blue colors characteristic of Imari porcelain, whose name comes from the site of the Japanese kilns. The Chinese themselves eventually copied the Imari palette, and the blue and red colors with gilt also influenced the designs of so-called gaudyware (white earthenware painted with colorful floral designs) made centuries later in England.

The great era of Chinese export porcelain commenced with the rebuilding of the Chinese kilns at Jingdezhen. The opening of Canton in 1699 and its role as a trading center for the next 125 years allowed millions of porcelain objects to reach the West. Through the eighteenth century, the potters at Jingdezhen organized for efficient production to meet

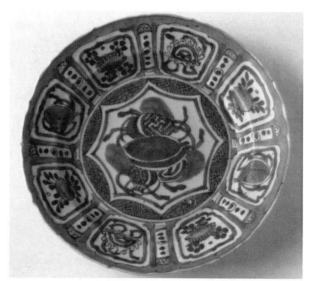

FIGURE 12-11. This dish lay under the ocean for some 350 years before being rescued. It was part of the cargo of a ship in the Dutch East India trade that sank in 1613 off the island of St. Helena in the south Atlantic. This early seventeenth-century porcelain is sometimes called Kraak, a term that may have been taken from the word "carrack," the name for the Portuguese ships on which the porcelain was transported to Europe. (Dish, China, 1600–1612. Porcelain [hard-paste]; H 1⅓ in., Diam 8⅓ in. 1977.62 Winterthur Museum.)

Western demand and developed transportation systems from the potteries to trading sites, part of a well-developed international trading system.[11] Numerous porcelain forms were made specifically for Western markets. Chinese potters also eventually produced Chinese forms for export, especially those objects related to tea drinking, a custom with Eastern antecedents. A covered bowl with a simple, Eastern-style convex lid probably became a sugar bowl on a Western tea table.[12]

Some forms are clearly Western inspired but carry Chinese decoration. A mug, for example, may be shaped like those made in Europe but carry a Chinese decorative motif of bas-relief plum blossoms.[13] On the other hand, some Chinese porcelain ornamental serving pieces are Western in both form and decoration. Western objects that entered China encouraged potters to emphasize new in their designs, now known as the famille rose palette. Chinese potters used them widely after 1714. In famille rose colors, an opaque pink hue is common. In famille verte colors, a translucent green predominates.[14] Ceramic scholars have debated the technological and stylistic origins of the colors. The Chinese potters called the opaque rose colors "foreign colors," suggesting their popularity in foreign markets.[15]

Also in response to Western influences, Chinese potters developed monochromatic brown-black drawings that are known as *encre de chine* (ink of china), a collector's term. Contemporary documentary references call them pencil wares or penciled wares. The stark, dark drawings on white porcelain look like engravings, and it was Western prints that inspired the technique. Finely drawn political cartoons on porcelain bowls plainly show this inspiration.[16]

Small-scale repetitive borders with small central designs suited tastes in the young United States in the late 1700s. A two-handled cup shows the predominantly white background, repetitive border patterns, and isolated central design that filled the crates in American ships as they entered the China trade at the turn of the nineteenth century (see fig. 12-10.)[17] This cup is decorated with the insignia of the Order of the Cincinnati, a design that also appeared on porcelain owned by George Washington.

The fashion for Eastern porcelain profoundly affected European ceramic production. Experimentation that led to the European manufacture of porcelain as well as fine white earthenware, the only ceramic ever to challenge porcelain's desirability, dominates eighteenth-century European ceramic history. First came tin-glazed earthenware, then white salt-glazed stoneware, and finally white earthenware (creamware).

The technology of tin glazes allowed potters to make earthenware that looked similar to Chinese porcelain. The process of adding ashes of burned tin to a lead glaze to produce an opaque white glaze disseminated from the Middle East through southern Europe to Holland and England by about 1550. The city of Delft in Holland gave its name—delftware—to both Dutch and English tin-glazed wares. Decorations on delftware are characterized by an extensive use of blue, a color that was stable in firing and mimicked Chinese blue-and-white wares, and by a spontaneous "free-hand" quality of the design, which was painted onto the chalky white glaze before it was fired.[18] As Chinese porcelain gradually entered the elite households of Europe, tin-glaze designs could imitate the Chinese wares at a fraction of the cost. By the second quarter of the 1600s, English potters were producing earthenware in imitation of Ming dynasty wares. At times they combined blue hues from cobalt, a stable colorant, with green from copper, purple and purplish-black from manganese, brick red from iron, and yellow from antimony (see fig. 12-4).[19] With the beginning of the eighteenth century, potters also used a bright polychromatic palette, sometimes in imitation of the Chinese famille verte palette.[20]

Although delft potters could imitate colors, the thinness, translucency, and delicate quality of drawing on porcelain eluded them. The tin and lead glaze of delftware created a chalky surface that widened brush strokes as it absorbed colors; as the colors became part of the glaze, the opportunity to correct mistakes diminished.[21] Delft may have looked like porcelain, but it did not match its utility as tea ware. The glaze chipped easily and often cracked at the touch of hot liquid, leaving the absorbent earthenware body exposed. Delftware was neither practical for brewing tea nor pleasant for drinking. Delft plates, dishes, and bowls, therefore, were more common than mugs and cups.[22]

White salt-glazed stoneware had neither the disadvantage of chipping glaze nor that of absorbency. Until the early 1700s, utilitarian stoneware was grayish or buff-colored, but about 1720, deposits in Dorset and Devon, England, yielded a white clay that, when combined with calcined (burned) flint, formed a durable white body. Molded decoration became characteristic of stoneware as potters discovered that the nature of the clay meant they could either press mold or slip cast the wares. Molds were used from the mid-1600s, but when plaster of paris was brought to England, the

technology was so improved that molding became a commercial option. These thin-walled, durable wares were more practical for tea wares than was tin-glazed earthenware. Stoneware plates allowed those who could not afford porcelain to set elegant tables.[23]

With plaster molds for pressing and slip casting, potters made stoneware objects with finely detailed bas-relief designs. This technology suited the application of baroque and rococo decoration to ceramics. The compartmentalized designs on stoneware teacups are reminiscent of a paneled or lobed effect, accented by gadrooning, on some baroque silver objects.[24] Slip casting allowed detailed, delicate molding that reproduced such rococo design elements as curving floral sprays and rocaille. Some pressed plates have compartmentalized designs that are outlined in curving boundaries, which are reminiscent of rococo cartouches engraved on silver.

A major step toward finding an equal to porcelain was the perfection of a cream-colored earthenware body and a clear, glasslike lead glaze, without lingering iron impurities that would give unwanted tints.[25] A white earthenware clay, with the addition of flint for durability, formed the body. Creamware was perfected by the 1750s, and early dated examples are decorated in a manner similar to tin-glazed earthenware. As decorative techniques evolved, potters used underglaze color to create a "tortoiseshell" finish. Soon, tortoiseshell, plain creamware, and creamware covered with colored glazes were available for the consumer. Josiah Wedgwood, an important producer of creamware, called his ware "cream colored ware." In the 1760s, England's Queen Charlotte permitted him to call his creamware "Queensware." Having made a breakfast and tea set for the monarch, Wedgwood thereafter called himself "Potter to the Queen" to exploit the impact of royal support.

Consumer desire for a truly white earthenware body and the Staffordshire potters' experimentation eventually produced a new glaze in the 1770s, which was called "China glaze." Wedgwood began making the white-bodied ware in 1779 and, again in characteristic fashion, gave it a new name, "pearl white," to distinguish his wares from the products of his competitors. Today, many ceramic historians call this ware "pearlware." In pearlwares, cobalt imparts a hint of blue to the glaze to heighten whiteness. A bluish tinge where the glaze has pooled on an object is an indication of pearlware.[26]

The surface of creamware and of pearlware opened exciting avenues for pottery decorators. The smooth, light-colored body was a better surface than white stoneware for printed and painted ornament, both over- and underglazes.[27] Sponged wares, blue and red "gaudyware," floral-decorated white-bodied wares, and the array of transfer-printed wares give ample evidence of what one scholar calls a "revolution in decoration."[28]

European Porcelain

While some potters experimented with and succeeded in achieving porcelain's white appearance, others worked toward duplicating porcelain itself. By 1710, European potters were having some success. After years of experimentation, potters near Dresden (in present-day Germany) successfully produced an impervious white, translucent ceramic body; their success meant that Westerners finally had mastered the intricacies of porcelain production. Some of the names of the European and English potteries are still in use today—Meissen in Germany; Sèvres in France; and Worcester, Derby, and Chelsea in England (see fig. 12-7). A Chinese porcelain plate design of the mid-1700s using a central scroll was an inspiration for a similar plate made at the Bow Porcelain Works in England, perhaps a decade later (see fig. 12-8).

Mutual East-West influences on porcelain were affected by trading patterns. By the early 1800s, the British dominance in the China trade ended. Excise taxes eventually doubled the cost of incoming porcelains between 1779 and 1800, just when independence allowed American merchants to trade with the East on their own. The United States maintained a solid trading position through the first half of the 1800s. Numerous examples of early nineteenth-century Chinese export porcelain with American motifs show this great change in trade.

The fever for Chinese porcelains eventually declined. For most of the eighteenth century, however, the desire for porcelains, copies, and imitations strongly motivated potters and decorators, both in China and Europe, to study each other's wares for stylistic inspiration. The interaction of East and West was, for centuries, an important influence on the ceramics that were available in the colonies and young United States.

Style Changes Related to Marketing

Toward the end of the 1700s and into the early 1800s, a new impetus emerged: the development of a consumer market. The desire to sell products and

make money changed the way ceramics looked. English potters, led by that quintessential entrepreneur Wedgwood, expanded markets by making the objects desirable and accessible. European royalty, nobles, and aristocrats had long been ceramic enthusiasts.[29] Internationally, Wedgwood and his contemporaries also made enthusiasts of those with less-exalted status. Wedgwood linked his desire to make money with an astute sensitivity to his customers' tastes and aesthetic trends, many of which he set. The emergence of ceramics as a fashionable and available commodity in the late 1700s helps to explain why English ceramic collections are large and diverse. Many potters were experimenting, still more were selling, and many people were buying.

Wedgwood was the son of a potter and the acquaintance of important scientists. Widely copied, his experiments with color additions to unglazed stoneware clay produced a product called black basaltware in 1769.[30] With basaltware, Wedgwood tapped the contemporary interest in the antique—Egyptian statues were carved of rock basalt.[31] Wedgwood also supervised more than four thousand experiments to perfect jasperware in the mid-1770s. Jasperware was white stoneware clay, initially completely colored and later "dipped" or brushed with a stained clay, with white, molded decoration applied to the colored ground. Although copied by other potters, the ware is most commonly associated with Wedgwood, even today.

One of Wedgwood's most astute aesthetic judgments was to promote neoclassical design elements. He named his factory Etruria for the country of the Etruscans, who flourished in the sixth century B.C. Wedgwood attempted to duplicate a first-century A.D. Roman glass cameo vase known as the Portland or Barberini vase. He eventually succeeded in making copies in jasperware.[32] His understanding of the interest in neoclassicism and his astute awareness of his customers' interests led to his commercial success as well as stylistic developments in ceramics that continue to be influential today.

Summary

The continuum from an unglazed red earthenware flowerpot to the rare jasperware copies of the Portland vase expresses the range of possibilities open to the potter, the ceramic decorator, and the consumer. The development of style in ceramics appeared as makers and users explored and exploited the possibilities. Some obvious evidences of development include sgraffito-decorated earthenware, influenced by an ethnic tradition; various white-bodied tea and dinner wares, affected by cross-cultural influences and social practices; and the diversity of transfer-printed wares, stimulated by the desire to expand ceramics markets. The fashionable, cosmopolitan baroque, rococo, and neoclassical styles are also evident in ceramic collections.

MAKING AND MARKETING CERAMICS

Manufacturing diverse ceramic objects and getting them to consumers—locally and internationally—is complex. This section provides basic information about ceramic bodies as well as forming, firing, and decorating techniques and major changes in marketing ceramics that occurred in the late 1700s.[33]

Clay's plasticity allows for its myriad shapes. It may be modeled into delicate forms by hand or thrown on a potter's wheel to form hollow, symmetrical, or circular objects. Using a simple method, a drape-molded plate is made by rolling out a circle of clay, draping and pressing it over a mold, trimming any excess, and letting it dry on the shape. Jiggering and jollying are mechanical molding methods used after the mid-nineteenth century to form circular shapes on a wheel. With clay pressed against a mold form and spinning on a wheel, a potter presses a profile against the clay to complete the shape. A potter can shape the foot and rim of a plate this way.

Molds can also shape more complex forms. Block molds of a finished object, made of fired clay and often finished by hand, serve as master molds. Working molds can then be made from the master mold. A modeler who made a master mold was a skilled craftsman.[34] Press molding or slip casting can also be used to form objects. Press molds produce intricately shaped objects such as lifelike creamware vegetable-shape dishes and wall pockets with human faces. Pressing produces a sharply defined object, and press molds wear well. In slip casting, slip (liquid clay) is poured into a plaster mold, which absorbs water, leaving the remaining slip as a thin layer of clay to dry and shrink away from the mold, producing a finely detailed object.

All of these clay products can air dry to become leather-hard, but firing is necessary to fuse the ingredients of the body and to fuse glaze to the body. Large amounts of fuel were needed to achieve the high firing temperatures. Firing a large kiln could take days, and in Staffordshire, as much as ten tons of coal were needed to process one ton of clay.[35] English potteries, therefore, were located near sources of coal. Coalport,

the English porcelain factory located on the Severn River, acknowledges this connection in its name.

In addition to fusing the body, potters may need to fire wares to set any decoration. Each firing adds cost, effort, time, and risk of breakage, yet potters took such risks to add favored decoration. Glazes, which essentially are thin layers of glass, may cover the whole ceramic body or be confined to specific design areas. Some are utilitarian; the transparent lead glaze on earthenware, for example, makes such wares impervious to water.

Some colors, such as blue from cobalt, are applied to unfired wares. The frequent appearance of blue in Eastern porcelain, American stoneware, and English ceramics derives not only from imitation but also from technical ease (see fig. 12-9). Some colors, not stable in the high temperatures necessary for underglaze firing, are applied on top of the glaze and mature in firings at low temperatures. Basically a thin layer of "colored glass" painted on the ware, overglaze colors allow a highly detailed and controlled decoration. Painted on the surface, the glazes create an impasto, a light brushstroke texture, which is visible with careful examination. Some colored decoration on ceramics is not a glaze but a slip. Applied before final glazing, slip may cover an object overall or only in specific design areas. Overall slip coloring is difficult to distinguish from an overall colored glaze. Careful observation may distinguish the opaque slip from the colored glaze, which, except for tin-glazed ware, is usually translucent. A familiar use of an overall slip is the off-white or buff ground into which a design is incised in the Pennsylvania German sgraffito ware (see fig. 12-3). Colored clays can be painted on, poured on from cups with narrow openings, or combed after pouring.

The plasticity of clay allows many decorative techniques that are based on forming and piercing. Molded decoration can be attached to a body with a layer of liquid clay. The raised white raised designs on Wedgwood's famous jasperware were molded (see fig. 12-6). Molded decoration can be either as sprig molded (in which the clay relief is applied by hand after it is released from the mold) or as mold-applied (in which the whole mold, into which clay has been pressed, is rocked across the moistened surface of a pot until the ornament attaches to the pot).

Other ceramic decorating techniques are luster decoration and clay staining. Luster decoration gives a metallic sheen to a ceramic object, either overall, as when an earthenware statuette appears to be made of silver, or when various motifs in the design are highlighted with luster (see figs. 12-1, 12-2). A famous example of clay staining is Wedgwood's black basalt-ware, which is made from clay mixed with various metallic coloring compounds.

Printed decoration on ceramics took advantage of the light-colored earthenware bodies perfected in England. Used on earthenware tiles by the mid-1700s, printed decoration began appearing on pottery by the late 1760s and had several effects. It allowed the ceramic decorator to rely on a printed design rather than his or her freehand work, and it allowed standardized designs on many ceramic pieces, thus taking a major step toward mass production in ceramics.[36] Although early printed designs were small in scale compared to the overall dimensions of the pot, printing eventually allowed detailed designs over the whole ceramic body. Decorators exploited this process by printing exotic, mythological, nationalistic, and topographic images. Printed decoration also increased the number of new and different decorated objects available at lower cost than hand-decorated ware.

Printing on ceramics was a British development. Transfer printing was perfected by Sadler and Green of Liverpool in the mid-1750s, at about the same time that Josiah Wedgwood was perfecting creamware. In fact, the two firms signed a mutually exclusive agreement that lasted about thirty years. Only Wedgwood creamware showed Sadler and Green designs.[37] By 1776, printed wares were sold in America and were specifically mentioned in one New York City merchant's accounts.[38] A decorator used one of two methods to print on ceramics. In bat printing, the earlier method, the printer transferred a design from an oiled, engraved plate to a glue bat, a thin, floppy piece of animal glue, like a slice of gelatin. The printer rolled the oiled bat over the pot, and the design, in oil, was transferred. Color, which was sprinkled on the ceramic object, adhered only to the oiled lines and was set in a final firing. Sometimes a "squished" or irregular area or trapped air bubbles can be detected in a bat-printed design.

In another method, paper was used to transfer the design. After an engraver carved a design in a copper plate, a printer applied a special ink made of a ceramic flux and a pigment; he then printed the design on paper, which was permeated with soap. A decorator applied and rubbed the paper on the glazed surface of a plate, cup, or bowl and washed away the paper, thereby depositing the waxy, oily color on the object. Sometimes it is possible to see a "seam" in the design

where parts of the printed design meet. The design was set by firing.

As visitors look at objects in a ceramics collection, they see, in general, the same forms: plates, bowls, cups, jugs, and jars. They see an amazing diversity, however, in decoration, which may lead to thoughts of the people who valued these objects long ago.

Marketing Ceramics

The ceramics used by people in British North America in the 1700s came from both near and far. There was an extensive domestic and foreign trading network that made local, European, and Asian ceramics available. Although these trading networks continued, English ceramics became increasingly important in the United States market as the nineteenth century approached. The following discussion traces these concepts through two "periods" in ceramic marketing. The first runs from about the mid-1600s, when ceramics came to be more widely used, until about 1750–1775. The second runs from that time period into the antebellum years of the 1800s.

Potters in the colonies in the earlier period supplied at least some utilitarian redwares and stonewares.[39] Probably from any pottery in Europe and the colonies, peddlers left with dishes and cups filling their baskets. Their markets extended as far as their energies and their supplies lasted. Fairs, the traditional method of market sales in central towns, also made pottery available to customers.[40] Some potteries extended their markets via the coastal trade. "Philadelphia" pottery was shipped as far afield as Boston, where it was identified and, for some reason, favored.[41]

Concurrent with this local distribution was an extensive international trade that brought Dutch, German, French, and Eastern ceramics to the colonies.[42] Before 1750, several households around Plymouth, Massachusetts, contained such diverse ceramics as brown German stoneware, English or Dutch delftwares, and English earthenware.[43] Following good colonial mercantile practices, such wares traveled in ships through English ports to arrive in North America. Ceramic wares were gathered as part of a large shipment of "dry goods" that included textiles, metals, and paper goods.[44] Usually, a merchant or importer sold these goods from his warehouse near the dock to both retail and wholesale customers, including shopkeepers far away from the port.[45]

Some porcelain from China and Japan was shipped through English firms that extended credit to American dry goods importers.[46] Throughout the 1600s and most of the 1700s, Holland and then England dominated the China trade, and European merchants were the sources for what little porcelain entered the North American colonies. In turn, European merchants' supplies were controlled by their Chinese counterparts from trading houses in Canton. Special orders of novel forms or underglaze decorations were sent to the potteries at Jingdezhen. Orders for painting over the glaze, as was done for personalized porcelains, were filled at painting factories near Canton.[47]

By the end of the 1700s, England and China became the major suppliers of ceramics to the young United States, with Staffordshire potteries producing the bulk of the wares. Even utilitarian earthenwares were imported.[48] As the Napoleonic Wars of the late 1700s and early 1800s disrupted European commerce and as European nations erected tariff barriers to save their potteries from the onslaught of English wares, English potters turned to the more open and, after the War of 1812, stable United States market. From the end of the War of 1812 until the Civil War, the American markets generally consumed 40 to 50 percent of Staffordshire exports.[49]

Another look at the career of Josiah Wedgwood explains England's ascendancy in the ceramic trade. Wedgwood developed ceramic bodies that virtually replaced white stoneware and delft, although they never challenged the premier place of the fine porcelain made at Meissen and Sèvres.[50] His "pearl white" body was suitable for the blue underglaze and printed decoration that successfully rivaled the most-favored Chinese blue-and-white wares.[51] Wedgwood's success in courting the favor of style leaders made his wares desirable. The London showroom display of his service for Russia's Catherine the Great in 1774 attracted throngs of people for more than a month. The set was decorated with images of English scenes and country houses, which were sure to bring the owners to the exhibition. Even for a line of inexpensive flowerpots, Wedgwood wrote, "They want a name—a name has a wonderful effect I assure you—Suppose you present the Duchess of Devonshire with a Set and beg leave to call them Devonshire flowerpots."[52]

Sponsorship by the famous was only one route for Wedgwood's efforts. Equally important was allowing customers to see and buy. By 1765 Wedgwood operated a London showroom where he could arrange his wares as they would be on a table at home,

in order to *do the needful* with the Ladys in the neatest, genteelest, and best method. The same, or indeed a

much greater variety of setts of Vases sho'd. decorate the Walls, and both these articles may, every few days be so alter'd, revers'd, and transform'd as to render the whole a new scene, Even to the same Company, every time they shall bring their friends to visit us.[53]

To the showrooms, with their changing displays, Wedgwood added such techniques as free shipping, traveling salesmen, displays where purchasers could help themselves, and all sorts of commendations in the press.[54] Through the English diplomatic corps, agents, and multilingual clerks who could answer requests in appropriate languages, he extended his markets.[55]

The United States became England's market by the late 1700s. Frederick Rhinelander, a china and glass merchant in New York City in the Revolutionary War era, imported more cream-colored earthenware than any other type of ceramic. His accounts mention only one potter by name: Wedgwood.[56] By the 1790s, creamware and pearlware replaced salt-glazed and brown stonewares, tortoiseshell wares, and tin-glazed earthenwares in the inventory of Gabriel Wood, a Maryland storekeeper.[57] These wares were readily available in the new republic.

Chinese porcelain merchants anticipated, as Wedgwood did, good returns from the American market. Samuel Shaw, supercargo on the *Empress of China*, the first American ship to sail for Canton in 1784, wrote that "when, by the map, we conveyed to them an idea of the extent of our country . . . they were not a little pleased at the prospect of so considerable a market."[58]

Any porcelain—English or Chinese or, especially in the early 1800s, French—continued to be an expensive choice for American ceramic consumers. A merchant on the Chesapeake in the 1790s stocked both English and Chinese porcelains; they constituted only 6 percent of his goods for two years in the mid-1790s but accounted for 24 percent of the value of his stock.[59] Porcelains were available, but were second to the overwhelming predominance of other English wares.

In the midst of this extensive international trade, American earthenware and stoneware potters continued production. They sold their wares locally and also relied on the well-developed coastal trade to extend their markets. In the 1700s and early 1800s, for example, wares from Connecticut and New Jersey turned up on Staten Island tables, and Staten Island potters, in turn, shipped their wares to Manhattan and thence to outlying country merchants.[60] Domestic potteries continued but could not compete with

English, European, or Asian makers of fine white tableware. Only the manufacture of such white wares as ironstone and hotel wares in the 1800s brought them commercial success.

LIVING WITH CERAMICS

Ceramics usage increased in homes in the colonies and young republic during the eighteenth and early nineteenth centuries. Ceramic objects filled a wide range of uses, and more people ate their food from ceramics than from metalwares or woodenwares.[61] Decorations, sizes, and available quantities increased.[62]

In most households in the 1600s, ceramics were not commonly used to prepare and serve food. Food generally was eaten from wood trenchers or pewter plates, and drinking vessels were made of pewter, leather, horn, or, more rarely, glass or silver. Dairying provided the main use for ceramics in most households at that time. Shards are frequently excavated in both New England and Southern sites and reflect the importance of dairy products as a protein source in the diets of colonists. Usually made of redware, these ceramic pans, jars, pitchers, and crocks, preferred for reasons of cleanliness, were used to skim, preserve, and prepare milk products.[63]

During the eighteenth century, some families began to use less-expensive English yellow earthenwares.[64] As the colonies developed and as production of European and English ceramics changed, more imported ceramics, especially tea wares, appeared. English salt-glazed stoneware increased in popularity in New England by the 1730s and 1740s, and was still common in the Chesapeake region in the 1770s.[65] In New England, delftware, combed slipware, and Westerwald stoneware were imported, as were mottled earthenware and dipped white salt-glazed stoneware.[66] A merchant's 1735 inventory gives the earliest evidence of porcelain in Plymouth, Massachusetts. Inventories of New England merchants and sea captains indicate that Chinese porcelain was present in quantity in their households by the 1750s, and by the 1760s, Chinese porcelain seems to have been almost as popular as delft and salt-glazed stoneware among the mariners, who had the opportunity and resources to buy Chinese wares. Porcelain appeared more often in such inventories, even though these seafarers were not the wealthiest individuals.[67]

Dating between 1723 and 1743 and recovered from the site of John Hicks's house in St. Mary's City, Maryland, ceramic fragments indicate usage similar to that of New England merchants and mariners. With his Chinese porcelain, English delftware, Rhen-

ish stoneware, and both domestic and imported earthenwares, Hicks, a landowner, merchant, and local official, owned 414 objects in 277 forms at a time when an average small landowner had approximately 13 ceramic vessels.[68] His assets at death—£383—placed him in the wealthiest 2 percent of inventoried planters of the three years prior to his death in 1753.[69]

The fashion for Eastern porcelain continued through the 1700s and early 1800s. Hicks owned about twenty pieces of porcelain, including fifteen cups and saucers related to the genteel practice of serving tea. His neighbor, William Deacon, "the grandee of the neighborhood," owned a porcelain dinner service for twenty.[70] George and Martha Washington owned at least one matched set of more than three hundred pieces of porcelain. Although not as widely owned as delftware, porcelain was available to wealthy Americans.[71]

After 1760, as ceramics became increasingly available and favored and tea decreased in cost, usage changed from earlier practices. More fine ceramics began to appear in more households. Although colonists favored orderly rooms with possessions carefully stored, they made exceptions of tea wares, which often were displayed on tea tables. Ceramic wares also graced mantel shelves, chests of drawers, and sideboards.[72] Potteries made and sold matched sets of ceramics; "complete" table sets included hundreds of pieces.[73]

By the third quarter of the eighteenth century, creamware was fashionable and, if undecorated, inexpensive. In 1770 George Washington replaced his white salt-glazed stoneware with newly fashionable but equally inexpensive creamware. The 250 items in the creamware set included plates, six dozen of which cost about the same as the same number of his white stoneware plates had cost thirteen years before.[74] As the size of his set suggests, the potteries turned out many forms, including punch strainers, oval-shaped fish drainers, pepper casters, hand wash basins, chamber pots, flowerpots, children's tea sets, and whistling toys.[75]

In the 1780s, pearlware joined creamware. Although by 1810, pearlware was the common ware, creamware and pearlware were made, sold, and used together through the 1820s. Most creamware from American archaeological sites is undecorated.[76] Some painted designs have been excavated at English pottery sites.[77] Decorated wares, however, were probably far less common on tables in the United States than less labor-intensive, less expensive undecorated creamware. In the 1820s, transfer-printed decoration became the predominant decoration on pearlware.[78]

English wares produced for export in the late eighteenth century were similar to those produced for home use. At times, however, ornament differed. To attract the export market in the United States, English manufacturers decorated creamware and pearlware with popular images, like the eagle. By the nineteenth century, sponge and spatterware, so-called gaudy Dutch, and dark blue printed wares were made in England almost exclusively for the American market.

Many colonists who lived far from trade centers or who were poor had more limited choices in tablewares. They probably still used wooden plates and lead-glazed redware. Red earthenware porringers were the most simple and least expensive vessels for food, and red earthenware "dairying" vessels remained popular into the nineteenth century. Today, redware is heavily represented in the shards recovered from archaeological digs. Despite the proliferation of ceramics in number and variety as the eighteenth century turned into the nineteenth, other choices for eating and preparing food persisted, including pewter.[79]

Ceramics for Tea

By the second quarter of the 1700s, tea wares appeared in households. Colonists in the upper classes used silver occasionally in addition to English ceramics of all kinds.[80] Chinese porcelain was considered to be elegant and became more readily available when direct trade with China opened after the Revolution.[81] In the mid-eighteenth century, tea drinking and ownership of tea wares attracted people in most social groups.[82] They wanted "Table and Tea Setts in particular and finer patters" and "Tea Potts Sugr dishes milk potts, Pint Basons &c to match the cups & saucers."[83]

A well-equipped eighteenth-century tea table displayed a teapot, slop bowl, milk pot, tea caddy, sugar container, tongs, teaspoons, and cups and saucers.[84] Ceramics were sold, although not necessarily made, in sets, but customers usually purchased single teacups, coffee cups, and breakfast cups with saucers and assembled sets as large or small as desired. By the late 1700s, people at most economic levels used tea wares, symbols of refinement.[85] It was only in the second half of the 1800s that large sets of tea wares and dinnerwares were made and sold as such.[86]

Various Uses of Ceramic Objects

Ceramic objects were used in various ways for presentation and display. Lengthy meals were a principal means of entertainment for the wealthy, and ceramics used for dining were prized. Scratch-blue

stoneware was preferred from the 1740s to the 1760s for engagement, baptismal, and birthday gifts.[87] Ornamental porcelains, including figurines and elaborate candleholders with branches, were among the most fragile, least available, and most expensive ceramic objects. Shards from such objects have been excavated from several sites in Virginia. Sturdy domestic wares were used in taverns. Archaeological excavations at tavern sites have revealed stoneware bottles with cobalt-blue decoration, glazed redware mugs, and delft punch bowls. These were less expensive, less fashionable choices after the late 1700s, when white-bodied earthenwares, such as creamware, and porcelain became readily available. Excavations at taverns that served elite customers yield shards of Chinese porcelain punch bowls. These customers used individual drinking bowls rather than large, common-use vessels found at working-class taverns, and wineglasses instead of stoneware mugs.[88] Shards of plates, teacups and saucers, teapots, saltcellars, sauceboats, and serving bowls of creamware and pearlware have also been recovered.[89]

Especially when studied with such other resources as bills of lading, merchant accounts, and shop and probate inventories, ceramics can indicate socioeconomic patterns and a widening dissemination of popular culture. Changes in political imagery, for example, can be traced in ornament on both inexpensive and expensive ceramics.[90] Ceramics also provide evidence of the passing of customs and values from generation to generation.[91]

CONCLUSION

The appearance and usage of ceramics changed markedly from the time of first European settlement on the Atlantic coast until the years of the new republic. Ceramics reflect significant changes in cooking and eating, keeping clean and healthy, entertaining guests, acquiring new goods, and displaying wealth and taste. The collections displayed at many museums and historic houses support interpretations of these themes.

During the time from 1620 to about 1860, European settlers and their descendants in the North American British colonies became users of ceramics. As the number and variety of forms expanded, Americans increasingly owned individual eating vessels and objects for specific foods. Chamber pots and washing bowls and pitchers encouraged habits of personal cleanliness. The marketing of ceramics is an early demonstration of satisfying needs and creating desires. Factors of trade and production, as well as the needs,

attitudes, and customs of the users, can reveal why a simple material—clay—became so variously formed, widely used, and highly elaborated.

NOTES

1. For a recent study of archaeology at a colonial site, see Kelso; for scholarship on English potteries, see the work of David Barker; for work on ceramics used in the British North American colonies, see the writings of George Miller and Ann Smart Martin. The journal *Ceramics in America*, published by the Chipstone Foundation, records the most recent work. Some articles may be read online at http://www.chipstone.org.
2. Savage and Newman, 45.
3. Miller and Earls, 90, state that underglaze blue decoration on wares imported from England became much more common beginning in the mid-1700s, when refining processes were set up in Staffordshire and access to raw materials improved.
4. Denker, 26; Miller and Earls, 92.
5. Schwind, "Pennsylvania German Earthenware," 187.
6. Schwind, "Pennsylvania German Earthenware," 191–99.
7. Schwind, "Pennsylvania German Earthenware," 197.
8. Kingery, 10–11, 230.
9. Palmer, 10.
10. Rinaldi, 60–63, 67, 100–102. The ceramics that were recovered from the sunken *Witte Leeuws* were decorated on the border and sometimes in the center with auspicious symbols related to longevity. The symbols, which come from Chinese religious traditions, may have been chosen because the dishes were made during a period of war and famine in China.
11. Palmer, 23.
12. Palmer, 114.
13. Palmer, 45.
14. Palmer, 17.
15. Palmer, 17–18.
16. Palmer, 17, 84, 85.
17. Palmer, 73.
18. Garner, 1.
19. Garner, 2.
20. Garner, 16–19.
21. Godden, 71–72.
22. Garner, 19–20; Emmerson, 40–57.
23. Godden, 71–72.
24. Flynt and Fales, 84; Baarsen et al., 223; see chapter 5 in this volume for more on baroque concepts of grand but compartmented space.
25. Halfpenny, 30–39.
26. Miller, "Origins," 83–84; Barker and Halfpenny, 71–77.
27. Barker and Halfpenny, 70.
28. Miller, "Origins," 90; see also Miller and Earls, 92.
29. McKendrick, Brewer, and Plumb, 100.
30. *Stonewares & Stone Chinas*, 59–78. See also examples illustrated in Godden, 115–16.

31. McKendrick, Brewer, and Plumb, 113.
32. McKendrick, Brewer, and Plumb, 114.
33. This section about the techniques of making and decorating ceramics was developed from information supplied by curators of glass and ceramics at Winterthur, 1990–1999.
34. Barker and Halfpenny, 7.
35. Emmerson, 40–57.
36. Halfpenny, 30–39.
37. Williams-Wood, 24–26; Holdway and Drakard, 10; Halfpenny, 30–39.
38. Schwind, "Ceramic Imports," 32.
39. See Deetz, "Ceramics from Plymouth," 21, for a graphic representation of redware usage.
40. McKendrick, Brewer, and Plumb, 103.
41. Denker, 24.
42. Miller, "Marketing," 2.
43. Deetz, "Ceramics from Plymouth," 21.
44. Blaszczyk, 7.
45. Miller, "Marketing," 4.
46. Schwind, "Ceramic Imports," 23.
47. Palmer, 22–24.
48. Blaszczyk, 14.
49. Miller, "Marketing," 3.
50. McKendrick, Brewer, and Plumb, 100, 103.
51. Schwind, "Ceramic Imports," 32.
52. Letter from Josiah Wedgwood to his partner, Thomas Bentley, February 9, 1778, as quoted in McKendrick, Brewer, and Plumb, 112; McKendric, Brewer, and Plumb, k, 121–22.
53. Wedgwood to Bentley, June 1, 1767, as quoted in McKendrick, Brewer, and Plumb, 118.
54. McKendrick, Brewer, and Plumb, 118.
55. McKendrick, Brewer, and Plumb, 129.
56. Schwind, "Ceramic Imports," 31.
57. Blaszczyk, 1b.
58. As quoted in Palmer, 25.
59. Blaszczyk, 18.
60. Denker, 29–32.
61. Janowitz, 51.
62. Deetz, "Ceramics from Plymouth," 25; Brown, 45.
63. Deetz, In Small Things Forgotten, 53–55.
64. Martin, 19; Schwind, "Ceramic Imports," 33; Baugher and Venables, 46–47.
65. Brown, 45; Blaszczyk, 11–13.
66. Deetz, "Ceramics from Plymouth," 24.
67. Brown, 48.
68. Brown, 48.
69. Carr, 82–91; Stone, 104, 112–15.
70. Stone, 105, 121.
71. Stone, 104, 124; Carr, 191.
72. Deetz, "Ceramics from Plymouth," 21; Stone, 104.
73. Golovin and Roth, 51.
74. Detweiler, 30, 54, 57.
75. Schwind, "Ceramic Imports," 23, 31.

76. Noël Hume, 235–36.
77. Miller, "Marketing," 90.
78. Barker and Halfpenny, 70–82.
79. Myers, 58.
80. Martin, 18.
81. Schwind, "Ceramic Imports," 25.
82. Roth, 65–80.
83. Golovin and Roth, 55; Carr and Walsh, 66–67.
84. From a letter written January 20, 1781, by New York merchant Frederick Rhinelander to Hodgson and Donaldson, as quoted in Golovin and Roth, 54.
85. Schwind, "Ceramic Imports," 23.
86. Miller and Earls, 83.
87. Roth, 74.
88. Detweiler, 44.
89. Patrick, 44.
90. Patrick, 44.
91. Nelson, 93.

BIBLIOGRAPHY

Barber, Edwin AtLee. *The Pottery and Porcelain of the United States: An Historical Review of American Ceramic Art from the Earliest Times to the Present Day.* 3rd ed., rev. and enl. New York: G. P. Putnam's Sons, 1909.

Brown, Marley. "Ceramics from Plymouth, 1621–1800: The Documentary Record." In *Ceramics in America*, edited by Ian M. G. Quimby, 41–74. Winterthur, Del.: Henry Francis du Pont Winterthur Museum, 1973.

Carr, Lois Green. "Ceramics from the John Hicks Site, 1723–1743: The St. Mary's Town Land Community." In *Ceramics in America*, edited by Ian M. G. Quimby, 75–102. Winterthur, Del.: Henry Francis du Pont Winterthur Museum, 1973.

Deetz, James. "Ceramics from Plymouth, 1620–1655: The Archeological Evidence." In *Ceramics in America*, edited by Ian M. G. Quimby, 15–40. Winterthur, Del.: Henry Francis du Pont Winterthur Museum, 1973.

Denker, Ellen Paul. "Ceramics at the Crossroads: American Pottery at New York's Gateway 1750–1900." *Staten Island Historian* 3, n.s. 3 & 4 (Winter/Spring 1986): 21–36.

Detweiler, Susan Gray. *George Washington's Chinaware.* New York: Harry N. Abrams, 1982.

Diethorn, Karie. *Domestic Servants in Philadelphia, 1780–1830.* Philadelphia: Independence National Historical Park, 1986.

Godden, Geoffrey A. *British Pottery: An Illustrated Guide.* London: Barrie and Jenkins, 1974.

Hillier, Bevis. *Pottery and Porcelain, 1700–1914: England, Europe, and North America.* New York: Meredith Press, 1968.

Hood, Graham. *Bonnin and Morris of Philadelphia: The First American Porcelain Factory, 1770–1772.* Chapel Hill: University of North Carolina Press for the Institute of Early American History and Culture, Williamsburg, Va., 1972.

Janowitz, Meta. "New York City Stonewares from the African Burial Ground." In *Ceramics in America 2008*, edited

by Robert Hunter, 41–66. Milwaukee, Wis.: Chipstone Foundation, 2008.

McKendrick, Neil, John Brewer, and J. H. Plumb. *The Birth of a Consumer Society: The Commercialization of Eighteenth-Century England.* Bloomington: Indiana University Press, 1982.

Miller, George L. "Marketing Ceramics in North America." *Winterthur Portfolio* 19, no. 1 (Spring 1984): 1–5.

———. "Origins of Josiah Wedgwood's 'Pearlware.'" *Northeast Historical Archaeology* 16 (1987): 83–95.

———. "A Tenant Farmer's Tableware: Nineteenth Century Ceramics from Tabb's Purchase." *Maryland Historical Magazine* 69, no. 2 (Summer 1974): 197–210.

Miller, George L., and Amy C. Earls. "War and Pots: The Impact of Economics and Politics on Ceramic Consumption Patterns." In *Ceramics in America 2008,* edited by Robert Hunter, 67–108. Milwaukee, Wis.: Chipstone Foundation, 2008.

Mountford, Arnold R. "Staffordshire Salt-Glazed Stoneware." In *Ceramics in America,* edited by Ian M. G. Quimby, 197–216. Winterthur, Del.: Henry Francis du Pont Winterthur Museum, 1973.

Roth, Rodris. *Tea Drinking in 18th-Century America: Its Etiquette and Equipage.* Washington, D.C.: Smithsonian Institution, 1961.

Additional Sources

Adams, Elizabeth, and David Redstone. *Bow Porcelain.* London: Faber and Faber, 1981.

Baarsen, Reinier, et al. *Courts and Colonies: The William and Mary Style in Holland, England, and America.* New York: Cooper-Hewitt Museum, 1988.

Barker, David. "Discovering Staffordshire Ceramics." In *International Ceramics Fair and Seminar.* London: International Ceramics Fair and Seminar Ltd., 1991.

Barker, David, and Pat Halfpenny. *Unearthing Staffordshire: Towards a New Understanding of 18th-Century Ceramics.* Stoke-on-Trent, Eng.: City Museum and Art Gallery, 1990.

Baugher, Sherone, and Robert W. Venables. "Ceramics as Indicators of Status and Class in Eighteenth-Century New York." In *Consumer Choice in Historical Archaeology,* edited by Suzanne M. Spencer-Wood. New York: Plenum Press, 1987.

Beaudry, Mary C. "Ceramics in York County, Virginia, Inventories 1730–1750: The Tea Service." *Conference on Historic Site Archeology Papers* 12 (1978): 201–10.

———, ed. *Documentary Archaeology in the New World.* Cambridge: Cambridge University Press, 1988.

Blaszczyk, Regina Lee. "Ceramics and the Sot-Weed Faction: The China Market in a Tobacco Economy." *Winterthur Portfolio* 19, no. 1 (Spring 1984): 7–20.

Busch, Jane. *Philadelphia Kitchens.* Philadelphia: Independence National Historical Park, 1986.

Carr, Lois Green, and Lorena S. Walsh. "Changing Lifestyles and Consumer Behavior in the Colonial Chesapeake." In *Of Consuming Interests: The Style of Life in the Eighteenth Century,* edited by Cary Carson, Ronald Hoffman, and Peter J. Albright, 59–166. Charlottesville: University Press of Virginia for the United States Capitol Historical Society, 1994.

Catts, Wade P., et al. "The Place at Christeen." *Final Archeological Investigations of the Patterson Lane Site, Complex Christiana.* New Castle County, Del.: Delaware Department of Transportation, 1989.

Deetz, James. *In Small Things Forgotten: The Archaeology of Early American Life.* Garden City, N.Y.: Anchor Books, 1977.

Emmerson, Robin. "Pottery and the Liverpool Trade." In *Success to America: Creamware for the American Market,* by S. Robert Teitelman, Patricia A. Halfpenny, and Ronald W. Fuchs II, 40–57. Woodbridge, Eng.: Antique Collectors' Club, forthcoming.

Flynt, Henry N., and Martha Gandy Fales. *The Heritage Foundation Collection of Silver.* Old Deerfield, Mass.: Heritage Foundation, 1968.

Garner, F. H. *English Delftware.* London: Faber & Faber, 1948.

Golovin, Ann, and Rodris Roth. "New and Different: Home Interiors in Eighteenth-Century America." Unpublished exhibition script. Washington, D.C.: National Museum of American History, 1988.

Halfpenny, Patricia A. "Creamware and the Staffordshire Potteries." In *Success to America: Creamware for the American Market,* by S. Robert Teitelman, Patricia A. Halfpenny, and Ronald W. Fuchs II, 30–39. Woodbridge, Eng.: Antique Collectors' Club, forthcoming.

Herman, Bernard. "The Multiple Materials, Multiple Meanings: The Fortunes of Thomas Mendenhall." *Winterthur Portfolio* 19, no. 1 (Spring 1984): 67–86.

Holdway, Paul, and David Drakard. *Spode Printed Ware.* London: Longman, 1983.

Kelso, William M. *King's Mill Plantation, 1619–1800: Archaeology of Country Life in Colonial Virginia.* Orlando, Fla.: Academic Press, 1984.

Kingery, W. David, and Pamela B. Vandiver. *Ceramic Masterpieces: Art, Structure, and Technology.* New York: Free Press, 1986.

Klaber, Pamela. "Oriental Influences on English Porcelain." In *Antique Dealer and Collectors' Guide* (April 1978): 94–99.

Martin, Ann Smart. "The Role of Pewter as Missing Artifact: Consumer Attitudes Toward Tablewares in Late Eighteenth-Century Virginia." *Journal of the Society for Historical Archeology* 23, no. 2 (1989): 1–27.

Myers, Susan H. "Marketing American Pottery: Maulden Perrine in Baltimore," *Winterthur Portfolio* 19, no. 1 (Spring 1984): 51–66.

Nelson, Christina H. "Transfer-printed Creamware and Pearlware for the American Market." *Winterthur Portfolio* 15, no. 2 (Summer 1980): 93–115.

Noël Hume, Ivor. "Creamware to Pearlware: A Williamsburg Perspective." In *Ceramics in America*, edited by Ian M. G. Quimby, 217–54. Winterthur, Del: Henry Francis du Pont Winterthur Museum, 1973.

Otto, John Solomon. "Artifacts and Status Differences: A Comparison of Ceramics from Planter, Overseer, and Slave Sites on an Antebellum Plantation." In *Research Strategies in Historical Archeology*, edited by Stanley South, 91–118. New York: Academic Press, 1977.

Palmer, Arlene. *A Winterthur Guide to Chinese Export Porcelain.* New York: Crown Publishers, 1976.

Patrick, Steven Edward. *Deposited in This City: The Archeological Evidence of Philadelphia, The Capital City, 1790–1800.* Philadelphia: Independence National Park, 1987.

Rinaldi, Maura. *Kraak Porcelain: A Moment in the History of Trade.* London: Bamboo Publishing, 1989.

Salwen, Bert, Sarah T. Bridges, and Nan A. Rothshild. "The Utility of Small Samples from Historic Sites: Onderdonk, Clinton Avenue, and Van Campen." *Journal of Historical Archeology* 15 (1981): 79–94.

Savage, George, and Harold Newman. *An Illustrated Dictionary of Ceramics.* London: Thames and Hudson, 1985.

Schwind, Arlene Palmer. "The Ceramic Imports of Frederick Rhinelander, New York Loyalist Merchant." *Winterthur Portfolio* 19, no. 1 (Spring 1984): 21–36.

———. "Pennsylvania German Earthenware." In *Arts of the Pennsylvania Germans*, by Scott T. Swank et al., 171–99. New York: W. W. Norton, 1983.

South, Stanley, ed. *Research Strategies in Historical Archeology.* New York: Academic Press, 1977.

Stone, Gary Wheeler. "Ceramics from the John Hicks Site, 1723–1743: The Material Culture." In *Ceramics in America*, edited by Ian M. G. Quimby, 103–40. Winterthur, Del: Henry Francis du Pont Winterthur Museum, 1973.

Stonewares & Stone Chinas of Northern England to 1850. The Fourth Exhibition from the Northern Ceramic Society. Stoke-on-Trent, Eng.: City Museum and Art Gallery, 1982.

Turnbaugh, Sara Peabody. "Seventeenth- and Eighteenth-Century Lead-Glazed Redwares in the Massachusetts Bay Colony." *Journal of Historical Archeology* 17, no. 1 (1983): 3–17.

———, ed. *Domestic Pottery of the Northeastern United States, 1625–1850.* Orlando, Fla.: Academic Press, 1985.

Ulrich, Laurel Thatcher. "Martha Ballard and Her Girls." In *Work and Labor in Early America*, edited by Stephen Innes, 70–105. Chapel Hill: University of North Carolina Press, 1988.

Watkins, Lura Woodside. *Early New England Potteries and Their Wares.* Cambridge, Mass.: Harvard University Press, 1950.

Wilcoxen, Charlotte. *Dutch Trade and Ceramics in America in the Seventeenth Century.* Albany, N.Y.: Albany Institute of History and Art, 1987.

Williams-Wood, Cyril. *English Transfer-Printed Pottery and Porcelain: A History of Over-Glaze Printing.* London: Faber and Faber, 1981.

Glassware

Glass objects gleam in many historic interiors just as they probably did centuries ago. Visitors can readily imagine people pouring from these bottles, drinking from these glasses, and illuminating their evening pleasure and duties with these lamps. The decorative quality of many glass objects balances their obvious function. Today, ownership of glass is ordinary. Glass is considered to be disposable or recyclable, so visitors may not realize the extent to which people in the past valued all glassware, including utilitarian bottles and window glass.

LOOKING AT GLASS

The play of light over and through glass often increases not only its beauty but also the viewer's fascination with a solid object that is nevertheless transparent or translucent. A ray of light is refracted as it passes through glass, giving a brilliance that is often the most striking visual quality of the object. For centuries, glassmakers attempted to produce colorless, crystal-clear glass. Even today, we call fine glass "crystal," for rock crystal has often been the standard by which glassmakers judge their material.

Two blown bottles and a pressed glass compote demonstrate different colors, forms, and ornamental techniques in glass. The first bottle was made in Maryland in 1788 (fig. 13-1), the second in Pennsylvania between 1769 and 1774 (fig. 13-2), and the compote was made in Massachusetts between 1830 and 1845 (fig. 13-3).

Color

In the eighteenth century, most glass objects meant for table use were as colorless as the glassmaker could produce. Windows and bottles of greenish glass were the common, profitable products of most colonial glasshouses, but tablewares in blue and purple also were produced.[1] Intentionally colored table glass became increasingly popular in the nineteenth century, and glassmakers experimented with new effects that included opalescence and unusual color shadings. The Maryland bottle is considered colorless glass, but it has a slight grayish tint. The Pennsylvania bottle is deep purple, and the compote is colorless.

Form

Shapes of glass objects range from simple, functional, round and rectangular forms to elaborate, decorative configurations. In 1788 a glassmaker at John Frederick Amelung's New Bremen, Maryland, manufactory blew a bottle into a mold that gave it square sides with high shoulders and a short, cylindrical neck—a simple, functional shape. The shape contrasts markedly with the more decorative facets and curves of the compote. The rounded shape of the Pennsylvania bottle is typical of "pocket bottles" used to carry liquids, alcoholic or therapeutic.[2] Some glass objects integrate interesting shapes within the overall form, as in eighteenth-century English wineglasses with stems that contain air twists or twisted threads of opaque white glass.

Ornament

Ornament of various types and motifs is relatively easy for museum visitors to see and distinguish. At times, a glassblower would decorate a form by applying more glass to the blown body and drawing it into various shapes. The glass gather (massive layer of molten glass) applied to the body as decoration has a fluid look, as do applied glass threads. Eighteenth- and nineteenth-century glassmakers used molds with patterns—from simple ribs and diamonds to more complicated designs. The Pennsylvania bottle was blown into a patterned mold, resulting in a diamond-over-flute design.

Glass objects were decorated by engraving, cutting, pressing, enameling, gilding, and painting to enhance visual appeal. The ball, chain, ring, wreath, two birds, and inscription on the Maryland bottle were wheel-engraved. The motifs on the compote show the decorative possibilities of pressing glass in a mold, from the floral designs on the exterior to the classically inspired

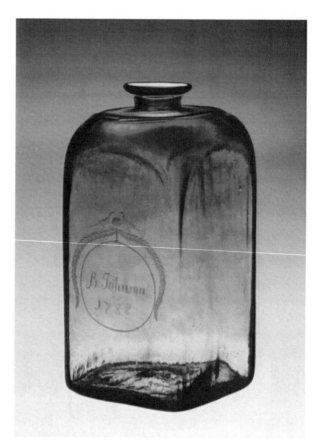

FIGURE 13-1. The shape of this bottle, one of nine made for Colonel Baker Johnson of Frederick, Maryland, fit into a partitioned walnut case. Bottles and window glass made up the great majority of glass manufactured in eighteenth-century America. (Case bottle, Frederick County, Md., 1788. Nonlead glass; H 7⅕ in., W 3½ in., D 3⅖ in. 1973.357 Winterthur Museum.)

paw feet on the shaft. A champagne flute exemplifies fashion in cut glass dating from the early nineteenth century (fig. 13-4).

THINKING ABOUT STYLE

Fashionable cosmopolitan styles influenced the decoration and forms of finely crafted glass tablewares and lighting devices. Functional considerations influenced how bottles looked, which changed over time from squat, rounded forms of the early eighteenth century to tall, cylindrical forms of the mid- to late eighteenth and early nineteenth centuries, reflecting a growing trend to age wines in bottles, which required that they be stored on their sides.[3]

Baluster-stem wineglasses, fashionable from about 1695 to the 1720s, exhibit baroque characteristics in their massive curved elements and the brilliance in the air bubbles trapped in stems. Engraved motifs of roses,

grapevines, insects, and birds recall rococo designs, as do the cabriole legs on three-footed cream jugs (fig. 13-5).[4] Air-twist wineglasses, fashionable throughout mid-eighteenth-century English colonies, also are rococo in inspiration, as are the facet-cut stems made slightly later in the 1770s. The diamond-and-fan pattern on the champagne flute reflects the growing interest in the neoclassical taste.

Ornaments on late eighteenth- and early nineteenth-century engraved glassware often displays classical elements in their symmetrically arranged swags, tassels, eagles, and floral bands (fig. 13-6). From the late 1820s through the 1840s, cornucopias, lyres, eagles, and baskets of fruit decorated much molded-glass tableware and bottles. By the 1830s, dolphin-shape candlesticks had appeared, as had pier tables with dolphin-shape front legs (fig. 13-7). Reflecting a romantic revival, Gothic pointed arches occasionally appeared on glasses and lampshades in the first half of the nineteenth century.

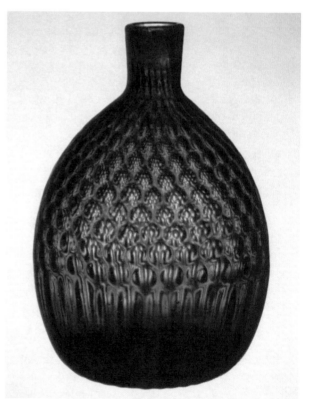

FIGURE 13-2. Pocket bottles survive in larger numbers than other glass forms of the eighteenth century. The decoration of this bottle, created by blowing into metal molds, was probably inspired by cut floral motifs in Continental glass. The purple color results from the use of manganese dioxide in the glass batch. (Pocket bottle, Manheim, Pa., 1769–1774. Nonlead glass; H 5¼ in., W 3½ in., D 2¾ in. 1959.3081 Winterthur Museum, bequest of Henry Francis du Pont.)

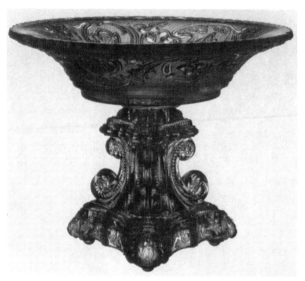

FIGURE 13-3. The C-scroll base of this compote resembles pillar-and-scroll bases of center tables in the empire style. The compote form was a dramatic dinner table decoration for displaying the fresh fruit that closed the dessert course. (Compote, probably Sandwich, Mass., 1830–1845. Lead glass; H 5⅜ in., Diam of dish 7⅜ in. 1967.97 Winterthur Museum.)

MAKING AND MARKETING GLASS OBJECTS

From Mesopotamia and the eastern Mediterranean, glassmaking radiated throughout the Mediterranean world with the advance of the Roman Empire, where glassmakers used blowing, casting, and molding techniques. After the fall of Rome in the fifth century, European glassmaking declined until the Venetians revived the production of colorless or *cristallo* glass during the Renaissance. They dominated glass markets in Europe in the sixteenth and early seventeenth centuries.[5] Documentary and archaeological evidence reveals that a few English colonists in Jamestown and Massachusetts owned Venetian wineglasses. Commercially successful glasshouses were operating in the British North American colonies by the mid eighteenth century.

Knowledge of glassmaking technology adds to the appreciation of these forms. An amorphous (noncrystalline) compound, glass is made by fusing silica (derived from quartz, flint, or sand), an alkali (such as potash, soda, or lead oxide), and a stabilizer (usually lime) in a clay crucible at high temperature. These ingredients are neither rare nor precious. The quality of the raw materials, however, is important; for example, the fewer iron impurities in the sand, the less green the glass.

There is not a single formula for glass. Most successful glassmaking relied on glassmakers' skills in working with local raw materials. Adding cullet (bits

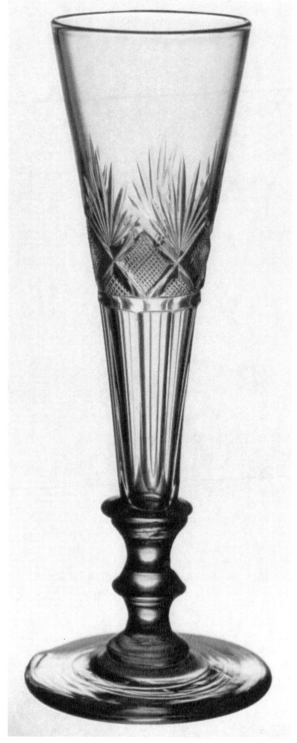

FIGURE 13-4. Glass that includes lead in its composition is especially receptive to cutting with stone or copper wheels; it is also highly refractive. Both qualities make it ideal for this strawberry, diamond, and fan pattern. The glitter and sparkle of this decoration was an appropriate complement to the newly popular effervescent champagne in nineteenth-century America. (Champagne flute or wineglass, United States, England, or Ireland, 1815–1835. Lead glass; H 7 in., Diam of bowl 2⅛ in. 1968.128.1 Winterthur Museum.)

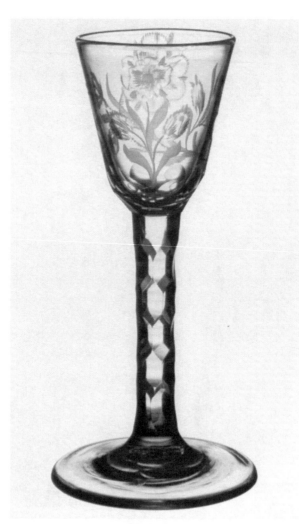

Glass melts at about 1400 degrees Celsius, and an abundance of fuel was required to maintain the furnace temperature. All glasshouses in eighteenth-century North America were located near tracts of wooded land. In 1747 Benjamin Franklin, a neighbor of Caspar Wistar, who owned a New Jersey glassworks, wrote concerning the glassworks' fuel supply: "Our glasshouse consumes Twenty-four Hundred Cords of Wood per Annum tho' it works but Seven Months in the Year.... It is split small and dried well in a Kiln before 'tis thrown into the Furnace. The Cutting, Hauling, Splitting and Drying of this Wood, employs a great many Hands, and is the principal Charge."[7] As a by-product, wood also "furnishes at the same Time [a] great Part of the Ashes that are Wanted"—that is, potash, often used as the alkaline ingredient in glass-making.[8] Also used in soapmaking, potash became a major colonial export to England.

The ingredients for a batch of glass were melted in a huge pot, made from special clay called "fire clay." In colonial times, cracked or poorly made pots that burst in a furnace could halt production for months and

FIGURE 13-5. Because it did not affect the taste of beverages, glass was an ideal material for drinking vessels. Wineglasses customarily had stems that were decorated in baluster shapes, with twists of air or opaque colored rods. As seen here, they also had facet-cut stems known as "cut shanks." Lazarus Isaac, the first glasscutter and engraver known to have worked in America, advertised in 1773 that he could cut wineglass stems in "diamonds." (Wineglass, England, 1770–1790. Lead glass; H 5¾ in., Diam of bowl 2⅛ in. 1968.167 Winterthur Museum.)

of broken glass) to the mixture eased the fusing process. Adding lead oxide to a batch, a specialized process not attempted in America until the eighteenth century, produced heavy, soft, brilliant glass.[6] Other ingredients could compensate for the "natural" color of glass, which is green/brown, due to the presence of iron impurities. Manganese dioxide, called "glassmaker's soap," was a decolorizer that, in small quantities, counteracted a green tint, and, in large quantities, made glass purple. Cobalt was used to produce blue glass. Copper produced green and red glass; silver and uranium made glass yellow; and gold imparted a ruby color.

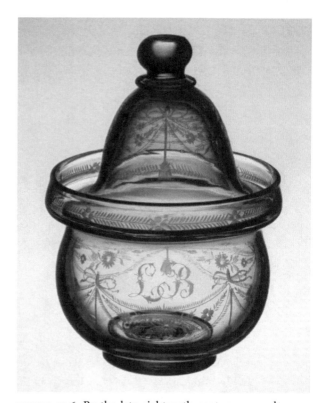

FIGURE 13-6. By the late eighteenth century, sugar became more available and was used on everything from meat and fish to wine and tea. The high dome of this glass sugar bowl lid, which fit inside the raised rim of the bowl, is a nineteenth-century fashion. (Sugar bowl with cover, United States, 1815–1835. Lead glass; H 7 in., Diam of bowl 5¹⁄₁₆ in. 1959.3120 Winterthur Museum, bequest of Henry Francis du Pont.)

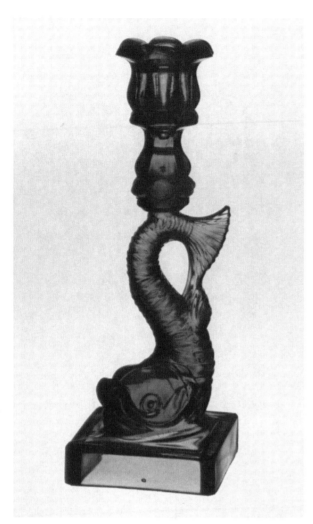

FIGURE 13-7. The origin of the dolphin design for this pressed-glass candlestick can be found in ancient art, but American glassmakers probably copied the figure from English earthenware candlesticks made at Leeds Pottery. Similar dolphins can be seen as supports on pier tables of the empire style. (Candlestick [one of two], probably Boston and Sandwich Glass Company, Sandwich, Mass., 1845–1865. Lead glass; H 10⅜ in., base 3¾ in. square. 1973.459.2 Winterthur Museum, gift of Mrs. Harry W. Lunger.)

could lead to bankruptcy. Because pots often wore out after three or four months, specially trained pot makers regularly replaced them to avoid costly breakage.

Window glass for colonial buildings was made by either the crown or the cylinder method. Using the crown method, a glassmaker blew a molten gather of glass into a bubble, shaped it into a large, flattened globe, then attached a pontil rod opposite the blowpipe and removed the pipe, leaving an opening in the glass globe. The glass "crown" on the pontil was reheated and spun, and the disk flattened into a large circular sheet from which window glass could be cut.[9] The crown method required a team of eight men and

great physical strength, particularly from the glassblower, to handle the cumbersome disk, usually four to five feet in diameter.[10]

In the cylinder method, a gaffer (head glassblower) blew and shaped a long, hollow cylinder about one foot in diameter and several feet long. Slit lengthwise and placed in a special "flatting" oven, the cylinder was flattened into a sheet. Once annealed (heated to remove or prevent internal stresses), the sheet was cut into panes of the desired size.[11] Larger sheets could be made by the cylinder method, but the clarity was not as good as in crown glass.

Glassmakers used several different methods to form glass objects, and each produced objects with slightly different appearances. Looking closely at the objects reveals clues about production. Glassmakers formed objects by blowing, using part-size molds, blowing into full-size molds, and pressing.

Blowing

Blowing glass required the concerted efforts of a team of workers in which specialized skills and experience earned rank and salary: a skilled gaffer, who blew and formed the glass; a gatherer, who brought a gather of molten glass on a blowpipe to the gaffer; a sticker-up, who periodically reheated the gather; and a carry-in boy, who placed the finished piece on a tray in a cooling oven for annealing. With a gather of glass on the end of his pipe, a glassblower blew through the pipe to inflate an object. He used pincers, paddles, and shears to shape the glass. The production of freeblown glass required skill and time. Often, free-blown objects or parts of objects show the curvilinear lines and lack of hard edges that are characteristic of a material worked in a molten state.[12]

Molding

Reducing the time and labor required to make glass, molds were used to both shape and decorate. They could produce objects of uniform size and capacity. Part-size molds gave pattern, while full-sized molds, as the name implies, were used to form an object that was blown to its finished size and shape within the mold.[13]

Glassmakers used dip molds and part-size molds to pattern gathers of glass before blowing to finished size. One-piece dip molds were used to create such designs as ribbing. Hinged part-size molds were used to create more elaborate patterns and had to be opened for removal of a patterned gather. With a dip or part-size mold, a glassblower blew a gather of glass into the

mold, extracted the decorated bubble, and continued to blow and shape it to achieve the desired size and form of the object. As the mold was patterned, so was the extracted glass, and the ornamental elements remained regardless of how much the gather was inflated. If a glass object has a simple pattern with soft edges, it may have been pattern-molded and then blown to full size. The diamonds in a honeycomb design and the flutes on the Pennsylvania pocket flask were made in this way (see fig. 13-2).

Full-size molds that shaped, sized, and patterned glass objects were developed in the nineteenth century. In about 1820, the first such molds were used to make standard-size liquor bottles. Workers with little training could produce standard glass objects more quickly than blowers making free-blown glass. If a glass object has a complex, detailed pattern, it may have been produced in a full-size mold. In the competitive struggle for the market in the United States, manufacturers on both sides of the Atlantic used molds with three, four, or five hinged parts to produce glass that imitated English cut-glass patterns. The three most-used patterns were ribs and flutes; ribs and diamonds; and ribs, diamonds, and sunburst (fig. 13-8).

Pressing

An American innovation in glassmaking technology was the development in the 1820s of the glass press that was used to produce full-size, completed objects. A less expensive process than molding, pressing created an object by squeezing molten glass into a metal mold. The finished product had the design on one side, from the mold, and a smooth surface on the other from the plunger. One disadvantage of pressing was a wrinkled surface, which was caused by the contact of molten glass with the cool metal surface of the mold. Covering one side of the object with a stippled design, made up of tiny raised dots, obscured the wrinkles and resulting cloudiness; such glass is called "lacy" pressed glass today. Pressed glass objects often have an elaborate overall design and crisp details.

With little skill, a two-man team could produce about one hundred pressed glass objects in an hour. The challenge was getting the proper quantity of glass into the molds; too much produced an object that was too thick, and too little made an incomplete object. To achieve a properly glassy surface, the team also had to be careful to keep the molds at proper temperature; if a mold was too cool, the glass would not flow, but if a mold was too hot, the glass would adhere to both plunger and mold. Factories

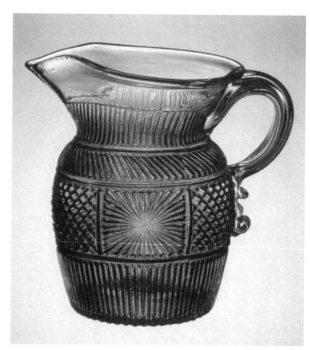

FIGURE 13-8. Made by blowing glass into a full-size hinged mold, the body of this pitcher was intended to look like cut glass. The pattern of three repeating panels of diamond and sunburst can be felt on both the inside and outside of the pitcher. If the decoration were true cut glass, the inside of the pitcher would feel perfectly smooth, while the exterior decoration would feel quite sharp. (Pitcher, probably Massachusetts, 1815–1840. Lead glass; H 6½ in., Diam 4⅗ in., L 6⅗ in. 1959.3221 Winterthur Museum, bequest of Henry Francis du Pont.)

all over the United States made pressed glass in the nineteenth century. The result was a relatively inexpensive glass product that many people could afford. Many early pieces of pressed glass have decoration that is similar to cut glass.

Marketing Glass Objects

Establishing a glassworks in the colonial period required a substantial capital investment to buy timbered land as well as technical know-how to direct the building of the furnaces. An owner also had to hire skilled labor, including the services of at least one expert who knew how to mix glass batches, supervise control of the furnace, and blow the glass. The ever-present need for abundant firewood usually placed glasshouses far from their markets; therefore, ready access to water or overland transportation was essential for financial success.

Although efforts were made to start glasshouses in Jamestown in 1608 and 1621, in Massachusetts in 1639, and in New York in 1645, commercial success did not occur until the eighteenth century. Even so,

of the nearly twenty glasshouses established between 1732 and 1790, only three were even slightly profitable. English mercantilist economic policy discouraged the development of industries in the colonies, and the government did not permit English glassmakers to emigrate. England's strictures may explain why profitable eighteenth-century glassworks in North America were started by German colonists. The owners of three such glassworks whose works have been well documented are Caspar Wistar, Henry William Stiegel, and John Frederick Amelung. Wistar arrived in Philadelphia from Hilsbach, Germany, in September 1717 and became a wealthy merchant and brass-button maker. In 1738 he purchased more than two thousand acres of wooded land along Alloway's Creek near Salem, New Jersey. In 1739, in a cooperative financial arrangement, Wistar and several German glassmakers, whose resettlement to New Jersey he aided, established the first commercially successful glassworks.

The Wistar glassmakers produced utilitarian objects, mainly window glass using the cylinder technique. They also made bottles, distillation retorts, and glass tubes used in electrical experiments. In a letter, Benjamin Franklin said that Wistar tubes had "a greenish cast, but [the glass] is clear and hard, and, I think, better for electrical experiments than the white [colorless] glass of London, which is not so hard."[14] Today, the fame of the Wistar glassworks rests mainly on a few surviving pieces of table glass. Their form and decoration reflect the Germanic origin of their makers. Molded and pincered decoration in a wafflelike pattern on the finials of Wistarburgh sugar bowls has Germanic antecedents.[15]

In Manheim, Pennsylvania, Henry William Stiegel, another German immigrant, started the next commercially significant glassmaking enterprise. Stiegel first advertised in the February 7, 1765, *Pennsylvania Gazette*: "Notice, that the Glasshouse, which he has erected in the Town of Manheim is now completely finished, and the Business of Glassmaking in it carried on; where all Persons may be suited in the best Manner; with any sort of Glass, according to their Order."[16] Stiegel concentrated on making bottles and window glass. Surviving records indicate that the bottles ranged in size from pocket bottles of less than a pint to those of eight quarts.

Bottles are not easily associated with any particular works. It is often only possible to say that a particular bottle is similar in form to others attributed to a maker. Bottles similar to attributed Stiegel bottles include such varied colors and designs as blue and amethyst pocket flasks in a diamond pattern; blue, amethyst, and colorless flasks in the diamond-daisy pattern; and—the rarest—colorless and amethyst flasks in the daisy-in-hexagon pattern.

Encouraged by the nonimportation agreements of 1765 and 1767, Stiegel decided to compete with the English production of lead table glass and recruited five English glassblowers to direct production in Manheim. In the 1769–1770 season, his workers blew 37,200 objects in thirty-eight forms, both new (decanters, wineglasses, mustard pots, and dessert wares) and familiar (cream pots, salts, sugar bowls, tumblers, and mugs).[17] Stiegel's sales were slow, perhaps because of the colonists' continued preference for English goods. The repeal of the nonimportation acts in 1770 compounded Stiegel's marketing difficulties, and in 1773 he hired Lazarus Isaac, an English glasscutter who could engrave fashionable, naturalistic rococo motifs and new neoclassical designs. With his business unable to absorb the costs of concentration on fine glass production, however, the Stiegel glassworks was bankrupt by 1774. Although the business failed, the glassworks did succeed in imitating English glass, including some cut and engraved glassware in 1773 and 1774.[18]

In 1784 John Frederick Amelung arrived in Baltimore from Germany. Accompanied by seven members of his family and sixty-one German workers, he planned to establish a glassworks. He bought an existing glass manufactory in New Bremen, Maryland, and began production in 1785. Archaeological evidence suggests that two items were produced in quantity: plain tumblers in a variety of sizes and drawn-stem wineglasses. However, he also produced the most elaborately engraved glass and the only signed glass made in America in the eighteenth century. Today Amelung glass is admired for its elaborate rococo engraving. The case bottle in figure 13-1 is attributed to the New Bremen Glassmanufactory because the birds and date numbers are similar to those on a tumbler on which the name of the glass works is engraved.[19] A covered tumbler carries the coat of arms of Pennsylvania and is inscribed "New Bremen Glass Manufactory 1791," and another is signed and dated "the 20th of June 1788." A dark amethyst sugar bowl and a sugar bowl with a green tint, topped with a flamboyant swan finial, are also attributed to Amelung's works. Like Stiegel's, Amelung's glassmaking career ended in bankruptcy, but the likely cause was the competition from English and Bohemian glass that was less expensive. The New Bremen Glassmanufactory ceased production in 1794.

In 1800 Benjamin Bakewell started a glassworks in Pittsburgh that became very profitable. In 1808 he began making lead glass, and until 1818 he and his partner, Benjamin Page, were the only commercial producers of fine cut and engraved tableware in the United States. In 1825 Bakewell patented machine-pressed glass furniture pulls.[20]

In New England in the nineteenth century, making glass—especially for tableware and lighting devices—became a major industry. Several manufactories, interrelated through common investors and workers, produced glass for most of the century. Thomas Cains of Bristol, England, worked at the South Boston Flint Glass Works from 1812 to 1827 and founded the Phoenix Glass Works, where he continued to manufacture until he died in 1865. Some of Cains's workers took over the Boston Porcelain & Glass Manufacturing Company in 1815, which was purchased by the New England Glass Company in 1818. That glassworks became the largest and most successful in the new nation. Some examples of their pressed glass are marked with "N.E.G.CO." or "NE/GLASS/COMPANY/BOSTON." In 1878 William Libbey took over the company and renamed it the New England Glass Works. Ten years later his son Edward moved the works to Toledo, Ohio, and in 1892 the name changed to the Libbey Glass Company.[21]

Organized in 1825 by Deming Jarves, who had been an investor in the New England Glass Company, the Boston and Sandwich Glass Company of Sandwich, Massachusetts, was profitable until the 1880s, when it was unable to compete with midwestern companies that used abundant, inexpensive natural gas for fuel and had access to less expensive labor.[22]

LIVING WITH GLASS OBJECTS

Before 1800 most churches relied on daylight for illumination. Sometimes window glass was a royal gift to a colonial church; Queen Anne, for instance, gave a "Box of Glass" to the Immanuel Church of New Castle, Delaware. Seventeenth-century Dutch settlers brought the tradition of stained glass windows for their churches in New Netherland. In 1656 Evert Duyckinck provided two decorated windowpanes for the Church of St. Nicholas, and he was paid two and one-half beavers per glass. By 1827, colored panes were being made in the United States, and in 1831 the Boston and Sandwich Glass Factory exhibited a "truly elegant" head of Christ in stained glass.[23]

By the mid-1700s, windows in homes of the wealthy had a double-hung sash and held larger lights than the earlier casement-type windows that were formed of small, diamond-shaped panes. However, window glass probably continued to be an expensive purchase until some of the glasshouses in New England, New York, western Pennsylvania, and the Midwest began production.[24] Most people who owned glass only had bottles, tumblers, or simple drinking glasses, often described as "common glasses." Glass forms for serving food were both rare and expensive; they included sugar bowls, fruit bowls, comfit dishes, dessert glasses, and salvers. As fragments found at several settlement sites demonstrate, a few of the earliest colonists even used Venetian glasses. Samuel Sewall's diary entry for October 1, 1697, confirms that fine glass was used for tableware and that its breakage was noteworthy: "A Glass of spirits my Wife sent stood upon a Joint-Stool that, Simon W. jogging, it fell down and broke all to shivers: I said twas a lively Emblem of our Fragility and Mortality."[25]

A traveler in the United States between 1818 and 1820 observed that the use of glass had increased dramatically in homes. He noted that in the dining room "there is always a very elegant mahogany sideboard decorated with silver and metal vessels of the household as well as with beautiful cut glass and crystal."[26] Housekeeping manuals suggested appropriate arrangements for sideboard displays; one stated that mixing in a few blue wineglasses with the clear would "add greatly to the splendor."[27]

Varieties of bottles increased in the nineteenth century. Water from the Ballston and Saratoga springs in New York were commercially bottled by 1819. Specialized bottles were produced for snuff, mustard, ink, and various kinds of medicines. Glass jars with airtight lids eased the problem of food storage. John L. Mason's patents made his name synonymous with high-quality preserving glassware.[28]

Molded flasks were especially common in the nineteenth century. Those small enough to fit into a pocket were used to "carry the comfort of life into the field," as an advertisement explained.[29] Today, the molded designs on flasks provide a topical history of the United States, depicting scenes of patriotism, economics, and popular culture. There were also more than one hundred designs molded with decoration of eagles. The rise of the temperance movement and the distillers' practice of bottling their own liquor diminished the popularity of flasks.

By the 1820s the market for lighting fixtures was strong despite their expense. Candlesticks and sconces with cut glass prisms glittered on the tables and walls in homes of the wealthy. Many families centered a lamp

on a parlor table. Hall lamps and mantel lamps, used in pairs, were also popular. Glass was a component of many—in the shades, in chimneys that enhanced the brightness of the flames, and in the reservoirs that revealed the level of the fuel supply. Before independence, chandeliers in churches and theaters were generally foreign-made. Christ Church in Boston, for example, had one intended for New France that English privateers captured. In 1802 St. Paul's Chapel in New York City ordered six Irish chandeliers, which survive today, but by 1819 the New England Glass Company announced "chandeliers—for church and hall—made to any pattern or drawing."[30]

Displayed prominently in Puritan meetinghouses, hourglasses reminded worshippers of human mortality, and, as early as the seventeenth century, congregations used them to time sermons. Sometimes elaborate stands for hourglasses emphasized their presence. A satirical seventeenth-century print depicts a preacher, hourglass in hand and ready to turn it again, saying, "I know you are good fellows; so let's have another glass."[31]

CONCLUSION

The colonists' need for bottles and windows spurred glassmaking in British North America, and at least a glass bottle or two was needed in most households.[32] Even with raw materials and fuel, colonial glassmaking was a risky business because of the need for substantial finances, the dependence on technical knowledge and labor from abroad, and the pressure of foreign competition. By the middle of the nineteenth century, however, glassmakers in the United States were successful leaders in the production of utilitarian and fashionable glassware.

GLOSSARY OF GLASS TERMS

Air twist. "Wormed" shank; spiral thread of air in a glass stem.

Anneal. Gradual cooling of glass through controlled reduction of heat in an annealing oven.

Batch. Mixture of raw materials that are melted together to produce glass.

Blank. Undecorated glass vessel, specifically one prepared for cutting, engraving, or etching.

Blowpipe. Long, hollow iron tube, usually thick and heavy, used to form a bubble for subsequent blowing.

Bull's eye. American term for a concave, round-ball motif used on cut or pressed glass; foreign terms for this motif are roundelet, Kugel, printie, and puntie. This sometimes refers to the thickened, scarred center of a crown-glass windowpane that was discarded or remelted.

Cut glass. Glass decorated by the application of a rotating progression of wheels of iron, stone, and wood.

Dip mold. Small, cup-shaped mold, usually of iron, with grooves cut into the inner surface in a pattern. The glass blower inserts a gather of glass into the mold to pattern it, removes the patterned gather, and blows it to form the desired size and shape.

Enamel. Extrinsic decoration of hard, glossy, vitreous colored glass fused onto a glass surface.

Engraving. Decoration of a glass blank by the application of a series of copper wheels of various sizes; the design is usually unpolished.

Etching. Decoration of glass blank by the application of corrosive acid to a surface that is first coated with wax and resin; a design is drawn on this coat with sharp instruments to remove the coating where the acid will corrode the glass.

Flint glass. Any glass that contains flint-bearing sand as an essential ingredient; usually designates glass of high lead content.

Flux. Alkaline or metallic substance (such as potash or lead oxide) used to assist in the vitrification of silica by lowering the melting point.

Free blown. Glass blown without the aid of a mold or press.

Gaffer. Master blower and head of a shop or glassmaking team.

Gather. Glob of molten glass on the end of a blowpipe.

Green glass. Glass made of sands with high iron content and the simplest, least-expensive ingredients: sand, potash, and soda.

Lead glass. Glass with high lead content; most suitable for cutting.

Mold-blown glass. Glass given its final form and/or decoration by being blown into a mold.

Mold marks. Slight ridges left on the surface of glass from the seams or joints of mold.

Part-sized mold. Dip mold or hinged mold about one-third the size of a finished article; used to impart a surface design to pattern-blown glass.

Pontil mark. Scar on the bottom of glass where it has been separated from the pontil rod; on later glass, this mark has usually been polished or ground smooth.

Pontil rod. Long, solid iron rod used to hold a vessel during finishing processes after removal from the blowpipe.

Pressed glass. Molten glass poured into a mold and pressed manually or with mechanical plunger; not blown during any stage.

NOTES

1. Palmer, "To the Good," 213.
2. Palmer, *Glass in Early America*, 364.
3. Wilson, 7–9.
4. Palmer, "To the Good," 219.
5. Palmer, *Glass in Early America*, 3.
6. Palmer, *Glass in Early America*, 1.
7. Palmer, "Wistarburgh Enterprise," 79.
8. Palmer, "Philadelphia Glasshouse," 107.
9. Palmer, *Wistars*, 14.
10. Palmer, *Glass in Early America*, 386.
11. Palmer, *Wistars*, 14; *Glass in Early America*, 386.
12. Palmer, *Glass in Early America*, 1.
13. Palmer, *Glass in Early America*, 1–2.
14. Palmer, *Wistars*, 18.
15. Palmer, *Wistars*, 12.
16. Palmer, "To the Good," 204.
17. Palmer, "To the Good," 211.
18. Palmer, "To the Good," 218–20.
19. Lanmon and Palmer, 18, 44; Palmer, *Glass in Early America*, 360.
20. Gardner, 92.
21. Wilson, 198–213, 229–34; Palmer, *Glass in Early America*, 265, 336.
22. Wilson, 261.
23. Schwind, *Craft Art*, 18, 19.
24. Wilson, 5–7; Palmer, *Glass in Early America*, 386–98.
25. Sewall, 145.
26. Garrett, 89.
27. Garrett, 89.
28. McKearin and Wilson, 234–35, 254–55.
29. Palmer, *Glass in Early America*, 364.
30. Schwind, *Craft Art*, 17–18.
31. Schwind, *Craft Art*, 7.
32. Palmer, *Glass in Early America*, 343.

BIBLIOGRAPHY

Lanmon, Dwight P., and Arlene M. Palmer. "John Frederick Amelung and the New Bremen Glassmanufactory." *Journal of Glass Studies* 18 (1976): 9–128.

Lanmon, Dwight P., et al. *John Frederick Amelung: Early American Glassmaker*. Corning, N.Y.: Corning Museum of Glass Press, 1990.

McKearin, George S., and Helen McKearin. *American Glass*. New York: Bonanza Books, 1950.

Palmer, Arlene. *Glass in Early America: Selections from the Henry Francis du Pont Winterthur Museum*. Winterthur, Del.: Henry Francis du Pont Winterthur Museum, 1993.

———. "Glass Production in Eighteenth-Century America: The 'Wistarburgh Enterprise.'" In *Winterthur Portfolio 11*, edited by Ian M. G. Quimby, 75–101. Winterthur, Del.: Henry Francis du Pont Winterthur Museum, 1976.

———. "A Philadelphia Glasshouse, 1794–1797." *Journal of Glass Studies* 21 (1979): 102–14.

———. "'To the Good of the Province and Country': Henry William Stiegel and American Flint Glass." In *The American Craftsman and the European Tradition, 1620–1820*, edited by Francis J. Puig and Michael Conforti, 202–39. Minneapolis: Minneapolis Institute of Arts, 1989.

———. *The Wistars and Their Glass, 1739–1777*. Millville, N.J.: Museum of American Glass at Wheaton Village, 1989.

Additional Sources

Gardner, Paul Vickers. *Glass*. New York: Cooper-Hewitt, 1979.

Garrett, Elisabeth Donaghy. *At Home: The American Family, 1750–1870*. New York: Harry N. Abrams, 1990.

Innes, Lowell. *Pittsburgh Glass, 1797–1891: A History and Guide for Collectors*. Boston: Houghton Mifflin, 1976.

McKearin, Helen, and Kenneth M. Wilson. *American Bottles and Flasks and Their Ancestry*. New York: Crown Publishers, 1978.

Schwind, Arlene Palmer. *Craft Art and Religion*. New York: Committee of Religion and Arts of America, 1979.

———. "The Glassmakers of Early America." In *The Craftsman in Early America*, edited by Ian M. G. Quimby, 158–59. New York: W.W. Norton for the Henry Francis du Pont Winterthur Museum, 1984.

Sewall, Samuel. *Samuel Sewall's Diary*, edited by Mark Van Doren. New York: Macy-Masius Publishers, 1927.

Spillman, Jane Shadel, and Susanne K. Frantz. *Masterpieces of American Glass*. New York: Crown Publishers for the Corning Museum of Glass, 1990.

Wilson, Kenneth M. *New England Glass and Glassmaking*. New York: Thomas Y. Crowell Co., 1972.

Silver Objects

SILVER, MADE INTO USEFUL AND DECORATIVE objects, has long played a significant role as an indicator of social and economic position. In 1688 William Fitzhugh wrote from Virginia: "I esteem it as well politic as reputable to furnish myself with an handsome Cupboard of plate which gives myself the present use and Credit, is a sure friend at a dead lift, without much loss, or a certain portion for a Child after my decease."[1] By the early 1800s, citizens of the young United States continued to esteem silver objects for personal use on dining tables, as jewelry, and even for civic recognition of the accomplishments of military leaders and statesmen.[2]

Owning silver hollowware—the bowls, dishes, and pots called "plate"—was a prerogative of the wealthy throughout the colonial period. However, by the 1760s even some middling households owned silver. By the end of the century, many Boston household inventories included a small piece of silver for dining or some flatware.[3]

Museum visitors can understand the meaning of silver, which survives to the present day. Silver objects are still given as gifts to mark memorable occasions, and visitors themselves may have experienced the sense of importance that using or giving silver confers. On the other hand, we live in a time when silver, especially in electroplated objects, is more widely available. Its look can be easily duplicated with modern materials such as polished stainless steel, chrome, or aluminum. The absolutely smooth, shiny surface is neither unusual nor so highly desired for display or investment, and its status in the past may be difficult to grasp.[4]

Nevertheless, silver offers some important interpretive strengths. Because of its value and malleability, silver was worked into fashionable objects and offers interesting comparisons to style seen in furniture and architecture. A silver object, too, commonly bears the mark of the person who made or sold it, and often some engraving identifying the owners. It is well documented, compared to other media. Silver, which so easily catches the eye, can catch the interest as well.

LOOKING AT SILVER OBJECTS

Understanding the design elements present in a silver object, regardless of its style, helps us to understand its attraction and meaning. The descriptive categories of line, proportion, texture, ornament, material, and color will be used to describe a coffeepot and a teapot. The coffeepot was made between 1785 and 1800 by Joseph Anthony of Philadelphia (fig. 14-1). The teapot was made by William Van Buren about 1795 in New York City (fig. 14-2).

Line

The body of the Anthony coffeepot is composed of curves and reverse curves. The silhouette is accentuated by the curves of the handle and spout. Although the Van Buren teapot is oval in plan, the taut, straight lines of its profile dominate the silhouette, including the spout.

Proportion

Proportion describes how various dimensions of an object and the sizes of its various parts relate to one another. Height dominates width in the Anthony coffeepot. The base, however, is proportionately smaller than the main part of the body, giving the object an appearance of instability. The proportions of the lid balance the in-curving sides at the bottom, emphasizing the elongated appearance. In the Van Buren teapot, on the other hand, the horizontal dimension is greater and gives the pot the appearance of sitting firmly on the table surface.

Texture

The malleability of silver permits the smith to produce surfaces of varying texture, but a smooth, lustrous, shiny surface is a striking and highly valued characteristic of most silver objects made and used in the colonies and young republic.[5] The smith produced the surface by careful hammering and polishing, revealing his skill and workmanship. The lustrous surface shines on the smooth areas on both the Anthony and Van Buren pots.

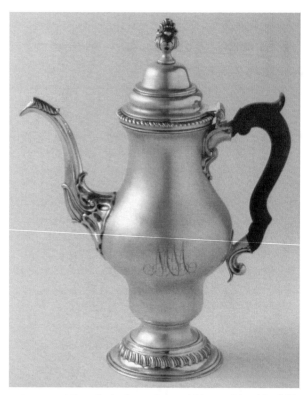

FIGURE 14-1. Joseph Anthony Jr. used his considerable skills to make elegant silver coffeepots, including one for George Washington, as well as jewelry and non-silver items such as shaving cases, corkscrews, and fruit and penknives. The cast, stepped foot of this coffeepot is especially unusual. It is not known to whom the engraved initials "MM" refer. (Coffeepot, Joseph Anthony Jr., Philadelphia, 1785–1800. Silver, wood; H 12¾ in., W 10 in. 1976.276 Winterthur Museum, gift of Mr. Marshall P. Blankarn.)

A smith used various tools to vary the texture of a silver surface. Textures give depth to the surface, allowing the light and shadow to play across it and provide visual interest. On the Anthony coffeepot, deeply textured gadrooning (decoration consisting of a series of lobes) around the edges of the top and base shines at high points, disappearing into shadows in the valleys, in a rhythmic pattern. On the Van Buren teapot, a much less three-dimensional texture is achieved by beading and engraved ornament used at the top and base. The smooth, bright surface texture of the Van Buren teapot is enhanced by this low-relief ornament.

Ornament

Both pots are ornamented, but with different motifs. On the Anthony coffeepot, curves are the most striking impression. The rhythmic curves of gadrooning and the curves and reverse curves of the body walls, spout, and wooden handle stand out. Even the naturalistic ornament, including leaf motifs

on the spout end and a cast lid finial, are a series of curves. The gadrooning and foliage are treated in a sculptural way.

Although the Van Buren pot contains as much ornament, its low-relief, small-scale, and regular geometric motifs give an impression of restraint. The engraved banding of small-scale scallops and a three-leaf design reminiscent of bellflowers at the top and bottom of the body are flat and regular. The body is ornamented with foliage, but it is low-relief engraving of floral swags, not sculptural, curvaceous leaves.

Color

The qualities of silver as a material have traditionally given it a valued place as a "noble" metal, indicating that in its pure state, it does not react with oxidants in the air.[6] Its color is strikingly recognizable. In its pure state it is white, and when polished, it assumes a brilliant reflective luster.

THINKING ABOUT STYLE

American silversmiths and their customers looked to the metropolitan centers of Europe, and particularly London, to inspire the forms and ornamentation of their silver objects.[7] Silver production in the colonies and early republic was primarily an urban activity.[8] In Boston, Philadelphia, and New York, and, later, Baltimore, people were wealthy enough and concerned enough with culture and fashion to demand stylish silver. Colonists brought English domestic silver to America and continued to order it from London, the hub of British culture. Just before the American Revolution, London-made objects could be ordered and received within a year.[9] It often took less than a

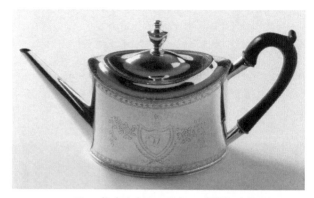

FIGURE 14-2. Very little is known about William Van Buren. The few examples of his surviving work include this teapot and a matching sugar bowl with lid. By the end of the eighteenth century, matching sets of silver were increasingly desirable. (Teapot, William Van Buren, New York, N.Y., 1795–1796. Silver, wood; H 6¾ in., L 12⅜ in. 1977.79 Winterthur Museum, gift of Mr. Marshall P. Blankarn.)

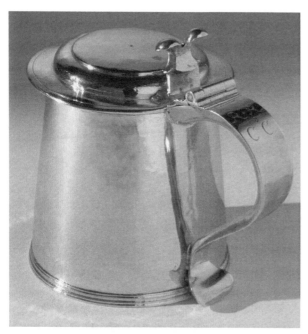

FIGURE 14-3. Much surviving seventeenth-century American silver has a history of ownership by a church. This broad tankard with wide, overhanging three-step lid was bequeathed by a loyal parishioner to Charlestown Church in Massachusetts. The maker, Jeremiah Dummer, is thought to have been among the ten wealthiest merchant-goldsmiths in Boston in the early 1700s; well over one hundred pieces of his work survive. (Tankard, Jeremiah Dummer, Boston, 1676. Silver; H 6¹⁄₁₆ in., Diam [base] 5⅛ in., W [including handle] 7³⁄₁₆ in. 1964.679 Winterthur Museum, gift of Henry Francis du Pont.)

decade for English designs to be produced by smiths in the colonies.[10]

Seventeenth-century silver objects display the design characteristics fashionable in all the decorative arts at that time. Line and proportion emphasize horizontality, as evidenced by a tankard made in 1676 by Jeremiah Dummer (fig. 14-3). Ornament on silver objects, as on furniture, is controlled, abstract, and influenced by a mannerist aesthetic. Smiths tended to juxtapose disparate design elements freely.

At the turn of the eighteenth century, silver showed influences of a baroque aesthetic that emphasized more three-dimensionality, with rhythmic projections. Gadrooning suggested the baroque interest in light and dark contrasts. Flowing curves and reverse curves also emphasize rhythmic variations in line. A sugar box made by Edward Winslow in 1702 is an example of this style, with its elaborate surface, fine proportions, gadrooning, contrasting smooth and worked areas, repetitive use of the leafy motif, and symbolic use of classical ornament (fig. 14-4).

A silver teapot made by Josiah Austin in Charlestown, Massachusetts, between 1740 and 1760 illustrates the key characteristics of fashionable silver objects made at that time (fig. 14-5). In 1753 Londoner William Hogarth published *The Analysis of Beauty*. Chief among his ideas was a belief that there was a basic S-shape line of beauty formed by using exactly the correct amount of curvature. The line of the body and spout on Allen's teapot reflects this preference. The pot's rounded contours give it a self-contained appearance.

During the 1750 to 1775 period, an emphasis on form and line gave way to a focus on intricate asymmetrical surface ornamentation. In the restless style of the rococo, lines that were once simply curved appear doubly curved. The smooth surfaces of basic forms were covered with embellishment that included naturalistic flowers and leaves. An asymmetrical shell replaced the earlier symmetrical scallop shell. In the rococo taste, even the basic shape has a delicate, unbalanced look. Coffeepots and teapots were apple or inverted-pear shaped and appear lighter and less stable than the heavy, substantial forms inspired by the sculptural quality of the baroque. Some lids are double

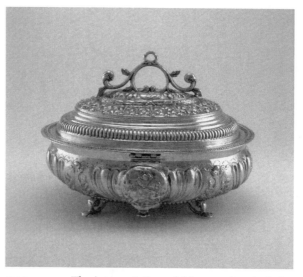

FIGURE 14-4. The interpretation of this sugar box includes a discussion of both the image of a hero on horseback slaying an enemy—a common theme in epic love poems—and the belief that the sugar it contained increased fertility. It was, indeed, an appropriate gift for a newly married couple named Oliver. This box is one of only nine surviving American silver sugar boxes. With the passage of time, sugar became less valuable and no longer required a lockable storage container. (Sugar box, Edward Winslow, Boston, 1702. Silver; L 8¼ in., W 7¾ in., H 5¼ in. 1959.3363 Winterthur Museum, gift of Henry Francis du Pont.)

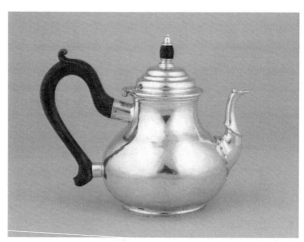

FIGURE 14-5. This curvaceous teapot is an unusual shape for a silversmith from Boston, where the apple-shape teapot was more popular. Nevertheless, it is a successful work with an especially beautiful spout. (Teapot, Josiah Austin, Charlestown, Mass., 1740–1760. Silver, wood; H 6½ in., Diam 4¾ in., W [including handle] 8¼ in. 1967.1906 Winterthur Museum, bequest of Henry Francis du Pont.)

domed and capped with a pineapple, and handles are double scrolled.

In a cruet stand made about 1770 by John David of Philadelphia, shells and C-scrolls are everywhere (fig. 14-6). Perilously perched reverse scrolls support the asymmetrical frame of five sections, and rings of gadrooning keep the bottles in place on this stand, which is the epitome of lightness and airiness.

A coffeepot made by Joseph Richardson Jr. of Philadelphia between 1790 and 1801 displays the classical influences also evident in furniture in the federal style (fig. 14-7). It shows early classical-revival taste, marked by a focus on simplicity, symmetry, order, and restrained use of ornament. Surfaces are smooth, proportions are delicate, and shallow, curved lines abound. The urn shape was especially preferred and was frequently adapted to objects for the tea table. Cartouches, or frames, for central, engraved ciphers alluded to classical inspiration in the form of shields or wreaths. Reeding (a series of small, parallel convex moldings) provided orderly decoration.[11] The lines of the Richardson coffeepot are accentuated by rows of beading at the top and bottom. The ornament has the effect of drawing the eye through a progression of oval shapes of different sizes. A pierced gallery at the lid contributes to the effect. Rhythm and balance are enhanced by repeating in the lid the shape used to form the base.

By 1810, as the interest in antiquity quickened, styles became more strongly related to the heavier forms and figures on monumental Egyptian, Greek, and Roman examples.[12] Often artisans combined many motifs in one object. Ornament included sphinxlike figures, heavy paw feet, rams' heads, asps, flowers, waterleaves (long, straplike, feather-shaped leaves), and heavy lobed borders and bases. Urn and boat shapes remained fashionable but appeared visually heavier and thoroughly decorated. Much of this ornament was cast rather than engraved.[13]

A covered ewer made between 1815 and 1820 by Thomas Fletcher and Sidney Gardiner, prominent Philadelphia silversmiths, includes classical references (fig. 14-8). A floral band outlines the top, and a broader band of stylized leaves surrounds the bottom. Small leaves on the lid echo those on the body. A small dolphin rests on these leaves, and a scaly serpent surrounds a hound's head at the top of the handle, with the tail of the snake reappearing at the bottom. The base is supported by shaggy lion-paw feet with pronounced claws. The result is a striking object that

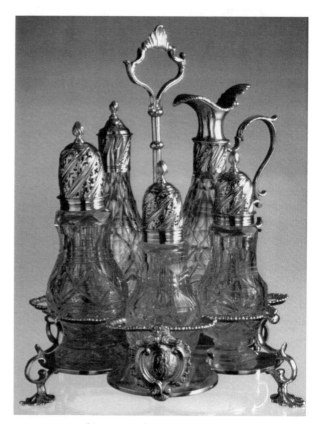

FIGURE 14-6. This extraordinary rococo cruet frame establishes its maker, John David, as a remarkable craftsman. His work was so admired that he was commissioned by other Philadelphia silversmiths to make objects for them. On a fashionable eighteenth-century dinner table, the bottles in the stand held condiments such as dry mustard, vinegar, catsup, and herbs. (Cruet stand, John David, Philadelphia, ca. 1770. Silver, glass; H 10¾ in., W 9⅞ in. 1959.3362 Winterthur Museum, gift of Henry Francis du Pont.)

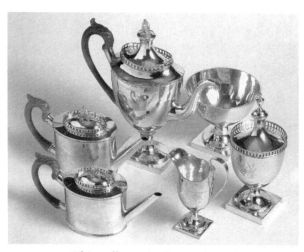

FIGURE 14-7. This coffeepot in the neoclassical taste is one piece of a large set that includes two teapots (one of which may have been used for hot water), a sugar urn with lid, creamer, waste bowl, tongs, and twelve teaspoons. The teapots are made of rolled sheet silver, an efficient and less costly method of working the silver than raising (hammering), which was used to shape the other hollowware in the set. (Coffeepot, Joseph Richardson Jr., Philadelphia, 1790–1801. Silver, wood; H 13 in., W 4½ in. 1957.825 Winterthur Museum, gift of Henry Francis du Pont.)

relates to empire furniture with its carved motifs of flora and fauna.

MAKING AND MARKETING SILVER OBJECTS

The hope of finding silver and gold was a prime motivation for the exploration and settlement of the New World. Spanish explorers of America succeeded in this quest, and at the same time overpowered the indigenous populations of Aztecs in Mexico in 1521 and of the Incas in Peru in 1532. The consequent flow of silver to Europe had a profound economic effect. Between 1521 and 1660, about eighteen thousand tons of silver went to Europe from the New World, making Spain the richest nation of the time. As Spain paid off foreign loans and purchased goods from other European nations, this silver was dispersed throughout Europe, usually in the form of coins. This Mexican and Peruvian silver, often in the form of used vessels or coins, was the major source of silver for smiths in the colonies and young republic.[14]

Although the North American colonies yielded little silver and gold, silversmiths were among the first to settle there. Quantities of European silver coinage, especially Spanish, came to the colonies, making silver available to colonial silversmiths. One English observer wrote in 1698 that in Pennsylvania "they have constantly good price for their Corn, by reason of the great and quick vent into Barbados and other islands;

through which means silver is becoming more plentiful than here in England, considering the number of people."[15] As a result of this favorable trade, some colonial Americans had surplus metal they could use to commission silver objects.

Handcrafted silver objects were the products of strong arms and long hours. Whether the craftsman made teaspoons or a teapot, he began by weighing the required amount of silver, melting it, then casting it into an ingot or disc of the desired size. Once cast, the ingot had to be worked into a finished object. Silver's ductility and malleability allow it to be drawn out or hammered thin without breaking. Thus, silver could take on many varied forms under the hands of the smith. A craftsman's account book suggests that a silversmith needed ten working days to complete a plain teapot.[16]

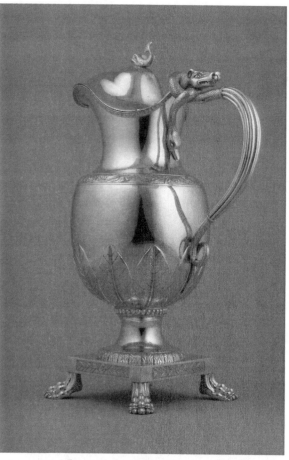

FIGURE 14-8. Like much furniture of the time, this silver ewer took its design inspiration from the French interpretation of classical ornament. In addition to household items such as this ewer, Philadelphia silversmiths Thomas Fletcher and Sidney Gardiner are known especially for the monumental presentation silver forms they created for heroes of the War of 1812. (Covered ewer, Thomas Fletcher & Sidney Gardiner, Philadelphia, 1815–1820. Silver; H 16 in., W [including handle] 10⁶/₁₆ in., D 6¾ in. 1969.16 Winterthur Museum.)

Silversmiths most likely made more spoons than anything else.[17] To do so, they cut sheet silver into rectangular shapes, hammered or formed the rectangle of silver on one end to make the handle and hammered the other end on a steel swage (form) to shape the bowl. A smith used a variety of techniques to make a hollowware object. Raising with a hammer was the most important in the eighteenth century. Beginning with a sheet of silver, the silversmith raised the metal into a vessel by hammering it over stakes of various sizes. Using assorted small hammers, he worked outward in concentric circles, being careful to hammer evenly to achieve uniform thickness. Since hammering makes the silver brittle, the silversmith had to reheat and slowly cool the metal periodically to restore its malleability. This process was called annealing.

After the desired shape was achieved, the silversmith removed the hammer marks by planishing (finishing) the object with a flat-faced hammer against an anvil, a process that could take as long as the original shaping. When he was satisfied with the quality of the body, previously cast pieces (such as handle, sockets, spouts, or finials) were soldered on.

Additional ornament could be added by chasing, by doing repoussé work, or by engraving. In chasing, a smith ornamented the object by indenting the metal with a hammer and shaped punches. The tools did not have a cutting edge and did not remove any metal. In repoussé work, a smith ornamented the metal by hammering from the back or inside of the work. Thus, the design appeared in relief on the object. It was then chased from the front to sharpen the detail. In engraving, the smith made a design by cutting into the metal with a sharp tool. In this process, thin shavings of metal were removed.[18] In the well-developed silver trades of a city like Boston, engraving was the work of a specialist, contracted by the smith responsible for the job.[19]

Silversmiths learned their trade by apprenticing to a master craftsman for a period of approximately seven years. Generally an apprentice did not come from the lowest order of society, and only those who were "well recommended" were accepted.[20] Taking an apprentice was more than a business arrangement of work for payment; it was accepting an addition to the family, with all the attendant responsibilities for temporal and spiritual welfare. When Boston silversmith John Hull took in Jeremiah Dummer and Samuel Paddy as apprentices in 1659, he asked, in his diary, for "the Lord's blessing on them and for His help in faithfully discharging his trust to the two young men."[21]

An apprentice performed such tasks as polishing finished objects, tending the forge, pumping the lathe, and drawing wire. Gradually he assumed more responsibility until he made complete objects himself.[22] The master also employed journeymen or day laborers, sometimes recent immigrants, who were well trained but lacked the money to set up their own shops.[23] However, among the well-developed silver trades in cities, other varied arrangements augmented these traditional craft relationships. Smiths might partner and mark an object with both initials. A smith might mark and sell both his own wares and objects that were imported or made by others. Thomas Fletcher and Sidney Gardiner, the most successful silver merchants in Philadelphia between 1811 and 1842, were collaborators as well as specialists, with Fletcher conducting the business and Gardiner supervising production.[24]

By the late eighteenth century, the development of a new material and new machines changed the metalsmith's work. Fused plate, familiarly known as Sheffield plate (although not manufactured in that English city alone), was made by heating sheets of silver and ingots of a base metal—often copper—until the two became one. Fused plate may be rolled or hammered to the correct thickness and then worked much as a sheet of solid silver. The process of fusion was probably known in England long before it became commercially important. By the mid-eighteenth century, English smiths were making fused-plate objects and exporting them to the colonies.[25] These objects became important sources of design, especially for silversmiths working in the silver centers of Boston, New York, and Philadelphia.[26]

Many fused-plate objects clearly show classical-revival design elements such as urns, swags, and vases, which were fashionable when the material was becoming a commercial success. The vase-shape finial on an oil lamp made in England as well as the urn form of the base suggest classical ornament (fig. 14-9). Electroplating developed after about 1840, when experiments with electricity proved that an electric current passing through a liquid could cause atoms of metal in the liquid to deposit on a submerged metal object. In electroplating, silver could be deposited on the base metal after the object was formed, a major difference from fused plate. This technique and the discovery of important silver deposits in the western United States in the mid-nineteenth century finally made silver widely available.[27]

At the same time that fused plate was becoming more widely used, rolling machines were producing

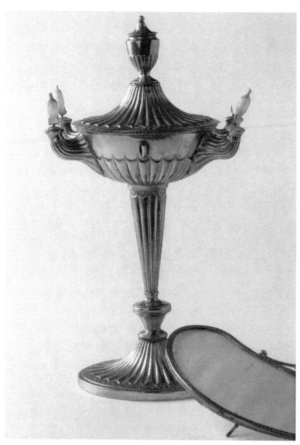

FIGURE 14-9. Oil lamps produced more illumination than candles, and the silk shades softened the glare. The materials used in lighting devices were important as reflectors and enhancers of the light. This lamp, with its urn-shaped reservoir and shield-shaped frame, was made of fused plate. (Oil lamp, England, 1800–1810. Silver plate on copper, silk; H 21 in., W 9 in., D 6½ in. 1959.675 Winterthur Museum, bequest of Henry Francis du Pont.)

flat sheets of silver, eliminating the need for long hours of hammering. The body of a teapot, for example, could be formed by shaping a rectangle of sheet silver into a circular or oval tube, soldering it closed, then adding a top and bottom. This technology affected the appearance of silver by producing very smooth, mirrorlike surfaces, such as on the William Van Buren teapot pictured earlier (see fig. 14-2). Lids and bases of coffeepots and teapots could also be formed by cutting from a flat sheet of silver.

Decorative techniques such as die stamping and die rolling, which could be done by machine, were developed in the manufactories of Birmingham and Sheffield, England. Die stamping was used to stamp out thin, detailed ornament that could be soldered on any silver object. Die-rolled ornament was produced by the yard and soldered on or between parts of an object. Shops were able to stockpile mechanically mass-produced parts and produce silver objects almost on demand.[28] In addition, producing and selling die-rolled or die-stamped ornament to other metal workers was another source of revenue for numerous successful shops.[29]

Marketing Silver

The colonial silversmith was both manufacturer and retailer. Surviving account books reveal that many sold goods made by others as well as their own products. Between 1758 and 1774, Philadelphia silversmith Joseph Richardson ordered from his London agent standard items such as "Single Belleyed milk Potts" to weigh about three ounces, ten pennyweight, each.[30] Silversmiths working in the same city sometimes collaborated in making an item for a particular customer. For example, a teapot and a sugar bowl were marked by Joseph and Nathaniel Richardson, while the matching cream pot bears the mark of Joseph Anthony Jr. All three objects, made about 1785, are engraved with the owner's initials, "S.M.N."[31]

Most silver made during the time of the colonies and young republic bears the mark of its maker, its seller, or both. American silver marks, a boon to present-day scholars, are derived from a long English tradition of marking silver to prevent fraud. Since about 1300, English smiths have been legally bound to take a finished article to a guildhall or an assay office, where the actual purity of silver in the article was tested. The piece was given a hallmark, identifying where it had been assayed. After the assay, a smith impressed his own mark. Other marks on English silver indicate the year and the place of manufacture and adherence to the British sterling standard, which required that the article be 92.5 percent pure silver. The only articles exempt from the assay were those made for royalty and those made of silver supplied by the customer.

Colonial smiths continued the marking tradition, often impressing initials during the colonial period or a surname with initials in the days of the early republic. In America, however, strict control by guilds and legal requirements to assay silver never developed a mandatory regulated marking system. The guarantee of the silver was the reputation of the maker or seller. The mark, such as the letters "REVERE" stamped in a rectangle, was the shop mark guaranteeing that the object met Paul Revere's standards but not that Revere actually made the object.

To make a living, silversmiths also sold imported goods. Newspaper advertisements, in listing objects for sale, usually stated which items were made by the

craftsman himself and which were imported. Many silversmiths also did a great variety of repair work, and some offered cleaning services.[32] The daybooks of Paul Revere Jr. show that he earned money from cleaning teeth, making harness fittings and small items such as shoe buckles, and engraving and producing advertisements and labels for other goods.[33]

Silversmiths frequently promised to offer a good price for old silver. Before the establishment of banks, many fulfilled banking functions, accepting money on deposit and making loans. The majority also had additional sources of income, engaging in such activities as land speculation, shipping, and tavern keeping. Some eventually became wealthy merchants.[34] If silversmiths had to be resourceful in order to maintain financially successful enterprises, so also did many of the customers who wished to patronize them. In 1739 Elizabeth Duche procured tea tongs from Joseph Richardson with a combination of cash payment, barter (twenty-five pounds of rice), and exchange of services (washing his linen).[35]

More commonly, customers supplied at least part of the metal needed to make an item. In July 1743 artist John Smibert, living in Boston, wrote to his London agent, ordering artist's supplies and a silver teapot for his wife. His letter shows that he sent old silver to be remade and relied on London opinion in matters of fashion:

> [T]he old Cups and spoons are a commission from my Wiffe who desires you will be so good as to get her a Silver tea pott of the middle size but rather incling to ye Large and weighty ye fashion she leaves intirely to you only would not have the top with hinges, but to take of[f]. I have sent a Sketch of ye Arms which I know you wil take care to get done by a good engraver with proper Ornaments. I do not expect the old silver wil pay for the tea pott which I would hve a pretty one.

Nine months later, Smibert's nephew ordered a similar pot, an example of the impact of London-made objects in the colonies: "Sir: I hope youl excuse the trouble I now give you, occasioned by the Tea Pott you sent which is admired by all the Ladies and so much that in behalf of one of them . . . I must beg the favour of you to send such another one of the same fashion and size only the top to have a neat hinge."[36] When George Washington ordered twelve cups in 1777, he gave the silversmith sixteen silver dollars to melt down.[37] In 1783 Anna Rawle offered one of the Richardsons "an old fashioned tankard and cup which he says will make a handsome coffee pot."[38] She asked her mother's approval, pointing out that "in their present form they are useless, being of an uncommonly antique appearance."[39]

By the first half of the 1800s, most silver was made in urban enterprises that employed a larger number of workers, both journeymen and apprentices, than was common during the colonial period. In 1809–1810, for example, the firm of Fletcher & Gardiner, then still in Boston, employed at least five workers, apprentices, repairers, and jewelrymakers.[40] The 1820 Federal Census of Manufactures credited Fletcher & Gardiner with the largest workforce in the Philadelphia silver trade.[41] Workforces were becoming larger and workers more specialized, trends that were occurring at the same time in the furniture trades. The person who made the silver object was no longer, in many cases, the person who sold it.

LIVING WITH SILVER OBJECTS

From the beginning of European colonization, silver ownership granted status and dignity to those who could afford it. Owning silver was a means of saving, and the items were more easily recoverable if stolen than the comparable weight in coins. In homes and public places, silver meant significant wealth. For the most part, owning silver hollowware was limited to the highest levels of society, but as the eighteenth century reached its end, small silver articles such as spoons became more widely owned.[42] The conspicuous use of silver still aroused comment, however. In 1772 Maryland's Charles Carroll wrote to his son to "keep an Hospitable table. But lay out as little money as Possible in dress furniture and shew of any Sort, decency is the only Point to be aimed at."[43] Even in the early 1800s, an elegant dining table ornamented with silver was sometimes criticized, as were other suspected evidences of corrupting wealth and power.

In the seventeenth century, English immigrants followed the centuries-old custom of displaying silver by placing it on the most ostentatious piece of furniture, such as a court cupboard. Silver plates, a dram cup or two-handled cup, a beaker, tankard, or, especially in New England and New York, a porringer might be found on a cloth on the top of a cupboard, creating what William Fitzhugh described in 1688 as a "handsome Cupboard of plate."[44]

A dram cup was a small, shallow dish, usually with two loop handles, only two or three inches in diame-

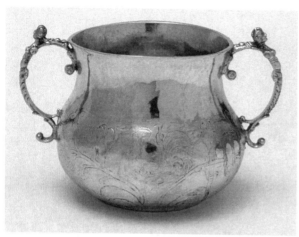

FIGURE 14-10. This cup has two cast handles in the form of caryatids and is engraved on each side with a turkey surrounded by flowers. The maker, Robert Sanderson Sr., is considered by many to be the father of American silversmithing. He and his business partner, John Hull, became mint masters when, in 1652, the General Courts of the Massachusetts Bay Colony established a mint for coining money. The appointment suggested respect for the men's skill and honesty. (Caudle cup, Robert Sanderson, Boston, ca. 1675. Silver; H 5 in., W 7¾ in., Diam 5¾ in. 1961.504 Winterthur Museum, gift of Henry Francis du Pont.)

ter. A larger two-handled cup like one made by Robert Sanderson in Boston in about 1685 was fashionable in both the seventeenth and eighteenth centuries. Cups of this sort varied in size, and some had covers. They were used on special occasions (fig. 14-10). Other drinking vessels that might have appeared in a silver display on a cupboard are beakers, mugs, and tankards. In general, tall cups with flat bases were known as beakers, shorter cups with rounded bases as tumblers, and those with handles simply as cups. Large cups with a single handle were called either mugs or canns. Both terms were used in the eighteenth century. The tankard was a lidded version of the mug. Used for beer, ale, or cider, tankards came in sizes ranging from one pint to a gallon. Small ones were sometimes given to brides or nursing mothers.[45]

By the eighteenth century, silver usually was displayed in the parlor with the family's best china and tableware.[46] A Connecticut girl born in 1791 recalled the parlor closet in her family's house as being filled with "silver cans, tankards, and flagons." She particularly "enjoyed brief glimpses of that parlor at night, lighted by two stately candlesticks, and an antique candelabra and [she thought] it was as the hall of Alladin."[47]

When tea became the preferred beverage at social gatherings in the eighteenth century, some of the implements were silver. A complete tea table held a teapot, a container for milk or cream and one for sugar, a slop (or waste) bowl, a tea canister, tongs, teaspoons, and cups and saucers. If the service was metal, it usually was composed of the pot, sugar bowl, and creamer, with the possible addition of a slop bowl. Tea canisters were also made in silver. The pieces could be purchased as a set or individually. The tongs and teaspoons were usually silver. They could sometimes be placed on the table in a silver "Boat for Tea Spoons."[48] All of these objects, whether silver, ceramic, or, in the case of sugar bowls and creamers, glass, could be kept in a closet or on a tea table when not in use or arranged on a silver tray for serving.[49]

Toward the end of the eighteenth century, sideboard tables and then sideboards became focal points for display in dining parlors. Marble or richly polished wood tops set off gleaming silver and glass. Carefully placed candles or lamps, when lit, added to the brilliance of the display as did round girandole mirrors with reflective, convex glass and candle arms.[50] In the 1820s, sets of silver had many more pieces and apparently were used as much for show as for serving. To guard against theft, many owners counted and then stored their silver in locked closets. In a further effort to reduce damage and loss, the lady of the house in many families washed the silver, fine china, and glassware with her own hands. This might be done in the back parlor after a servant had brought in a pail of hot, soapy water.[51]

When necessary, silver was polished with a variety of materials, usually a mild abrasive such as a linen cloth with hot, soapy water or rottenstone (a type of decomposed limestone) and oil. In 1827 Robert Roberts, servant of the governor of Massachusetts, recommended making a silver polishing powder with one-half pound of powdered chalk, one-half ounce of quicksilver, and two ounces of hartshorn balls in fine powder.[52]

Silver has long been a symbol of family continuity, handed down from generation to generation. Sometimes the line of descent is recorded on the object itself. A porringer by John Hull and Robert Sanderson has the initials of both Isaac and Mary Vergoose and their grandson, H. Fleet. Gifts of silver objects have also been an important means of honoring special family milestones such as births, christenings, and marriages as well as special national milestones such as victories at sea or the completion of a canal.[53] A sugar box made by Boston silversmith Edward Winslow about 1702 was a gift of William Partridge to Daniel and Elizabeth

Oliver (see fig. 14-4). Its impressive size indicates the value placed on sugar in the late seventeenth century, and its design suggests Italian marriage chests of the mid-sixteenth century. Two other sugar boxes made by Winslow at about the same time are associated with the marriages of their owners. However, this box, with its bas-relief of a classical head and martial scene, reminiscent of the Roman concept of virtue, seems appropriate for the birth of a male child. Elizabeth Oliver gave birth to her first son in June 1702, and the sugar box may well have marked that occasion.[54]

Silver jewelry, buckles, and buttons were regarded as stylish accessories for both women and men. As early as 1651, however, the Massachusetts General Court pointed out that this sort of dress was only "allowable to persons of greater estates or more liberal education" and that the court had an "utter detestation and dislike, that men or women of mean condition should take upon them the garb of gentlemen, wearing gold or silver lace, or buttons, or points on their knees."[55] Other small forms made of silver include boxes for patches, tobacco, or snuff; boatswains' whistles; inkstands; thimbles; wine funnels; napkin rings; and snuffers.

Silver and gold have long been favored for communion services in churches. Since the Middle Ages, the Roman Catholic Church required silver and gold for such vessels. These metals were nonreactive and less likely to infect the consecrated elements. Church doctrine also decreed that only vessels of precious metals could hold the body and blood of Christ. Even churches that rejected Roman ways, like the Congregational churches in New England, replaced their pewter, ceramic, glass, or wood communion vessels as silver became available.[56]

Different congregations used different silver forms, often symbolizing their conceptions of church membership and organization. Anglicans favored patens and chalices and used flagons for dispensing communion wine. If every adult member was allowed to take communion, large vessels like flagons were needed for wine. Some strict separatist groups used beakers, simple domestic forms, for communion. Puritans in New England also used a cup on a stem (a standing cup) or a two-handled cup. Passed from hand to hand, these forms reminded communicants of the intimacy and equality at the Lord's Supper. Tankards or flagons were also used, possibly to pour wine as needed into the cup.[57]

A set of six silver tankards by Paul Revere II were purchased as communion vessels by the Third Church

in Brookfield, Massachusetts, in 1768 and paid for with a bequest from Mary Bartlett, the widow of Ephraim Bartlett. Their names are engraved on the vessels, reminding the congregation that they were people of faith as well as wealth.[58]

Traditionally, presentation pieces awarded to individuals for acts of military or civic importance were also made of silver. Military hero Stephen Decatur owned enough silver dishes to serve a meal. Louisa Catherine Adams, who attended a party at his house, mentioned the display "of all the beautiful plate which was presented to [him] as tributes."[59] Another large group of ceremonial silver consists of the objects made to be given to native peoples as tokens of peace. In the eighteenth century, gorgets (protective throat plates) were considered particularly desirable, as were medals, wristbands, and armbands. Both the Dutch in New York and Quakers in Philadelphia commissioned large quantities. After the Revolution, the United States government continued to commission these silver objects, and Joseph Richardson Jr. of Philadelphia was asked to make hundreds of armbands and wristbands to give to Indian chiefs. Oval medals were also made in quantity. Many had the seal of the United States on one side and a scene including George Washington on the other.

CONCLUSION

Silver utensils and hollowware continue to be admired on some tables prepared for entertaining, and silver objects have also held their place as gifts marking life's special occasions. However, silver does not command as much respect and deference as William Fitzhugh hoped for in describing a "handsome Cupboard of plate." The development of fused plate and electroplate allowed objects made with little silver to look like sterling, and the discovery of large silver deposits in the western United States undermined its rarity.[60] Silver is more widely available and less expensive than it was in earlier times. Thus, silver objects in museums and historic houses may spark fruitful conversations about how the objects have acquired different values and meanings over time.

NOTES

1. Fales, *Early American Silver*, 4.
2. Waters, 21; Fennimore and Wagner, 40.
3. Falino, 156–57.
4. In England, for example, demand for silver had been trending downward since the end of the nineteenth century signaling a similar decline in the silver manufacturing trades; Glanville, *Silver*, 10.

5. Bushman, 4–5.

6. Lanford, 3.

7. The wealthy customers of Paul Revere Jr. and other silversmiths in Boston tended to purchase large silver objects from abroad but looked to Revere and his colleagues for small objects or for repairs; Falino, 56–57; Falino and Ward, 4.

8. Falino and Ward, 5.

9. Heckscher and Bowman, 71.

10. Hood, 13–14; Roe and Trent, 480–82.

11. Hood, 162–63.

12. Fales, *Early American Silver*, 32.

13. Hood, 193.

14. Bushman, 11.

15. Fales, *Early American Silver*, 231.

16. Hood, 19.

17. Fales, *Early American Silver*, 201.

18. Ward and Ward, 18.

19. Falino and Ward, 22.

20. Ward and Ward, 15.

21. Quimby, 85.

22. Ward and Ward, 17.

23. Ward and Ward, 17.

24. Falino and Ward, 74, 109; Waters, 24; Fennimore and Wagner, 35–36.

25. Rainwater and Rainwater, 19–20.

26. Fennimore and Wagner, 43

27. Rainwater and Rainwater, 18–21.

28. Victor, 23–27.

29. Fennimore and Wagner, 76.

30. Fales, *Joseph Richardson*, 74–75, 239.

31. Quimby, 330, 439.

32. Fales, *Early American Silver*, 284.

33. Falino, 156–58.

34. Falino and Ward, 133.

35. Garrett, 254.

36. As quoted in Foote, 87–88.

37. Fales, *Early American Silver*, 231.

38. Garrett, 263.

39. Garrett, 263.

40. Fennimore, "Elegant Patterns," 4.

41. Waters, 28.

42. Walsh and Carr, 12; Carson, 68.

43. As quoted in Carson, 69–70.

44. As quoted in Fales, *Early American Silver*, 4; Ward and Ward, 102; Garvan, 547.

45. Ward and Ward, 125–27.

46. Garrett, 49.

47. Garrett, 51.

48. Roth, 446–53.

49. Roth, 449.

50. Garrett, 87–90.

51. Garrett, 174–75.

52. Roberts, 87–88.

53. Fennimore and Wagner, 40–41, 70.

54. Nygren, 47–52.

55. Ward and Ward, 35.

56. Fennimore, "Religion in America," 23; B. Ward, "Feasting Posture," 3.

57. B. Ward, "Feasting Posture," 3–24.

58. B Ward, "Feasting Posture," 19.

59. Carson, 48.

60. Rainwater and Rainwater, 18; Victor, 29; Ward and Ward, 33.

BIBLIOGRAPHY

Buhler, Kathryn C. *American Silver, 1655–1825, in the Museum of Fine Arts, Boston.* 2 vols. Boston: Museum of Fine Arts, 1972.

Buhler, Kathryn C., and Graham Hood. *American Silver: Garvan and Other Collections in the Yale University Art Gallery.* 2 vols. New Haven, Conn.: Yale University Press, 1970.

Bushman, Richard Lyman. "The Complexity of Silver." In *New England Silver & Silversmithing, 1620–1815*, edited by Jeannine Falino and Gerald W. R. Ward, 1–15. Boston: Colonial Society of Massachusetts, 2001.

Fales, Martha Gandy. *American Silver in the Henry Francis du Pont Winterthur Museum.* Winterthur, Del.: Henry Francis du Pont Winterthur Museum, 1958.

———. *Early American Silver.* New York: E. P. Dutton, 1973.

———. *Early American Silver for the Cautious Collector.* New York: Funk and Wagnalls, 1970.

———. *Joseph Richardson and Family: Philadelphia Silversmiths.* Middletown, Conn.: Wesleyan University Press for the Historical Society of Pennsylvania, 1974.

Falino, Jeannine. "'The Pride Which Pervades Thro Every Class': The Customers of Paul Revere." In *New England Silver & Silversmithing, 1620–1815*, edited by Jeannine Falino and Gerald W. R. Ward, 152–82. Boston: Colonial Society of Massachusetts, 2001.

Falino, Jeannine, and Gerald W. R. Ward, eds. *Silver of the Americas, 1600–2000.* Boston: Museum of Fine Arts, 2008.

Fennimore, Donald L., and Ann K. Wagner. *Silversmiths to the Nation: Thomas Fletcher and Sidney Gardiner, 1808–1842.* Woodbridge, Eng.: Antique Collectors' Club, 2007.

Glanville, Philippa, ed. *Silver.* London: Victoria and Albert Museum, 1996.

Heckscher, Morrison H., and Leslie Greene Bowman. *American Rococo, 1750–1775: Elegance in Ornament.* New York: Metropolitan Museum of Art and Los Angeles County Museum of Art, 1992.

Kane, Patricia E. *Colonial Massachusetts Silversmiths and Jewelers: A Biographical Dictionary.* New Haven, Conn.: Yale University Art Gallery, 1998.

Nygren, Edward J. "Edward Winslow's Sugar Boxes: Colonial Echoes of Courtly Love." *Yale University Art Gallery Bulletin* 33, no. 2 (Autumn 1971): 38–52.

Quimby, Ian M. G. *American Silver at Winterthur.* Winterthur, Del.: Henry Francis du Pont Winterthur Museum, 1995.

Roe, Albert S., and Robert F. Trent. "Robert Sanderson and the Founding of the Boston Silversmith's Trade." In *New England Begins: The Seventeenth Century*, edited by Jonathan L. Fairbanks and Robert F. Trent, 3:480–89. Boston: Museum of Fine Arts, 1982.

Venable, Charles. *Silver in America, 1840–1940: A Century of Splendor*. Dallas: Dallas Museum of Art, 1994.

Ward, Barbara McLean, and Gerald W. R. Ward, eds. *Silver in American Life: Selections from the Mabel Brady Garvan and Other Collections at Yale University*. New York: American Federation of Arts, 1979.

Additional Sources

Baarsen, Reinier, Phillip M. Johnston, Gervase Jackson-Stops, and Elaine Evans Dee. *Courts and Colonies: The William and Mary Style in Holland, England, and America*. New York: Cooper-Hewitt Museum, 1988.

Belden, Louise. *Marks of American Silversmiths in the Ineson-Bissell Collection*. Charlottesville: University Press of Virginia for Winterthur Museum, 1980.

Bradbury, Frederick. "Old Sheffield Plate." In *The Antiques Book*, edited by Alice Winchester, 234–43. New York: Bonanza Books, 1950.

Carson, Barbara. *Ambitious Appetites: Dining, Behavior, and Patterns of Consumption in Federal Washington*. Washington, D.C.: American Institute of Architects Press, 1990.

Fennimore, Donald. "Elegant Patterns of Uncommon Good Taste: Domestic Silver by Thomas Fletcher and Sidney Gardiner." Master's thesis, University of Delaware, 1971.

———. "Religion in America: Metal Objects in Service of the Ritual." *American Art Journal* 10, no. 2 (November 1978): 20–42.

Foote, Henry Wilder. *John Smibert, Painter*. Cambridge: Harvard University Press, 1950.

Garrett, Elisabeth Donaghy. *At Home: The American Family, 1750–1870*. New York: Harry N. Abrams, 1990.

Garvan, Anthony N. B. "The New England Porringer: An Index of Custom." In *Annual Report of the Board of Regents of the Smithsonian Institution for the Year Ended June 30, 1958*, 543–52. Washington, D.C.: Government Printing Office, 1959.

Glanville, Phillipa. *Silver in England*. Winchester, Mass: Allen and Unwin, 1987.

Gruber, Alain. *Silverware*. New York: Rizzoli, 1982.

Hood, Graham. *American Silver: A History of Style, 1650–1900*. New York: Praeger Publishers, 1971.

Jackson, Charles James. *English Goldsmiths and Their Marks*. Los Angeles: Borden Publishing Co., 1921.

Lanford, William A. "'Mineral of that Excellent Nature': The Qualities of Silver as a Metal." In *Silver in American Life: Selections from the Mabel Brady Garvan and Other Collections at Yale University*, edited by Barbara McLean Ward and Gerald W. R. Ward, 3–9. New York: American Federation of Arts, 1979.

Matson, Cathy. "Philadelphia in the Early Republic." In *Silversmiths to the Nation: Thomas Fletcher and Sidney Gardiner, 1808–1842*, by Donald L. Fennimore and Ann K. Wagner, 10–19. Woodbridge, Eng.: Antique Collectors' Club, 2007.

Myers, Susan H. "Marketing American Pottery: Maulden Perrine in Baltimore." *Winterthur Portfolio* 19, no. 1 (Spring 1984): 51–66.

Rainwater, Dorothy T., and H. Ivan Rainwater. *American Silverplate*. Nashville, Tenn.: Thomas Nelson, 1968.

Roberts, Kenneth, and Anna M. Roberts, trans. and eds. *Moreau de St. Mery's American Journey, 1793–1798*. Garden City, N.Y.: Doubleday & Company, 1947.

Roberts, Robert. *The House Servants Directory*. Waltham, Mass.: Gore Place Society, 1977.

Roth, Rodris. "Tea Drinking in Eighteenth-Century America: Its Etiquette and Equipage." In *Material Life in America, 1600–1860*, edited by Robert Blair St. George, 439–62. Boston: Northeastern University Press, 1988.

Sewall, Samuel. *Samuel Sewall's Diary*, edited by Mark Van Doren. New York: Macy-Masius Publishers, 1927.

Victor, Stephen K. "'From the Shop to the Manufactory': Silver and Industry, 1800–1970." In *Silver in American Life: Selections from the Mabel Brady Garvan and Other Collections at Yale University*, edited by Barbara McLean Ward and Gerald W. R. Ward, 23–32. New York: American Federation of Arts, 1979.

Walsh, Lorena S., and Lois Green Carr. "Changing Lifestyles and Consumer Behavior in the Colonial Chesapeake." Unpublished typescript, 1969.

Ward, Barbara McLean. "The Edwards Family and the Silversmithing Trade in Boston." In *The American Craftsman and the European Tradition, 1620–1820*, edited by Francis J. Puig and Michael Conforti, 66–91. Minneapolis: Minneapolis Institute of Arts, 1989.

———. "The European Tradition and the Shaping of the American Artisan." In *The American Craftsman and the European Tradition, 1620–1820*, edited by Francis J. Puig and Michael Conforti, 14–22. Minneapolis: Minneapolis Institute of Arts, 1989.

———. "Hierarchy and Wealth Distribution in the Boston Goldsmithing Trade, 1690–1760." *Essex Institute Historical Collections* 126, no. 3 (July 1990): 129–47.

———. "'In a Feasting Posture': Communion Vessels and Community Values in Seventeenth- and Eighteenth-Century New England." *Winterthur Portfolio* 23, no. 1 (Spring 1988): 1–24.

———. "'The Most Genteel of Any in the Mechanic Way': The American Silversmith." In *Silver in American Life: Selections from the Mabel Brady Garvan and Other Collections at Yale University*, edited by Barbara McLean Ward and Gerald W. R. Ward, 15–22. New York: American Federation of Arts, 1979.

Ward, Gerald W. R. "The Democratization of Precious Metal: A Note on the Ownership of Silver in Salem,

1630–1820." *Essex Institute Historical Collections* 126, no. 3 (July 1990): 171–200.

———. "The Dutch and English Traditions in American Silver: Cornelius Kierstede." In *The American Craftsman and the European Tradition, 1620–1820*, edited by Francis J. Puig and Michael Conforti, 136–51. Minneapolis: Minneapolis Institute of Arts, 1989.

———. "'An Handsome Cupboard of Plate': The Role of Silver in American Life." In *Silver in American Life: Selections from the Mabel Brady Garvan and Other Collections at Yale University*, edited by Barbara McLean Ward and Gerald W. R. Ward, 33–38. New York: American Federation of Arts, 1979.

Warren, David B., Katherine S. Howe, and Michael K. Brown. *Marks of Achievement: Four Centuries of American Presentation Silver*. New York: Harry N. Abrams in association with the Museum of Fine Arts, Houston, 1987.

Waters, Deborah D. "Rich and Fashionable Goods: The Precious Metals Trades in Philadelphia, 1810–1840." In *Silversmiths to the Nation: Thomas Fletcher and Sidney Gardiner, 1808–1842*, by Donald L. Fennimore and Ann K. Wagner, 20–31. Woodbridge, Eng.: Antique Collectors' Club, 2007.

Wees, Beth Carver. "Design Drawings for Fletcher and Gardiner's Hollowware and Swords." In *Silversmiths to the Nation: Thomas Fletcher and Sidney Gardiner, 1808–1842*, by Donald L. Fennimore and Ann K. Wagner, 80–109. Woodbridge, Eng.: Antique Collectors' Club, 2007.

Pewter Objects

Consisting primarily of tin, pewter is a fragile alloy. Few early pewter objects survive in their original forms because they were often melted and formed into new objects. Many colonists and early Americans, therefore, invested in pewter that was used and re-used from generation to generation, artisan to artisan, and sometimes country to country. Thomas Danforth Boardman, a nineteenth-century pewterer of Hartford, Connecticut, noted that "from the Landing of the Pilgrims to the Peace of the revolution Most all, if not all, used pewter plaits and platters, cups and porringers imported from London & made up of the old worn out. This was done in Boston, New York, Providence, Taunton and other places."[1] Those who could not afford pewter tablewares used wooden plates and dishes, or ceramics, both pottery and porcelain, which were increasingly common after 1780.

LOOKING AT PEWTER OBJECTS

Line, proportion, and ornament are important characteristics when looking at pewter, as can be seen by comparing two pewter teapots by William Will, who worked in Philadelphia between 1764 and 1798.

Line

Curved lines shape one of Will's teapots and outline its domed top (fig. 15-1). The elaborately curved wooden handle balances the curved spout. On another teapot, straight lines define the drum shape, which is accented by the flat lid and straight spout (fig. 15-2). Molding at the base and three rows of beading at the top of the body attract the viewer's gaze to another straight line, a horizontal one. The lines of the curved pot draw the viewer's eyes over the pot; in contrast, the straight-sided pot appears simpler in form.

Proportion

Proportion shows subtle relationships among the parts of an object. Will, for example, balanced the wide, low shape of the pear-shape teapot with the high dome of the lid. A slight sense of imbalance occurs, however, in comparing the small spout to the larger curved handle, perhaps relating to the human hand and comfort of use. The straight-sided teapot is not as tall but is slightly wider overall. The spout and handle appear to be more balanced.

Ornament

Moldings and inscribed lines ornament many pewter forms, and Will's two teapots are good examples. On the pear-shape pot, the rhythmic scribed and molded lines on the domed lid, at the lid's edge, and where the body curves outward ornament the object and enhance the proportions. On the drum-shape pot, lines ornament the flat lid and the top and bottom of the body, emphasizing the straight sides. Beading and cast decorative finials ornament both.

THINKING ABOUT STYLE

Some pewter objects, particularly hollowware (vessels such as teapots, creamers, and jugs), exhibit style characteristics that were fashionable at the time of their creation. In the seventeenth century, for example, pewter tankards often had flat tops and protruding handles. These designs show similarities to the horizontal emphasis in seventeenth-century furniture, with its broad proportions, straight lines, and multiple moldings.

By the first half of the eighteenth century, pewterers made tankards with double-domed tops and newly fashionable teapots in round and pear shapes (fig. 15-3). Their deep reverse curves show similarities to the ornament on William and Mary–style furniture, particularly the swirling lines of burl veneer and the C-scrolls carved on the crest rails and stretchers of many chairs. The dynamic qualities of contrasting curved lines suggest movement through space, a characteristic of baroque design tradition.

By the second half of the eighteenth century, craftsmen who could afford new molds responded to the principles of rococo style. Evident in coffeepots and cream pots, doubly curved lines predominate (fig. 15-4). By the 1790s, urn and drum shapes, suggestive of the classical revival styles, replaced the curving

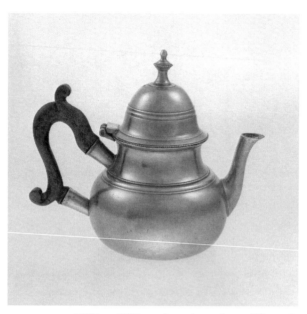

FIGURE 15-1. William Will made at least three differently shaped teapots. This quart-size pot is distinguished by its disc-shaped pewter finial and beading, which is a feature of the classical style. (Teapot, William Will, Philadelphia, 1785–1798. Pewter, wood; H 7¼ in., W [including handle] 9 in., Diam 5¼ in. 1958.657 Winterthur Museum, gift of Henry Francis du Pont.)

contours of earlier forms. Stylistic changes had little effect on plates, however. Throughout the eighteenth century, pewter plates with single-beaded rims were preferred, and most pewterers working between 1700 and 1810 made them (fig. 15-5).[2]

MAKING AND MARKETING PEWTER OBJECTS

Pewter is an alloy of tin and small amounts of copper, antimony, bismuth, or lead. Antimony adds strength; bismuth makes castings precise; lead, although rarely used in the best English pewter, facilitates casting of the alloy. Most of the pewter used in the colonies came from England.[3] With mines producing most of the tin used in England, its colonies, and Europe, pewter was important to that country's economy. Moreover, English guilds of pewterers were sufficiently powerful to ensure the use of English-made pewter in the colonies. By the mid-eighteenth century, more than three hundred tons of pewter were shipped annually to the British North American colonies, equivalent to almost 1 million eight-inch pewter plates.

Almost from the beginning of settlement, the North American colonies attracted some English-trained pewterers who profited from reworking the pewter from worn objects. As early as 1635, Richard Graves emigrated from England and settled to work in Salem, Massachusetts. By 1640 three other pewterers were

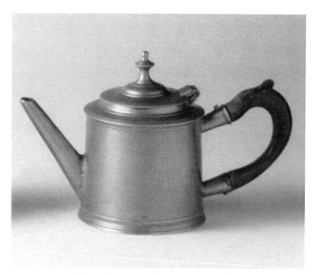

FIGURE 15-2. The silhouette of this teapot is like many of the Chinese export porcelain teapots imported at the turn of the nineteenth century. Although its shape is new, the maker has retained details of decoration, such as the finial shape, that he used in earlier fashions. (Teapot, William Will, Philadelphia, 1764–1798. Pewter, wood; H 6⅕ in., W [including handle] 10⅛ in., Diam 4¾ in. 1958.656 Winterthur Museum, gift of Henry Francis du Pont.)

working in Boston. A dish with a broad rim, attributed to Edmund Dolbeare of Massachusetts, was made sometime between 1670 and 1711. In 1700 at least nine pewterers worked in Massachusetts, two in Virginia, two in Pennsylvania, and one in Maryland.

The best pewter, according to a London appraiser's handbook of the 1750s, was "easily known by its nearly resembling silver."[4] American pewterers emphasized

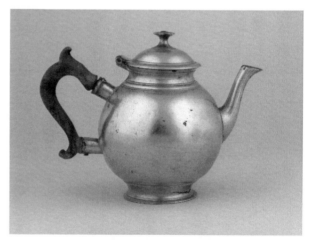

FIGURE 15-3. Teapots of the round shape are unknown in English pewter, according to Charles Montgomery in *A History of American Pewter.* This American pot follows the form of an early silver pot made in New York City between 1705 and 1710. (Teapot, John Bassett, probably New York, N.Y., 1740–1760. Pewter, wood, iron; H 6⅓ in., W 9 in., Diam 4¾ in. 1967.1370 Winterthur Museum, gift of Charles K. Davis.)

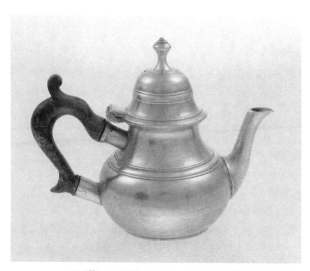

FIGURE 15-4. William Will was an active, prolific craftsman who continuously reworked his designs and molds to reflect the latest fashion. Many pewterers followed the styles set by porcelain and silver. (Teapot, William Will, Philadelphia, 1764–1798. Pewter, wood; H 6¼ in., W [including handle] 8 in. 1961.1680 Winterthur Museum, bequest of Henry Francis du Pont.)

the quality of their wares by comparing them favorably with those imported from England. They varied the contents of alloys according to the intended use of the object. Utilitarian items had a high percentage of lead; for example, a bedpan made by William Will has 13 percent lead and 83 percent tin. To "resemble silver," pewter in teapots, tankards, and church vessels is 90 to 95 percent tin.

Craftsmen formed a few of the earliest colonial dishes by casting pewter into flat disks, which they hammered into shape over a tool called a swage. Hammering made the metal hard and strong. By the late eighteenth century, if a pewterer thought it necessary to strengthen a plate or dish, he usually hammered it on the curved part between rim and bottom. Most pewter objects, however, were made in molds. Designing and creating the best molds required the skills of trained workers in brass. Some molds were imported. Some American pewterers made their own; materials other than brass, such as wood or soapstone, were also common. Molds were expensive, and craftsmen therefore sometimes shared them, often within families, from one generation to the next. With an old piece of pewter, a container in which to melt it, a small fire, and a mold in which to pour the molten material, a farmer or other nonartisan colonist could make such uncomplicated objects as spoons and buttons.

After an object was removed from the mold, hammering or skimming on a lathe was necessary, followed by hand burnishing. The quality of a molded pewter product, therefore, reflected the metal, the mold, and the maker's skill in smoothing the new object. Many objects required more than one mold. Combining the components into a completed, serviceable product required professional expertise. Philip Will, brother of William, created an innovative and interesting flagon by using several molds (fig. 15-6). The flagon, whose handle design appeared on some silver objects made in New York at the same time, is one of only three surviving pieces made by Philip; the other two pieces are plates. In other examples of creativity with molds, William Will made a chalice of molded parts for salt dishes placed bottom-to-bottom (fig. 15-7), and the lid of a covered chalice attributed to Johann Christoph Heyne was cast from the same mold as the base. The similar curving profiles are visible evidence (fig. 15-8).

Pewter was sometimes embellished with engraving. Unlike elaborate ornament fashionable on European pewter, a name and date in a simple design was the usual decoration for American pewter. Paint was also used. Nineteenth-century pewter tea- and coffeepots sometimes show metal handles painted to simulate wood.

Late in the eighteenth century, Britannia metal appeared in the United States from England.[5] Britannia was less expensive to produce, shinier, and harder than regular pewter because of the absence of lead and the presence of at least 3 percent antimony and a small amount of copper. While competing with, and losing ground to, imported objects made of Britannia, American pewterers struggled to discover its formula, and by 1875 were making millions of objects

FIGURE 15-5. A one-piece vessel cast in a two-part mold was known as sadware in the seventeenth and eighteenth centuries. Plates fell into this category. They were made by most pewterers and were sold by the pound. (Plate, Peter Young, New York, N.Y., 1775–1795. Pewter; Diam 8⅝ in. 1965.2494 Winterthur Museum, bequest of Henry Francis du Pont.)

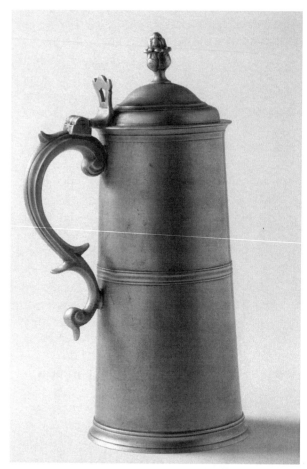

FIGURE 15-6. This flagon is noteworthy because it was made from a combination of molds and shows rococo ornament in the budlike finial and handle. Philip Will, like most pewterers, not only created new high-quality pieces but also repaired pewter wares. (Flagon, Philip Will, New York, N.Y., 1766–1787. Pewter; H 13⅖ in., W 7½ in., Diam 5½ in. 1982.5 Winterthur Museum.)

of Britannia. As Charles Montgomery notes: "To pewterers in the period 1806–1875, Britannia clearly meant a kind of super pewter that was easily worked and that sold extremely well. To the public, Britannia meant an alloy that was sparkling and bright, wrought in new-fashioned forms, contemporary with those of silver and Sheffield plate."[6]

Pewterers usually sold their wares by weight in units of a dozen directly from their own shops; one dozen nine-inch plates weighed about ten pounds, and a dish cost about as much as a skilled craftsman earned in a day. Large shops capable of volume production often conducted wholesale and retail trade and also consigned objects to rural peddlers. Some stocked a variety of imported wares. If a pewterer did not have the molds to complete an order, he bought parts from a craftsman who did. Pewterers bought and sold both parts and completed pieces among themselves. Ob-

jects bore the mark of the artisan who received the original order.

LIVING WITH PEWTER OBJECTS

In colonial America, spoons were the most numerous pieces of pewter, followed by plates. Colonists used basins that were 6 to 12 inches in diameter (8-, 9-, and 10½-inch sizes were the most common) and 7½- to 10-inch plates for serving food.[7] Porringers, which were small basins with handles, were used for both eating and drinking. Other drinking vessels included mugs and tankards. Mugs were lidless, and usually decreased in diameter from bottom to top. Most had straight sides, although tulip-shape or bellied mugs

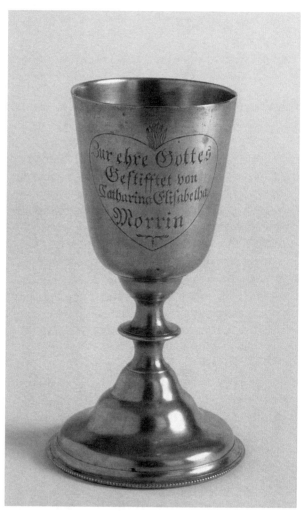

FIGURE 15-7. Its use as a communion vessel in many Christian traditions heightens the inherent prestige of the chalice form. In this example, the engraving translates from German as "the gift of Catherine Elizabeth Morris/to the Glory of God." It is enclosed in an engraved flaming heart. (Chalice, William Will, Philadelphia, 1795. Pewter; H 7⅞ in., Diam 4⅖ in. 1958.24 Winterthur Museum purchase with funds provided by Mr. Joseph France.)

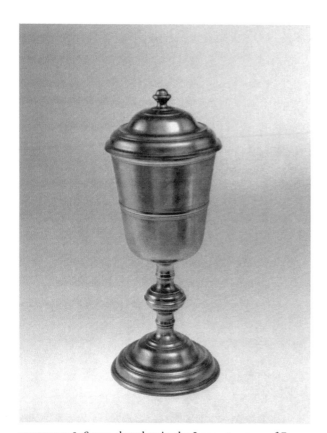

FIGURE 15-8. Some churches in the Lancaster area of Pennsylvania still have their pewter communion services made by Johann Christoph Heyne. This magnificent covered chalice is one example of his work. (Chalice with cover, Johann Christoph Heyne, Lancaster, Pa., 1756–1780. Pewter; H 10⅔ in., Diam 4⅓ in. 1953.97a,b Winterthur Museum, gift of Edgar Sittig.)

were made, especially in Philadelphia in the mid-1700s (fig. 15-9). As tea and coffee became favored drinks in the eighteenth century, pewter was used for pitchers, cream pitchers, teapots, and coffeepots. In the second quarter of the nineteenth century, tea- and coffeepots became important products for pewterers.[8] One inventory study of Chester County, Pennsylvania, showed pewter's dominance as tableware in all wealth groups through the eighteenth century.[9]

Pewter objects were desirable, and owners kept them polished. Advice to nineteenth-century housewives was that pewter and Britannia should "first be rubbed with a flannel rag dipped in oil to remove any spots," then washed in soapy water, wiped dry, and rubbed with powdered chalk or whiting and sweet oil; buffing with a clean rag or soft piece of leather completed the task.[10]

Churches used pewter communion vessels, baptismal bowls, and candlesticks of the finest quality; many exhibit excellent workmanship as well as varied

designs. Johann Christoph Heyne, a German-born artisan who mostly worked in Lancaster, Pennsylvania, made and sold church objects with Germanic motifs. His work includes a flared-base flagon with cherub-head feet and a covered chalice (see fig. 15-8). Pewter could also be found in practical and humble objects: boxes for shaving soap and tobacco, the worms (spiral-twisted piping) that captured alcoholic spirits in a still, funnels, spittoons, bedpans, ladles, and baby bottles. Soldiers and field hands drank from pewter canteens; curtains hung from pewter rings; clothing was fastened with pewter buttons; and shoes were decorated with pewter buckles. Pewterers made oil lamps in great quantity from about 1830 through the 1860s. Constantly experimenting to design and produce efficient burners, they often specialized in their production.

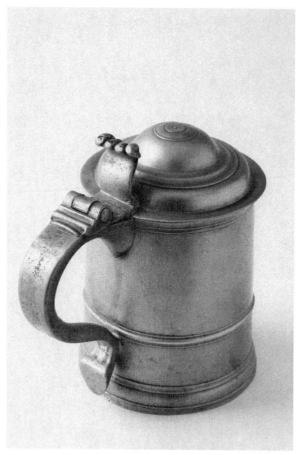

FIGURE 15-9. The double-dome top of this tankard is a change from the previously fashionable flat top. The tankard may be the earliest surviving piece of Boston hollowware whose maker, John Carnes, can be identified. Carnes held many local government positions in Boston. (Tankard, John Carnes, Boston, 1723–1760. Pewter; H 6½ in., W [including handle] 7⅜ in., Diam 4½ in. 1965.2268 Winterthur Museum, bequest of Henry Francis du Pont.

CONCLUSION

Because of pewter's intrinsic value, beauty, and ease of working, it graced many homes in the colonies and early republic. Rapidly changing styles and rising production costs, however, combined with the eighteenth-century development of inexpensive ceramics and the nineteenth-century development of electroplated silverwares, caused a decrease in the production of individually crafted pewter objects.

NOTES

1. Montgomery, 7.
2. Montgomery, 137.
3. Montgomery, 7.
4. Montgomery, 27.
5. Montgomery, 39.
6. Montgomery, 39.
7. Montgomery, 143, 133.
8. Montgomery, 103–31, 168–70.
9. Disviscour, tab. 1.4, 35, 42–50, app. 1.
10. Garrett, 176.

BIBLIOGRAPHY

Kerfoot, John Barnett. *American Pewter.* New York: Crown Publishers, 1942.

Montgomery, Charles F. *A History of American Pewter.* Rev. ed. New York: E. P. Dutton, 1978.

Montgomery, Charles F., and Patricia E. Kane. *American Art, 1750–1800: Towards Independence.* New Haven, Conn.: Yale University Art Gallery, 1976.

Additional Sources

Disviscour, Jeannine A. "Treen in Chester County, Pennsylvania, 1683–1787: A Contextual Analysis." Master's thesis, University of Delaware, 1991.

Garrett, Elisabeth Donaghy. *At Home: The American Family, 1750–1870.* New York: Harry N. Abrams, 1990.

Laughlin, Ledlie Irwin. *Pewter in America: Its Makers and Their Marks.* 3 vols. Barre, Mass.: Barre Publishers, 1969, 1971.

Thomas, John Carl. *Connecticut Pewter and Pewterers.* Hartford: Connecticut Historical Society, 1976.

———. *Pewter in American Life.* N.p.: Pewter Collectors' Club of America, 1984.

Ward, Barbara McLean, ed. *A Glimpse into the Shadows: Forgotten People of the Eighteenth Century.* Winterthur, Del.: Henry Francis du Pont Winterthur Museum, 1987.

Iron, Copper, and Copper-Alloy Objects

EUROPEAN IMMIGRANTS TO THE NEW WORLD WERE accustomed to using metals. With iron and steel tools they cleared and farmed land, and with objects of iron—and later, copper, brass, and bronze—they cooked food, distilled drink, and heated and lighted their homes.[1] The search for ore, especially of precious gold and silver, encouraged some of the first colonization. England was an iron-importing country, and pig iron from her North American colonies entered her foundries and forges to become finished goods.[2] Metals, therefore, were vital to colonists to fill their own needs and to exchange for much-needed finished goods from the mother country.

Museum visitors often look at the iron pots and brass candlesticks of an earlier era from the perspective of a culture that uses metals as avidly as European colonists but in different kinds, quantities, and ways. We inherited the transportation and industrial revolutions of the nineteenth century that depended on iron. Today, iron, steel, and copper undergird structures as well as transportation and communication systems. These metals replace the wood frames of buildings and ships familiar to the colonists. In our homes, metals such as aluminum and stainless steel help us fulfill domestic and personal needs, with iron, copper, and brass usually being more decorative than utilitarian.

This chapter addresses the place of iron, copper, and copper alloys (including brass, bronze, and paktong) in homes in the North American colonies and new republic. Encouraged to look at iron chimney backs, copper kettles, and brass candlesticks, visitors may find metal objects fascinating gateways to the perspectives of people in the past.

LOOKING AT METAL OBJECTS

Either because of its reassuring familiarity, as with a copper kettle, or its intriguing novelty, as in a flint tinderbox lighter, the form of a metal object often attracts notice. Especially if highly polished, color can catch the light and the eye and lead to the identification of the material. As in many categories of decorative arts, close attention to ornament yields information about an object's function, both practical and symbolic. Metal objects are often not as elaborately decorated as ceramics or glass, but looking at ornament can lead to discussions of technique and meaning. These characteristics of form, color, material, and ornament help visitors to understand metal objects.

Form

Because metal melts and then solidifies and is malleable, metalworkers can create forms by casting liquid metal in molds, hammering soft metal (called forging or raising), and shaping metal sheets that have been hammered or rolled. Each technique produces characteristic forms, and some metals respond better to one method than another. Casting, for instance, produces self-contained forms such as cast-iron kettles with thick, substantial walls. Forging creates such complex objects as iron pipe tongs with elongated and thin silhouettes. Sheet-metal objects have smooth surfaces and walls that are thinner than cast-metal objects.

Color and Material

Iron objects typically appear black and dull, like a chimney back marked "Aetna" (fig. 16-1). Steel, a more refined iron product, has a silvery color, and when highly polished, may imitate silver. A yellow-red color identifies copper, the base of many alloys. Adding tin to copper makes bronze and imparts a gold cast. Copper plus zinc makes brass, which varies from a coppery color (little zinc) through a golden color to a yellowish white or even blue-white color (much zinc). Zinc and nickel added to copper make paktong, also known as tutenag or India metal. Nickel gives the alloy the color of silver, which paktong often imitates. In andirons made between 1780 and 1800, paktong supplies the sheen of silver at a high melting point, a practical consideration for fireplace equipment.[3]

Sometimes patination, plating, or paint masks the true color of metal. Patination is a thin, colored film that results from normal aging and use or from chemical processes such as the application of acids for a

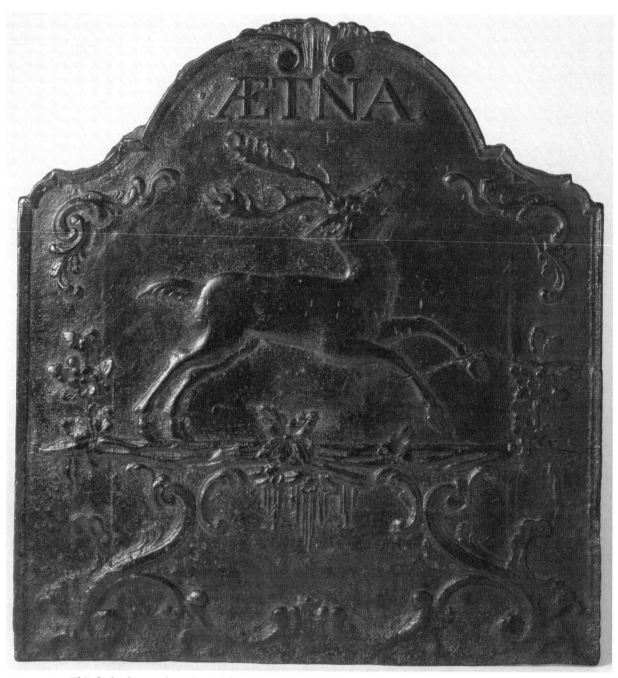

FIGURE 16-1. This fireback appeals to the eye through its cast design of a leaping stag surrounded by leafy scrolls. The word "AETNA" above the stag's head identifies the iron furnace where the fireback was made and may refer to Mount Aetna with its volcanic fires. (Fireback, Burlington, N.J., 1770–1774. Iron; H 31^7/10 in., W 29¾ in., D 9/10 in. 1958.2750 Winterthur Museum, bequest of Henry Francis du Pont.)

specific color. Patinas are highly vulnerable to wear, and the surviving patination is rare. In plating, which is used for practical and ornamental reasons, a thin film of one metal is deposited on a body of a different metal. Some copper and brass objects were gilded, silvered, or tinned (also called whitening). Many tinned sheet-iron objects were painted for protection and decoration. Black and occasionally red were back-

ground colors for an array of decorative motifs and hues.

Lacquer or shellac preserves the surface texture of an object and can be combined with a colorant. Occasionally, on an eighteenth-century brass object, an original lacquer coating protects matte and burnished surface textures; continual polishing would have smoothed the textures into a uniform

FIGURE 16-2. A spatula is one of the cooking utensils commonly made for a new bride. The inlaid copper hearts are decoration beyond necessity. (Spatula, Pennsylvania, 1810–1830. Iron, copper; L 12⁹/₁₀ in., W 2⅖ in., D 4 in. 1965.1617 Winterthur Museum, bequest of Henry Francis du Pont.)

surface. Occasionally, two materials and two colors combine on a single object for utilitarian or decorative purposes. A late eighteenth-century metalworker stamped copper heart shapes into the handle of a kitchen utensil (fig. 16-2).

Ornament

Although as a group metal artifacts of iron, copper, or alloys did not receive the elaborate ornamentation characteristic of silver, ceramics, or furniture, decoration on metal objects is varied in technique and motif.[4] Some decoration is raised above the surface as part of a casting or stamping process, as the lettering on a fireback or the motifs of flowers, plants, figures, and shells stamped on brass furnishing hardware in the late eighteenth and early nineteenth centuries. Some motifs are punched or engraved into the surface, as in the initials, date, and floral and wreath design on a brass tobacco box (fig. 16-3). Sometimes decoration results from cutting or filing away metal. Beyond protection from rust or other decay, paint often decorates tinned sheet-iron objects.

THINKING ABOUT STYLE

Style in metal objects results from an interplay of design elements chosen for usefulness and decorative effect. A metalworker who recognized the particular characteristics of the raw material worked in an efficient way to produce an object acceptable to a customer. The design elements that resulted from a tradition of craft practices or from reliable, appropriate solutions to daily needs sometimes persisted for many years, but those that resulted from knowledge of fashion typically appeared for only short periods of time.

FIGURE 16-3. Tobacco boxes like this one were often lined with tin to ensure that the tobacco did not interact with the copper. This stylish box supports the idea that tobacco was held in high esteem in the seventeenth century. In fact, it was believed to have medicinal qualities. (Tobacco box, England, 1679. Copper, brass; H ⅘ in. W 3 in., D 3⁹/₁₀ in. 1964.717 Winterthur Museum, bequest of Henry Francis du Pont.)

Unlike designs that are craft- or use-specific, fashionable elements on metal objects may be compared to other design elements. Metal objects therefore present an interesting case study for the definition of style, which emphasizes repeated design elements chosen within contexts. A metalworker and a metalware owner made decisions that were influenced by multiple interrelated contexts. Copper teakettles provide excellent examples.

Tea drinking was a social event that became increasingly popular in late eighteenth-century British America, and a kettle was necessary to provide boiling water for the infusion of tea leaves. Kettles of copper, which conducted heat well and resisted rust and corrosion, served this function. References to teakettles appear in colonial inventories in the second quarter of the eighteenth century.[5] A comparison of two copper kettles reveals various design choices and styles. One with a hinged handle, marked "HUNNEMAN, BOSTON," illustrates a basic, familiar kettle design that was probably influenced more by production and utility than fashion (fig. 16-4). The kettle has a flat base; slightly flared sides; sharply rounded, almost angled shoulders; a "gooseneck" spout; and domed lid. The bail handle is flat and wide. Although the lid handle is more decorative than a plain knob handle, no design element appears purely decorative.[6]

The second, a copper kettle-on-stand, is decorated not only by cast and chased-and-repoussé motifs but also by patination, an overall brown coating (fig. 16-5). The decoration on the body and the cast decoration

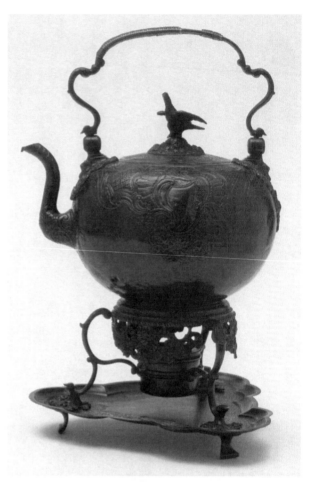

FIGURE 16-5. The patination (dark coloring) of this teapot adds to the decorative effect of the antique bronze. The surface, made by immersing the pot in a mixture of sulfur, pearl ash, and water, also prevented tarnish. (Teapot and stand, probably London, 1730–1760; tray ca. 1850. Copper, tin, rattan; H 13⁹⁄₁₀ in., W 9⁴⁄₅ in., D 7¼ in. 1959.4.4 Winterthur Museum purchase with funds provided by Henry Francis du Pont.)

on the stand show rococo influences, fashionable at the time the object was made. An asymmetrical rococo cartouche on the sides is similar to a cartouche that might ornament the broken pediment of a mahogany high chest made in Philadelphia when the rococo taste was stylish there. The C-curves and foliate pad feet of the kettle stand seem inspired by the same sources as a cabriole leg on a tripod table.

Beyond decoration are other differences. With its rounded base and applied foot rim that fits snugly into the stand, the kettle-on-stand does not follow the typical flat-bottom copper kettle design. It also has a bail handle wrapped in rattan, a flammable material indicating that the kettle was not designed to boil water by sitting in hot embers or hanging from a wrought iron hook in a fireplace. It was intended to keep water hot and, like highly decorated ceramic tea wares, to im-

FIGURE 16-4. Copper kettles received heavy use and therefore provided coppersmiths like William Hunneman with a great deal of repair work. His records also show a strong demand for new kettles. The materials for making and repairing came in the form of rolled sheet copper from England or from a rolling mill in Canton, Massachusetts. (Teakettle, William C. Hunneman, Boston, 1769–1856. Copper, brass; H 11 in., W 10½ in., D 7⁴⁄₅ in. 1989.65 Winterthur Museum.)

press those who saw it.[7] Rather than being brought to a parlor from a kitchen, set on a hearth while needed, and removed to a kitchen for storage, such a kettle-on-stand probably stayed in an owner's parlor even when not in use. In its style, it compares more closely with silver versions made in London or the colonies in the second quarter of the eighteenth century.[8]

Metal lighting devices may be analyzed in the same way as kettles. Which designs were motivated by use or by the necessities of efficient production? Which designs were influenced by fashionable, cosmopolitan styles? Allowing people to be active before dawn and after dark, lighting devices needed to hold a wick and fuel, which usually consisted of waxes from plants or animal fats. Small vessels that held liquid fat were simple and sufficed for utilitarian lighting. Two examples include a small hanging copper vessel with a hinged lid, narrow at one end to support a wick, as well as an iron lamp designed to be nailed to a wooden beam, containing two shallow pans, each pinched on an end for a wick. Another early lighting device was a candlestick, which supported tallow or wax tapers. Preferably of durable and inflammable material, a candlestick needed a socket or pricket (spike), a base, and a cup to catch drips. Candles made well enough to reduce dripping allowed the drip pan to become small and shallow.[9]

Modifications in European candlestick design permit broad dates for stylistic forms. Because designs persist for long periods and one change may coexist with earlier elements, precise dates are difficult to establish. During the sixteenth and seventeenth centuries, most European countries produced candlesticks with deep, wide, and conical bases inspired by Persian candlesticks that came to the West via Venetian merchants. Changes in the first half of the seventeenth century include trumpet-shape, squared, hexagonal, or octagonal bases. Until the late 1600s, a central drip pan was a typical feature of wide-based and baluster-shape candlesticks. In the early 1700s, however, squared bases with chamfered corners appeared, and in the mid-1700s in England and on the European continent, segmented circular bases with swirled gadroons or scallops became more common (fig. 16-6). Through the last half of the 1700s and the first quarter of the 1800s, tapered columns with urn-shape and leaf decoration reflected fashionable classical revival design.[10]

Some lighting devices, however, are more distinctive, showing how the brass founder was influenced by fashionable designs and the needs of particular social

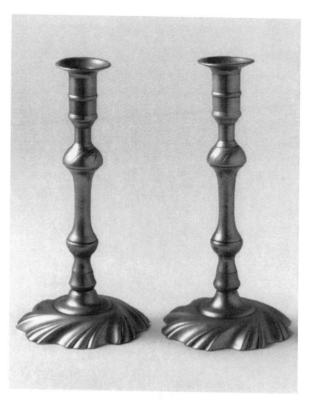

FIGURE 16-6. This brass candlestick has a spiral-decorated base as well as knop and bobeche, to catch dripping wax. This design was made in silver as well as brass, and the candlesticks were usually sold in pairs. (Candlestick, England, 1740–1760. Brass; H 8½ in., Diam 4⅕ in. 1959.2918 Winterthur Museum, bequest of Henry Francis du Pont.)

behaviors. A pair of brass candlebranches offers an excellent example of asymmetrical foliate rococo design (fig. 16-7). Their style suggests that the people who used them to light their rooms had a cosmopolitan knowledge of fashion and elite practices of socializing in the evening—two contexts for interpretation.[11]

In the late 1700s, Aimé Argand of Switzerland developed the first advance toward a more intense light source than candle flames.[12] An argand lamp has a central base topped by a fuel reservoir. A sidearm carried fuel to one or two wicks enclosed by chimneys at the ends of arms. This basic design—fuel reservoir, sidearm, and wick—is apparent in other lighting devices that used oils throughout the nineteenth century. Primarily of copper and plated with silver, some argand lamps clearly show the influence of classical designs, incorporating urn, column, and patera motifs (fig. 16-8).

MAKING AND MARKETING METAL OBJECTS

Making an object from metal required a lengthy, laborious, and expensive process of extracting, refining, and forming ore. Success in North America

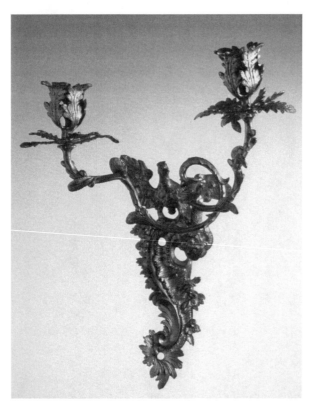

FIGURE 16-7. The fact that these rococo candlebranches held two candles and were fixed to a wall suggests that the original owners enjoyed after-dark amusements. Illumination was provided by wax, not tallow, candles, which were neater and more reliable but more costly. (Sconce, probably London or Birmingham, 1760–1780. Brass; H 13½ in., W 13 in., D 9⅓ in. 1957.126.26 Winterthur Museum.)

with these various steps depended on knowledge about resources for ore, how to mine them, and, in the colonial period, how to suit metal production to England's economic policy.

Iron was plentiful and relatively easy to extract in North America. Some iron ores were found among the stones of farmlands or on the surfaces of bogs; extraction required more labor than technical knowledge. With three or four workers able to supply enough ore for one blast furnace, miners dug ore from open pits and abandoned them for new sites after reaching a depth of twenty to forty feet.[13] Plentiful supply and ease of extraction helped make the colonies producers of one-seventh of the world's pig, wrought, and cast iron before the Revolution.[14]

Copper was profitably mined, although in small quantities, in the British North American colonies. Deposits were reported as early as 1659 in New Jersey. From 1717 until about 1750, when drainage problems ended the mine's profitability, ore from the Schuyler mine near Belleville, New Jersey, was sold in Europe. In 1705 copper was discovered and mined near Sims-

bury, Connecticut, and small-scale efforts also existed in Maryland and Virginia. The Lake Superior region contains one of the world's great copper deposits, and although Native Americans knew about the ore, colonists did not. The copper deposits were not revealed to government explorers until 1819.[15]

Much of the copper, brass, and bronze worked by British American metalworkers, however, was im-

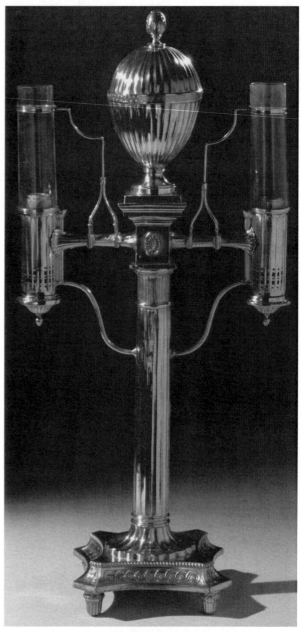

FIGURE 16-8. The design of this argand lamp shows a preference for classical motifs: an oval patera, column, and water leaves. This type of lamp was intended to give more light than other devices with no smell or smoke. (Argand lamp, Matthew Boulton's Soho Manufactory, Birmingham, Eng., 1784–1809. Fused plate, glass; H 24½ in., W 11¼ in., D 6½ in. 1961.1725 Winterthur Museum, bequest of Henry Francis du Pont.)

ported from England in sheets or as finished goods.[16] England had major copper deposits and encouraged colonists to purchase finished goods. In addition, no workable deposits of zinc (needed to make brass) or tin (needed to make bronze) were available in the colonies.[17]

The process of refining separated the metal from its impurities. Most copper ore mined in the colonies was exported unrefined, but for iron, production was extensive. In the colonial period, iron was extracted from iron ore in a blast furnace, which was usually a hollow stone pyramid twenty-five to thirty-five feet high, containing iron ore, charcoal for fuel, and a "flux" (often limestone to combine with and eliminate impurities). Skilled iron founders carefully controlled the charge and the firing to determine the quality of metal produced. At the end of a firing, a founder broke a small dam at the bottom of the furnace, and iron flowed into trenches in the floor and hardened into ingots, called pigs. Assisting founders in the iron-making process were workers to fill and wall the furnace, miners, colliers (who charred wood into charcoal for fuel), and many woodcutters.[18]

Some iron needed further processing before it was ready for metalworkers. Through a process of heating, cooling, and hammering, a refiner could make blacksmith-ready bar iron. Some went to a mill, where hammers and rollers produced sheets. With the controlled addition of carbon, some iron became steel, able to withstand hard wear and flexing.[19] By remelting and casting refined ore, hammering bar iron into a desired shape, or hammering sheet iron into shape, a metalworker made usable objects. In some cases, a metalworker might plate an object for durability or decoration.

Iron often was cast in molds shaped in loam or sand; copper, a softer metal, did not lend itself to such a technique. To make a flat object (such as a fireback or stove plate), a molder at a colonial ironworks pressed a wooden pattern directly into the sand of the floor of the furnace; he then removed the pattern and let molten metal run into the molded depression (see fig. 16-1). To make hollowware, molders used flasks, which were wooden frames packed firmly with sand around a wooden pattern. After removing the pattern, molders allowed molten iron to flow into the sand mold and harden. When they removed the casting from the mold, they finishing the object by smoothing rough edges or removing unwanted metal. This technique allowed such lightweight casting as a nineteenth-century iron porringer.[20] Similar casting methods produced brass and bronze objects. Brass candlesticks, for example, could be cast in two halves in a mold. A metalworker finished the product by filing away stray bits of metal, polishing the surface, and joining the halves. Bronze is hard and brittle, and lends itself well to casting. Colonial bronze objects are usually thick walled, heavy, and without fine finish.

Another process for forming metal objects was hammering into a desired shape. A blacksmith formed such wrought-iron objects after the pig iron had been heated and hammered in a refinery forge (or "finery") to remove carbon and impurities and toughen the iron's internal structure; such a process made iron less brittle and easier to work than when it was taken directly from the furnace.[21] A smith heated the material, then hammered it into desired forms. The long, thin shape of iron objects such as forks hanging at a hearth is a visual clue to manufacture by hammering, in contrast to the solid, heavy appearance of cast objects.

Forming metal into sheets was a third way of working metal. Workers at a plating or rolling mill used large water-powered hammers or rollers to form bars into sheets that were cut to form slit iron rods, some of which were cut further to make nails. Sheets were used to make such objects as copper teakettles. Copper, because of its softness, lent itself to rolling into sheets. Many copper objects show the thin walls, hammer marks, and seams made by coppersmiths working with a sheet.

Although some was domestically produced, most sheet copper and brass was imported from Britain during the colonial period.[22] William Hammond, owner of the Fountain Copper Works in Frederick County, Maryland, did, however, provide domestically produced sheet copper. His advertisement indicates that domestic production could not satisfy demand:

> Having erected a furnace . . . , in Frederick Country, I am now making a quantity of sheet copper. . . . It is not probable the quantity I make will be sufficient for the demand . . . To prevent trouble, those who want their orders executed must send the money with them to the manager of the Copper Works, or to my house in Baltimore (July 18, 1780.)[23]

An advertisement of Philadelphian Benjamin Harbeson lists the usual forms received by copper merchants who imported goods (fig. 16-9):

> Benjamin Harbeson & Son, at their Copper Warehouse No 75, north side of Market Street, opposite Strawberry alley, Have just received a compleat as-

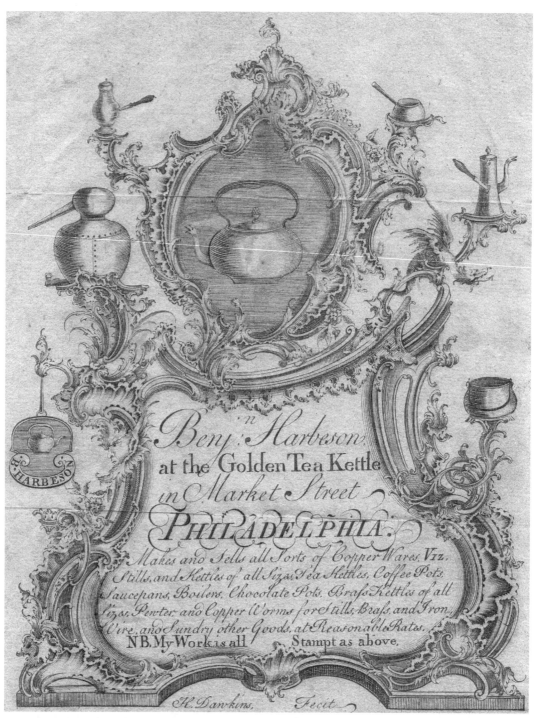

FIGURE 16-9. Benjamin Harbeson's career as a coppersmith lasted more than fifty years. He offered many forms to his customers: stills, teakettles, chocolate pots. These and other forms are illustrated in his broadside as part of a rococo design that gives his address as "At the Golden Tea Kettle" on Market Street. The broadside also guarantees "My Work is all Stampt" so that there would be no dispute as to the shop from which the work came and no question about the reliability of the products. Not all coppersmiths marked their work. (Benjamin Harbeson broadside, Philadelphia, ca. 1764. Joseph Downs Collection of Manuscripts and Printed Ephemera, Winterthur Library.)

sortment of Copper in Sheets and bottoms, stills, cocks, rivets, borax [used by metalworkers as a flux], brass kettles in nests, and as usual, stills from 30 gallons to 250, and which they are determined to sell on reasonable terms for cash or the usual Credit.[24]

Copper sheets were seamed in many ways, and some objects hold visual clues to the technique. One technique was riveting—drilling holes in overlapping edges, inserting thin copper rods, and then hammering both protruding ends into heads. The seams on a copper still show rivet heads (fig. 16-10). A smith also could make a dovetailed seam by cutting one edge into tabs and bending every other tab at right angles to the sheet edge. He then laid the opposite straight edge against the bent tabs, hammered them against the sheet, spread solder or spelter over all, and hammered the joint smooth.[25] Spelter, made of copper and zinc, melted at a lower temperature than copper, so the smith could heat, melt, and flow it into a joint without affecting the object he was making. On some

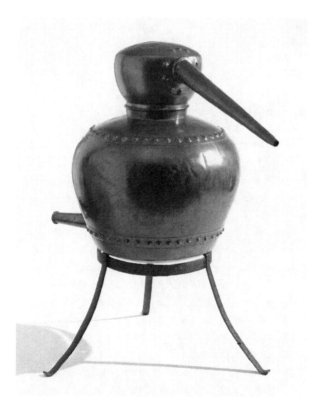

FIGURE 16-10. Copper stills were made with dovetailed, riveted joints in a process called scrubbing. If done in a workmanlike manner, it resulted in a fully watertight vessel. Stills of less than a one-hundred-gallon capacity were typically used by farmers in the winter season. Larger ones were made for commercial distilleries. (Still, Michael Baker Jr., Philadelphia, 1813–1824. Copper, lead, iron; H 33⅘ in., W 42 in., Diam 20⅘ in. 1990.28 Winterthur Museum.)

pots, one can faintly see the tabs of a dovetail joint. In another joining technique, generally associated with industrial production, each seam edge is folded over its opposite.

A metalworker could stamp a thin sheet of metal by hammering it against a die, a raised model of a design. This technique was useful for striking a mark or for decorating an object. In the mid-eighteenth century, a simultaneous method for stamping and cutting opened the way to efficient production of small, stylish metal objects in volume. Hardware for furniture benefited from this new technique. Painting, lacquering, and patinating and plating could also coat the surfaces on some metal objects for practical or aesthetic purposes. Tinning usually was accomplished by dipping a sheet of iron into a vat of liquid tin. Re-tinning, as with the inside of a kettle, was done by brushing molten tin on the areas of loss. Because copper is toxic, colonial metalworkers tinned the inner surfaces of copper vessels made to hold edibles. Tin on outer surfaces of sheet iron was a brilliant white when new or polished, rivaling silver.[26] Tin coatings wore out with use, and a portion of a metalworker's livelihood came from re-tinning.

Objects made of less valuable metals were sometimes coated with gold or silver, giving the appearance of the precious metal without the expense. In one process, liquefied, powdered, or leafed precious metals were applied to finished products, which were then heated. Ormolu, for example, is bronze, brass, or copper that was brushed with liquefied gold mixed with mercury; heat volatized the toxic mercury to produce a gilt coating.[27] Fused plate, or Sheffield plate, is a process in which rolled and heated sheets of silver and copper, plus a flux (a substance used to promote fusion between metals), were heated and pressed between rollers. A metalworker formed objects from these sheets. In electroplating, used in metalware production after the 1840s, a worker placed an already formed object in a bath containing silver. An electric current passing through the bath caused silver to deposit on the object.[28]

The marketing of metal products changed during the colonial and early national periods from localized distribution to extensive marketing of diverse objects to suit growing consumer demand. In some ways, the distribution of brass objects at the beginning of the nineteenth century follows the pattern of marketing to consumer demand in the young United States that occurred with English ceramics. In the seventeenth century, English metalworkers handled iron, steel,

and brass in a shop with few fellow workers. They produced objects that factors or chapmen (traveling salesmen) carried in their packs from the manufacturing sites to shops for sale.[29] In the eighteenth century, however, changes in Birmingham, the center of brass making, promoted extensive, large-scale marketing. In 1750 a merchant house opened in Birmingham that dealt directly with foreign markets. By 1769, merchants used pattern cards and pattern books as selling aids. In the same year, a canal linked Birmingham with an essential raw material source, coalfields, as well as market. In 1781 Matthew Boulton, a merchant-industrialist, helped to start the Birmingham Brass Company. Boulton invested in mines to provide raw materials and supported experiments that eventually applied steam power to brass production. As the scale of brass manufacturing escalated, the use of stamped brass hardware increased on furniture in the federal and empire styles.

LIVING WITH METAL OBJECTS

In the colonies and young United States, metals were essential on farms, in shops, and in homes to provide light and heat; prepare and serve food and drink; and supply personal items such as buttons, buckles, and boxes as well as scientific and precision instruments, clocks, guns, and architectural and furnishing hardware.

Resistant to burning and breaking, metal was preferred for lighting devices. Wrought iron was used in seventeenth-century New England for simple triangular hanging vessels that contained vegetable or fish oil or animal fat (tallow).[30] Odorous and smoky, oil lamps provided little light from feeble flames that often extinguished themselves.[31] Candles were an improvement in that the fuel—tallow or wax—was solid and storable. In seventeenth-century New England, silver, brass, pewter, and ceramic candlesticks were used, with brass and pewter the most numerous. Middling households generally had four candlesticks, enough to provide necessary but not abundant illumination after dark.[32] Both brass and iron were used to make accoutrements for maintaining candlelight, from ember tongs for lighting candles to douters for extinguishing flames and, until 1820, snuffers to trim wicks.[33] Until the snuffless wick came into use, wicks were not consumed by the flame and had to be trimmed as many as eight to ten times per hour.[34]

Wealth allowed people to have more and better light. As evidenced by mice and rats who feasted on tallow candles, the vegetable, fish, and animal oils used to make them were foodstuffs, and to use foodstuffs to provide light rather than nourishment was a choice some people did not have. Less messy but more expensive than tallow, wax candles were customary in aristocratic circles in France and England by the mid-eighteenth century, and numerous wax candles were a sign to guests that the host had spared no expense for an evening event.[35]

Aimé Argand's lamp was the first major improvement in lighting devices since the time of the ancient Egyptians. Perfecting the lamp between 1780 and 1784, Argand incorporated two advances that, according to various estimates, made the lamp as bright as ten to twenty tallow candles. A hollow tubular wick, enclosed between two tubes, allowed oxygen to reach the flame on both the inside and the outside of the wick. A glass chimney intensified the light by increasing the draft.[36] Argand's invention inaugurated a century of experimentation with lighting fuels and devices that culminated in electric lighting, which finally made light-after-dark individualized, adequate, and ubiquitous. Many activities and social patterns changed accordingly.

The heat needed for cooking and heating was made possible with metal objects. Used to support burning wood, the horizontal arms of andirons or firedogs generally were of iron; the vertical, more visible, sections were sometimes made of brass or paktong and displayed fashionable ornament. Unprotected, crumbling bricks often toppled chimneys, from which sparks escaped that set houses on fire. Chimney backs or firebacks, made of iron, shielded bricks at the rear of fireplaces from the stress of heating and cooling.

As a domestic fuel, coal replaced wood more widely and earlier in wood-poor England than in British North America. As early as the second quarter of the eighteenth century, however, coal was available to wealthy, urban households. By the late 1820s and early 1830s, brass coal grates were being made in the young United States, sometimes designed to be built into the masonry of a fireplace.[37]

Stoves intrigued colonial experimenters as most promising for heating improvements. The Massachusetts Bay Colony records state that in 1652 John Clarke was issued a patent to protect his invention to save firewood and to warm rooms.[38] Benjamin Franklin turned his ingenuity to the problem and developed the Franklin stove in 1744; its improvement was its air box, which heated the air drawn into the room. Charles Willson Peale, interested in heating his museum for

open hours in the evening, won a contest sponsored by the American Philosophical Society for a fireplace design that was affordable for the poor.[39] Stoves used primarily for space heating were named for their shape and form. A five-plate stove was simply a rectangular solid made of five iron plates; the sixth side gave onto a small wall opening connected to the large cooking fireplace in the next room, an arrangement often seen in a Pennsylvania German house. The fire in the five-plate stove could be stoked and cleaned, then, from the larger fireplace. An upright stove was called a cannon stove because of its cylindrical shape.

Food and drink preparation that used heat required metal objects, and iron was a mainstay on cooking hearths. Seventeenth-century New Englanders boiled or roasted most of the food they prepared—grains, bread, cake, fish, poultry, and meat. They used kettles, pots, skillets, a variety of skimmers, ladles, forks, stands, and andirons.[40] Iron pots and kettles were cast, and utensils and fireplace hardware were often wrought. More varied diets, more diverse preparation techniques, and more attention to food presentation required more specialized cooking utensils. Colonists used teakettles, many of copper, more often in the second half of the eighteenth century than earlier.[41] Saucepans, with flat bottoms or bulbous bottoms and sides sloping to a small mouth, were made in various sizes. Stewpans and straight-sided covered pots also were used. An increase in the number and variety of pots in a cook's kitchen allowed foods to be prepared and presented at table separately.

The distillation of agricultural produce into beverages required stills, for which copper was the preferred material. As fermented mash, made from a grain, was heated with water in a still, alcoholic vapor rose to the top (the still head) and flowed into the worm (spiral tube) for collection. Further heatings and distillations improved purity and taste.[42] Surviving stills are rare. Their metal was too valuable. Stills' importance to farmers was greater than their survival rate. The Whiskey Rebellion in the summer of 1794 demonstrates how crucial stills were to the agricultural economy in the frontier areas. When Congress passed a tax on whiskey that Alexander Hamilton proposed to raise governmental revenues, farmers in western Pennsylvania rebelled. President George Washington subsequently called out the militia, illustrating the power and legitimacy of the new national government.

The plasticity and durability of metal made it useful for clothing fasteners and personal items. Brass buckles were first made in Birmingham, England, in the late 1600s and fastened shoes until shoelaces became common after 1800. Some buckles were simple, and others adorned an entire shoe front. Small boxes of steel and brass survive from the seventeenth and eighteenth centuries. Hard and rust resistant, brightly polished, silvery colored steel often shined like silver; brass mimicked gold.

Iron supplied Americans with architectural hardware. Early log-house and mortise-and-tenon construction did not make as much use of nails as late nineteenth-century framed construction, but as building became more permanent and complex, metal nails, hinges, locks, and knockers became crucial. By the mid-nineteenth century, iron fittings were plentiful enough that they decorated houses of all values in Baltimore, for example.[43]

CONCLUSION

Struck by the abundance of metal objects in many museums and historic houses, visitors may rightly conclude that such items were vital to early American life. With metals in domestic settings being more decorative than utilitarian today, visitors and interpreters may find themselves discussing the many aspects that have led to this change.

NOTES

1. In interpreting collections of decorative arts or household implements, pewter is often categorized with iron, copper, and copper alloys as a nonprecious or base metal. In this book, a separate chapter addresses pewter objects.
2. Mulholland, 19–21.
3. Gentle and Feild, 77–81.
4. Fennimore, "1776," 103.
5. Herrick, 3.
6. Herrick, 3.
7. Herrick, 3.
8. Herrick, 18–20.
9. O'Dea, 1–3; Laing, 15.
10. Michaelis, 49–130.
11. Laing, 40.
12. Laing, 60–61.
13. Bining, 70.
14. Hopewell, 97.
15. Mulholland, 40, 53; Kauffman, 14–15.
16. Kauffman, 25–26.
17. Mulholland, 35, 46.
18. Hopewell, 52–53.
19. Hopewell, 16–17.
20. Hopewell, 50–51; Tyler, 141–53.

21. Hopewell, 16–19.

22. Mulholland, 36, 46–47.

23. As quoted in Kauffman, 22.

24. *Pennsylvania Packet* (Claypoole's American Daily Advertiser), August 11, 1796, as quoted in Kauffman, 24; Fennimore, *Metalwork*, 46.

25. Kauffman, 43.

26. DeVoe, 61.

27. Gentle and Feild, 79, 83.

28. *Technological Innovation*, 71–72.

29. Gentle and Feild, 47–49.

30. Fairbanks and Trent, 2:250.

31. Fennimore, *Metalwork*, 243.

32. Fairbanks and Trent, 2:251.

33. Fennimore, *Metalwork*, 239–41.

34. Laing, 36.

35. Laing, 49; Russell, 16; O'Dea, 1.

36. Laing, 60–61.

37. Fennimore, *Metalwork*, 155.

38. Pierce, 35–36.

39. Hart, 335–41.

40. Fairbanks and Trent, 2:166, 223–28.

41. Herrick, 5–6.

42. Kauffman, 102–8.

43. Carson et al., 116–24; Alexander, 173.

BIBLIOGRAPHY

DeVoe, Shirley Spaulding. *The Tinsmiths of Connecticut.* Middletown, Conn.: Wesleyan University Press for the Connecticut Historical Society, 1968.

Fairbanks, Jonathan L., and Robert F. Trent. *New England Begins: The Seventeenth Century.* 3 vols. Boston: Museum of Fine Arts, 1982.

Fennimore, Donald L. *Iron at Winterthur.* Winterthur, Del.: Henry Francis du Pont Winterthur Museum, 2004.

———. *Metalwork in Early America: Copper and Its Alloys from the Winterthur Collection.* Winterthur, Del.: Henry Francis du Pont Winterthur Museum, 1996.

———. "1776: How America Really Looked: Metalwork." *American Art Journal* 7, no. 1 (May 1975): 93–106.

Gentle, Rupert, and Rachael Feild. *English Domestic Brass, 1680–1810, and the History of Its Origins.* London: Paul Elek, 1975.

Kauffman, Henry J. *American Copper and Brass.* New York: Bonanza Books, 1979.

Laing, Alastair. *Lighting: The Arts and Living.* London: Her Majesty's Stationery Office, 1982.

Additional Sources

Alexander, Robert L. "Neoclassical Wrought Iron in Baltimore." *Winterthur Portfolio* 18, nos. 2/3 (Summer/Autumn 1983): 147–86.

Bining, Arthur Cecil. *Pennsylvania Iron Manufacture in the Eighteenth Century.* Harrisburg: Pennsylvania Historical Commission, 1938.

Butler, Joseph T. *Candleholders in America, 1650–1900: A Comprehensive Collection of American and European Candle Fixtures Used in America.* New York: Crown Publishers, 1967.

Carson, Cary, Norman F. Barka, William M. Kelso, Garry Wheeler Stone, and Dell Upton. "Impermanent Architecture in the Southern American Colonies." *Winterthur Portfolio* 16, nos. 2/3 (Summer/Autumn 1981): 135–96.

Hart, Sidney. "'To Encrease the Comforts of Life': Charles Willson Peale and the Mechanical Arts." *Pennsylvania Magazine of History and Biography* 150, no. 3 (July 1986): 323–57.

Herrick, Pamela. "The Use of Teakettles in the American Home, 1740–1820." Unpublished manuscript, 1990.

Hopewell Furnace. *A Guide to Hopewell Village National History Site, Pennsylvania.* Washington, D.C.: U.S. Department of Interior, 1983.

Kauffman, Henry J., and Quentin H. Bowers. *Early American Andirons and Other Fireplace Accessories.* Nashville, Tenn.: Thomas Nelson, 1974.

Michaelis, Ronald F. *Old Domestic Base: Metal Candlesticks from the 13th to 19th Century.* Woodbridge, Eng.: Baron Publishing, 1978.

Mulholland, James A. *A History of Metals in Colonial America.* Tuscaloosa: University of Alabama Press, 1981.

O'Dea, W. T. *A Short History of Lighting.* London: Her Majesty's Stationery Office, 1958.

Peirce, Josephine H. *Fire on the Hearth: The Evolution and Romance of the Heating Stove.* Springfield, Mass.: The Pond-Ekberg Company, 1951.

Russell, Louis S. *A Heritage of Light: Lamps and Lighting in the Early Canadian Home.* Toronto: University of Toronto Press, 1968.

Simpson, Marc. *All That Glisters: Brass in Early America.* New Haven, Conn.: Yale Center for American Art and Material Culture, 1979.

Sonn, Albert H. *Early American Wrought Iron.* 3 vols. New York: Scribner's Sons, 1928.

Technological Innovation and the Decorative Arts. Wilmington, Del.: Eleutherian Mills-Hagley Foundation, 1973.

Tyler, John D. "Technological Development: Agent of Change in Style and Form of Domestic Iron Castings." In *Technological Innovation and the Decorative Arts*, edited by Ian M. G. Quimby and Polly Anne Earl, 141–65. Winterthur, Del.: Henry Francis du Pont Winterthur Museum, 1974.

Weaver, William Woys. *America Eats: Forms of Edible Folk Art.* New York: Harper and Row, 1989.

Paintings and Pictures

VISITORS FREQUENTLY TRY TO IMAGINE PEOPLE LIVING with the objects they encounter at museums and historic sites. Portraits on the walls stimulate such thoughts. The sitters represent people who made choices about the kinds of objects on display, who gave meaning to them, and who were affected by them. The artists participated in these choices: choices involving poses, clothing, and props. In most cases, we know about the lives of both the maker and the buyer of a portrait. Guides may use this knowledge to infuse interpretations with vitality.

However, we do not see paintings as people in the eighteenth or nineteenth centuries did. We do not see them in the same settings, with the same knowledge of the sitter, family, or cultural and societal implications. The paintings may not even look the same to us as they did to their first owners. Time and the varying types of care that a picture received may change its look. Colors can shift; varnishes can yellow; glazes can be cleaned off; and paint losses can be aggressively over-painted. Without knowing the care and conservation history of a painting, an interpreter must be careful about drawing precise conclusions from a painting's appearance.

LOOKING AT PAINTINGS AND PICTURES

Analyzing three characteristics of paintings—color, line, and iconography—may help visitors when looking at paintings.

Color

Color can direct a viewer's attention and in some cases evoke an emotional response. In his *Portrait of Mrs. Perez Morton*, Gilbert Stuart's skill with color draws the viewer's eye to the contrast of pale white and pink skin against a dark dress and shadowy bust of George Washington (fig. 17-1). White highlights the bracelet Mrs. Morton fastens and anchors a diagonal line of light from her hands to her head. Despite the bust of Washington, a national hero, in the background, color helps the figure of the woman to dominate the painting.

In *Washington at Verplanck's Point*, John Trumbull also used color to focus on a figure. The contrast of a cream background in the horse, vest, and breeches with Washington's dark coat draws the viewer's eye to the president's head and the gray-white clouds that surround his head in ethereal light (fig. 17-2). Color is applied to evoke an emotional response from viewers.

Line

Line is the continuity of direction.[1] Like color, line draws viewers' eyes, creates and balances patterns, and affects responses. Thomas Sully portrayed Benjamin Tevis in a strong, vertical posture with his head slightly turned (fig. 17-3). At first glance, the posture appears formal and rigid, yet the turn of the head against the shoulders and chest forms curves. Curving lines in the lapel, collar, curly hair, sideburns, and lips create movement that energizes the portrait of a young man. While influencing the viewer's perception of Tevis as aggressive, the curves also connect the portrait to the strongly curved decorative motifs of furniture in the empire style, fashionable at the time the portrait was painted.

Iconography

Iconography refers to the images and symbolism in a painting. Artists in the colonies and young republic show the influence of European tradition in their use of iconography. In the 1780s, Charles Willson Peale portrayed Dr. Benjamin Rush, an eminent physician and a signer of the Declaration of Independence (fig. 17-4). He wears a banyan, a loose robe, probably silk. In the eighteenth century, such a robe became an artistic convention. It represented a less formal outer layer of a man's clothing while at home, but also indicated learning, affluence, and confident accomplishment in a world of art, commerce, and public affairs.[2] Rush sits in front of shelves of books, undoubtedly similar to those he owned. A volume of Hippocrates' work symbolizes a medical figure esteemed by Rush and Peale.[3]

FIGURE 17-1. Mrs. Perez Morton's image dominates this Gilbert Stuart portrait just as her character and talent dominated the city of Boston. Her poetry earned critical praise; note the paper and pen in the portrait. This is one of three poses executed by Stuart in 1802 when the Mortons were visiting Philadelphia. (*Sarah Wentworth Apthorp Morton (Mrs. Perez Morton)*, Gilbert Stuart, Philadelphia; 1802–1803. Oil on canvas; H 29½ in., W 23½ in. 1963.77 Winterthur Museum, gift of Henry Francis du Pont.)

The artist connected the physician with medical history and expected viewers to do the same.

American portraits often include objects or parts of objects that the subjects might have owned or chosen to include. Such objects strengthen the intended impression of a person of affluence and taste.[4] In John Trumbull's portrait of his wife, the hexagonal gold-and-white box with oval medallions—a fashionable accessory at the time in its use of a gold and white palette and the lines and geometric shapes used for decoration—reflects the classic, oval features of the sitter and confirms her knowledge of up-to-date classical design (fig. 17-5). The setting for Mrs. Trumbull's portrait is a simple draped background.[5]

THINKING ABOUT STYLE

Referring to manner or technique in paintings, style can denote an artist's individual way of working; it can also refer to similar elements in a group of paintings by various artists. Such elements reveal the subjects' or artists' choices and suggest relationships between the paintings and the world of their creators. An artist's manner of applying paint, the choice of colors, and the presentation of the sitter are some ways to identify style.

Artists generally used paint in one of two ways: the linear or the painterly approach. With a linear approach, paint directed a viewer's eye along outlines and stressed boundaries between each form. In a painterly approach, color and technique were used to draw a viewer's eye away from the edges of a painting, to move the eye from mass to mass, and to see a sum of forms rather than individual forms; edges between forms are not stressed.[6] John Singleton Copley's *Portrait of Mrs. Roger Morris* shows a linear approach (fig. 17-6). Copley probably mixed pigments on a palette to achieve the creamy white tint for Mrs. Morris's forehead and then meticulously applied the paint to

FIGURE 17-2. Trumbull's painting shows George Washington standing by his horse Dexter. The painting was a gift for Martha Washington. According to her grandson George Washington Peale Custis, this image of Washington was the "most perfect extant." (*Washington at Verplanck's Point*, John Trumbull, Virginia, 1790. Oil on canvas; H 30⅛ in., W 20⅛ in. 1964.2201 Winterthur Museum, gift of Henry Francis du Pont.)

FIGURE 17-3. Thomas Sully's portrait of Philadelphia auctioneer Benjamin Tevis shows an exemplary use of line. It is also rich in contrasts of light and dark. Tevis paid $100 for this likeness. (*Benjamin Tevis*, Thomas Sully, Philadelphia, 1822. Oil on canvas; H 30¼ in., W 25¼ in. 1975.115.1 Winterthur Museum.)

canvas.[7] By applying specific colors within particular areas, he defined the brow and cheekbones in the same way. On the canvas, the viewer sees smooth paint applied by an artist working in a "draughtsmanlike manner," working within the line.[8]

In contrast is Gilbert Stuart's *Portrait of Mrs. Perez Morton*. The viewer first sees a dark-haired woman in a dress with coat and white lace. Closer examination reveals the white lace to be an abstract arrangement of white and gray brush strokes with white and black zigzag lines. The artist's use of brushstroke and layers of various pigments directly on the canvas is a painterly technique that imitates light and allows a viewer's eye to "mix the colors."

Although artists could apply paint in various ways, certain conditions of a colonial painter's environment favored a style that emphasized linear paint application. Native-born artists often learned their methods from work in sign, coach, or ship painting as well as from studying available painters' manuals and British prints. For those without the means or connections to travel to Europe to study, the opportunity to learn from a practicing artist or within an artistic commu-

nity was limited. This provided a limited understanding of applying color to create a painting.

Both before and after the Revolutionary War, painters in America worked within a context that was English or European—reflecting European business practices (such as ways of attracting new commissions, purchasing materials, or charging for their work), color palettes, and presentations of sitters. Influences of baroque and classical revival styles will serve as examples.[9] Painted in England by an Englishman, William Verelst's *Audience Given by the Trustees of Georgia* illustrates elements of the baroque style (fig. 17-7). The geometric floor, vertical columns, and paneled walls reflect baroque interest in organizing space. On the right, near the only window, which is open to light and air, the Native Americans hint at the era's artistic and scientific fascination with exoticism and light. Showing a baroque interest in light-and-dark contrasts, broad dark areas alternate with a few light ones. With the exception of blue in two coats

FIGURE 17-4. Dr. Benjamin Rush of Philadelphia was a man of strong opinions known for his abrasive criticisms of the government and for his many altruistic activities. He fought against slavery and capital punishment and stayed in Philadelphia during the yellow fever epidemic. In his affectionate letters to his wife and in published writings, he expressed his support of education for women. (*Dr. Benjamin Rush*, Charles Willson Peale, Philadelphia, 1783–1786. Oil on canvas; H 49¾ in., W 40 in. 1959.160 Winterthur Museum, gift of Mrs. Julia B. Henry.)

FIGURE 17-5. Her beauty and neoclassical features seem to have made Sarah Trumbull a favorite subject in her husband's paintings. An English woman, Sarah married John Trumbull on October 1, 1800, during the time he served in England on diplomatic assignments for the United States. Consequently, scholars differ as to the date and place where the portrait was completed. (*Sarah Hope Harvey Trumbull [Mrs. John Trumbull]*, John Trumbull, New York, N.Y., ca. 1805. Oil on canvas; H 29⁹/₁₀ in., W 25³/₅ in. 1960.150 Winterthur Museum purchase with funds provided by Henry Francis du Pont.)

and red on a coat and dress, the palette is dominated by grays, browns, and blacks. The thirty-five portraits in Verelst's painting reveal baroque characteristics of portraiture adopted by American painters. With straight posture and eyes gazing toward distant ideals rather than nearby reality, the subjects in the painting present aristocratic bearings; many are turned three-quarters toward the viewer. These portraits illustrate the aristocratic ideals of elegance and dignity.

In the early eighteenth century Sir Godfrey Kneller, painting in England, set a standard for such formal, aristocratic portraits. Reproduced as mezzotints (prints in black, gray, and white), works by Kneller and others were imported into the British North American colonies; the subjects' straight postures, three-quarter positions, and idealized, dignified countenances greatly influenced artists in the colonies.[10] In some late eighteenth-century portraits, the position of the sitters suggests movement away from the straight-back, formal, aristocratic posture of the Kneller-inspired paint-

ings to a relaxed posture. Charles Willson Peale, for example, created a gentle S-curve in the line from Dr. Benjamin Rush's head through his torso and legs and a strong reverse S-curve with Edward Lloyd's bending toward his family (fig. 17-8). Such curves, described by William Hogarth as the "line of beauty," are strongly associated with a baroque influence that is manifested in furniture in the Queen Anne style.

Shifts in body positions suggest changes in manners and in relationships between people in the paintings. Portraits of a husband and wife gazing formally at the viewer from separate canvases emphasize the importance, wealth, or social position of each individual. After 1760 we begin to see images of a husband and wife together in one painting, sometimes looking at or touching each other.[11] In their portrait by Henry Benbridge, Mrs. Purves's leaning on her husband's shoulder accents their relationship as husband and wife rather than their positions as members of influential families (fig. 17-9). Toward the end of the century, marriages founded on mutual attraction as well as

FIGURE 17-6. John Singleton Copley's portrait shows Mary Philipse Morris as a woman of strength and wisdom. The portrait was one of thirty-seven Copley completed during his six-month stay in New York City in 1771. The Morris family were loyalists who moved to England at the outset of the Revolutionary War. (*Mary Philipse Morris (Mrs. Roger Morris)*, John Singleton Copley, New York, N.Y., 1771. Oil on canvas; H 30 in., W 24½ in. 1964.23 Winterthur Museum purchase with funds provided by Henry Francis du Pont.)

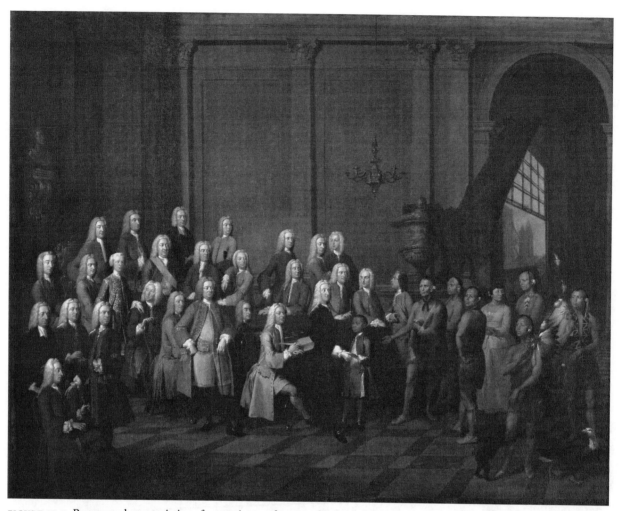

FIGURE 17-7. Baroque characteristics of portraiture often emphasized upright posture and eyes looking outward, as if to distant ideals. The ideal of a refuge for those who had been in debtors' prison prompted James Oglethorpe to found the colony of Georgia, where there was to be no slavery and land was to be divided equally. Unfortunately, war, mismanagement, and the vagaries of human nature intervened. (*Audience Given by the Trustees of Georgia to a Delegation of Creek Indians*, William Verelst, London, 1734–1735. Oil on canvas; H 48½ in., W 61⅜ in. 1956.567 Winterthur Museum, gift of Henry Francis du Pont.)

practical considerations were accepted, and the positions of portrait subjects indicate this change.[12] Images of children hint at changing attitudes toward parental duties. In *The Edward Lloyd Family*, Lloyd's leaning toward his wife and child implies affectionate interaction with them. His hand around his daughter's waist suggests not only familial pride in the next generation but also a parent's delight in a young child.

Positions of sitters also hint at relationships between the subjects and the viewers. With their relaxed postures and leisure activities, the Purves and Lloyd families appear to invite the viewer to sit for a visit. To the well-informed contemporary viewer, relaxed postures suggested poses from classical or Renaissance images.[13] Joined to a preference for light colors and careful attention to depicting fine textiles, jewelry,

and needlework, the characteristic suggests the rococo style in colonial portraits. In Copley's portrait, Mrs. Morris appears lost in reverie, the viewers' eyes drawn to her calm expression and to the fine scarf and brooch and needlework belt.[14]

Throughout the late eighteenth century, ancient civilizations on the Mediterranean shores inspired artists. Whether painting antique or contemporary subjects, European and American artists often worked in a vertical, elongated, sculptural style to accomplish idealistic portrayals. Their subjects were precisely drawn and clearly lighted. Although their subject matter was often less overtly classical than that of European painters, Americans strove for similar renderings and used similar means.[15] They sought to depict persons who exhibited the classical virtues of courage and loyalty. In

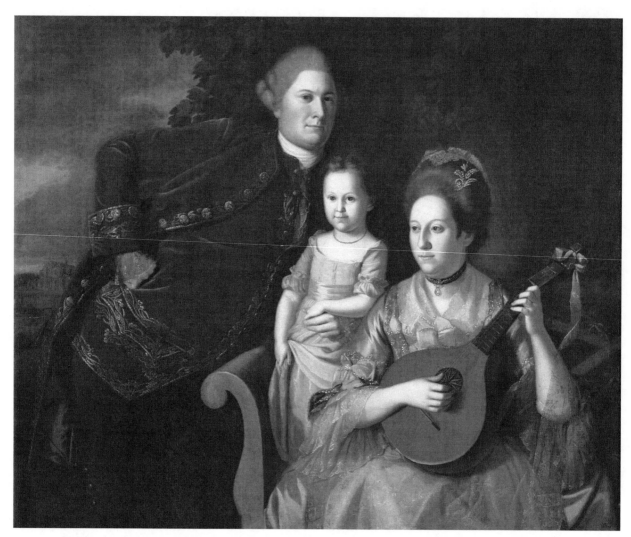

FIGURE 17-8. This family portrait of Edward Lloyd IV, Elizabeth Tayloe Lloyd, and young Anne Lloyd reflects a change from formality to greater intimacy in portraiture. It continued the tradition of showing family wealth and culture through the depiction of rich textiles and details such as the mansion in the background. (*The Edward Lloyd Family*, Charles Willson Peale, Talbot County, Md., 1771. Oil on canvas; H 48 in., W 57 in. 1964.124 Winterthur Museum.)

the portrait of Washington, John Trumbull captured these elements in the carefully drawn, statuesque figure (see fig. 17-2). The hero of the Revolutionary War gazes thoughtfully into the distance. Gilbert Stuart portrayed Mrs. Perez Morton adjusting a bracelet on her arm in a less public, more intimate setting than Trumbull's Washington. Mrs. Morton's connection to neoclassical ideals of virtue and beauty are evident in the background bust of Washington, in the shallow curve of the arm of the chair, and in her own oval face, clearly defined features, and large dark eyes above a small, carefully drawn mouth.[16]

In these portraits from the late 1790s and first half of the 1800s, white, black, and red often appear. White and black were suitable colors for men's attire, which was more somber in style after the Revolution than

before, and white was appropriate for the simple, classical clothing style preferred by young women. Artists continued to set off their subjects with red drapery, a practice mentioned in a late seventeenth-century artist's manual but probably used long before.[17] Landscape paintings, although not as numerous as portraits in early America, also show classical influences. In the tradition of topographic drawings and engravings, William Birch's *Solitude, Home of John Penn* indicates ownership of a country seat by depicting a classical revival building set on a hill (fig. 17-10).[18]

The frames on paintings also reflect stylistic change. Carved and gilded rococo-style frames were made in Boston to complement John Singleton Copley's many pre-Revolutionary portraits. At present, two dozen such frames remain with their Copley portraits. In 1771

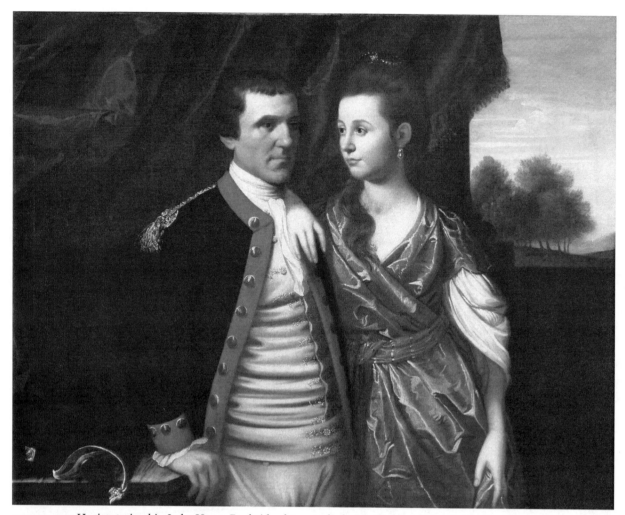

FIGURE 17-9. Having trained in Italy, Henry Benbridge later studied with Benjamin West in London and became a portrait painter there. Later, Benbridge moved to Charleston, South Carolina, where he painted this portrait of Eliza Anne Pritchard and Captain John Purves. (*Captain John Purves and His Wife*, Henry Benbridge, Charleston, S.C., 1775–1777. Oil on canvas; H 40 in., W 50⅓ in. 1960.582 Winterthur Museum, bequest of Henry Francis du Pont.)

the artist is known to have charged Ezekial Goldthwait £19.12.0 each for two portraits, which also included "two carved Gold Frames" for £9 each. These frames are attributed to John Welch, a carver who gained renown in Boston for his work in the rococo style. Copley documents suggests that Welch sometimes executed both the carving and gilding, but at other times employed a specialized craftsman, a japanner, to gild the frames.[19]

American painters were no more bound to the standards of European artists than English artists to Italian or French styles, but both were affected by artistic movements on the Continent. Hence, imitating and combining elements of baroque, rococo, and neoclassical styles, many American artists developed their skills to work in fashionable and profitable ways.

MAKING AND MARKETING PAINTINGS AND PICTURES

In the colonies and early years of the republic, limners, painters, and draftsmen all produced pictures. Limners, a word originally applied to illuminators of medieval manuscripts, painted watercolor miniatures and eventually portraits.[20] Painters used oil paints for projects that included coach, ship, sign, and furniture decoration. Draftsmen with military training drew maps and recorded sites and fortifications. Whatever they called themselves, artists earned their living as best they could. They completed decorative painting on homes, ships, and furniture. They sold prints and materials for painting and they gave lessons, which attracted customers who might eventually commission a portrait.[21] Techniques that served painters well in

FIGURE 17-10. William Birch was an engraver and painter. He published four editions of Philadelphia views, including such sites as the Arch Street Ferry, the Water Works, and the Market House. Even before publication of the final edition, Birch had three hundred subscriptions. John Penn Jr., the grandson of William Penn, built the structure shown in this painting. (*Solitude, Home of John Penn,* William Birch, Philadelphia, 1796–1808. Oil on wood; H 14⅝ in., W 21⅝ in. 1957.916 Winterthur Museum, gift of Henry Francis du Pont.)

decorative painting also served for portrait painting: a consistent but limited format and a few subtleties of modeling.[22] John Smibert, one of the first artists to make a living through portraiture in America, worked as a house and coach painter in England before he engaged in formal study.[23]

English prints, especially mezzotints of aristocrats and nobles, significantly influenced portrait artists in the British American colonies. Hundreds of imported mezzotints showed American artists and sitters the aristocratic portrait ideal that was fashionable in early eighteenth-century London.[24] They also offered prototypes for images and illustrated iconography but, until the second half of the eighteenth century, did not demonstrate color.[25] Limners studied paintings of their predecessors as well as European paintings and copies of old masters. When Smibert came to Boston in 1729, he brought copies of European paintings and sculpture, which he exhibited. His own work influenced Robert Feke and John Singleton Copley.[26]

Wealthy patrons sometimes acquired collections that could inspire young painters. Cornelius Steinwyck arranged at least thirty-nine pictures in his New Amsterdam house in the late 1600s, and after William Byrd II built Westover in Virginia between 1730 and 1734, he hung more than forty portraits on the walls.[27] Portraits of royalty and public officials most likely hung in colonial capitals.[28] While in his teens, Copley used his observations of paintings for his portrait of the Gore children by imitating a pose of two girls by Joseph Blackburn, a standing boy by Smibert, and a small boy by Joseph Badger—all his predecessors in American portraiture.[29]

Aspiring artists could also read artists' manuals from England. In 1758 R. Dossie published *The Handmaid to the Arts* in two volumes. The title page of volume one promised that the book would explain "the nature, use, preparation, and composition, of all the various substances employed in painting . . . The several devices employed for . . . making designs from nature

... [and] The various manners of gilding, silvering, and bronzing ... [and] the art of japanning." Volume 2 covered inks and sealing wax, the art of engraving and etching, porcelain, papier-mâché, glass, and "the various methods of counterfeiting gems." The books show how closely decorative painting was allied with painting of portraits, landscapes, seascapes, and other pictures. In the 1760s Charles Willson Peale purchased a copy of Dossie's book, and in 1799 Archibald Robertson, a New York artist, indicated that he thought the volumes were helpful as he recommended them to his younger brother, "You should get the book called the 'Handmaid of the Arts' as it is the best I know treating of Materia Pictoria."[30]

Another manual, Polygraphice, written by William Salmon in 1672, gave directions for preparing pigments, for making "mixt or compound colours," and for applying colors to make faces, draperies, and landscapes: "For Pearls, your ground must be Indico and white, the shadows black and pink."[31] Like mezzotints, books were important and available, but they did not teach how to "build" a painting with color.[32] Studying with another painter was an effective way to learn these skills. Charles Willson Peale traded a saddle to John Hesselius for painting lessons and later spent two years in Benjamin West's London studio.[33] After much thought and hesitation, John Singleton Copley eventually left Boston for England and Italy and settled permanently in London, where he exhibited with and learned from members of the Royal Academy.[34] For military men, training in accurate representation of military maneuvers, which was important in the tradition of landscape painting, occurred in military academies or on the job.

John Trumbull used all three methods—reading, studying existing works, and personal instruction—to develop his talent. Such manuals as Charles du Fresnoy's De Arte Graphic or Horace Walpole's Anecdotes of Painting would have been available when he studied at Harvard. In 1778 he moved to Boston: "There I hired the room which had been built by Mr. Smibert ... and found in it several copies by him from celebrated pictures in Europe, which were very useful to me.... Mr. Copley was gone to Europe, and there remained in Boston, no artist from whom I could gain oral instruction; but these copies supplied the place, and I made some progress."[35] In the 1780s Trumbull studied with Benjamin West in London.[36]

Materials used by artists affect the finished appearances of their paintings by influencing techniques. Painters purchased materials from shopkeepers, who bought from importers or ordered directly from Europe. John Smibert used and sold materials from his "colour shop" in Boston by 1734.[37] Until at least 1749, two years before his death at age sixty-one, he ordered supplies for his shop from an artist friend in London because "there is none of my friends so well acquainted with the people who deal in those articles."[38] Smibert ordered "cloaths" (prepared canvases), pigments, palette knives, gold and silver leaf, frames, chalks, and brushes as well as prints to sell.[39] By the 1760s, shop owners regularly advertised supplies from London.[40] Copley obtained his supplies from his brother-in-law, a London merchant.[41]

Marketing Paintings and Pictures

Most painters found that in order to make a living, they had to vary the kinds of painting they did or the places where they painted. Travel was a fact of business even for accomplished artists.[42] John Wollaston worked in New York, Philadelphia, Annapolis, Virginia, the West Indies, Charleston, and England between 1749 and 1767. Even a customer satisfied with his or her portrait had limited need for another. A painter constantly had to look for new jobs, either through commercial activities that put him in contact with potential customers or through traveling to new areas.[43] Copley left the colonies in 1774 for travels in Italy, where he received portrait commissions, and then settled in England. He made the change after years of consideration. Seven years before he went to Europe, he wrote: "I am now in as good business as the poverty of this place will admit. I make as much money as if I were a Raphael or a Correggio, and three hundred guineas a year, my present income is equal to nine hundred a year in London."[44] He obviously was aware of the opportunities for someone in his line of work.

A letter from Charles Willson Peale shows a similar attempt to find an advantageous place for business. He wrote in 1771, comparing his situation in Maryland with his prospects in Philadelphia:

I have been offered the interest of several Gentlen. in Philadelphia, of Mr. Dickinson in particular, to get Business in that City. And I have some thoughts of going there to settle.... The Quakers are a principal part of the Money'd People there and If I can get a few of the Heads to have thier [sic] familys portray'd, I need not fear hav:g all the encouragement I can desire.[45]

Smibert, on the other hand, mostly lived and worked in one place—Boston—in the 1730s. His sitters came from as far away as coastal Connecticut and Albany. In 1740 he journeyed to New York and Philadelphia.

In the colonial period, portraiture served the wealthy. From surviving portraits painted between 1700 and 1796, scholars estimate that less than 1 percent of the population were portrayed.[46] Wealth, rather than social or religious affiliations, most closely influenced the choice to sit for a portrait.[47] Since ways to wealth were, in general, land ownership and international trade, these occupations are well represented in portraits, as are physicians, attorneys, and the clergy.[48] In the eighteenth century, a portrait was a significant expense. Smibert earned £20 to £25 sterling for a bust-length portrait and £40 to £50 sterling for a knee-length portrait in the 1730s—comparable to the cost of a desk, chest of drawers, or silver teapot.[49]

Colonists often considered portrait painters as tradesmen or craftsmen. Some artists themselves thought that painting was more a craft than an art.[50] Their work, however, placed them among those at the pinnacle of society, and some, such as Copley, moved into the upper levels. Familiarity with elite circles was a significant marketing tool. One well-executed portrait for a family with connections often ensured other commissions. Charles Willson Peale benefited from his connections with families in Maryland and Pennsylvania. Philadelphia merchant John Cadwalader and his two brothers-in-law, Edward Lloyd and Richard Bennett Lloyd, commissioned sixteen of Peale's paintings.[51] Cadwalader, who paid for nine of Peale's works, was a favorite cousin of John Dickinson, whose portrait Peale painted in 1770.[52]

Reputation, endorsements, and letters of introduction also attracted portrait commissions. Peale and his son Rembrandt worked for Charles Carroll of Carrollton, a signer of the Declaration of Independence, as well as for his son, Charles Carroll of Homewood, and his relatives Barrister Charles Carroll and Nicholas Carroll.[53] Similarly, while Copley painted in the colonies between 1753 and 1774, his sitters came from a limited and tightly entwined society. He painted more than twenty-five portraits for the relatives of Josiah Quincy and his brother-in-law John Hancock, a signer of the Declaration of Independence. More than 80 percent of Copley's identified North American sitters are members of twenty-eight families.[54]

As the eighteenth century came to a close, the number of portraits painted increased; scholars estimate that two-thirds of surviving colonial portraits date

from after 1750.[55] One reason is that more painters practiced after 1750 than before.[56] There was also an increase in the kinds and numbers of other consumer goods and in the number of families who accumulated wealth to pass down in a family line, which needed documentation in family portraits.[57]

In the late 1700s and early 1800s, another change in portraiture occurred: the introduction of mechanical aids. With such devices as Charles Willson Peale's physiognotrace (for copying the profile of a sitter) and photography after 1834, portraitists produced images quickly and inexpensively. Selling profiles for 20 cents each, Rufus Porter produced twenty silhouettes in an evening. By comparison, John Smibert's account books list 241 portraits completed in the twenty-three years between his arrival in America in 1728 and his death in 1751.[58]

Charles Balthazar Julien Fevret de Saint-Mémin's early years illustrate the travel necessary to make a living. Born in France in 1770 but a resident of New York City; Burlington, New Jersey; Philadelphia; Washington, D.C.; Baltimore; Annapolis; Richmond; and Charleston, Saint-Mémin was an engraver and portraitist. To create his precise and delicate likenesses, he used a pantograph (which reduced each image for engraving onto a copper disk), and pastels. His work was popular and so successful that he employed two assistants. In 1817 he returned to France, where he lived until his death in 1852.[59] *An Osage Warrior* is a fine example of his portraits (fig. 17-11). Silhouettes illustrate the trend toward inexpensive and reproducible images. Charles Willson Peale worked with the new technique, and a series of silhouettes of the 1810s and 1820s is attributed to him. One, of Victorine du Pont, occurs in two versions (fig. 17-12).

On the east coast of British North America and in the new republic, portraiture and picture making evidenced English training and its influence on artists. Practicing their crafts wherever they could, artists used their networks of kinship and social connections to acquire elite patrons. In the 1800s the availability of mechanical instruments helped them to enlarge their appreciative audiences by supplying images to other groups of the community as well.

LIVING WITH PAINTINGS AND PICTURES

In the colonies and early republic, as in England, portraiture was the most popular kind of painting.[60] In America most were commissioned for enjoyment and for the decoration of interiors that displayed their owners' tastes and status. Depicting family members

FIGURE 17-11. Charles Saint-Mémin first used a physiogno-trace to outline the profile of this Native American man. The details done in watercolor show the artist to have great skill and control. This portrait was one of a series of Native American people commissioned by Meriwether Lewis upon the occasion of their visit to Washington after the Louisiana Purchase. (*An Osage Warrior*, Charles Balthazar Julien Fevret de Saint-Mémin, Washington, D.C., 1806–1807. Watercolor and graphite on paper; H 7⅕ in., W 6⅖ in. 1954.19.3 Winterthur Museum.)

at the time of major events in their lives, portraits helped to record a family's history as well as its place in society.

When David Hall purchased Benjamin Franklin's interest and became sole owner of their print shop, he commissioned portraits of his children, William, David Jr., and Deborah. At a time when only the affluent could afford portraits, especially of children, and when the half- or three-quarter-length portraits were more common and cost less, the Halls' three full-length, life-size portraits declared their wealth, English heritage, and pride in the family. The boys are dressed in adult male clothing, a practice common in the mid-1700s for boys by about age six or seven. Though curled, their hair is not powdered, and David does not wear the collar or white cravat of an adult. Both boys stand in traditional but imaginary settings that, with their bookshelves, ships, hilltops, and distant church spire, suggest connections between the Hall family history and the elite worlds of learning, international trade, and English landed aristocracy (fig. 17-13).[61]

Rembrandt Peale painted the portrait of Victorine du Pont Bauduy in the year of her marriage, and Benjamin West's unfinished *American Commissioners of the Preliminary Peace Negotiations with Great Britain* immortalizes official appointments (fig. 17-14). Saint-Mémin's watercolor *An Osage Warrior* honors the arrival of a tribal delegation to meet with President Thomas Jefferson in Washington. Such events have left a legacy of portraits, often of elites but sometimes of people who were laborers, Native Americans, or African Americans.[62] Paintings were usually displayed in significant and appropriate architectural settings, and commissioning such portraits and pictures was a sign of wealth, pride, and respect for family history.

FIGURE 17-12. In Philadelphia, Charles Willson Peale opened a museum where making silhouettes was a major attraction. Using a specially designed version of a physiognotrace, visitors could make silhouettes of themselves. Moses Williams, a man who was enslaved and later freed by Peale, worked helping patrons use the machine. He later became skilled at cutting the profiles freehand. (*Victorine du Pont*, Charles Willson Peale, Philadelphia, 1807–1822. Paper; H 5 in., W 4 in. 1967.206.2 Winterthur Museum, gift of Mr. and Mrs. E. du Pont Irving.)

FIGURE 17-13. The fantastical setting in which we see David Hall is matched by the backgrounds that the artist used in portraits of Hall's brother William (in a palatial library) and his sister Deborah (in an Italian garden). His backgrounds created settings to which his subjects aspired. (*David Hall*, William Williams Sr., Philadelphia, 1766. Oil on canvas; H 70⅞ in., W 45⅞ in. 1959.1333 Winterthur Museum, gift of Henry Francis du Pont.)

CONCLUSION

Portraits and pictures show one way in which people in the past recorded and displayed representations of important people and places for decoration and instruction. Many sitters belonged to a select group of the population, a small proportion of those wealthy enough to pay a painter for his services. As they did centuries ago, the images depict people who would have been comfortable among the objects displayed in many museums and historic houses, and the portraits encourage visitors to associate the objects they see with people, then and now.

NOTES

1. Taylor, 47.
2. Lovell, 49–50, 99–102.
3. Richardson, *American Paintings*, 70.
4. Craven, 47, 77.
5. Craven, 138, 164, 170, 176, 386; Lovell, 52–53, 75.
6. The analysis of the linear or painterly qualities of a work is an art historical method deriving from the work of Heinrich Wölfflin. It can be a useful way to draw visitors' attention to an artist's techniques and intents.
7. Lovell, 56–68.
8. For a description of Peale's similar manner of working, see Craven, 386.
9. Lovell, 14, 55–56.
10. Craven, 132–63; Fowble, *Two Centuries*, 106.
11. Lovell, 148–52.
12. Lovell, 2.
13. Fowble, "Example of Classical Nudity," 51.
14. Rebora et al., 186, 300.
15. Richardson, *Short History*, 69–101.
16. Richardson, *American Paintings*, 94.
17. Salmon, 157.
18. Richardson, *Short History*, 92–93.
19. Heckscher and Bowman, 137–38; Rebora et al., 151–54.
20. Saunders and Miles, 42; Craven, 81.
21. Lovell, 13–14.
22. Saunders and Miles, 5.
23. Craven, 152.
24. Belknap, 273–77; Lovell, 19, 75.
25. Wax, 53–54; Craven, 136.
26. Evans in Smibert, 5.
27. Craven, 91, 206.
28. Saunders and Miles, 20.
29. Prown, *John Singleton Copley*, Vol. 1, 21.
30. Richardson, *Short History*, 83; Robertson, 14.
31. Salmon, 160.
32. Craven, 35.
33. Craven, 383.
34. Craven, 351.
35. John Trumbull quoted in Cooper, 4.
36. Richardson, *Short History*, 78.
37. Foote, 85.
38. John Smibert, Boston, to Arthur Pond, London, April 6, 1749, as quoted in Foote, 100.
39. Foote, 101–105.
40. Saunders and Miles, 38.
41. Saunders and Miles, 38–39.
42. Saunders and Miles, 18.
43. Lovell, 13–15.
44. Craven, 323.
45. As quoted in Saunders and Miles, 34.
46. Saunders and Miles, 44.
47. Saunders and Miles, 16.
48. Saunders and Miles, 44.
49. Saunders and Miles, 19.
50. Saunders and Miles, 19; Craven, 383; Schmiegel, "Encouragement," 87.
51. Schmiegel, "Encouragement," 88.

FIGURE 17-14. Planned by West to be one of set of pictures related to the struggles of the British colonies for independence, this unfinished portrait was a challenge. Four Americans—John Adams, John Jay, Henry Laurens, and William Temple Franklin—were painted from life, but not all at the same time nor in the same place. Benjamin Franklin's likeness was derived from a bust and a copy of another artist's portrait of the statesman. West reported that he did not finish because one of the British commissioners refused to pose. (*American Commissioners of the Preliminary Peace Negotiations with Great Britain*, Benjamin West, London, 1783–1784. Oil on canvas; H 28¾ in., W 36⁵⁄₁₆ in. 1957.856 Winterthur Museum, gift of Henry Francis du Pont.)

52. Johnson and Malone, 5:299; Schmiegel, "Encouragement," 89, 91.
53. Schmiegel, "Encouragement," 88; *Charles Carroll*, 7, 16.
54. Prown, *John Singleton Copley*, vol. 1, 139; Downs, 225.
55. Saunders and Miles, 44.
56. Calvert, 90.
57. Golovin and Roth, 4; Lovell, 10–11.
58. Craven, 152.
59. Richardson, *American Paintings*, 98.
60. Saunders and Miles, 44.
61. After learning printing and bookselling in Edinburgh and London, David Hall Sr., arrived in Philadelphia in 1743 to be an assistant to Benjamin Franklin. In 1748 he became Franklin's partner and in 1766 bought the business, including the *Pennsylvania Gazette*. Richardson, *American Paintings*, 40; Calvert, 94–97.
62. African Americans appear in their portraits and sometimes in portraits of their employers as servants or slaves. Billy Lee, George Washington's servant, appears in Edward Savage's *The Washington Family* (1789–1990); Saunders and Miles, 44.

BIBLIOGRAPHY

Craven, Wayne. *Colonial American Portraiture: The Economic, Religious, Social, Cultural, Philosophical, and Aesthetic Foundations*. Cambridge: Cambridge University Press, 1986.

Lovell, Margaretta M. *Art in a Season of Revolution: Painters, Artisans, and Patrons in Early America*. Philadelphia: University of Pennsylvania Press, 2005.

Richardson, Edgar P. *American Paintings and Related Pictures in the Henry Francis du Pont Winterthur Museum*. Charlottesville: University Press of Virginia, 1986.

———. *A Short History of Painting in America: The Story of 450 Years.* New York: Harper and Row, 1963.

Saunders, Richard H., and Ellen G. Miles. *American Colonial Portraits: 1700–1776.* Washington, D.C.: Smithsonian Institution Press for the National Portrait Gallery, 1987.

Additional Sources

Belknap, Waldron Phoenix Jr. *American Colonial Painting: Materials for a History.* Cambridge: Harvard University Press, Belknap Press, 1959.

Benes, Peter, ed. *Painting and Portrait Making in the American Northeast.* The Dublin Seminar for New England Folklife Annual Proceedings. Boston: Boston University, 1994.

Black, Mary. "Introduction." In *Ammi Phillips: Portrait Painter, 1788–1865,* edited by Barbara C. and Lawrence B. Holdridge, 9–18. New York: Clarkson N. Potter for the Museum of American Folk Art, 1969.

Calvert, Karen. "Children in American Family Portraiture, 1670–1810." *William and Mary Quarterly,* 3d ser., 39, no. 1 (January 1982): 87–113.

Charles Carroll of Carrollton: An Exhibition Commemorating the 200th Anniversary of His Birth. Baltimore: Baltimore Museum of Art, 1937.

Cooper, Helen A., ed. *John Trumbull: The Hand and Spirit of a Painter.* New Haven, Conn.: Yale University Art Gallery, 1982.

Dossie, R. *The Handmaid to the Arts.* London: Printed for J. Nourse at the Lamb opposite to Katherine Street on the Strand, 1758.

Downs, Joseph. *American Furniture: Queen Anne and Chippendale Periods, 1725–1788.* New York: Macmillan, 1952.

Foote, Henry Wilder. *John Smibert, Painter: With a Descriptive Catalogue of Portraits and Notes on the Work of Nathaniel Smibert.* Cambridge, Mass.: Harvard University Press, 1956.

Fowble, E. McSherry. "A Century of the Nude in American Art: 1750–1850." Master's thesis, University of Delaware, 1967.

———. "*Rinaldo and Arminda*: An Example of Classical Nudity in Eighteenth-Century American Painting." In *Winterthur Portfolio 5,* edited by Richard K. Doud, 49–58. Winterthur, Del.: Henry Francis du Pont Winterthur Museum, 1969.

———. *Two Centuries of Prints in America, 1680–1880: A Selective Catalogue of the Winterthur Museum Collection.* Charlottesville: University Press of Virginia for the Henry Francis du Pont Winterthur Museum, 1987.

Golovin, Anne, and Rodris Roth. "New and Different: Home Interiors in Eighteenth-Century America." Unpublished exhibit script. Washington, D.C.: National Museum of American History, 1987.

Heckscher, Morrison H., and Leslie Greene Bowman. *American Rococo, 1750–1775: Elegance in Ornament.* New York: Metropolitan Museum of Art and the Los Angeles County Museum of Art, 1992.

Johnson, Allen, and Dumas Malone, eds. *Dictionary of American Biography.* 22 vols. New York: Charles Scribner's Sons, 1930.

Miller, Lillian B., ed. *The Peale Family: Creation of a Legacy, 1770–1870.* New York: Abbeville Press in association with the Trust for Museum Exhibition, and the National Portrait Gallery, Smithsonian Institution, 1996.

Neff, Emily Ballew. *John Singleton Copley in England.* Houston: Museum of Fine Arts, 1995.

Nivelon, F. *Rudiments of Genteel Behavior.* London, 1737.

Prown, Jules David. *American Painting from the Colonial Period to the Present.* Rev. ed. New York: Rizzoli, 1977.

———. *John Singleton Copley.* 2 vols. Cambridge, Mass.: Harvard University Press, 1966.

———. "John Trumbull as History Painter." In *John Trumbull: The Hand and Spirit of a Painter,* edited by Helen A. Cooper, 22–92. New Haven, Conn.: Yale University Art Gallery, 1982.

Rebora, Carrie, et al. *John Singleton Copley in America.* New York: Metropolitan Museum of Art, 1995.

Robertson, Andrew. *Letters and Papers of Andrew Robertson, A., Born 1777, Died 1845. Miniature Painter to His Late Royal Highness the Duke of Sussex,* edited by Emily Robertson. London: Eyse and Spottiswoode, 1895.

Salmon, William. *Polygraphice; or, The Arts of Drawing, Limning, Painting, &c.* London: Printed for A. & I. Churchill & I. Nicholson, 1672.

Schmiegel, Karol A. "A Checklist of Oil Paintings in the Winterthur Museum." Winterthur Library, 1981.

———. "Encouragement Exceeding Expectation: The Lloyd-Cadwalader Patronage of Charles Willson Peale." In *Winterthur Portfolio 12,* edited by Ian M. G. Quimby, 87–102. Winterthur, Del.: Henry Francis du Pont Winterthur Museum, 1977.

Smibert, John. *The Notebook of John Smibert. With Essays by Sir David Evans, John Kerslake, and Andrew Oliver.* Boston: Massachusetts Historical Society, 1969.

Taylor, Joshua C. *Learning to Look: A Handbook for the Visual Arts.* Chicago: University of Chicago Press, 1957.

Wax, Carol. *The Mezzotint: History and Technique.* New York: Harry N. Abrams, 1990.

Wölfflin, Heinrich. *Principles of Art History: The Problem of the Development of Style in Later Art.* New York: Dover Publications, 1929.

Prints

INVENTORIES AND NEWSPAPER ADVERTISEMENTS GIVE testimony to the popularity of prints in early American homes. Prints were decorative, edifying, and affordable. Varnished or "framed and glazed," they were hung throughout the house, most commonly in entrance halls, stairwells, and rooms used for dining.

In looking at a collection of eighteenth- and nineteenth-century prints today, the viewer might be drawn to evidences of technique, admiring the careful craft that reproduced the image. Iconography might also attract examination. Prints suggest how much people knew of political, spiritual, or economic developments, and of the powerful men and women involved in them. In looking at prints from the current vantage point of a culture where images are pervasive, viewers might consider how people in the past gained knowledge of the way the world looked outside their own sphere. Today, prints serve decorative functions much as they did in the past, but their function as sources of information was greater in the past than it is today.

LOOKING AT PRINTS

In looking closely at the prints that were made and used in the colonies and young republic, the eye is drawn to the image and to the quality of the line and lights and darks that make up the image. Giving visitors the chance to look closely at a print can heighten their sensitivity to images that were seen and valued in former times and to the techniques of making multiple copies that allowed prints to flourish as decorations in domestic settings.[1]

In looking at portraits, the demeanor of the subject, clothing and other accoutrements, and details of the setting are important. Two small line-engraved portraits of Britain's Queen Anne (reigning 1700–1714) and her husband, Prince George of Denmark, remain in their original cast lead frames (figs. 18-1, 18-2). Only their heads and shoulders appear, a fairly standard convention of portraiture, but enough to show what appear to be fur- and lace-trimmed robes and scepters across their arms. The shoulder-length curled hair on the man and the equally curled but shorter hair on the woman suggest the styles of Jacobean England. The thick, swirling curves ornamenting the high top of the frames mimic the curled hair and are reminiscent of tall carved chairbacks in the William and Mary style, fashionable at the time these portraits were made.

The broad expanses of white in these prints is the visual evidence that they were made with a process requiring the printmaker to work the dark lines, not the light voids. Even to the naked eye, the fine, dark lines show crisp edges and tapered ends, as if they were incised with a sharp instrument. This is easiest to see in the woman's torso. These are hints to the viewer that the print is an engraving, made by printing from a copper plate into which the printmaker had cut steady lines with the sharply pointed V-shape blade of the burin or graver.[2]

Satirical prints or genre scenes reveal relationships among the characters depicted and details of costume and interiors. Who is depicted? What are they doing? Who is the center of attention? Who is at the periphery? How do the details of furnishings compare and contrast with period settings and other images of the time?

In *A Society of Patriotic Ladies, at Edenton in North Carolina*, several women sit at a table; their carefully coifed hair, trimmed dresses, and hats suggest that wealthy women are entertaining their peers (fig. 18-3). The large window in the background is decorated with elegant scalloped flounces and swags, and a guest sips from a bowl apparently decorated with floral sprigs. A chair in the foreground shows the curved cabriole legs, vase-shape back splat, and curved crest rail characteristic of the Queen Anne style. One woman signs a paper, a promise to avoid tea and English-made fabrics. Allowing for license on the printmaker's part, the scene shows us details of a Revolutionary-period interior.[3] The image appears to be made up of white and various shades of black. It is the areas of various tones, rather than individual lines, that produce the scene. The darkest areas are almost velvety. Looking very closely with the naked eye at an actual print,

FIGURE 18-1. Queen Anne reigned as the last Stuart monarch of Great Britain from 1702 to 1714. Perhaps this line-engraved portrait was a souvenir of her coronation in 1702. (*Anne Regina*, England, 1700–1714. Laid paper, ink; H 1⅖ in., W 1⅓ in. 1955.556 Winterthur Museum.)

of print, then a particular style of print purchasing and usage developed. The choice of subject matter and method of framing often made a difference to the print purchaser. If someone in the seventeenth century had only one print, most likely it was a map.[6] Maps of the world and British colonial America were especially favored, although before 1750, they were often inaccurate. As explorers added information (usually to existing copper plates in the engraving centers of Amsterdam and London), maps became more helpful. While a variety of decorative motifs often ornamented early maps in the eighteenth century, decoration gradually was limited to the cartouche. Subjects generally were selected from symbols, allegories, and contemporary heroes. Engraved portraits probably were the second choice of most print owners.

By the 1730s, choices in subject matter increased, as did consumer interest. Inventory and other records suggest, however, that maps and charts continued to be the first choice, with portraits engraved in line and mezzotint holding second place.[7] Prospects, views, and landscapes appear close behind in popularity.

not an illustration, it is possible to see that the lighter areas appear crisscrossed with rows of dots at various angles. This is the characteristic trace of the rocker, the serrated tool used to roughen the printing plate for a mezzotint, until it appeared like fine sandpaper, its tiny depressions and surrounding copper burrs holding the ink and pressing it into the paper with velvety depth. The printmaker produced the tones by working from dark to light, rubbing away some of the sandpapery depth to smooth the plate so it would hold less ink and produce a lighter area.[4] Each print rewards study of its image and the quality of its lines and often varying tones with an understanding of the printmaker and the society that produced these images.

THINKING ABOUT STYLE

In *Two Centuries of Prints in America, 1680–1880* (1987), E. McSherry Fowble points out that "prints are popular images often influenced less by an individual engraver's aesthetic sense than by his concern to ensure commercial success by satisfying public taste and need."[5] If many people were choosing a certain kind

FIGURE 18-2. This print of Prince George, husband to Queen Anne, is presented in the original molded-lead frame with elaborate crests and crowns. Notice the loops for hanging. (*Prince George of Denmark*, England, 1700–1714. Laid paper, ink, watercolor; H 1⅖ in., W 1⅓ in. 1955.555 Winterthur Museum.)

The text visible within the image reads:

> We the Ladys
> of Edenton do
> hereby Solemnly
> Engage not to Conform
> to that Pernicious Custom
> of Drinking Tea, or that we the
> aforesaid Ladys will not promote ye wear
> of any Manufacture from England
> untill such time that all Acts
> which tend to Enslave this our
> Native Country shall be Repealed

FIGURE 18-3. Mezzotints like this one, apparently made for display in the homes of colonials, were often printed and sold in England. This print is marked "London, Printed for R. Sayer, & J. Bennett, No. 53 in Fleet Street." (*A Society of Patriotic Ladies, at Edenton in North Carolina*, London, 1775. Laid paper; H 14¼ in., W 10¼ in. 1957.1255 Winterthur Museum, bequest of Henry Francis du Pont.)

Prospects of New York, Boston, Charleston, and Philadelphia were favored, along with views of London and other English cities, country estates, and gardens.[8] "Sea pieces" were also popular, as were political cartoons and the prints of William Hogarth.[9]

English satirical prints, which had first emerged in the 1600s, were fashionable. Potent expressions of political opinion, they were one of the predominant art forms of the age, admired for the graphic skill of the engraver as well as the pungency of the message.[10] The majority of English cartoons relating to America, like the majority of London newspapers, displayed a viewpoint that was pro-American or at least anti-government.[11] Nations often were represented symbolically: France was a dandy or fop; Spain a don in doublet and hose; Holland a burgher merchant. North America usually appeared as a Native American. England might be represented by Britannia, a lion, or, in the late eighteenth century, a stout John Bull. *The Able Doctor; or, America Swallowing the Bitter Draught* is typical. Britannia sobs as a Frenchman and a Spaniard watch Lord North pour tea down the throat of a native woman representing America (fig. 18-4). Some prints of the Revolutionary era, even if printed in England, focused on colonial leaders.[12]

Other Revolutionary War cartoons focused on colonial loss of liberties. Stressing enlightened concepts concerning human rights and liberties, these prints revealed those values that united citizens of the diverse colonies. The Stamp Act was termed "taxation without representation." An English print of the period depicts the proposed distributor of the stamps being tarred and feathered near Boston's "Liberty Tree." Another 1775 print, *The Patriotik Barber of New York; or, The Captain in the Suds*, caricatures a well-authenticated New York event (fig. 18-5). Barber Jacob Vredenburgh refused to complete the shaving of Captain John Crozier on discovering that he was the commander of a royal ship. Wig boxes in the foreground bear the names of New York resistance leaders. On the back wall are portraits of Pitt and Camden, a speech of Chatham, and the Articles of Association agreed to by Congress.

Some prints made in the colonies also provided symbolic portrayal of these ideas. Paul Revere Jr.'s *Bloody Massacre* speedily reported an event of wide public interest and is an early example of American protest art (fig. 18-6). Revere seeks to evoke the viewer's outraged response. He captures the spirit of the first real battle for independence. Revere is also

FIGURE 18-4. First published in a London magazine in the spring of 1774, this mezzotint was soon copied by others, including Paul Revere. (*The Able Doctor; or, America Swallowing the Bitter Draught*, London, 1774. Laid paper, ink; H 5 in., W 8¼ in. 1976.40 Winterthur Museum.)

FIGURE 18-5. Printed for Robert Sayer and John Bennett, this mezzotint helps clarify events in American history as well as depicting how a wig shop might look about the time of the Revolutionary War. (*The Patriotick Barber of New York; or, The Captain in the Suds*, London, 1775. Laid paper, ink; H 14 in. W 10 in. 1957.1258.1 Winterthur Museum, bequest of Henry Francis du Pont.)

responsible for other early political cartoons, perhaps inspired by similar English prints.

As the Revolution came to an end, United States citizens chose prints that celebrated their accomplishments. Pictures of their first president were produced. No American printmaker could have asked for a more marketable subject than George Washington, a well-known, attractive war hero. Beginning with Philadelphia artist and engraver Charles Willson Peale and then later artists like Gilbert Stuart, Edward Savage, and their subsequent copyists, there was no shortage of Washington portraits from which to engrave.[13]

Between the Revolution and the War of 1812, British efforts to thwart United States shipping generated anger and concern. As they had done during the Revolution, citizens readily accepted cartoons satirizing figures and events connected with this issue. In the early nineteenth century, American cartoons came into their own with such prints as *Plain Sewing Done Here/Symptoms of a Locked Jaw* (fig. 18-7). Printmakers and sellers found ready markets for subjects other

than political prints. Landscapes, views of city scenes, scenes of antiquity, genre pictures, and scenes of calamitous events such as fires or steamboat or railway accidents all caught public attention.

Those who could afford to do so often had their prints framed according to current fashion, sometimes including glazing, sometimes not.[14] Black-painted frames with carved and gilt details were commonly used in the eighteenth century. Documents of the period reveal some preference for red or blue frames as well. Stephen Whiting and his son advertised in a Boston newspaper on May 16, 1771, that they did, in their shops, "varnishing, japanning and gilding ... to Frames of all Sorts."[15] As the eighteenth century progressed, frames became more elaborately carved and gilded, reflecting current London fashion. When Richard Eagles of North Carolina died in 1769, he owned "thirty gilt picture frames of the newest fashion, ten plain gilt frames of the old fashion, and forty-five plain frames of the old style."[16] By the 1780s, Americans began to use the oval-shape frame as well as the rectangular style. In 1787 Charles Willson Peale produced a series of portraits of notable Americans all "neatly framed in double oval frame: the inner frame (which is under the glass) is gilt."[17] It was typical in the eighteenth century to cut off the descriptive border when framing.

In the 1790s, gold frames began to surpass black frames in popularity. By the second decade of the nineteenth century, gold frames with glass mats enameled in black, white, gold, or a combination of these became one of the most popular surrounds for prints, needlework, and watercolors.[18]

MAKING AND MARKETING PRINTS

Recognition of the various techniques used in printmaking can add to the pleasure of the viewer. The changes in techniques had varied goals. Some allowed reproduction of more images, more quickly or easily, and more accurately. Some European artists in the 1500s used the technique of etching to avoid some of the labor of engraving.[19] Other changes allowed a printmaker to achieve a particular kind of image that suited the taste of consumers in a particular time and place. For example, aquatint can produce some of the effects of watercolor wash, which was attracting great interest when printmakers were experimenting with aquatint in the late 1700s.[20]

At times printing techniques are divided into relief, intaglio, or planographic processes. In relief printing, the printing surface that holds the ink stands away

FIGURE 18-6. In addition to engraving the picture, Paul Revere Jr. added text to the bottom of this print to persuade colonials to become patriots. (*The Bloody Massacre Perpetrated in King Street BOSTON on March 5th. 1770*, Boston, 1770. Laid paper, ink, watercolor; H 10¾ in., W 9¼ in. 1955.500 Winterthur Museum, bequest of Henry Francis du Pont.)

from the block or plate. Woodcut is a relief process. In intaglio printing, ink is held in incisions made in the surface of the plate. The rest of the plate is wiped clean. Engraving is an example of an intaglio process.[21] In planographic techniques, the image is produced from a flat surface. Lithography, in which the printmaker draws the image on a flat surface with a greasy medium and then rolls ink over the surface, where it adheres only to the drawn greasy surface, is a planographic technique.[22]

Woodcut was used by early printmakers to transfer an image to paper. With sharp knives, the design to be transferred was cut from a block of wood, working the

grain as much as possible and leaving a raised image to be printed. Woodcut in this manner works much like letter type. The raised parts print the image. Printing may be done in a press or simply by putting paper on the previously inked block and rubbing the paper with an implement such as a spoon. The printed design forms an indentation in the paper. Wood engraving is a type of woodcut that flourished at the end of the 1700s, especially in England, when new, smooth paper allowed fine detail to be transferred from the block. Wood engravings are cut on the end grain, that is, on the cross section of the wood. This technique became a leading method of book and magazine illustration in

FIGURE 18-7. Lithographer David Claypoole Johnston, who moved to Boston in 1825, published many caricatures of local, social, or political significance. (*Plain Sewing Done Here/Symptoms of a Locked Jaw*, Boston, 1834. Wove paper, ink; H 8⅓ in., W 7 in. 1973.372 Winterthur Museum.)

the nineteenth century.[23] A particular challenge for the woodcutter was reversing any letters or words so that the print would read properly.

Intaglio processes include line engraving, mezzotint, line etching, stippling, and aquatint. They are techniques for working an image into the surface of a metal plate, usually copper. In line engraving, the oldest of the intaglio processes, the engraver uses a tool called a burin to cut a picture into the smoothly polished surface of a metal plate. The burin is held parallel to the body and pushed along the metal surface. The sharp, V-shape burin presses down into the metal, runs deeply and surely through, creating a sharp-edge line, and rises up out of the metal at the end, allowing the line to come to a sometimes barely perceptible point. The engraver cannot create shades of gray very easily with this linear method. Crosshatched lines of varying degrees of closeness is the easiest way.[24] To change direction, the engraver turns the plate, not the tool. Thus he looks at his work from constantly changing points of view (see figs. 18-1, 18-2).

Etching was developed in the sixteenth century. In this process, the lines are not cut with a tool; rather, a printmaker prepares the plate by covering it with an acid-resistant covering. The image is drawn into and through the coating. The plate is immersed in an acid bath until the lines are sufficiently bitten by the acid.[25] The coating or ground is then removed and the plate is ready for printing using a press. The etched line has less regular edges than the engraved line because the acid bites the line edge less evenly than the sharp tool cuts it. The ends of the line are rounded, without the tapering end of the engraved line. Usually a magnifying glass is helpful to see these differences.[26] The action of acid on copper takes time. Etchers quickly learned that they could achieve a range of depth, and therefore strength, in their lines by exposing lines in the plate to the acid for varying lengths of time. *The Accident in Lombard-Street* was etched, printed, and published by Charles Willson Peale (fig. 18-8).

In creating a mezzotint, the whole plate is roughened with a curved, serrated tool called a rocker. The rocker raises a slight burr as it works the plate, which catches the ink. In printing, these ink burrs give a characteristic velvety depth to the dark areas of mezzotint. But the burrs can quickly wear away during multiple printings. Sometimes printmakers reworked the plates, leaving evidence on the finished print that is recognizable to the practiced eye.[27] After the plate is worked, the roughened surface is smoothed in appropriate places and in varying degrees to create a picture. Areas that are completely smooth print white and are the highlights. Areas that are totally rough print black. One advantage of mezzotint is the range of gray tones that are possible by variable smoothing of the rough, worked plate. Sometimes, in the pale grey areas of a mezzotint, it is possible to see the elongated dots that are the remains of the rocker lines worked over the whole plate.[28] Because mezzotint permits shading and produces tone and texture, it was regarded as especially useful for making portraits.

In stippling, the plate is covered with a wax ground. The craftsman then pricks through the acid-resistant ground with an etching needle to create a network of tiny dots. The advantage of stipple is that a wide and subtle range of tones is available to the printmaker simply by varying the number and size of the dots in a particular area.[29] After the design is completed, the plate is immersed in acid as in etching.

To create an aquatint, the printmaker drops powdered resin onto the surface of a heated metal plate. The heat fixes the resin to the surface. The plate is then

FIGURE 18-8. Few early American street scenes with architectural renderings exist. Charles Willson Peale's etching also includes this verse: "The pye from Bake-house she had brought/But let it fall for want of thought/And laughing Sweeps collect around/The pye that's scatter'd on the ground." (*The ACCIDENT in Lombard-Street PHILADA. 1787*, Philadelphia, 1787. Laid paper, ink; H 8¼ in., W 11¾ in. 1962.88 Winterthur Museum purchase with funds provided by the Caroline Clendenin Ryan Foundation, Inc.)

dropped in acid. "Since this ground is porous, the acid bites into the plate in tiny pools around each particle."[30] The metal covered by resin remains untouched, holds no ink when the plate is inked, and prints as tiny white points while the bitten metal retains the ink and provides the dark ground. To see the lacelike network of an aquatint usually requires magnification.[31] Generally, the greater the amount of resin applied to the plate, the paler the printed area will be. However, a considerable range of tone, from palest gray to richest black, can also be achieved by controlling biting, stopping out in successive stages, or simply by scraping into the bitten ground.[32]

The qualities of aquatint are especially easy to see in John Hill's pictures of Niagara Falls, engraved in 1829 (fig. 18-9). Hill, one of the foremost aquatint engravers working in New York City in the period between 1820 and 1840, was particularly successful in making the medium work for him in giving texture and structure to the rocks and water. He gave these elements form and substance by varying the grain of his resin in laying down the ground for etching the copperplates and using bold strokes of stop-out material to control the etching process. John James Audubon's prints of *The Birds of America* are well-known aquatints.

To print from plates prepared with any of the intaglio methods required a specially designed printing press capable of great pressure. The plate was first inked with a thick black ink. Next, the ink was rubbed into the cutout space, and finally the plate was rubbed smooth to eliminate the excess ink. Dampened paper, protected by felt blankets, was placed over the inked plate and passed through the press. The intense pressure exerted by the press crushed the damp paper into the lines of the plate so that it drew the ink out of the excised lines onto the paper, resulting in the raised quality of the image. In most etchings and engravings, this can be easily seen by looking at the image from the side.

Printmaking in the British Colonies and United States

Very few prints of any kind were made in seventeenth-century English-speaking America. The earliest datable print appeared in Boston about 1670, a

FIGURE 18-9. Niagara Falls was a popular destination for travelers in the nineteenth century. Perhaps John Hill's aquatint could have been bought as a souvenir or as a visual delight for those fascinated with natural wonders. (*Niagara Falls*, New York, N.Y., 1829. Wove paper; H 23¼ in., W 18½ in. 1958.2059 Winterthur Museum, bequest of Henry Francis du Pont.)

woodcut portrait of the Reverend Richard Mather.[33] Made by John Foster, the portrait was engraved from two blocks with the head and shoulders on one block and the torso on the other. Foster is also thought to have engraved the first map produced in the English colonies. The map is approximately twelve by fifteen inches and shows New England from Nantucket to Pemaquid Point and from New Haven almost to the White Mountains. The lengthy title of the map was set in type and mortised into the block. The title relates that the map is of New England,

> Being the first that was ever here cut, and done by the best pattern that could be had, which being in some places defective, it made the other less exact, yet doth it sufficiently shew the Scituation of the Countrey, and Conveniently well the Distance of Places . . . the figures that are joyned with the Names of Places are to distinguish such as have been assaulted by the *Indians* from others.[34]

By 1686 the first rolling printing press suitable for printing from metal plates was imported into America by a group in the Massachusetts Bay Colony, primarily

to print money. In 1690 the Massachusetts government authorized the printing of bills to the sum of 7,000. Printed from engraved copper plates, the bills were America's first paper money and the first use of this method of printing in the colonies. The earliest surviving engraved picture, which may or may not have been printed on this press, was issued in 1701. Copperplate presses, while expensive, were durable. This one could have served a number of engravers in the ensuing fifty years.

With the arrival of London-trained Francis Dewing in 1716 or 1717, Boston had its first professionally trained printmaker. Peter Pelham was next to arrive in 1727, and his work includes a mezzotint portrait of Sir William Pepperrell (fig. 18-10). John Smibert provided the portrait from which Pelham worked. By the end of the eighteenth century, skilled copperplate printers seem to have been present in the major population centers.

Marketing Prints

Booksellers were probably the first to sell prints in the colonies, offering primarily maps. They might also

FIGURE 18-10. Sir William Pepperell was a merchant from Kittery Point, Maine, who, as a member of Maine's militia, commanded forces that were successful in battle against the French at Louisburg. In 1745 King George III recognized his achievement by awarding him the rank of baronet, as indicated in the title of this mezzotint engraved by Peter Pelham, after a painting by John Smibert. (*Sir William Pepperrell Bart.*, Boston; 1747. Laid paper; H 17½ in., W 12 in. 1967.232 Winterthur Museum.)

keep a few printed pictures in stock, especially those of well-known figures. After 1725 the choice in subject matter increased greatly, as did consumer interest in a broader variety of subjects, including views and landscapes, political and social satire, juvenile instruction and amusement, and historical subjects. Printseller shops opened in Boston, New York, and Philadelphia. At these shops, itinerant peddlers and shopkeepers in small towns and rural villages could buy printed pictures for resale.[35] Emigrant artists also sold prints as a source of supplementary income.[36]

With paper and copperplate presses in short supply until after the Revolution, no colonial engraver could rely on his craft alone for his living. Some augmented their stock with imported prints, especially from England. They could make their selections from catalogues distributed by English printsellers to describe their inventory. These imported prints also had a place in modeling design as well as in demonstrating fine workmanship. Domestic printmakers were inspired to strive for similar effects, and their customers learned what to look for.

Engraving plates were expensive, but printmakers needed to make money. They endeavored, therefore, to print potentially popular subjects and to constantly offer new images. Sometimes printmakers advertised for subscribers to underwrite the cost of an issue. This was a practical way to publish a set of prints and also developed the interest and enthusiasm of potential purchasers. Printsellers advertised prints as being decorative and relatively inexpensive ornaments for homes. Robert Kennedy's notice in the *Pennsylvania Chronicle* for December 12, 1768, lists the sorts of prints available: maps, mezzotints, and engraved portraits of English royalty, ladies of quality and celebrated beauty, and other illustrious characters; views of America and the elegant gardens of England; religious subjects, landscapes, historical subjects, and battles by sea and on land; perspective views for the diagonal mirror, and humorous and miscellaneous designs as well as sporting pictures of horse racing and hunting.[37] A shopper might also purchase prints at public auctions or, in the nineteenth century, at an auction warehouse. These prints were advertised as "valuable," "handsome," or "curious."[38]

LIVING WITH PRINTS

Among the luxuries available in the British colonies, maps and printed pictures were probably the least expensive, and pictures on the walls have been a part of domestic interiors from the earliest years of settlement. Aside from any educational or economic uses, Americans enjoyed them as household decoration and for amusement.[39] Advertisements sometimes mentioned where the prints might best be displayed. A notice in the *Boston Gazette* for April 4–11, 1720, announced: "to be sold at Publick Vendue a Collection of choice Pictures, fit for any Gentleman's Dining-Room or Stair-Case." In 1758 John Welch of Boston also advertised a number of mezzotint prints, "Both large and small Pictures suitable for a Stair-Case." An advertisement in a New York newspaper on August 7, 1779, gave notice of the sale of elegant pictures of the royal dockyards set off with "very elegant gilt Frames" and thought to be "proper furniture for the Halls of the First Personages in this City."[40] Treasured as household decorations, maps seem to have been among the possessions of all levels of society. As regional maps became available, they found a ready market among local residents.[41] Throughout the period of colonization and nation building, maps were important to those who explored and settled the vast area that would become the United States.

Most engraved pictures, however, appear to have belonged primarily to the wealthy, especially before 1725, and some individuals owned large numbers. The 1685 inventory of one New Yorker listed fifty-nine pictures, most in frames. The 1690 inventory of David Fox of Lancaster County, Virginia, recorded twenty-five pictures of the "Senses" in just one room.[42] By the mid-eighteenth century, some owners apparently displayed prints as a reflection of their good taste. Collections of prints for sale were often advertised as "most genteel," "handsome," or "choice." In advertising a set of English prints in 1783, James Reynolds of Philadelphia informed his potential customers that "to persons of taste in the polite arts, these performances cannot fail of giving the greatest satisfaction."[43]

Some of these prints no doubt conveyed European taste and aesthetics to those eager for this knowledge. In these pictures, they could examine the latest style in furniture, clothes, and even art. A set of the *Twelve Months* not only provided entertainment and pleasing decoration but also suggested how an eighteenth-century lady should dress, amuse herself, and take care of her house (fig. 18-11). Today, these prints continue to provide a rich pictorial resource for these aspects of eighteenth-century life. Beyond their uses for house-

FIGURE 18-11. Carington Bowles printed and sold hundred of prints from his well-located shop in St. Paul's Church Yard, London. Works such as this mezzotint were sometimes displayed in homes in the colonies. (*February*, London, 1784. Laid paper, ink; H 14 in., W 10 in. 1964.892.2 Winterthur Museum, bequest of Henry Francis du Pont.)

hold decoration and personal amusement, prints enjoyed a broader social role and were displayed in a variety of public places. Travelers report their presence in such diverse places as taverns, barbershops, and ships' cabins.

> We stopped in the harbor (at Cape May, Massachusetts) to be shaved by a woman named Becky who in due form exercises all the functions of a Barber. She has her shop decorated with all the pictures which belong to such places of resort from the meanest Black print to the best engraving with all the songs which are in the taste of the varied multitude of her customers.[44]

In the centuries between 1620 and 1860, prints were especially important as a swift means of recording and reporting events of public importance. For this reason, among others, colonial leaders were interested in establishing printing presses and reliable sources

of paper supply. Nathaniel Hurd published *H–ds–n's SPEECH from the Pillory* within days of the event. Seth Hudson and his partner, Joshua Howe, were punished on the pillory for forgery and counterfeiting. Prints were also exhibited in traveling shows. Thomas Williamson's announcement in the *Maryland Gazette* for February 21, 1750, is typical:

> Notice is hereby given That there is lately arrived at Annapolis, and to be seen at the House of Mr. Thomas Williamson sundry curious and delightful PROSPECTS of most of the PUBLIC BUILDINGS, PALACES, HOSPITALS &c. in Europe: Views of SHIPPING, Inside prospects of sundry CHURCHES, RIVERS, LAKES and FOUNTAINS. It is the same which has been advertised in the Pennsylvania Papers for the six Months past, and has given Universal Satisfaction to all who have seen it.[45]

Many drawing and painting instructors relied heavily on prints as teaching tools. John Singleton Copley, Benjamin West, John Hesselius, and John Greenwood are among the many American-born artists who worked from prints in developing their talent for painting. Ample evidence that students expected to learn by copying prints is provided by newspaper advertisements, such as that of a Charleston drawing instructor on November 26, 1784, noting that he intended "immediately to open a drawing-school, for the purpose of instructing youth . . . having a large collection of prints and studies of every kind, suitable for such an undertaking."[46] In academies from Massachusetts to Pennsylvania, nineteenth-century teachers directed their students to prints as models for both needlework and watercolors.

Engravers were called on to prepare plates for the printing of money. Indentured currency was printed with an elaborate design along the left edge and bound into books. As the bills were put into circulation, they were cut from the binding through the design with an undulating stroke. A bill could be verified by matching it against the appropriate tab, provided, of course, that it had not become too mutilated while in circulation.[47] Silversmiths Jeremiah Dummer, Nathaniel Hurd, John Coney, and Paul Revere are among the craftsmen who engraved copper plates from which Massachusetts paper money was printed. Obviously, when a large amount of money was involved, indenturing was not a practical test for counterfeiting. In Philadelphia, Benjamin

Franklin introduced a complex method of printing. Plaster molds were taken of leaves that were then recast into metal and printed as part of the design of the currency. Franklin first used nature prints for currency in 1739. Later his partner, David Hall, continued the practice with a new partner into the early 1770s. In 1775 another technique for printing money was developed. A thick rag paper with mica flakes and blue fibers was developed for an issue of Continental currency.

The British encouraged counterfeiters in an effort to reduce colonial currency to worthlessness. Thus, colonial governments were forced to constantly change designs and denominations in order to stay ahead of the counterfeiters. Bills were printed in red and black. Within the devices and border designs, rectangular, diamond-shape, triangular, or circular sections were cut out, inked separately, and printed together.[48] Following the Revolution, American engravers continued to make great strides in printing paper money. In 1836, a visitor from Paris wrote in his journal: "Banknote Engraving is certainly carried to the highest state of perfection in the United States . . . have myself read a notice, posted up at Boston . . . Bank notes made here to any pattern."[49]

CONCLUSION

Printmakers sought to entertain, to reproduce information, and to satisfy the viewer's "need to know" with their products. Their prints tended to reflect the interests and, especially from the 1760s on, the urgencies of their lives and times. For this reason, many of these pictures still "speak" to us today, and in some sense they bring us into the presence of remote people and events. In so doing, they add another dimension to our understanding of our past.

NOTES

1. Identifying printing techniques from visual evidence is a complex and fascinating study. Books by Antony Griffiths and Bamber Gascoigne in particular can be helpful.
2. Gascoigne, 9a.
3. Fowble, 156–57.
4. Gascoigne, 53a.
5. Fowble, xii.
6. Fowble, 16.
7. Fowble, 19.
8. Fowble, 20.
9. Fowble, 17.
10. Duffy, 9.

11. Thomas, 28.
12. Thomas, 118.
13. Fowble, 302.
14. Fowble, 25.
15. Fowble, 25.
16. Fowble, 26.
17. Fowble, 289.
18. Fowble, 27.
19. Griffiths, 60.
20. Griffiths, 89–97.
21. Griffiths, 31.
22. Gascoigne, 51b; Griffiths, 100.
23. Fowble, 275; Griffiths, 22–24.
24. Gascoigne, 52b, 53c.
25. Gascoigne, 10a; Griffiths, 56–57.
26. Gascoigne, 52c; Griffiths, 58.
27. Griffiths, 83.
28. Gascoigne, 53a.
29. Gascoigne, 53c.
30. Griffiths, 89.
31. Gascoigne, 53b.
32. Chamberlain, 32–33, 57.
33. Holman, 26.
34. Holman, 39, 41.
35. Fowble, 12.
36. Fowble, 13.
37. Fowble, 16.
38. Fowble, 15.
39. Fowble, ix–x.
40. Fowble, 15.
41. Fowble, 7.
42. Fowble, 9–10.
43. Fowble, 6.
44. Fowble, 22.
45. Dolmetsch, 68.
46. Fowble, 13–14.
47. Fowble, 512.
48. Fowble, 511.
49. Fowble, 514.

BIBLIOGRAPHY

Dolmetsch, Joan. D., ed. *Eighteenth-Century Prints in Colonial America: To Educate and Decorate.* Williamsburg, Va.: Colonial Williamsburg Foundation, 1979.

Fowble, E. McSherry. *Two Centuries of Prints in America, 1680–1880.* Charlottesville: University Press of Virginia for the Henry Francis du Pont Winterthur Museum, 1987.

Gascoigne, Bamber. *How to Identify Prints: A Complete Guide to Manual and Mechanical Processes from Woodcut to Ink-Jet.* New York: Thames and Hudson, 1986.

Griffiths, Antony. *Prints and Printmaking: An Introduction to the History and Techniques.* 2nd ed. Berkeley and Los Angeles: University of California Press, 1996.

Additional Sources

Burns, Rex. *Success in America: The Yeoman Dream and the Industrial Revolution.* Amherst: University of Massachusetts Press, 1976.

Chamberlain, Walter. *Etching and Engraving.* London: Thames and Hudson, 1972.

Duffy, Michael, ed. *The English Satirical Print, 1600–1832.* Cambridge: Chadwick-Healey, 1986.

Holman, Richard B. "Seventeenth-Century American Prints." In *Prints in and of America to 1850*, edited by John D. Morse, 26–41. Charlottesville: University Press of Virginia, 1970.

Thomas, Peter D. G. *The American Revolution.* Cambridge: Chadwick-Healey, 1986.

Tyler, Ron. *The Image of America in Caricature and Cartoon.* Austin, Tex.: Amon Carter Museum of Western Art, 1975.

Textiles

TODAY PEOPLE LIVE SURROUNDED BY TEXTILES—IN homes, work environments, and even our vehicles. Because textiles, often made of fibers unknown before the twentieth century, are relatively inexpensive, many people prefer to buy new socks rather than darn old ones, and rarely remake unfashionable adult clothes into usable children's clothing.

In the time of the colonies and young republic, however, even wealthy people had fewer clothes and used fewer textiles in the home than a person of less wealth might today. Although almost everyone owned some textiles, those who possessed highly decorated textiles were displaying their status. The limited quantity and variety of textiles was due primarily to the cost of the materials and the technology and skill needed for manufacture. Despite these strictures, a relatively wide range of textiles was made.

Visitors to historic houses and museums see many reproduction textiles on display. Originals of the kind and quality needed to furnish a historic interior accurately have often not survived, and those that have are often housed for study rather than put on public display.

A museum curator must make many decisions in planning and furnishing a room with textiles. Research can sometimes reveal textile types used in the time period to be interpreted, the manner in which they were made, and the methods for constructing upholstery or window hangings. Understanding more about textiles and their designs, old and new, can enhance the pleasure of viewing a well-designed interior.[1]

LOOKING AT TEXTILES

Textiles offer a visual feast of color and texture on two-dimensional surfaces. The way a textile was processed, woven, and finished often influenced the design with which it could be ornamented. Therefore, understanding the material or fibers, although less obvious to visitors than the design, will help visitors appreciate the workmanship and value of the textiles to their original makers and owners.

Fiber

Although the fiber may not be obvious, it strongly affects how the cloth is woven, finished, decorated, or used. The primary fibers used in textiles in the colonies and young republic were wool, flax, cotton, and silk. Wool consists of animal fibers, principally from sheep, whose appearance and qualities are altered according to the type of breed. Quality also is affected by the part of the animal from which the wool was taken.[2] Different processing techniques can produce wools of differing qualities. Worsted yarn (a smooth, hard yarn) is made from long, combed fibers, and wool (a soft yarn) is made from short, carded fibers. A wool fabric is warm and absorbs moisture.

Linen is processed from fibers of the flax plant, which requires mild climates and ample labor and water. Flax was grown in the colonies to produce fibers for cloth and seeds for export to Europe. Linen provides cool clothing, it can be bleached white, and it can be pressed, which provides design opportunities.[3]

Cotton fibers are produced from the bolls of the cotton plant. Cotton has neither the shine of linen nor the flexibility of wool. However, it makes a soft, cool fabric. It has been found in archaeological sites in China, Ethiopia, and the Middle East. It was eventually grown in India and imported to Europe and, in the eighteenth century, to North America.[4] In the nineteenth century, cotton became important in the economy of the South, for domestic trade to the cotton mills of the industrialized northeast and for international trade to Great Britain. The linkage of cotton with a labor system based on enslaved people profoundly affected the history of the United States.

Silk has been long associated with India and China. The mulberry tree, source of food for the silkworm, is native to those areas.[5] Many successful attempts were made to produce silk through the nineteenth century in the United States. The quality and color of the silk is determined by the type of worm, what it eats, and at what point in the cocoon's development the silk is processed into thread.[6] The qualities of the fiber used

FIGURE 19-1. This textile is a plain-weave cotton; it is the printed design that adds interest. The animated scene includes a tree, two ladies with a child, two additional ladies and a gentleman in conversation, a lady and dog being rowed in a pleasure boat, and a couple walking. The two blue threads in the selvage indicate that the fabric was woven in England for export. (Textile panel, D. Richards, Manchester, Eng., 1780–1790. Cotton; H 47¾ in., W 29 in. 1957.45 Winterthur Museum, gift of Henry Francis du Pont.)

to make yarn influence how the yarn will be woven and ornamented. Silk and wool take dye more easily than cotton and linen.[7] Tightly woven cotton provides a good surface for painting and printing, techniques that Europeans learned from textile workers in India (fig. 19-1). Consequently, preferences for certain fibers and ornament and changes in technology are often interrelated.

Texture

The fiber from which a textile is made and the way that fiber is woven combine to give the cloth texture. The smooth, nubby, patterned, or pile surface of a fabric is often the result of how individual yarns were spun and woven together, as well as how the cloth was finished. After necessary preparations and processing, fibers are spun, or twisted into a continuous thread for strength. The spinner creates an S or Z spiral, depending upon the natural qualities of the fiber and per-

sonal technique.[8] When yarn is woven, the interplay of the spirals in the warp (which runs the length of the cloth) and weft (which interlace with the warp at right angles) can determine the tightness of the weave. How yarns are woven together also affects the appearance of the fabric. There are three primary weaves—plain, twill, and satin—and each places a vertical warp at right angles to the weft. *Plain* weave is the simplest, most basic weave, in which alternating weft threads travel over and under the warp thread, evenly interlacing the warp and weft. The result is a smooth, unbroken surface. Linen sheeting is an example. *Twill* weave, on the other hand, is identifiable by a distinct diagonal pattern, created by the binding points (point at which a weft thread changes its orientation to the warp thread, going over rather than under, or under rather than over). A common modern example of twill weave is denim. In a *satin* weave the binding points are so widely dispersed that they are usually not visible as a diagonal line. Weft threads appear to "float" over the surface of the warp. The smooth, shiny look of satin is created by light reflecting off the "floats" of warp threads, which cross the top of many weft threads before dipping under again. These three basic weaves may be varied and combined to produce more complicated weave structures.

The way cloth is finished after weaving also imparted various textures. Cloth can be calendered, that is, given a glossy, smooth surface by pressing the fabric against hard, polished rollers. A wavy or rippled pattern can also be achieved by this method. Glazing produces a smooth surface by treating the textile with a substance like starch before calendering.[9]

Ornament

The ornamental characteristics of textiles are usually the most striking and easiest to identify. Ornament may come from color or from a surface design, in which the line and motifs give the cloth a certain visual quality.

Color is introduced to textiles through various methods of dyeing the fiber, yarn, or whole cloth ("in the piece"), or by various ways of printing on the cloth. Through the ages, dyeing was considered a difficult task because of the limited availability of dyestuffs and the skill and knowledge needed to use them, particularly to create a fast or lasting color. Guilds jealously guarded their secrets in medieval Europe, and while historic records are not available to document American practice, professional dyers were known to have practiced here.[10]

The most common colors in America through the early nineteenth century were blue, red, yellow, and black.[11] Indigo, which makes blue, was an ancient dye, having been used for about five thousand years.[12] Derived from plants, it was a vat dye, applied to the textile in solution. Indigo was colorfast, that is, able to retain its color after exposure to sun and repeated washing. Cotton, wool, and silk could all be dyed with indigo. Other important dyes available in the eighteenth century and before were madder and quercitron. Madder was a vegetable dye widely used until the late 1800s, when it was replaced by synthetic dyes. Combining madder with various mordants (metallic oxides or minerals), a dye could achieve colors ranging from red to purple to dark brown. Quercitron was a yellow dyestuff derived from the inner bark of various oak trees and thus native to the eastern United States. It was used with cotton and wool. Like madder, quercitron was dyed with mordants.[13]

Weaving, painting, and printing a design on fabric account for much textile ornament (fig. 19-2). Weaving yarns of different colors together created

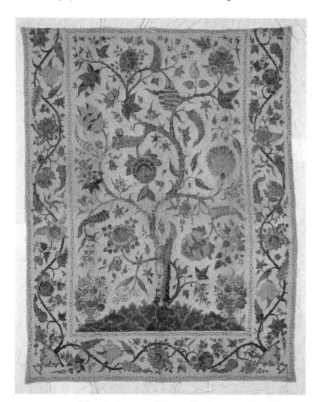

FIGURE 19-2. The design on this textile, imported to Europe from India, was painted, not printed. Textile scholar Linda Eaton notes that it was quilted in England or the American colonies, since the thread used, a two-ply linen, has not been found on Indian examples. (Quilt, Palampore, India, 1700–1800. Cotton, linen; L 111 in., W 87 in. 1960.780 Winterthur Museum, gift of Miss Gertrude Brinckle.)

relatively simple patterns of stripes and plaids or complex patterns of brocades and damasks. Line and color were added by hand painting or printing. Block, copper, and roller printing are the three printing processes illustrated in textiles of this period. A more subtle way of adding line was through texture. Sometimes a finished cloth was stamped with a design or watered to create a shiny, rippling effect. Over the centuries, such plain-weave fabrics as Egyptian linen and Indian and Chinese silk, although of a single color, also were considered luxurious and ornamental. Their value lay in the skill of the weaver and the quality of the fast dye.[14]

THINKING ABOUT STYLE

Textiles demonstrate a confluence of decisions regarding material, texture, and ornament. One of the factors affecting the choices was the desire to create a fashionable fabric. The small, brocaded flowers and medallions on fabric of the late seventeenth century mirror the low-relief patterns carved into the front panels of seventeenth-century chests. The copperplate-printed design in a cotton fabric of the 1780s and 1790s may bear images similar to those on English transfer-printed earthenware from the period. The woven silk stripe on a federal-style chair repeats the vertical reeding of a table leg.

Americans purchased and used fabrics that reflected European trends.[15] From the early seventeenth century to the mid-nineteenth century, consumers were also influenced by the color and pattern in imported Asian products. The pomegranate popular in English and French designs of the 1640s was based on the Italian Renaissance version of the mid-fifteenth century. It, in turn, was based on the Egyptian palmette and Chinese lotus of the ancient world.[16]

Until the mid-seventeenth century, most Western Europeans enjoyed textiles of one color whose weave or texture provided visual and tactile variety. Designs, when they were added, were based on natural forms and classical motifs. The pomegranate and ogee shape, common motifs of Renaissance Italy, were stamped on plain-woven wools and velvet silks and woven into compound weaves.[17] As the seventeenth century progressed, these remained fashionable but enlarged in scale. In the mid- to late seventeenth century, an explosion of pattern and color occurred as renewed trading with Asia brought more Eastern goods to use and copy. Both the material and the ornament of Chinese silks and Indian cottons were desirable. During the Renaissance, Italy continued to be an import

center for Eastern goods, but in the seventeenth century, France, the Netherlands, and England gained the upper hand.[18]

This trade pattern helped to establish the supremacy of various countries as cloth producers. French and Italian silks were considered the most fashionable of European fabrics from 1640 to 1770. Often based on Asian designs, silk patterns "became models for embroidery and textile printing as well as for fabrics woven of other materials."[19] Consequently, imports from the Far East, by influencing European silk designs, affected the patterns that people in the North American colonies desired on their homespun linen or in their hand-worked crewel.

Indian hand-painted and printed cottons were some of the most influential Asian textile imports. Europeans first acquired these cottons in the 1640s to resell for spices in the Indonesian islands. Although the Indians generally sold their inexpensive goods to the Europeans, "chintz," a period term for spotted cloth, created a fashion frenzy in Europe. The fast, rich colors and profusion of floral elements were acknowledged as technically difficult and aesthetically pleasing, compared to European fabrics. Despite this reverence, Europeans soon placed orders that reflected their own sense of fashion. In 1643, for instance, an Englishman placed an order for white backgrounds rather than the traditional Indian red.[20]

The floral and natural motifs on the cottons likewise changed to accommodate European tastes. The flowering tree, a central motif, became the "hybrid product of particular cultural cross-influences which prevailed in the seventeenth and eighteenth centuries."[21] Prior to 1675, Persian miniature and carpet designs, Chinese ceramics, and European Jesuit engravings influenced the tree design. Beginning in the 1660s, however, English, Dutch, and French pattern books supplied European designs that could be copied.[22]

The cross-cultural influences seen in these motifs were part of a larger movement to incorporate Far Eastern design elements with European classical traditions. Block-printed fabrics imitated floral chintz. The S-curves of the trunk and branches of the flowering tree and the polychromatic color schemes, while direct references to Indian cottons, also were elements of the baroque style in textiles. Damask fabrics, with their change in texture that created a sense of depth, and fabrics woven with metal threads to reflect light likewise appealed to consumers' baroque interest in space.[23] Floral motifs were favored through most of the eighteenth century. In the 1730s, interest in botany

and landscape painting, related to an English interest in Chinese garden designs, spurred a move to realistic-looking flowers. In the silk industry, attempts were made to use various shades of one color to create a natural, three-dimensional effect.[24] The size of flowers in seventeenth-century fabrics was small, but by the 1740s, flowers were larger than life size (fig. 19-3).[25]

Fashionable in the mid-eighteenth century, the rococo style—lighter and more fanciful than baroque—inspired textiles with asymmetrical designs (fig. 19-4). Around life-size flowers, ribbons of lace patterns meandered up and down the cloth. By 1775 the flowers no longer looked so natural, and they became small in scale again.[26] Large copperplate designs, appearing in the 1750s, continued the interest in pictorial images.

The century-long exposure to Indian cottons, coupled with the emergence of the development of copperplate printing, created a strong market for cotton. In England cotton supplanted silk as the most fashionable fabric about 1770.[27] Also in the 1770s, neoclassical design elements began to appear in European cottons

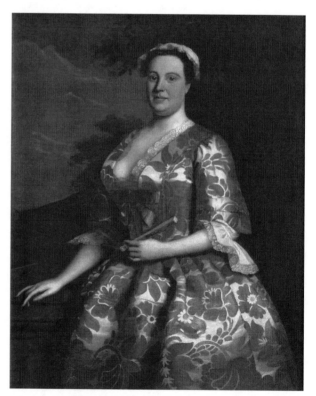

FIGURE 19-3. The design for the silk fabric in the dress worn by Mrs. Willing was made by an English woman, Anna Maria Garthwaite; the silk was woven near London. A dress of this fabric would have been fashionable when Mrs. Willing sat for her portrait in 1746. (*Mrs. Charles Willing*, Robert Feke, Philadelphia, 1746. Oil on canvas; H 50 in., W 40 in. 1969.134 Winterthur Museum purchase with funds provided by Alfred E. Bissell in memory of Henry Francis du Pont.)

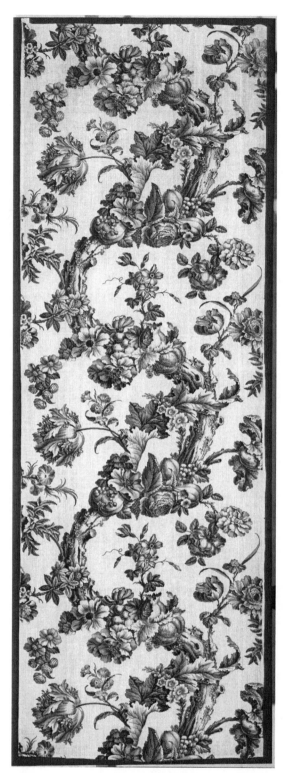

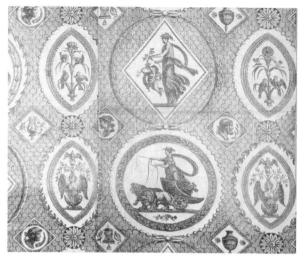

FIGURE 19-5. This copperplate printed design features large roundels enclosing classical figures, smaller diamonds surrounding classical busts, urns, and caducei. The additional images of eagles may have appealed to newly independent Americans as patriotic motifs as well as references to ancient civilizations. (Textile length, Oberkampf Factory, Jouy-en-Josas, France, 1800–1850. Cotton; L 38¼ in., W 36½ in. 1958.35.5 Winterthur Museum.)

and silk. Overall design scale diminished, and flowers appeared in sprigs. Even on Indian cottons, floral sprigs often replaced the flowering-tree motif.[28] Stripes replaced ribbons, and in some cases the entire design consisted only of stripes. Interest in compound-weave designs, brocades, and damasks all faded, but interest increased for fabrics of one solid color.[29] In the early to mid-nineteenth century, classical motifs like columns or pillars, anthemia, garlands, and volutes were woven or printed onto fabric (fig. 19-5).[30]

Two of the major changes in the design of nineteenth-century fabrics were the use of a broader color palette and the repeating designs made possible by the introduction of roller printing. As a result of chemical experimentation with vegetable and mineral dyes, a new yellow was introduced in 1783. By 1810 the textile palette also included new shades of brown, yellow, orange, blue, pink, and, most important, a solid green. After 1800, color schemes of blue, white, and silver; red, green, and yellow; or green, yellow, and brown became popular.[31] Aniline dyes, discovered in 1856, added new shades of greens, reds, and purples. Even people who employed simple lines in their fabric designs, like the Shakers, enjoyed the new, bright colors.[32]

Printing with blocks and rollers led to more rapid change in fashionable designs. Invented in 1783 and used with increasing frequency after the first decade of the nineteenth century, fabric printing was done with

FIGURE 19-4. The asymmetrical, naturalistic nature of this design complements those associated with the rococo taste, as seen in carved architectural ornament and other interior furnishings. This copperplate printed example is blue on a white ground, achieved by using indigo as a coloring agent. (Textile, designed by Francis Nixon for Nixon & Co., Philipsbridge, Surrey, Eng., 1765–1775. Cotton; L 104½ in., W 36 in. 1969.3889.3 Winterthur Museum, bequest of Henry Francis du Pont.)

engraved copper rollers mounted on a sort of printing machine. A so-called drab color scheme—a combination of yellow, brown, and green—became fashionable. Dark backgrounds were often seen with a variety of designs. Besides classical motifs, Chinese scenes and other exotic elements, such as palm trees, were popular between 1805 and 1815. In the 1820s, stripes or naturalistic scenes with ferns were popular. The interest in the natural world continued in the 1830s, when exotic birds and butterflies appeared on plain or patterned backgrounds.[33] Miniature images, particularly of American heroes and small flowers, were popular in roller prints of the centennial period. In general, advancements in textile production techniques often stimulated new fashions in designs. Whether the changes in manufacturing altered how a fiber was woven, a color produced, or an ornament applied, European and American consumers were quick to purchase fabrics made in the new ways.

MAKING AND MARKETING TEXTILES

Textile manufacturing processes evolved at a rapid pace during the 1620 to 1860 period. A consumer's choice of products was sometimes influenced as much by production technology as by cost and fashion.

Making Textiles

The basic process of producing cloth includes turning fiber into yarn, turning yarn into cloth, and adding ornament. Fibers were processed, aligned, and spun into yarn. Uniformity of spun yarn was essential for weaving. Begun in the late eighteenth century, machine spinning of cotton made it strong enough to be used as warp; before then, European-made "cotton" cloth had only cotton weft. Because of loom improvements, weavers needed increasing supplies of yarn. The two-harness treadle loom, a Chinese import used in Europe since the Middle Ages, had allowed long lengths of cloth to be made fairly quickly; in 1733, however, Englishman John Kaye increased the speed of the loom with his flying shuttle.[34]

Harnesses on the loom controlled the movement of the warp, creating spaces called sheds to allow the weft to be positioned among the warp yarns. The movement of the harnesses established repeats in a design, and the number of harnesses determined the design's complexity. The Jacquard loom, invented in 1804, was the first to significantly reduce the labor needed to create some compound weaves.[35] It used a series of hole-punched cards that allowed individual raising and lowering of the warp threads. These looms

worked best with silk or cotton and allowed woven, rather than printed, patterned cloth to come within the economic reach of more people.[36] Despite such advances, the process was slow and expensive; an entire day was necessary to weave one to four yards of patterned silk.[37]

For European fabrics, the designs themselves were the creation of fabric designers, primarily silk designers, who set the fashion. They needed a thorough knowledge of weaving and drawing.[38] Designers in France were usually employed by the large state silk manufactories. In England the designers sold their drawings directly to weavers or to mercers who ordered fabric woven and then distributed it. The mercers in England were usually responsible for determining the color palette.[39]

Fabric printing underwent dramatic change. Spurred by the fervor for Indian painted and printed cottons, English and French textile manufacturers responded with block, copper, and roller printing. These relied on mechanization to speed the process. Similar to woodcut printing on paper, block prints usually appeared on linen or, in the late eighteenth century, cotton. Block-printed designs, first successful in the 1670s in England, France, and the Netherlands, attempted to simulate Indian cottons and French and English silks.[40] A different block was needed for each color's mordant (dye fixative). After the mordant was printed, the cloth was dyed as a piece. The dye was fixed only where the mordant was printed. Additional colors might be added by hand, especially blue, as it did not require a mordant to be colorfast.[41] The size of the printing block determined the size of the design repeat. Block printing was done with a high degree of craftsmanship. Even when copperplate-printed textiles became available, fine block prints were often considered to be of higher quality.[42] Block printing continued to be used into the twentieth century, when it was replaced by the screen-printing process (fig. 19-6).

Francis Nixon, an Irishman, was credited with applying copperplate-printing technology to cotton and linen in 1752. Mordant was printed onto the fabric, and the result, after dyeing, was a one-color picture, approximately eighteen to thirty-six or thirty-nine inches square, with the characteristic cross-hatching and thin lines of an engraving. Common colors were red, blue, sepia, and black.[43] These pictures were copies from book engravings, sheet music, botanical prints, and chinoiserie designs. Some textiles printed for the American market featured American heroes.[44]

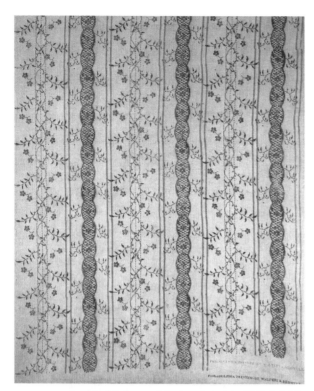

FIGURE 19-6. This fabric was block-printed in Philadelphia by a firm operating between 1775 and 1777. It is stamped "Philadelphia, Printed by Walters & Bedwell" and is the only known fabric so marked. (Textile length, Walters & Bedwell, Philadelphia, 1775–1776. Linen. 1958.605.4 Winterthur Museum, gift of Henry Francis du Pont.)

Roller printing, invented by Thomas Bell, a Scot, in 1783, eventually eclipsed block and copperplate printing by the 1830s. With a design on cylinders, a cloth of greater length and width could be printed much more quickly than with block printing. The diameter of the cylinders determined a design's repeat, which usually was about every sixteen inches. Until 1810, only one color was roller printed and the others were applied with blocks; after that date, up to six colors were printed. The 1876 invention of the duplex machine allowed eight colors to be printed simultaneously. Shading was accomplished by dots in a stipple effect.[45] The efficiency of roller printing enabled textile printers to surpass silk weavers in meeting the demand for fashionable patterned cloth.

Textile printers attempted to establish viable businesses in the British American colonies, and references have been found to fourteen printers—nine in Boston and five in Philadelphia—before the Revolutionary War.[46] The most well known today are Philadelphians John Walters and Thomas Bedwell (working 1775–1777) and John Hewson (working 1774–1821). Martha Washington bought printed textiles from Hewson.[47]

Although available, printing technology could not provide good to compete with the price and quantity of English goods until the late eighteenth century.

Colonial domestic textile production was a complex mix of household supply and labor joined with a nascent textile industry. Production practices varied according to the resources of particular regions. The expense of machinery and the skill needed to produce cloth meant that it was primarily a commercial venture of specialists.[48] From 1774 to 1800, Philadelphia had two cotton and linen glazers, seventeen block printers, eleven copperplate printers, and many fringe and cloth weavers and dyers. Because of the weak colonial economies, few survived in business for more than five years;[49] they could not compete with imported goods.

Sometimes, families undertook every step of textile production.[50] The major household contribution, however, was often supplying raw material, which was woven by a professional weaver. The material was either unprocessed, semiprocessed, or spun yarn. Involving many members of a family, male and female, the cultivation of sheep, flax, or silkworms was seasonal. Wool carding also was often an at-home activity, as carding machines were not developed until the 1760s. The combing of wool worsted fibers was usually done by a professional.[51] Both English and German immigrants relied on professional male weavers, who either had shops or traveled from area to area. Depending upon where and when one lived, professional bleachers, cleaners, fullers, and printers were available.[52]

Women have been associated with spinning and tape making, and undoubtedly many women in the seventeenth and eighteenth centuries did these tasks, but a pictorial or literary reference to a woman as a spinner could reflect on her good character, not her occupation.[53] In an age before elastic, snaps, and zippers, tapes of linen, cotton or wool were essential to hang curtains and towels and to function as drawstrings, ties, and garters. These tapes were made at home or in factories, and many inventories list tape or garter looms.[54] Netted and knotted fringes also could be made at home on a tape loom with appropriate attachments.

Mechanization came to the production of cloth with the introduction of European machinery and domestic inventions after the Revolutionary War. Emigrating from England in 1783 and eventually settling in Rhode Island, Samuel Slater, an apprentice cotton spinner, brought plans for a spinning machine. Plans for power looms were secreted to Massachusetts in

the 1820s, and by the 1830s, roller printing was established there, too. The invention of the cotton gin in 1793 by native son Eli Whitney spurred the American industry.[55]

Americans manufactured coverlets and other bed and table coverings. Linen coverlets were for table use; wool, linen, and cotton coverlets were for beds (fig. 19-7). The Jacquard loom, which aided in their production, was in this country by 1824, within twenty years of its invention.[56] The cost of textiles fell. Power looms cut the cost of weaving, and Jacquard looms and roller printing reduced the cost of patterned fabric. The domestic textile industry focused on utilitarian fabric for bedding and clothing, made and sold less expensively than imported goods. By 1850 it became more common to purchase completed fabric in the marketplace. Women could focus their sewing and quilting on ready-made fabric.[57]

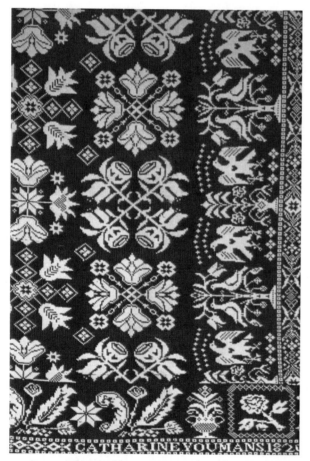

FIGURE 19-7. Jacquard looms use punch cards to allow great variety in the raising and lowering of warp threads and thus in the woven design. Coverlets made on these looms sometimes have the names and dates incorporated in the design, as this one does: "CATHARINE. YOUMANS. 1820." (Coverlet, possibly Bergen, N.J., 1820. Cotton, wool; L 91 in., W 67 in. 1982.70 Winterthur Museum.)

Marketing Textiles

British mercantile laws regulated textile production and importation to the British North American colonies. England, a major producer of textiles, particularly wool, had outstripped the domestic market for ready-made cloth. British leaders consequently wanted to sell ready-made fabrics in overseas markets. Because textiles were central to Britain's foreign trade, laws from 1720 to 1774 prohibited the use of Indian cotton in England, and excise taxes from 1712 to 1831 made fabrics from the European continent expensive. The role of the colonies was to provide raw materials and a market for finished goods.[58]

Fabric of all fibers, even silk, was imported to the colonies. From an English perspective, silks accounted for a small percentage of exports. The colonies, however, absorbed a greater share of this amount than other markets combined.[59] Linen, wool, and, after the Revolution, cotton were all imported in large quantities, too. Although some individuals in the colonies attempted to establish businesses for textile production, few could compete successfully with the relatively low English prices. In 1731 a governor from Massachusetts Bay reported that less than one-third of clothing worn there was made of colonial cloth.[60] A writer in the October 15, 1767, edition of *The New York Gazette; or, the Weekly Post-Boy* lamented: "unless you sell your Linnen, at least as cheap as they can have it from Silesia, Austria, Bohemia, and Russia, thro' England, Holland or Hamburg, I fear you will not establish an extensive Manufactory."[61]

Even during the Revolutionary War, when patriotic zeal was coupled with disrupted trading routes, the English continued to increase the amount of fabric they exported to the colonies.[62] In 1795, Canada and the United States together accounted for half of all English cotton exports.[63] After the Revolutionary War, the citizens of the new United States imported English fabric as well as fabric directly from France, India, and China.[64] Not until the 1830s did the United States become a major producer of fabric.[65]

Shipped in folded pieces, imported fabrics were unloaded and sold by auction and from shops. Newspaper advertisements for auctions and stores detailed long lists of textiles. Bewildering today, the names in the list were exotic and sometimes inconsistent, as they often were based on a place of origin or the grade of cloth. "Holland cloth," for example, was named for that area's distinction as a distribution center for the best of European linen; "calico," a cotton cloth, was named for Calcutta.[66] Textiles often accounted for a large portion of a store's inventory; in a Christiana,

Delaware, store in 1795, 68 percent of the inventory was textiles.[67]

Shopkeepers had a variety of ways of selecting textile patterns. Some sent special requests to England, some used samples and pattern books, and others accepted what was shipped.[68] The English factors, or agents, actually had the greater hand in determining the fashion for textiles, sometimes using the colonies as a dumping ground for old fabric.[69] Generally, though, Americans could purchase the latest in fashionable textiles if they could afford them.[70] The French silk houses adopted a policy to vary their designs once a year, and the race for fashion changed the status of textiles by making older ones dispensable.[71] English silk houses responded by trying to keep up with the annual changes. Some colonial Americans were able to buy fashionable silk in the form of ribbons, tapes, trims, or through special order of two or three pieces of English and French silk.[72]

Another way to purchase fashionable textiles was from an upholsterer as part of a finished piece of furniture, such as an easy chair, a bed, or a coffin. An upholsterer could be a taste setter through the fabric he chose to stock, use, and promote.[73] For example, an upholsterer, not a furniture maker or buyer, often chose the ornamental trim.[74]

Although not as expensive as patterned silk, American machine-made textiles in the early nineteenth century were not cheap. A jacquard coverlet cost between $10 and $20 in the 1840s, in comparison with the cost of a desk at $12 or a loom at $10.75. The cost of these textiles was a limiting factor in the quantity, quality, and type a person could own.

LIVING WITH TEXTILES AS HOME FURNISHINGS

The status of textiles for people living in the British North American colonies and new United States was evident in the ways they were used, despite the relatively high cost. Even old cloth in poor condition was still important for its initial cost, its ability to be renewed, and, perhaps, its sentimental and aesthetic value. Listings of old cloth in inventories, household inventory marking on linens, and extant pieces of darned fabric and slipcovers all attest to the attempts made to preserve cloth for extended use. In the nineteenth century, as manufacturing techniques made more types of textiles available to more people, some households seemed overrun with fabric coverings on windows, doors, chairs, tabletops, and even mantels.

The use of textiles as domestic furnishings began in earnest for Western Europeans in the sixteenth century, when they appeared as wall and bed hangings and cushion and table covers.[75] By the mid-seventeenth century, the fashion was set in France for en suite arrangements in which all of the textiles in one room were of the same fabric.[76] Almost immediately, the fashion reached colonial shores. In his letter book of 1719–1720, Samuel Sewall requested bed hangings to consist of "Curtains & Vallens for a Bed, with Counterpane, Head-Cloth and Tester, of good yellow watered worsted Camlet, w/Trimming, well made; and Bases if it be the fashion . . . Send also of the same Camlet & Trimmings, as may be enough to make Cushions for the chamber Chairs."[77] En suite arrangements continued to be fashionable into the nineteenth century.[78]

By 1600, most middle- and upper-class European households had at least one tablecloth, one hand towel, one banquet napkin, and several individual napkins.[79] In the Chesapeake region in the eighteenth century, linens and hand towels were some of the first amenities bought by colonists with discretionary monies.[80] Patterned linen, such as damask, had higher status than plain-woven linens, but any linens and beddings in the seventeenth and eighteenth centuries were marked with embroidered initials and numbers to signify sets and owners.[81] Cotton and linen cloth also were used as cupboard coverlets.[82]

A well-hung bed in a public room of a house displayed affluence. Used by the master and mistress in the seventeenth century, the beautifully draped bed in the parlor functioned, by the early 1800s, as a display of fashion and status.[83] Beds varied greatly in quality and price. The mattress, itself called "the bed," was a plain or striped linen bag filled with straw, wool, feathers, or some other malleable material loosely stuffed or tightly fit and sewn. Feather mattresses did not become common until after 1750, at least in the Delaware Valley, and were considered special enough to be passed on as inheritances.[84] Linen sheets usually covered mattresses until the American textiles industry began to supply cotton sheeting in the nineteenth century. Bedsteads were further outfitted with "bed furniture" that consisted of curtains, valances, a head-cloth, a tester, bases, and bed covers (blankets, quilts, woven coverlets, and bedspreads).

Depending on cost, consumers had many options for bed furniture. In the seventeenth century, linen and linsey-woolsey were the lowest-priced options. Wool in various grades was most common. Indian painted or English printed cottons were the most expensive. Silk was rarely used. Curtains hung on

tapes and rings and were pulled by hand to the bedstead corners when open (fig. 19-8). In the eighteenth century, a few wealthy colonists did have silk bed furniture; by the second half of the eighteenth century, though, some preferred cottons printed with woodblock or copper plates. Furniture check cloth also was an option. About the time of the Revolution, colonists began to use pulleys to draw their bed curtains. By the end of the eighteenth century and in the early nineteenth century, white cotton textiles with netting, woven candlewicking, or Marseilles work were used on beds. Cotton prints continued in popularity into the nineteenth century. Overall, however, the desire for fully hung beds declined as advice-book writers argued against them as deleterious to health.[85]

The status of the bed came from its practical and symbolic functions.[86] It also could be seen as an economic investment in quality goods. The finest bed with furniture made by Samuel Grant, an upholsterer in Boston, cost £86 in 1739; the desk-and-bookcase made by Job Coit in 1738 cost £50.[87] It would have cost one of Grant's seamstresses ten days wages to purchase the set of bed curtains she made of the lowest quality fabric that Grant sold.[88] Best beds were in parlors of most seventeenth-century New England houses and generally remained there into the early nineteenth century. In central Delaware, beds were listed in the parlors in some inventories made between 1780 and 1820.[89]

Upholstery added comfort and status to seating furniture. Seating forms increased in variety and kind from 1650 to 1800—from wooden forms or benches to side chairs, armchairs, easy chairs, and sofas. As with bed hangings, upholstery fabrics had various values based on textile quality and fashion. Silk and, in a few rare instances, wool velvets were considered the most luxurious upholstery fabrics until the Revolution. Plain and patterned silks came next, and caning and Turkey work also were popular in the seventeenth century. Caning was revived in the early nineteenth century. Black or red leather and plain, green wool serge were more common, however. In the mid-eighteenth century, wool damask, moreen, and printed cotton gained popularity. Prints and patterned or colored horsehair were more fashionable at the turn to the nineteenth century. From the seventeenth century, slipcovers had been used by the wealthy to preserve and update fabric coverings. Slipcovers, or "cases," as they were called, could be made of fabric that was more or less expensive than that which it covered (fig. 19-9).

Becoming popular in France in the seventeenth century and in England in the eighteenth century, the use of textile window hangings was not well established in the United States until the nineteenth century.[90] Curtains tended to appear first in the room with the best bed, whether a parlor or a chamber. A few wealthy Americans in the seventeenth century had, for instance, window curtains made to match their best bed curtains.[91] During the eighteenth century, some people used window curtains in their parlors, even if they did not have beds, as well as in their bedchambers. By the early nineteenth century, although some people still did not use window curtains at all, the most fashionable people sometimes had curtains in dining rooms, libraries, and secondary bedrooms.

The earliest curtains were simple rectangular pieces of fabric suspended from rods by fabric loops or metal rings or tacked to window frames. In the eighteenth century, Venetian and festoon curtains that were raised with rings sewn to the reverse of the fabric became popular. A Venetian curtain rises in a horizontal line, and a festoon curtain creates a diagonal swag. French curtains, as curtains that used draw mechanisms were called, were introduced in the 1790s.[92] A valance hung alone or enhanced any of the above styles. Valances often mimicked the shapes of bed valances, with straight sides in the early eighteenth century, "ears" in midcentury, and straight sides again in the late century. Gilded plaster cornices were fashionable from about 1825 to 1850. Lambrequins, which were large, boxy valances, came into use after 1835.[93]

The choice of fabrics for window treatments paralleled the fabrics chosen for beds and upholstery. Wool and, for the wealthy, silk were most fashionable before the mid-eighteenth century, when printed cottons began to be preferred.[94] Fabric choice was sometimes dictated by the room use as well—cotton for parlors and bedrooms and wool for dining rooms and libraries.[95] In the nineteenth century, when the styles of window treatments became more complex, many different fabrics—wool and cotton, for example—often hung at one window. An upper-middle-class person by 1850 often had sheer curtains of muslin or lace under wool drapes topped with a lambrequin and decorated with tassels and fringe.

Textiles in some amount were owned by almost everyone, but fabric furnishings remained status symbols for the prosperous throughout the seventeenth and most of the eighteenth centuries, depending upon region. Although 92.8 percent of inventories probated in Philadelphia between 1700 and 1775 included textiles, only 38.6 percent had table linens, 30.5 percent had beds with curtains, 9.9 percent had window

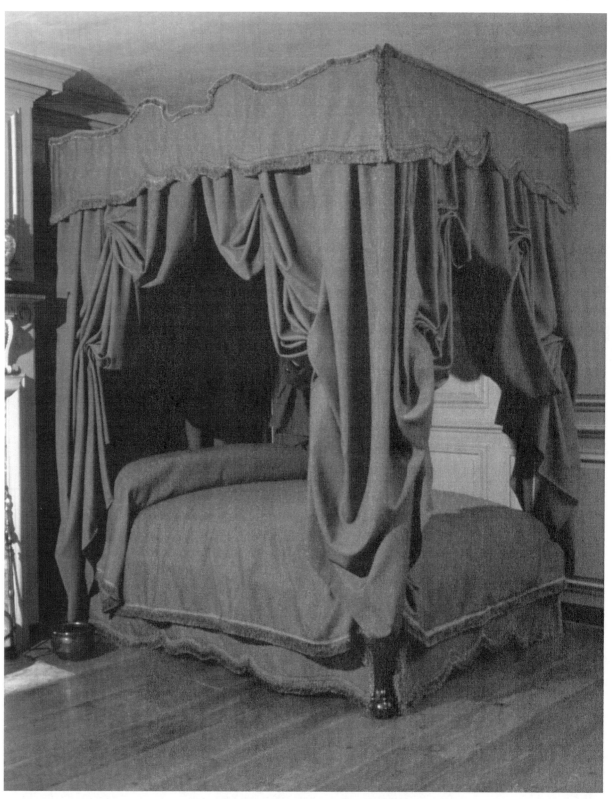

FIGURE 19-8. A fully hung bed required some fifty or more yards of fabric; it made a clear statement about the wealth of the owner. (Bedhangings, Brunschwig & Fils, Scalamandre, Inc., 1985. Plain-woven wool and silk; construction by Winterthur conservation staff. 1985.601a-l Winterthur Museum. Highpost bed, Massachusetts, 1760–1775. Maple, pine, mahogany; L 78½ in., H 90¾ in., W 58 in. 1955.792 Winterthur Museum, gift of Henry Francis du Pont.)

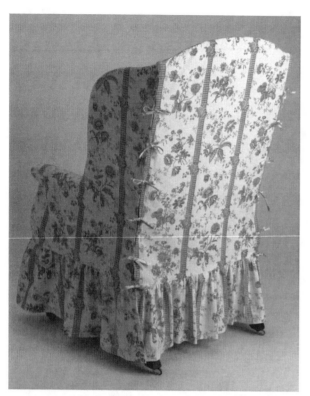

FIGURE 19-9. Following the custom of the time, this reproduction slip cover was made to fit the chair loosely. Fabric ties secure the cover. Usually these ties were made of plain woven strips made on a tape loop. (Slipcover; Brunschwig & Fils, Europe, 1988. Cotton. 90.501 Winterthur Museum.)

hangings, and 8.37 percent had upholstered seating furniture. The status quality of window hangings and upholstery was further evident when related to the larger percentage of ownership of silver—18.5 percent of inventories recorded silver ownership, in comparison with 9.9 percent with window hangings and 8.37 percent with upholstered seating furniture.[96]

These statistics, however, do not tell the whole story. Window hangings were rarer earlier in the century, and textile upholstery was rarer still. Of the 8.37 percent of inventories noting upholstered furniture, 3.1 percent listed only cushions, and they all dated before 1737. While three-quarters of the inventories noted beds by 1775, less than 40 percent had bed hangings. The owners of these luxury textile goods primarily were merchants. In declining order, textiles were owned by tradesmen, widows and spinsters, craftsmen, yeomen, and landless farmers. The inventories of the last three groups also included equipment for home production of textiles but no window hangings or textile upholstery.

In general, household textile production was not an urban practice in Philadelphia, though textile con-

sumption was. Twice as many urban dwellers owned bed hangings and table linens compared to rural inhabitants. One scholar concludes that as the cost of textiles fell, more people owned furnishing fabrics and the status of fabric fell, replaced by furniture. Comparative studies from other regions find similar trends but occurring later.[97] In Philadelphia's surrounding countryside in the eighteenth century, for instance, even bed and table textiles were rare. A study of Chester County, Pennsylvania, in 1750 discovered that there was one bed tick for every two people and that one-quarter of the households had sheets. One-third of the households had table linens, which usually was the first textile luxury purchased with disposable income.[98]

CONCLUSION

Some textile collections in museums and historic houses present visitors with a variety of textiles and usages that only a few Americans would have known between 1620 and 1860. We can join early Americans, though, in appreciating the time, materials, and money that went into producing compound-weave silk chair seats, voluminous wool bed curtains, and starkly white plain-weave hand towels.

NOTES

1. Nylander, *Fabrics*, 9–17.
2. Geijer, 1–4.
3. Coons and Koob, 34, 99.
4. Coons and Koob, 24.
5. Scott, 22, 62.
6. Geijer, 4–5.
7. Geijer, 206.
8. Geijer, 17.
9. Montgomery, *Textiles*, 184; Wingate, 95.
10. Hood, 271.
11. Hood, 271.
12. Petit, *Printed and Painted Fabrics*, 48.
13. Wingate, 295, 465, 617; Montgomery, *Textiles*, 286.
14. Geijer, 63.
15. Rothstein, "Silk Imports," 22–23.
16. Geijer, 149–50.
17. Scott, 12, 37, 167, 182.
18. Scott, 150–51, 184–90.
19. Geijer, 107.
20. Irwin and Brett, 3–4.
21. Irwin and Brett, 8–9.
22. Irwin and Brett, 8–9.
23. Cooper, 90–100.
24. Scott, 191; Geijer, 157; Rothstein, *Silk Designs*, 37.
25. Scott, 207.
26. Scott, 208.
27. Rothstein, *Silk Designs*, 26; Coons and Koob, 23–24.

28. Irwin and Brett, 20.
29. Rothstein, *Silk Designs*, 37, 56.
30. Rothstein, *Silk Designs*, 37.
31. Geijer, 159; Schoeser and Rufey, 42.
32. Gordon, 15.
33. *English Printed Textiles*, 7–8.
34. Geijer, 33–34; Coons and Koob, 60.
35. Geijer, 104.
36. Schoeser and Rufey, 66.
37. Thornton, 80; Rothstein, *Silk Designs*, 27.
38. Thornton, 25.
39. Cornforth, 109; Geijer, 104, 155; Thornton, 78.
40. *English Printed Textiles*, 1.
41. Petit, *Printed and Painted Fabrics*, 122.
42. *English Printed Textiles*, 5.
43. Nylander, *Fabrics*, 10.
44. Handler, 28, 30.
45. Petit, *Printed and Painted Fabrics*, 38.
46. Petit, *Printed and Painted Fabrics*, 96.
47. Petit, *Printed and Painted Fabrics*, 166–67.
48. Hood, 267.
49. Schoeser and Rufey, 45.
50. Coons and Koob, 5–6, 16–17.
51. Cooper, 52; Coons and Koob, 26.
52. Swan, 221; Carr, Morgan, and Russo, 32.
53. Stone-Ferrier, 216–20.
54. Cooper, 35.
55. Petit, *Printed and Painted Fabrics*, 182–84.
56. Schoeser and Rufey, 76.
57. Benfield, 76; Jensen, 87.
58. Petit, *Printed and Painted Fabrics*, 118; Coons and Koob, 20–21.
59. Rothstein, "Silk Imports," 21.
60. Cooper, 54.
61. Cooper, 46.
62. Cooper, 56.
63. Schoeser and Rufey, 30.
64. Coons and Koob, 21–22.
65. Schoelwer, 76.
66. Stone-Ferrier, 234; Petit, *Printed and Painted Fabrics*, 50; Montgomery, *Textiles*, glossary.
67. Catts et al., 3.
68. Montgomery, *Textiles*, 42.
69. Baumgarten, 224.
70. Rothstein, "Silk Imports," 22–23.
71. Geijer, 154; Weiner and Schneider, 10–11.
72. Baumgarten, 228; Rothstein, "Silk Imports," 23.
73. Jobe, 65.
74. Jackson, 131.
75. Schoeser and Rufey, 70.
76. Irwin and Brett, 23–24; Thornton, 82–83.
77. Montgomery, *Textiles*, 188.
78. Nylander, "Bed and Window Hangings," 175.
79. Burgers, 149.
80. Carr, Morgan, and Russo, 3, 79–80.
81. Cooper, 25–30.
82. Baumgarten, 234.
83. Garrett, 52.
84. Jensen, 48.
85. Nylander, "Bed and Window Hangings," 175.
86. Schoelwer, 27.
87. Jobe, 78.
88. Jobe, 76.
89. Cummings, 2; Twiss-Garrity, 19–20.
90. Thornton, 82.
91. Baumgarten, 232.
92. Montgomery, *Textiles*, 49–56.
93. Montgomery, *Textiles*, 59; Nylander, "Bed and Window Hangings," 183.
94. Montgomery, "Eighteenth-Century Hangings," 165.
95. Nylander, *Fabrics*, 22.
96. Schoelwer, 27–40.
97. Schoelwer, 27–40.
98. Schoelwer, 33–35; Jensen, 48–49; Carr, Morgan, and Russo, 379–80.

BIBLIOGRAPHY

Cooke, Edward S. Jr., ed. *Upholstery in America and Europe from the Seventeenth Century to World War I.* New York: W. W. Norton, 1987.

Coons, Martha, and Katherine Koob. *All Sorts of Good Sufficient Cloth: Linen-Making in New England, 1640–1860.* North Andover, Mass.: Merrimack Valley Textile Museum, 1980.

Eaton, Linda. *Quilts in a Material World: Selections from the Winterthur Collection.* New York: Harry N. Abrams, 2007.

Fiske, Patricia L., ed. *Imported and Domestic Textiles in Eighteenth-Century America.* Washington, D.C.: Textile Museum, 1976.

Garrett, Elisabeth Donaghy. *At Home: The American Family, 1750–1870.* New York: Harry N. Abrams, 1990.

Geijer, Agnes. *A History of Textile Art.* Stockholm: Pasold Research Fund, 1979.

Harris, Jennifer, ed. *5,000 Years of Textiles.* London: British Museum Press in association with the Whitworth Art Gallery and the Victoria and Albert Museum, 1993.

Montgomery, Florence M. *Printed Textiles: English and American Cotton and Linens, 1700–1850.* New York: Viking Press, 1970.

———. *Textiles in America, 1650–1870.* Reprint. New York: W. W. Norton, 2007.

Schoeser, Mary, and Ceclia Rufey. *English and American Textiles from 1790 to the Present.* New York: Thames and Hudson, 1989.

Schoeser, Mary, and Kathleen Dejardin. *French Textiles: From 1760 to the Present.* London: L. King, 1991.

Additional Sources

Baines, Edward. *History of the Cotton Manufacture in Great Britain.* 2nd ed. London: F. Class, 1966.

Baumgarten, Linda R. "The Textile Trade in Boston, 1650–1700." In *Arts of the Anglo-American Community in the Seventeenth Century*, edited by Ian M. G. Quimby, 219–74. Winterthur, Del.: Henry Francis du Pont Winterthur Museum, 1975.

Benfield, Lynn A. "The Productions of Cloth, Clothing, and Quilts in Nineteenth-Century New England Homes." In *Uncoverings 1981*, edited by Sally Garoutte, 77–96. Mill Valley, Calif.: American Quilt Study Group, 1982.

Burgers, C. A. "Some Notes on Western European Table Linen from the Sixteenth through the Eighteenth Centuries." In *Upholstery in America and Europe from the Seventeenth Century to World War I*, edited by Edward S. Cooke Jr., 149–62. New York: W. W. Norton, 1987.

Burnham, Dorothy K. *Warp and Weft: A Textile Terminology.* Toronto: Royal Ontario Museum, 1986.

Burnham, Harold B., and Dorothy K. Burnham. *Keep Me Warm One Night: Early Handweaving in Eastern Canada.* Toronto: University of Toronto Press for the Royal Ontario Museum, 1972.

Carr, Lois Green, Phillip D. Morgan, and Jean B. Russo. *Colonial Chesapeake Society.* Chapel Hill: University of North Carolina Press, 1988.

Catts, Wade P., et al. *The Place at Christeen: Final Archeological Investigations of the Patterson Lane Site Complex.* Archaeological Series 74. Dover: Delaware Department of Transportation, 1989.

Cooper, Grace Rogers. *The Copp Family Textiles.* Washington, D.C.: Smithsonian Institution Press, 1971.

Cornforth, John. "Triumph of Flowered Silk." *Country Life* 184, no. 36 (September 6, 1990): 106–109.

Cummings, Abbott Lowell. *Bed Hangings: A Treatise on Fabrics and Styles in the Curtaining of Beds, 1650–1850.* Hanover, N.H.: University Press of New England, 1994.

Dow, George Francis, comp. *The Arts and Crafts in New England, 1704–1775.* Topsfield, Mass.: Wayside Press, 1927.

Emery, Irene. *The Primary Structures of Fabrics: An Illustrated Classification.* New York: Watson-Guptill Publications, 1985.

English Printed Textiles, 1720–1836. London: Her Majesty's Stationery Office, 1960.

Gittinger, Mattiebelle. *Master Dyers to the World: Technique and Trade in Early Indian Dyed Cotton Textiles.* Washington, D.C.: Textile Museum, 1982.

Gordon, Beverly. *Shaker Textile Arts.* Hanover, N.H.: University Press of New England, 1980.

Handler, Mimi. "Toile: Engravings by the Yard." *Early American Life* 20, no. 5 (October 1989): 28–35.

Homespun to Factory Made: Woolen Textiles in America, 1776–1876. North Andover, Mass.: Merrimack Valley Textile Museum, 1977.

Hood, Andrienne D. "Textiles." In *Decorative Arts and Household Furnishings in America 1650–1920: An Annotated Bibliography*, edited by Kenneth L. Ames and Gerald

W. R. Ward, 265–80. Winterthur, Del.: Henry Francis du Pont Winterthur Museum, 1989.

Irwin, John, and Katherine B. Brett. *Origins of Chintz.* London: Her Majesty's Stationery Office, 1970.

Jackson, Linda Wesselman. "Beyond the Fringe: Ornamental Upholstery Trimmings in the Seventeenth, Eighteenth, and Nineteenth Centuries." In *Upholstery in America and Europe from the Seventeenth Century to World War I*, edited by Edward S. Cooke Jr., 131–48. New York: W. W. Norton, 1987.

Jensen, Joan M. *Loosening the Bonds: Mid-Atlantic Farm Women, 1750–1850.* New Haven, Conn.: Yale University Press, 1986.

Jobe, Brock. "The Boston Upholstery Trade, 1770–1775." In *Upholstery in America and Europe from the Seventeenth Century to World War I*, edited by Edward S. Cooke Jr., 64–89. New York: W. W. Norton, 1987.

Kraak, Deborah E. "Eighteenth-Century English Floral Silks." *The Magazine Antiques* 63, no. 6 (June 1998): 842–49.

Montgomery, Florence M. "Eighteenth-Century American Bed and Window Hangings." In *Upholstery in America and Europe from the Seventeenth Century to World War I*, edited by Edward S. Cooke Jr., 126–73. New York: W. W. Norton, 1987.

Nylander, Jane C. "Bed and Window Hangings in New England, 1790–1870." In *Upholstery in America and Europe from the Seventeenth Century to World War I*, edited by Edward S. Cooke Jr., 174–85. New York: W. W. Norton, 1987.

———. *Fabrics for Historic Buildings.* 4th ed. Washington, D.C.: Preservation Press, 1990.

———. *Our Own Snug Fireside: Images of the New England Home, 1760–1860.* New York: Alfred A. Knopf, 1993.

O'Connor, Deryn, and Hero Granges-Taylor. *Color and the Calico-Printer: An Exhibition of Printed and Dyed Textiles, 1750–1850.* Farnham, Eng.: West Surrey College of Art and Design, 1912.

Petit, Florence H. *America's Indigo Blues.* New York: Hastings House, 1974.

———. *America's Printed and Painted Fabrics, 1600–1900.* New York: Hastings House, 1970.

Rothstein, Natalie. *Silk Designs of the Eighteenth Century.* Boston: Bulfinch Press, 1900.

———. "Silk Imports into America in the Eighteenth Century: An Historical Survey." In *Imported and Domestic Textiles in Eighteenth-Century America*, edited by Patricia L. Fiske, 21–30. Washington, D.C.: Textile Museum, 1976.

Safford, Carleton L., and Robert Bishop. *America's Quilts and Coverlets.* New York: E. P. Dutton, 1972.

Schneider, Jane. "Rumpelstiltskin's Bargain: Folklore and The Merchant Capitalist Intensification of Linen Manufacture in Early Modern Europe." In *Cloth and Human Experience*, edited by Annette B. Weiner and Jane Schneider, 177–213. Washington, D.C.: Smithsonian Institution Press, 1989.

Schoelwer, Susan Prendergast. "Form, Function, and Meaning in the Use of Fabric Furnishings: A Philadelphia Case Study, 1700–1775." *Winterthur Portfolio* 14, no. 1 (Spring 1979): 25–40.

Scott, Philippa. *The Book of Silk.* London: Thames and Hudson, 1993.

Sheridan, Clare M., ed. "Textile Manufacturing in American History: A Bibliography." *Textile History* 18, no. 1 (1987): 59–86.

Stone-Ferrier, Linda. "Spun Virtue, The Lacework of Folly and the World Wound Upside-Down." In *Cloth and Human Experience,* edited by Annette B. Weiner and Jane Schneider, 215–42. Washington, D.C.: Smithsonian Institution Press, 1989.

Storey, Joyce. *The Thames and Hudson Manual of Dyes and Fabrics.* London: Thames and Hudson, 1978.

———. *The Thames and Hudson Manual of Textile Printing.* London: Thames and Hudson, 1985.

Swan, Susan Burrows. "Household Textiles." In *Arts of the Pennsylvania Germans,* by Scott T. Swank et al., 221–29. New York: W. W. Norton, 1983.

Thornton, Peter. *Baroque and Rococo Silks.* London: Faber and Faber, 1965.

Twiss-Garrity, Beth A. "Getting the Comfortable Fit: House Forms and Furnishings in Rural Delaware, 1780–1820." Master's thesis, University of Delaware, 1983.

Ulrich, Laurel Thatcher. *A Midwife's Tale: The Life of Martha Ballard, Based on Her Diary, 1785–1812.* New York: Alfred A. Knopf, 1990.

———. "Cloth, Clothing, and Early American Social History." *Dress* 18 (1991): 39–48.

Weiner, Annette B., and Jane Schneider, eds. *Cloth and Human Experience.* Washington, D.C.: Smithsonian Institution Press, 1989.

Wingate, Isabel B., ed. *Fairchild's Dictionary of Textiles.* New York: Fairchild Publications, 1967.

Needlework

FROM THE TIME OF EUROPEAN SETTLEMENT THROUGH much of the nineteenth century, families valued needlework for both its practical and its aesthetic qualities. Needleworkers, mainly women, made and ornamented clothing and other necessities and demonstrated their ability to do fine stitching. Needlework also provided women with opportunities to earn money, to socialize, and, in the nineteenth century, to do charitable work.

Girls usually learned plain sewing at home or while apprenticed to another family to learn the skills of housewifery. Girls whose parents could send them to embroidery school learned to do fancy work. Commonly done before marriage, it often was the major subject taught at such schools and continued to be part of the curriculum of early nineteenth-century academies.

By the early 1800s, sewing was considered part of what was becoming known as the woman's sphere, which included care of home and children and maintenance of a family's values. Girls learned that sewing allowed them to assist their families, use spare moments purposefully, and exercise their creativity. Teaching neatness, attentiveness, and patience, sewing helped a girl develop decorum, and, when she was older, "compose[d] the nerves and furnish[ed] a corrective for many of the little irritations of domestic life."[1]

Needlework offers opportunities to interpret the skills of the maker, the esteem in which her work was and is held, and changes in women's roles. The samplers, crewelwork, quilts, and lace clearly reveal women's educational attainments and contributions toward managing and decorating homes. The work shows the accomplishments of the girls who learned and the women who taught. Looking at needlework may lead museum visitors to picture a family in their parlor, as the women and girls sew something useful or fancy. The imaginary picture is peaceful, but in the background are tensions about a woman's place in her home and in her world.

LOOKING AT NEEDLEWORK

Needlework often covers its textile support material with color and design. It is these qualities that immediately attract attention and give needlework a place decorating walls, windows, beds, and clothing. A second look draws the museum visitor closer, to examine how these intricate designs were accomplished with fabric and yarn. Examining these three qualities—material, color, and design or ornament—can foster an appreciation of needlework.

Material

In the colonies of British North America, needleworkers used the four basic natural fibers—linen, wool, cotton, and silk—for both the support fabric and the yarns used to accomplish the design. (See chapter 19 for descriptions of the characteristics and processing of these fibers as well as their relative availability in the colonies and young United States.)

Elizabeth Rush worked her sampler on a linen textile using silk yarns, a common choice for a sampler, crewelwork, or canvaswork (fig. 20-1). Linen yarn occasionally was used to work the sampler design. For a pocketbook, linen provided the canvas support and wool the yarn for the design (fig. 20-2). Sometimes, a fine wool textile was used as both a support and the yarn to make the design. Wool yarns were often used for canvaswork. Since the name crewel is derived from a certain kind of wool, that fiber is most commonly used for crewelwork embroidery.

A white cotton fabric provides the support for a tambour design (fig. 20-3). Cotton fabric is often seen in the pieced quilts of the nineteenth century. Silk was a common material for the fabric support of needlework pictures, for the design materials of pictures and samplers, and for decorative effects in various other kinds of needlework.

Color

Needlework shows a wide range of color in its support and design material, but the choices were

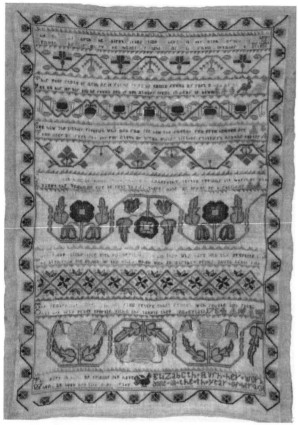

FIGURE 20-1. Elizabeth Rush demonstrated her needlework skills by using queen's, cross, outline, and satin stitches in her 1734 sampler. Queen's stitch was the most time consuming, as the needleworker had to place as least four or five stitches through one hole in the canvas. Elizabeth selected expensive silk yarns to further embellish her stylish sampler with yellows, reds, greens, and blues. (Sampler, Elizabeth Rush, Philadelphia, 1734. Linen, silk; H 18¼ in., W 13 in. 1975.116 Winterthur Museum purchase with funds provided by the Claneil Foundation.)

limited by knowledge about dyestuffs and color fastness. Elizabeth Rush chose a wide range of color for her sampler, as did the maker of the pocketbook. The tambour work shows the fashion for a white-on-white design at the turn of the nineteenth century.

Design

Looking closely at the needlework can quickly reveal patterns. Designs were used, copied, and reused. For example, on her sampler Elizabeth Rush worked floral bands with angular, meandering stems, and flowers, including carnations and rosebuds, that are symmetrical and often abstract. The floral bands connect her work to a group of other samplers made in Philadelphia in the first half of the 1700s.[2] The tambour work shows a much more curvilinear, naturalistic flower, influenced by the chain stitch technique of tambour.

The undulating bands of color on the pocketbook are a typical design for canvaswork pieces like chair seats and book covers. Scenes of human figures in pastoral settings could also be accomplished in canvaswork. Noticing the material, color, and design of needlework is rewarding in itself. But these visual elements lead to interesting interpretive questions. Why was the needlework designed in this particular way and how was the design accomplished?

THINKING ABOUT STYLE

The word *style* applies to both the techniques and designs of needlework. "Fancy" needlework reflected several styles of workmanship. Between 1640 and 1785, needleworkers employed a variety of stitches and meticulous workmanship to make such articles as petticoats, pockets, pocketbooks, and pictures.[3] These finely crafted items reflect not only the aesthetic preferences of the time but also the study and practice that were the focus of education for many young girls. The compartmented design of long, narrow seventeenth-century samplers, for example, recalls the rectilinear, paneled facades of seventeenth-century chests. The bird, flower, and foliage motifs in eighteenth-century needlework suggest designs that also appeared on some prints, textiles, and ceramics of that era.

Between 1785 and 1830, needlework was often completed for display, to show young women's accomplishments.[4] Their education curriculum offered scholastic subjects and focused on such "accomplish-

FIGURE 20-2. Many Irish stitches were required to solidly work a pocketbook that could endure generations of handling. In America, most needleworkers passed over three or four weft yarns to create the Irish stitch. A blue tape bound the edges of this pocketbook to give it further strength. (Pocketbook, North America, 1740–1790. Linen, wool; L 8½ in., W 4½ in. 1958.1584 Winterthur Museum, bequest of Henry Francis du Pont.)

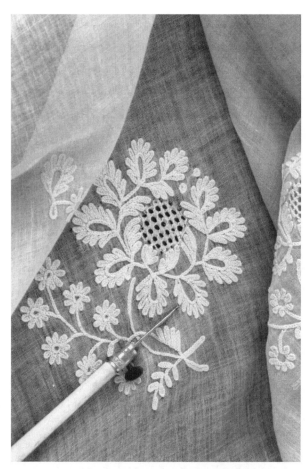

FIGURE 20-3. Using a tambour hook, the maker of this window hanging fabricated the flowers and then created their drawn-work centers on the plain-weave mull cotton fabric. (Window hanging, probably Europe, 1780–1820. Cotton; H 107 in., W 43 in. 1969.1345a,b Winterthur Museum, bequest of Henry Francis du Pont.)

ments" as painting, singing, and piano playing, in addition to needlework. Silk-on-silk pictures joined fancy samplers as favored forms of needlework. The shiny, showy appearance of silk pictures repeated the sparkling of bright, engraved silver and the highly polished veneered and inlaid surfaces of classical-revival furniture, as well as the classical motifs in the prints that were often design sources for needlework.[5]

After 1830, girls and women continued to produce needlework objects, but different materials, techniques, and images interested them. For example, a needleworker doing Berlin work often followed a commercially available charted pattern to make a design on canvas, usually made of cotton in a balanced weave. She worked the design with zepher yarns, also sometimes called Berlin, German, merino, or combinations of these and other terms, which, because of their processing, were generally fluffy, lustrous four-

ply yarns.[6] She might have used these same yarns for a knitted or crocheted project.[7] As in other textiles of the time, vivid colors prevailed. Strong maroons, purples, pinks, and oranges mingled with vibrant greens and blues. From 1840 to 1880, Berlin needlework decorated many household objects.[8] Women also produced colorful, well-composed quilts, as well as plain sewing and white-worked embroidery.

MAKING AND MARKETING NEEDLEWORK

Generally, women in colonial North America and the new republic created two kinds of needlework. Plain sewing served household needs, and fancy sewing was for display and accomplishment.

Plain Sewing

Plain sewing employed basic running, back, and hemming stitches. Most young girls began to learn these stitches as soon as they could hold a needle. By the age of five, many girls were expected to do a "stint" of sewing each day.[9] The stitches fashioned simple clothing and household articles and were the basis for fancy needlework. An article in a 1792 issue of a Philadelphia periodical, *The Lady's Pocket Library*, advised women that "all kinds of what is called plain work, though no very polite accomplishment, [women] must be so well versed in as to be able to cut out, make, and mend [their] own linen."[10]

Young girls also learned to mark and inventory textiles with letters and numbers stitched of tiny cross-stitches. To learn for this important task, they made marking samplers with rows of letters and numbers. Some contained as many as eight styles of letters and several different sets of numbers, but this kind of sampler was not meant for display.

Knitting usually accompanied training in plain sewing. Many children assisted in knitting stockings, shawls, and mittens. As with embroidery, women used knitting to display skill and artistry. A collection of pocketbooks, drawstring purses, and a pincushion at Winterthur displays the accomplishments of Mary Wright Alsop of Middletown, Connecticut. Worked on fine needles yielding twenty-one to twenty-six stitches per inch, the pieces are worked in "geometric, mosaic-like motifs" in as many as twenty colors of fine silk yarn.[11]

Quilting

Quilting, a form of plain sewing, is the process of stitching together three layers of fabric—top, filling, and lining. In the New World, eighteenth-century

petticoats, bodices, jackets, and coats were sometimes quilted. The top surface usually was wool or, in more elegant garments, silk. Worn under a skirt that was open in the front, quilted petticoats were fashionable in the mid-eighteenth century. Typically, the filling was carded wool fibers, and the lining, glazed or unglazed wool. Elizabeth Drinker recorded on August 26, 1763, that she had "put a gown skirt in ye frame, to Quilt this afternoon." Four days later, she wrote, "Sister and self finish'd my quilt this afternoon."[12] Some petticoats had elaborate, embroidered borders similar to designs of crewel-embroidered bed hangings and pictures.[13] Some surviving quilts document the practice of unstitching quilted petticoats and reusing the lengths in a bedcover, part of a tradition of frugal adaptive reuse of materials.[14]

The earliest American bed quilts usually were wholecloth; that is, tops made of the same type and color of fabric overall (fig. 20-4). Their ornamentation was the design produced by the stitches joining the layers. Quilted bed coverings in the colonial period were rare and expensive, and inventories often valued them as highly as bed hangings.[15] Quilt tops of patchwork designs are mentioned in colonial documents in the eighteenth century. Appraisers in Kent County, Maryland, used the word "patched" in describing a quilt in 1760, an early reference.[16] Eleven patchwork quilts, both pieced and appliquéd, are known that both date from the eighteenth century and are attributed to American makers; all date after 1770.[17] Pieced designs used simple patterns, usually composed of squares and triangles. Appliquéd designs often used motifs from one fabric sewn onto another, which became the top layer of the quilt.

In the nineteenth century, quilt making proliferated. Friendship quilts, in which blocks were made and signed by friends and relatives, were favored, especially between 1840 and 1860 in the Mid-Atlantic region. Historians can use the names and dates on the quilts to document networks—family, geographic, or religious—that strengthened communities.[18]

Fancy Needlework

Fancy work required the ability to execute a variety of embroidery stitches. Many girls made samplers that demonstrated their ability to do these stitches.

Samplers

Usually long, narrow, and without borders, many seventeenth-century American samplers displayed bands of intricate stitchery (fig. 20-5). They were

FIGURE 20-4. Each generation that owned this woolen quilt took special care to protect it from insect damage. The dark green fabric was imported from England, but someone in the United States stitched the intricate designs. (Wholecloth quilt, United States, 1775–1800. Wool; L 99 in., W 96 in. 1960.1129 Winterthur Museum, bequest of Henry Francis du Pont.)

not framed and were stored when not being used or worked. Often they served as pattern references for lettering styles or motifs that the worker wanted to remember or reuse.[19] Later embroidery samplers show compartmented designs often including alphabets, the name of the maker, the date of completion, and sometimes other useful information such as the school where the work was done or genealogical details for the maker. By 1720 some American needleworkers applied decorative borders to their samplers; a sampler made by Elizabeth Rush in 1734 is an example. Framed samplers were often displayed in family parlors, and the sampler's use as a record of accomplishment and display surpassed its use as a sewing reference.[20]

To make a darning sampler, both straight and L-shape cuts were put into cloth to simulate tears.

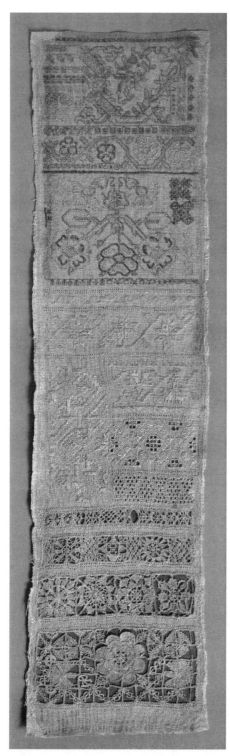

Usually using a contrasting color or texture of thread to facilitate later study, a darner then stitched the cuts to replace the woven structure of the cloth. Particularly during the last half of the eighteenth century, some women made samplers that displayed fine Dresden or drawnwork. This technique used various stitches to join the ground threads of a fine fabric into intricate patterns.

A sampler made by Frances Paschal in 1788 includes both Dresden and cutwork (fig. 20-6). In cutwork, a woman "worked the edges of the design elements in chain, buttonhole, or satin stitch to prevent the fabric from raveling and then carefully cut away the background fabric inside the stitching lines. Repeated rows of a variety of buttonhole stitches created needle-made lace to refill empty areas."[21] This type of needlework was used on baby caps, handkerchiefs, and aprons.[22] Samplers that depict genealogical records, a favorite subject in the eighteenth century, became even more popular in the nineteenth century (fig. 20-7).[23] Needlework maps and globes also survive from this period, the first quarter of the nineteenth century.

Similarity of design and/or technique can connect some samplers with specific schools. At Samuel Blyth's school in Salem, Massachusetts, mainly in the third quarter of the eighteenth century, samplers were made with elongated, irregular stitches in crinkly silk; all have a similar "scalloped" skyline that forms a valance-like top border (fig. 20-8). At the school run by

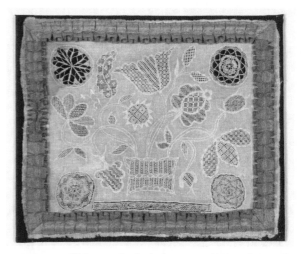

FIGURE 20-5. Mehitable Parson's sampler includes examples of lacework. Perhaps the most demanding forms of needlework, four lacework forms were practiced: cutwork, Dresden work, netting, and bobbin lace. Dresden work, known today as drawnwork, required that a few warp or weft threads be cut and the remaining threads be embroidered together. Many designs could be produced using such techniques. (Sampler, Mehitable Parson, Rowley, Mass., ca. 1700. Linen, silk; L 24 in., W 5½ in. 1987.2 Winterthur Museum, with funds provided by Collectors Circle.)

FIGURE 20-6. This sampler includes cutwork, Dresden work, and the satin, chain, and buttonhole stitches. Local newspapers sometimes printed advertisements for needlework classes, and Mrs. Mary Cary advertised "Dresden Work in all its variations" in the New York Mercury on September 24, 1753. (Sampler, Frances Paschal, Darby, Pa., 1788. Cotton, linen, silk; H 8⅞ in., W 11 in. 1959.89 Winterthur Museum, gift of Mr. and Mrs. Davis L. Lewis Jr.)

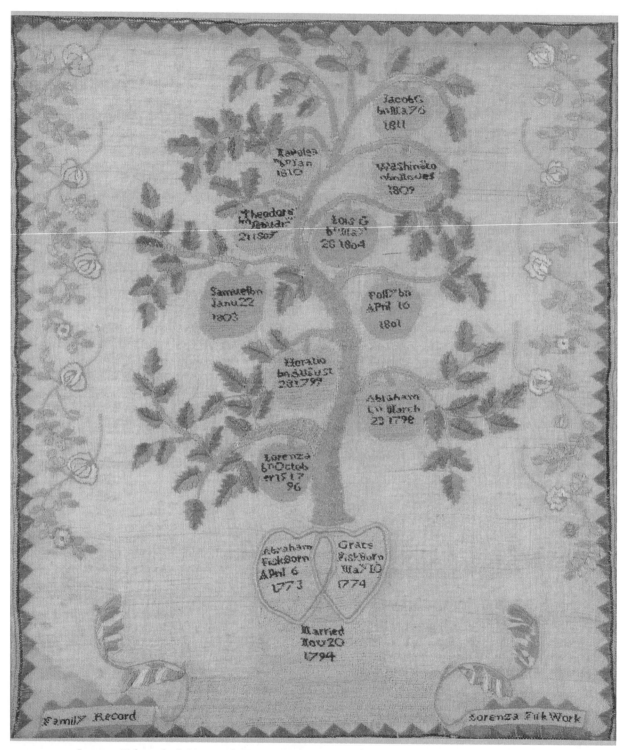

FIGURE 20-7. Lorenza Fisk worked this genealogical tree sampler to record her family history. Samplers like this one often include dates of births, marriages, and deaths. (Sampler, Lorenza Fisk, Massachusetts, 1811. Linen, silk; H 18¾ in., W 16¼ in. 1969.430 Winterthur Museum, gift of Mrs. Alfred C. Harrison.)

Miss Mary (Polly) Balch in Providence, Rhode Island, between 1785 and 1799, many samplers illustrate a public building, flanked by pillars and framed by a floral border on two or three sides.

Silk Work

Silk embroidery, considered in the eighteenth and nineteenth centuries to be a most elegant type of needlework, required silk thread and fabric. These were expensive in comparison with other materials, and in eighteenth-century America were usually available only in cities.[24] Especially in needlework pictures, silk threads were used on silk grounds. Occasionally designs were highlighted with gold or silver threads. In the middle years of the eighteenth century, Philadelphia girls produced some particularly fine silk embroidery (fig. 20-9).

When United States ships began direct trade with China after the Revolution, silk yarns and fabrics became less expensive and more available, and sparkling silk pictures became more popular. By the mid-nineteenth century, thread of many hues arrived on ships from China.[25] Applying lessons from art classes, some girls drew their own designs; others traced their designs from prints and copied scenic views, still lifes, and patriotic themes. After the death of George Washington in 1799, mourning pictures were fashionable.[26] Typical features included a willow tree, weeping figures, and a tomb or urn, in painting, needlework, or both.

Canvaswork

In the British North American colonies, canvaswork was another elegant and expensive form of needlework. Newspapers carried notices from teachers offering instruction in its techniques, which employed a variety of stitches on evenly woven linen canvas, ranging from eighteen to fifty-two threads per inch. Most canvas in the eighteenth century was imported. Makers usually used wool (crewel) yarns, and, for accent, silk and occasionally metallic yarns.

During the seventeenth and eighteenth centuries, common stitches were tent, cross, Irish, and Queen stitches. Because these stitches often distorted the canvas, women stitched the canvas ground to a frame before beginning work. The tent stitch, worked on

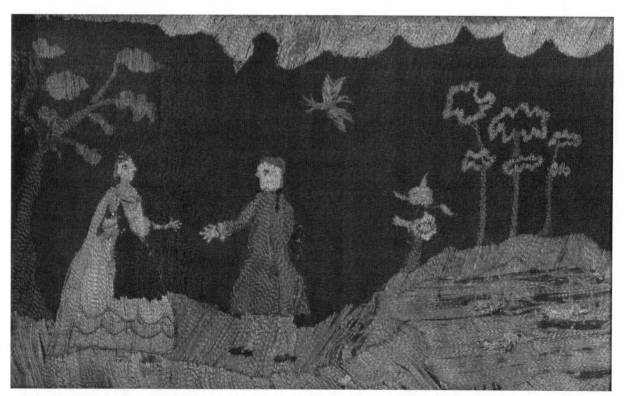

FIGURE 20-8. Mary Jennison created her colorful design with silk yarns and long stitches that quickly covered the large areas. Such stitches are associated with a Salem, Massachusetts, needlework school. Details such as the parasol, the pipe, and the clothing help researchers understand the finery used in the 1770s. (Needlework picture, Mary Jennison, Salem, Mass., 1773. Silk; H 8 in., W 13 in. 1955.137 Winterthur Museum, gift of Henry Francis du Pont.)

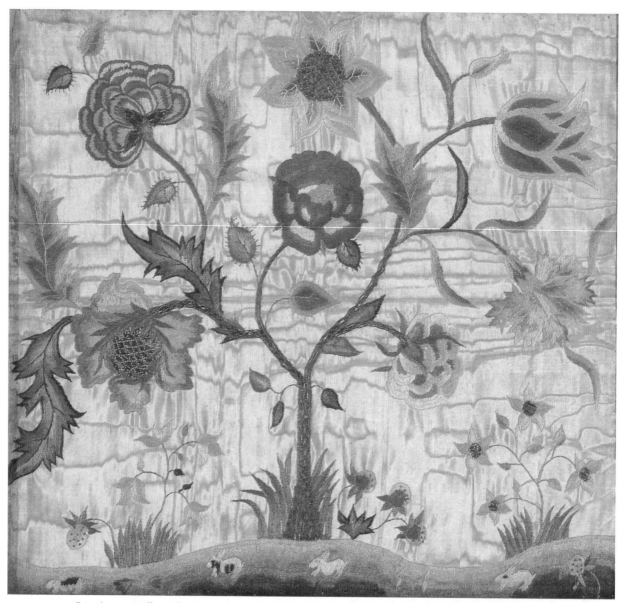

FIGURE 20-9. Creating a needlework picture using metallic threads, a cream silk fabric, beads, and polychrome silk yarns was quite expensive. Such delicate designs were treasured and saved. (Needlework picture, Philadelphia, 1750–1760. Silk, beads, muslin, crepeline, cotton, metal; H 16¼ in., W 17½ in. 1966.977 Winterthur Museum, bequest of Henry Francis du Pont.)

very fine canvas, was ideal for intricate designs and pictures. Many of the mid-eighteenth-century scenic canvaswork pictures that feature human figures in a landscape were created with the tent stitch. Some pictures required a year or more to make and, when completed, were prominently displayed.[27] With the Irish stitch, a needleworker's thread went up over four threads of the canvas and down over two. This stitch could be used for a variety of patterns, most of which were geometric. The Irish stitch wore well and often was used for chair seats, pocketbooks, and book covers. Difficult to do, the Queen stitch required the

maker to place four or five stitches in the same opening, creating a textured surface. The stitch accented such small items as pincushions, pocketbooks, and purses and enjoyed a period of popularity from 1780 to 1810. Many women purchased designs for canvaswork, and some hired artists to paint them. Art lessons were sometimes available for women, as a source of design for canvaswork.[28]

Women in the United States adopted Berlin work in the early nineteenth century. About 1804, a Berlin printseller published designs on paper, similar to modern graph paper, on which each square corre-

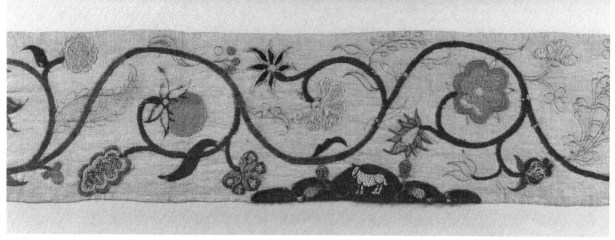

FIGURE 20-10. The design finely stitched on this petticoat border—including an undulating vine, flowers and leaves, strawberries, and animals—was inked on the textile as an embroidery guide. (Petticoat border, possibly Connecticut, 1700–1775. Linen, cotton, wool; H 95 in., W 7¼ in. 1962.33 Winterthur Museum.)

sponded to a square on canvas. Many designs were also colored, giving guidance on design development, as a needlework teacher might have done in a school.[29] New kinds of canvas were developed, with about twenty threads to the inch, which facilitated the design transfer. Between 1830 and 1870, Berlin work "eclipsed practically all other types of needlework" as many women applied this decoration to clothing and household furnishings.[30]

Crewelwork

In the seventeenth, eighteenth, and nineteenth centuries, the word *crewel* referred to lightly twisted two-ply yarns that were used for both crewelwork and canvaswork. The most popular support fabric for American crewel embroidery was plain-weave linen. Marked in ink on fabric, designs for crewelwork came from many sources. Some women prevailed on relatives or friends to create designs. Sarah Emery recalled that her Aunt Sarah "drew a lively vine of roses and leaves" for her skirt.[31] Teachers, engravers, and tailors provided designs. Sometimes a needleworker purchased marked fabric that also included suggestions for suitable stitches; usually, however, an embroiderer chose her own stitches and colors.[32]

Most early American crewelwork ornamented the bed hangings on best beds, taking the place of imported damask or brocade fabrics. As a scholar notes, "only a woman with great diligence, willing to invest several years of stitchery, would launch such a project, a project calling for the preparation of countless yards of fabric and hanks of yarn before embroidery could

even be started."[33] Women also used crewel embroidery to decorate dresses, petticoat borders, pockets, and pocketbooks (fig. 20-10).

Toward the end of the eighteenth century, crewelwork bed hangings became less fashionable and crewel-embroidered blankets became popular. To decorate heavy woolen blankets, thicker threads and larger stitches were used. Many women spun and dyed their own yarns. A project determined whether the yarn needed to be thick or thin, and colors were limited by the availability of dye materials. Women who lived in cities and larger towns could patronize dry-goods dealers, who stocked crewel yarns imported from England.

Regional preferences appear in crewelwork. Evidence indicates that large projects, such as bed hangings, were not generally done in Pennsylvania; instead, women chose to embroider such small items as pictures and pot holders.[34] New England embroiderers decorated petticoat borders, pockets, and slip seat covers.

Bed Rugs

One inventory study shows that rugs covered beds for wealthy people in the early 1700s, but disappeared, except for poorer people, by the 1800s. The reason is not clear. Most likely, these bed rugs were the coarse, commercially woven wool shag bed coverings that had been imported from England and widely used from the beginning of colonization. Green, blue, and red were the most common colors, and some homes contained one of each color.[35] In the eighteenth

century, New England women also made bed rugs by sewing wool in multicolored patterns with looped or running stitches through coarse linen or wool backings (fig. 20-11).

Tambour Work

A needleworker doing tambour work used a small hook, like a crochet hook, to pull loops of delicate yarn through fine fabric, often white muslin, making a pattern in chain stitch (see fig. 20-3). Tambour work was fashionable from the late eighteenth until the mid-nineteenth century. The sheer, classically styled dresses of the early 1800s made excellent backgrounds for tambour work, which, by the 1840s, could be done by machine.[36]

White Work

Needlework with a white background and white stitches included stuffed work, corded work, and candlewicking. Stuffed work describes the process of gently prodding cotton wadding into shapes stitched into two layers of cloth. The upper layer was a fine, shiny fabric, and the lower, through which the cotton was pushed, was coarse. Corded work describes a similar technique of threading soft, bulky yarn through

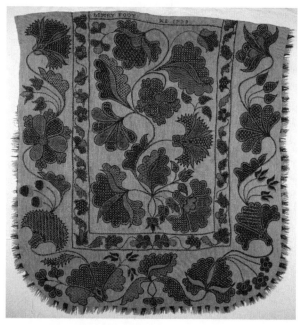

FIGURE 20-11. Mary Foot made this bed covering or bed rug in 1778, using darning stitches both to create patterns within the flower petals and to cover the wool background. Several similar bed rugs survive from southeastern Connecticut, including one made by Mary Foot's sister Elizabeth. (Bedcover, Mary Foot, New London, Conn., 1778. Wool; L 90 in., W 87 in. 1960.594 Winterthur Museum, bequest of Henry Francis du Pont.)

stitched channels to form stems or tendrils in the design.[37] Winterthur owns a white stuffed-work bedspread made in 1815 by Mary Remington of Warwick, Rhode Island, accompanied by stuffed-work bed valances and a dressing-table cover.[38]

Candlewicking is coarse embroidery using soft, bulky yarns on plain-woven fabric. Some examples make use of the French knot, satin and bullion stitches, as well as the clipped, tufted stitches generally associated with modern adaptations of earlier designs. Candlewick was made by machine from the early nineteenth century.

Marketing Needlework

Sewing provided daily work for many women, whether they did it for themselves and their families, or, in the case of enslaved women, as directed for the needs of owners or others in the household, or for customers, as a source of income. Some women left their homes by day to sew in the houses of clients or masters; others established shops. In 1787 one dressmaker wrote, "My daily bread depends on my labour."[39] Chloe Samson of Pembroke, Massachusetts, recorded in 1882 that she spent three days making a bed quilt for which she earned one shilling. In 1836 Miriam David Colt taught school, but sewed and quilted at night for extra money.[40]

How did women find a market for their skills and goods? In addition to word of mouth, newspapers also were useful. Throughout the eighteenth and early nineteenth centuries, newspapers advertised shops that supplied materials to make fashionable clothing and that sold clothing made-to-order. In 1749 Anne Griffith advertised in the *Maryland Gazette* that she did "Plain or Figured Corse or Fine quilting in the best and cheapest manner at her house" in Annapolis.[41] In 1791 M. Stimson of Philadelphia, "tambour worker and embroideress," offered to make ladies' gowns "with elegance and taste" and gentlemen's waistcoat patterns "equal to any imported." She also was willing to teach young ladies "the above business" as well as "plain work, Marking, Darning and all kinds of Needle Work. Reading with Propriety."[42]

Tailoring was sometimes the province of women. In New York in May 1792, "the Widow Campion" advertised that she was established in the "Tayloring Business" at No. 22 Water Street; she "employed Mr. Marshall, just arrived from London, who makes Ladies Habits and coats, also Gentlemen's apparel in the most elegant and newest fashion."[43] In another example of adaptive reuse of textiles in the 1790s,

Mrs. Causey of Boston informed the public that she carried on a

> Business not much practiced in this town, of buying, selling, and taking on commission, cast CLOTHES of men, women, and children; and to help those who are not able to pay the Tailors, Mantua-makers, and Milliners, with clothes ready to their hand, at a reasonable rate; and at the same time will give others an opportunity of clearing their houses of Cloathing outgrown, out of fashion, or useless to them.[44]

Some shops offered more than one service. On April 7, 1787, H & Amelia Taylor, "Upholsterers from St. James's, London," advertised in a Philadelphia newspaper that they did upholstery "in the best manner," either at their shop or in the patron's home, and supplied "Ladies Hair Petticoats, Rope hoops, Bishops, with every other kind of Needle work, made up in the most compleat manner. Wanted, a Young woman as an Apprentice."[45]

LIVING WITH NEEDLEWORK

In colonial North America, plain sewing was part of virtually every woman's life. Hemming, mending, and marking needed to be done. Twelve-year-old Anna Green Winslow, living with her aunts, wrote in her diary on March 9, 1772, that "this day's work may be called a piece meal for in the first place I sew'd on the bosom of unkle's shirt, mended two pair of gloves, mended for the wash two handkerchiefs (one cambrick), [and] sewed on half a border of a lawn apron of aunts."[46]

Needlework probably occupied a large proportion of a woman's time between the completion of her schooling, if she had that opportunity, and her marriage. She prepared the linens and bedding for her dowry and completed most of her decorative needlework.[47] After marriage, affluent women who lived in cities often relied "on the products and services of bakers, brewers, and candle makers, soap makers, fabric merchants, launderers, ironers, dry cleaners, and dressmakers," and therefore might find rare moments of leisure for fancy needlework.[48]

In both city and country, the mistress of a household depended on her knowledge of plain sewing to provide and repair clothing, bedding, towels, table linens, and other household goods. She needed either to do the work herself or supervise the work of others. Sarah Snell Bryant of Vermont described 189 days one year when sewing was her major work. In her thirty-eighth year, she made clothes for at least eleven people,

including herself, her husband, six children, a hired girl who lived in, and three nonfamily members. For them, she "produced 12 shirts, 7 short gowns, 4 'tyens,' 9 trousers, 5 jackets, and 3 frocks." In addition, she "made stockings, nightgowns, petticoats, overalls, pantaloons, breeches, handkerchiefs, and a cooler (short jacket)." Sarah also "spun a mop, wove tape," altered her husband's "great coat," and "made bags."[49]

Needlework was important in creating gifts and in binding generations together. Samplers and fabric in quilts often recalled family and friends, special events, and values. Nineteenth-century women made quilts that preserved kinship ties by using fabric from wedding dresses, infant clothes, and clothes of deceased family members or by including signatures of family members, schoolmates, or neighbors.[50] Because they legally did not own or bequeath property, women often gave treasured needlework to friends and relatives while living.[51]

During the colonial period, women sometimes quilted articles of clothing, especially petticoats. Diaries indicate that quilting and sewing often were done in company with others and provided a social occasion. Susannah Phelps, daughter of a wealthy Hadley, Massachusetts, family, quilted petticoats; her diary entries for the 1760s contain many references to quilting with friends at her house or theirs.[52] Not all quilting was done for personal use, however; references also exist to professional quilters.

Bed quilts before 1800 were rare and expensive. About 1800, however, when fabrics became more readily available, quilt making became a more common activity. Not only were quilts used as bed coverings, they hung in doorways and windows to cut down on drafts. In 1835 the inventory of Susan Ward showed that she owned "1 [pair of] dimity quilt curtains."[53] Suspended from attic or lean-to beams, quilts also served as room dividers.

Quilts were versatile articles for families who made the westward journey. They served as warm coverings for sleeping travelers, insulation in wagons, padding on seats, decorative throws on tables, and coverings for doors and windows. Many women packed baskets with sewing and visited from wagon to wagon; sewing and such activities as tatting, knitting, crocheting, exchanging recipes, and "swapping food for the sake of variety kept us in practice of feminine occupations."[54] Keturah Belknap, in preparation for a move to Oregon in 1848, spent six months sewing "clothes enough to last a year," six two-bushel bags (for which she first spun the thread) to transport

the food supplies, and finally, a wagon cover of two thicknesses, linen and muslin.[55]

Women stitched articles for charitable purposes, and by the nineteenth century, many towns and cities had societies that supplied soup, sewing, and firewood to the poor.[56] Women also held fairs and bazaars at which they sold their needlework, the proceeds supporting charitable and reform activities, such as the temperance movement and the abolition of slavery.

CONCLUSION

By 1800 the work of spinning and weaving began to transfer to factories, and manufacturing textiles at home became less important as women's work. Making or maintaining the stock of clothing and household textiles, however, still required women's skills. By the 1830s, schools, sermons, and popular literature emphasized the "cult of domesticity" in which women were believed to be "by nature" domestic and more pure, more pious, and more morally sensitive than men.[57] Women were enjoined to create homes that were retreats and bastions of morality against the greed and turmoil of the world. Evidence suggests, however, that few women had the time, money, or, in the case of enslaved women, legal status to live according to this ideal. Most were producers of some goods and purchasers of others. With industrialization of textiles, young, unmarried women could earn wages in textile factories, and factory owners valued the speed and accuracy of their work more than their needlework skills.

NOTES

1. Farrar, 122.
2. Ring, 330–31.
3. Swan, *Plain and Fancy*, 88.
4. Swan, *Plain and Fancy*, 175–80.
5. Richter, no. 25.
6. Belolan, 90.
7. Belolan, 94.
8. Swan, *Plain and Fancy*, 208; Belolan, 17.
9. Ferrero et al., 18.
10. Swan, *Plain and Fancy*, 39.
11. Kraak, 98–99.
12. Swan, *Plain and Fancy*, 210.
13. Rowe, 162–65.
14. Eaton, 129.
15. Garoutte, 22–23; Allen, 15.
16. Brackman, 14.
17. Brackman, 14.
18. Eaton, 41–46.
19. Kraak, 92.
20. Kraak, 93.
21. Swan, *Winterthur Guide*, 18–20.
22. Swan, *Winterthur Guide*, 25.
23. Sebba, 106.
24. Swan, *Winterthur Guide*, 89.
25. Richter, no. 43.
26. Richter, no. 25.
27. Swan, *Winterthur Guide*, 37–39.
28. Swan, *Winterthur Guide*, 31.
29. Swan, *Winterthur Guide*, 52.
30. Swan, *Winterthur Guide*, 63.
31. Swan, *Plain and Fancy*, 104.
32. Swan, *Plain and Fancy*, 108.
33. Swan, *Plain and Fancy*, 113.
34. Swan, *Plain and Fancy*, 111.
35. Allen, 16.
36. Swan, *Plain and Fancy*, 119–21.
37. Eaton, 28, 46.
38. Eaton, 14–31.
39. Sprigg, 69.
40. Brackman, 19.
41. Allen, 22.
42. Dexter, 167.
43. Dexter, 165.
44. Dexter, 143.
45. Dexter, 143.
46. Sprigg, 75.
47. Swan, *Plain and Fancy*, 127.
48. Swan, *Plain and Fancy*, 127.
49. Bonfield, 80.
50. Eaton, 34–46.
51. *Quilt Digest 1987*, 116–17.
52. Bonfield, 85.
53. Swan, *Plain and Fancy*, 216.
54. Baxandall, Gordon, and Reverby, 71.
55. Ferrero et al., 50.
56. Ferrero et al., 66.
57. Ferrero et al., 23.

BIBLIOGRAPHY

Eaton, Linda. *Quilts in a Material World: Selections from the Winterthur Collection.* New York: Harry N. Abrams, 2007.

Ring, Betty. *Girlhood Embroidery: American Samplers and Pictorial Needlework, 1650–1850.* 2 vols. New York: Alfred A. Knopf, 1993.

Swan, Susan Burrows. *Plain and Fancy: American Women and their Needlework, 1700–1850.* New York: Holt, Rinehart and Winston, 1977.

———. *A Winterthur Guide to American Needlework.* New York: Crown Publishers, 1976.

Additional Sources

Adamson, Jeremy E. *Calico and Chintz: Antique Quilts from the Collection of Patricia S. Smith.* Washington, D.C.: Renwick Gallery of the National Museum of American Art, Smithsonian Institution, 1997.

Allen, Gloria. "Bed Coverings: Kent County, Maryland, 1710–1820." In *Uncoverings 1985*, edited by Sally Garoutte, 9–32. Mill Valley, Calif.: American Quilt Study Group, 1986.

Bassett, Lynne Z., and Jack Larkin. *Northern Comfort: New England's Early Quilts, 1780–1850, from the Collection of Old Sturbridge Village*. Nashville: Rutledge Hill Press, 1998.

Baxandall, Rosalyn, Linda Gordon, and Susan Reverby, comps. and eds. *America's Working Women*. New York: Vintage Books, 1976.

Belolan, Nicole. "'The Blood of Murdered Time': Berlin Wool Work in America, 1840–1865." Master's thesis, University of Delaware, 2009.

Bolton, Ethel Stanwood, and Eva Johnston Coe. *American Samplers*. Boston: Massachusetts Society of Colonial Dames of America, 1921.

Bonfield, Lynn. "The Production of Cloth, Clothing, and Quilts in Nineteenth-Century New England Homes." In *Uncoverings*, edited by Sally Garoutte, 76–96. Mill Valley, Calif.: American Quilt Study Group, 1982.

Brackman, Barbara. *Clues in the Calico: A Guide to Identifying and Dating Antique Quilts*. McLean, Va.: EPM Publications, 1989.

Cooper, Grace Rogers. *The Sewing Machine: Its Invention and Development*. Washington, D.C.: Smithsonian Institution Press, 1976.

Cummings, Abbott Lowell. *Bed Hangings: A Treatise on Fabric and Styles in the Curtaining of Beds, 1650–1850*. Boston: Society for the Preservation of New England Antiquities, 1961.

Deutsch, Davida Tenenbaum. "Needlework Patterns and Their Use in America." *The Magazine Antiques* 139, no. 2 (February 1991): 368–81.

Dexter, Elisabeth William (Anthony). *Colonial Women of Affairs: Women in Business and the Professions in America before 1776*. 2nd ed. Boston: Houghton Mifflin, 1931.

Emery, Sarah. *Reminiscences of a Nonagenarian*. Newburyport, Mass.: William H. Huse & Co., 1879.

Farrar, Eliza Ware. *The Young Lady's Friend*. Boston: American Stationer's Company, 1836.

Ferrero, Pat, et al. *Hearts and Hands: The Influence of Women and Quilts on American Society*. San Francisco: Quilt Digest Press, 1987.

Garoutte, Sally. "Early Colonial Quilts in a Bedding Context." In *Uncoverings : The 1980 Research Papers of the American Quilt Study Group*, edited by Sally Garoutte, 18–27. Mill Valley, Calif.: American Quilt Study Group, 1981.

Hersh, Tandy, and Charles Hersh. *Cloth and Costume: 1750–1800*. Carlisle, Pa.: Cumberland County Historical Society, 1995.

Jensen, Joan M. *Loosening the Bonds: Mid-Atlantic Farm Women, 1750–1850*. New Haven: Yale University Press, 1986.

Kraak, Deborah E. "Textiles and Embroidery." In *Eye for Excellence: Masterworks from Winterthur*, by Donald L. Fennimore et al., 87–108. Winterthur, Del.: Henry Francis du Pont Winterthur Museum, 1994.

Nicoll, Jessica F. *Quilted for Friends: Delaware Valley Signature Quilts, 1840–1855*. Winterthur, Del.: Henry Francis du Pont Winterthur Museum, 1986.

Quilt Digest 1987. San Francisco: Quilt Digest Press, 1987.

Richter, Paula Bradstreet. *Painted with Thread: The Art of American Embroidery*. Salem, Mass.: Peabody Essex Museum, 2001.

Rowe, Ann Pollard. "Crewel Embroidered Bed Hangings in Old and New England." *Bulletin: Museum of Fine Arts, Boston* 71, nos. 365/366 (1973): 101–66.

Sebba, Anne Marietta. *Samplers: Five Centuries of a Gentle Craft*. New York: Thames and Hudson, 1979.

Sprigg, June. *Domestick Beings*. New York: Alfred A. Knopf, 1975.

Swain, Margaret. *Ayrshire and Other Whitework*. Shire Album 88. Aylesbury, Eng.: Shire Publications, 1982.

Ulrich, Laurel Thatcher. "Cloth, Clothing, and Early American Social History." *Dress* 18 (1991): 39–48.

———. *Good Wives: Image and Reality in the Lives of Women in Northern New England, 1650–1750*. New York: Alfred A. Knopf, 1982.

———. *A Midwife's Tale: The Life of Martha Ballard, Based on Her Diary, 1785–1812*. New York: Alfred A. Knopf, 1990.

———. "Of Pens and Needles: Sources in Early American Women's History." *Journal of American History* 77, no. 1 (June 1990): 200–207.

Warren, William Lamson. *Bed Ruggs/1722–1833*. Hartford, Conn.: Wadsworth Atheneum, 1972.

Floor Coverings

FLOOR COVERINGS WERE UNUSUAL IN EARLY AMERICAN homes. This may surprise visitors to museums and historic sites for at least two reasons. Firstly, soft floor coverings made of fibers are ubiquitous in modern homes and public spaces. Secondly, highly patterned carpets from east of the Mediterranean Sea, commonly called oriental rugs, were favored in many colonial-revival interiors of the early twentieth century, giving a visual impression that too easily affected assumptions about eighteenth-century practice. A visitor's focus on a carpet can lead to intriguing interpretations both of efficient use and reuse of local materials and of global trading networks.

Usually displayed on walls, tables, chests, or cupboards, carpets were rarely used on floors before 1750. By the mid-eighteenth century, a variety of floor cloths and carpets from England and the Middle East became more widely available than in earlier years. Carpets became fashionable, but expensive, floor coverings in England and America. Today, the terms "rug" and "carpet" are used interchangeably, but in the 1600s and 1700s, a "carpet" was a thick, often woolen, fabric cover for a bed, table, or floor. Before 1800 in America, "rug" or "rugg" referred to a bed cover. An early reference to the use of a rug, as opposed to a carpet, as floor covering appeared in the May 22, 1799, *New York Gazette and General Advertiser* advertisement of a variety of floor coverings that included "an assortment of hearth rugs."[1]

Although scholars do not know precisely when and where carpet weaving began, the oldest surviving remnant of a hand-woven carpet dates to about 500 B.C. and is from East Turkestan (central Asia).[2] The carpet-weaving belt extends from the Mediterranean Sea east to include present-day Turkey, Iran, the region of the Caucasus Mountains, central Asia, India, Pakistan, and China. Carpets often bear the name of the regions in which they are made; thus, there are Ushak and Anatolian carpets from present-day Turkey, Kuba carpets from the Caucasus, and Feraghans from present-day Iran. In general, these carpets have been termed oriental. In their areas of origin, carpets are prized articles that serve everyday functions as beds, storage bags, and seats. They also mark sacred spaces, decorate and warm the sides and floors of tents and houses, and shelter entrances.

During the Middle Ages, returning Crusaders and traders introduced Asian carpets to Europeans, and eventually Venetians established trade routes to supply wealthy Europeans with rare carpets. English Cardinal Thomas Wolsey, for instance, bought carpets for himself and for Henry VIII. In 1547 the carpets were described as "of English making" as well as "of beyond the sea making."[3] The king displayed his carpets on floors, tables, cupboards, and benches, and those who saw the array probably associated imported carpets with royalty and wealth.

The English attempted to start a carpet-weaving industry in the sixteenth century but were not economically successful until the seventeenth century, first in workshops at Kidderminster and then, in the mid-1700s, at Wilton. In 1775 William Calvary opened what was probably the first carpet workshop in Philadelphia; in 1787 William Sprague advertised his shop in the city. Peter Lowell had a small shop in Worcester, Massachusetts, in 1794.[4] In the early nineteenth century, carpet manufacturing became an important industry in the United States.

LOOKING AT CARPETS

The visual characteristics of carpets are intimately connected with the carpet's manufacture and structure, often revealed through careful examination and study, difficult in a museum or gallery setting. For visitors looking at an exhibition or a period room, a carpet's design, color, material, texture, and size may be the most immediately striking characteristics.

Design

Designs of carpets display either unified, overall design or repeated patterns. Often, central medallions dominate the fields (areas surrounded by borders).

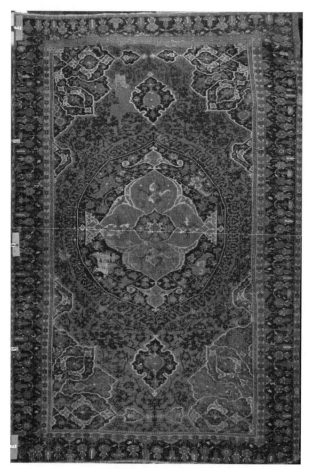

FIGURE 21-1. Ushak medallion rugs are perhaps the most famous product of Turkish looms from the sixteenth century. This central medallion design was borrowed from Persia, demonstrating that designs did travel from one country to another. (Rug, Turkey, 1600–1800. Wool; L 135 in., W 88¾ in. 1959.1417 Winterthur Museum, gift of Henry Francis du Pont.)

This kind of unified design can be seen on some Asian carpets, such as an Ushak, on French Aubusson-type carpets, and on American hooked rugs (fig. 21-8). Other carpets have repeating patterns, as seen on a French Aubusson-type carpet (fig. 21-2).

Color

Patterned carpets often are colorful. Middle Eastern weavers, however, usually used one shade of each color, and English and French weavers used many shades of colors. An Ushak carpet can display red, blue, cream, and green, while an English Axminster-type carpet exhibits several shades of red, orange, and gold. Material and weaving technique also affect color. Carpets made of wool and especially of silk reflect light, which adds sheen to their colors, and carpets with long pile react to light in a livelier manner than flat, short-pile woven carpets.

Material and Texture

Carpet weavers use yarns of silk, wool, linen, or cotton; occasionally, gold or silver threads appear in oriental carpets. Carpets woven of wool or cotton are soft to the touch, but silk carpets are the softest. The pile of a carpet determines the proper direction for stroking; the pile leans toward the end where knotting began.[5]

Size

Colonial homes contained carpets of various sizes. According to the March 26, 1754, *Boston Gazette* advertisement of a sale of household goods, a Turkey carpet "measuring Eleven and an half by Eighteen and an half Feet" was "very large." Some colonists had smaller carpets; a *Boston News-Letter* advertisement of February 20, 1755, notes a reward of three dollars for the return of a stolen "Turkey Carpet of various Colors, about a yard and half in length, and a Yard wide, fringed on each End."[6] In between were "Rich Persian carpets, 3, 4, and 4 by 5 yards square" advertised in the *Boston News-Letter* of January 29, 1761.[7]

THINKING ABOUT STYLE

Carpets from Asia vary in designs and details. Their designs influenced carpets made in Europe and, later,

FIGURE 21-2. This woolen rug was made in Aubusson, France. Rectangles and repeating diamond shapes give it a geometric, almost tile-like appearance. (Rug, Aubusson, 1700–1900. Wool; L 137¾ in., W 125 in. 1959.1425 Winterthur Museum, gift of Henry Francis du Pont.)

FIGURE 21-3. Tribal rugs like this one were woven by members of ethnic nomadic groups that each favored distinct colors and designs. There are three borders on this rug. The outermost is a tan vine with red octagons on a brown ground. The next shows a brown vine with white flowers on a white ground. The innermost features angular "S" forms and triangles on a red ground. (Rug, Afshar, Iran [formerly Persia], ca. 1912. Wool; L 42 in., W 31 in. 1959.1469 Winterthur Museum, gift of Henry Francis du Pont.)

in the United States. One common arrangement of design elements is a central field surrounded by a border of stripes, each with a different decoration (fig. 21-3). Another design consists of a motif in the middle of a field with a quarter of the motif repeated in each corner. Another group of carpets has a field with a dense, repeating pattern that is surrounded by the borders. Turkish and Caucasian motifs usually were geometric and abstract; plant designs, if used at all, were stylized and vaguely recognizable (fig. 21-4). Weavers in Persia, on the other hand, emphasized floral motifs in their carpet designs. Miniature paintings in the sixteenth century influenced some Persian carpet designs to include imagery of the hunt or garden.[8]

Scholars debate the identity of the first designers of carpets and the design sources. Through the centu-

ries, carpet weavers have crafted the designs that have become traditional and preferred in their villages and cities. Yet they were open to new ideas brought by trade, market forces, or political developments.[9] With supervision from designers in large workshops, city weavers wove complicated designs with many colors that required difficult dyeing processes. In contrast, rural weavers used a few colors to weave traditional geometric patterns.

FIGURE 21-4. A range of intense colors is typical of most Caucasian rugs. The Caucasus, located between the Black and Caspian seas, is a mountainous region where the inhabitants live in small villages. Carpets of this kind rarely reached the colonies of British North America. (Rug, Chicki-Kabistan, Caucasus, 1800–1900. Wool; L 80 in., W 34 in. 1959.949 Winterthur Museum, gift of Henry Francis du Pont.)

Imported carpets inspired the designs of many seventeenth- through nineteenth-century French and English carpets. Others, however, reflected current cosmopolitan stylistic trends; for example, carpets made for the court of Louis XIV were baroque in their line and carefully balanced proportion. Elaborate scrolls, natural motifs, insignia of royalty, and cartouches graced the centers of such carpets.[10] In the late 1750s, both French and English carpets featured asymmetrical lines, scrolls, shells, and other rococo motifs. A resplendent English example shows flowers and scrolls in reds, blues, greens, oranges, and golds on a black ground.

As early as 1760, Scottish architect Robert Adam, who worked for taste makers in England, designed carpets in the neoclassical taste, and by the 1790s, straight lines replaced the rococo curves and motifs. Colors, too, showed the influence of neoclassicism.[11] The color palette and motifs for early French Aubussons of the late eighteenth century suited the lightness and delicacy of many household furnishings of the time, and robust, bold designs and colors complemented the taste of the early nineteenth century. An English carpet combines a border that reflects an Asian-inspired design with a field in the English neoclassical style (fig. 21-5). The carpet was probably made about 1810.

MAKING AND MARKETING HANDWOVEN CARPETS

Yarns of wool or, rarely, silk, combined with cotton or hemp, are the principal materials of handwoven carpets. In traditional weaving societies, sheep's wool is the most commonly used fiber. Wool is strong and more resistant to fading, wear, rot, and mildew than other fibers. Silk, although beautifully reactive to light, does not wear as well as wool or cotton and is more likely to fade than other fibers. Cotton or hemp were often used to produce the warp and non-pile weft of the foundation textile on which, for pile carpets, the knotting was done. Handwoven carpets may or may not have pile. Carpets without pile are flat-woven. As in the past, artisans used one of two basic techniques to make carpets that have piles: hand-tied knots or wire-formed loops.

Carpets with Pile: Hand-Knotted to Form a Thick, Tufted Pile

To weave a hand-knotted pile carpet, the weaver starts at one side of the loom and ties a knot on the first two warp (lengthwise) threads. Moving across

FIGURE 21-5. Large carpets like this one were made for the great houses in England and were costly. They rarely survive as whole rugs. Most of the pile usually wears away, leaving the "collar," or part of the yarn wrapped around the warp threads. Such worn rugs resemble needlework rather than knotted pile. (Carpet, England, 1750–1770. Wool; L 308 in., W 181 in. 1967.704 Winterthur Museum, bequest of Henry Francis du Pont.)

the carpet, the weaver, using yarns of various colors according to the pattern, ties a knot on each pair of threads. With a horizontal row of knots completed, the weaver then adds from one to eight rows of weft (crosswise threads) and beats the weft with a comb to make the rug solid.[12] The interwoven warp and weft threads form the carpet's foundation, and the design comes from the rows of knots.

Varying with local weaving practices, two types of knots are used: the symmetrical, closed (Turkish or Ghiordes) knot and the asymmetrical, open (Persian) knot. Carpets from Asia have either type of knot; English and American "Turkey-work" and Axminster-type carpets, however, have only symmetrical knots, and those knots are more widely spaced. Axminster (the name of a town in Devon, England, where knotted-pile carpets were manufactured beginning in 1755) is a general term for English hand-knotted carpets.[13] Looms used to weave hand-knotted carpets are usually upright and hold the warp between the upper and lower beams. Because the distance between the beams determines the length of the carpet, if the beams roll, the carpet can be longer than the height of the loom.

Wire-Formed Pile Composed of Cut Loops (Wilton) or Uncut Loops (Brussels)

The wire-formed pile technique, probably developed around 1740 at Wilton and Kidderminster in England, uses a wire frame to bring colored threads of a woolen warp to the surface of a carpet to form a pile. These low-pile carpets were less expensive alternatives to hand-knotted pile carpets. They imitated a type of wool velvet used since the sixteenth century on the European Continent for upholstery and occasionally floor coverings.[14] Wire-formed pile consists of three sets of warp: a warp that, with the weft, forms the foundation; a stuffed warp to give body; and the warps of different colors (usually six) that form the pattern and pile when drawn to the surface. If the looped pile is cut, a soft, velvet-like surface known as "Wilton" is formed; "Brussels" carpets have uncut loops.[15] Woven strips from twenty-seven to thirty-six inches wide were stitched together to suit the requirements of the patron.

Carpets without Pile

Carpets made with a flat weave do not have piles. Flat-woven carpets include ingrains, tapestry-woven carpets such as Aubusson-type, and some carpets made at home.

INGRAIN WEAVE Ingrain carpets are loom-woven floor coverings without pile, in which two layers of cloth, one above the other, are woven simultaneously so that the design of the carpet is the same on both sides but the colors are reversed. Also known as Scotch and Kidderminster, these carpets were less desirable than other kinds because they did not wear as well (fig. 21-6).

TAPESTRY WEAVE With tapestry weave, the weft threads completely cover the warp. In slit-tapestry, slits occur where colors meet along the warp. Weavers use tapestry weave to make kilim carpets.

PLAIN WEAVE Plain weave was used for most carpets made at home. Least expensive and easiest to make was the list, or rag, carpet, in which strips of fabric were sewn together and then woven into a woolen or cotton warp (fig. 21-7). An early notation of a list carpet in the British North American colonies occurs in a Williamsburg inventory of 1749.[16]

Marketing Carpets

Americans usually acquired carpets through import or at auction as part of "genteel house furniture."[17] In 1760 Charles Carroll of Maryland ordered "One Turkey Carpet suitable for a Room 25 feet Long

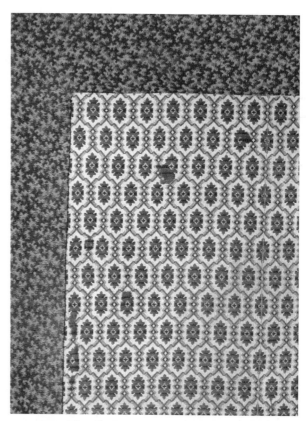

FIGURE 21-6. Ingrain carpets were woven in strips and sewn together. This carpet also has a border sewn around the perimeter. Ideally these carpets were installed as wall-to-wall floor coverings, often fitted around fireplaces. (Ingrain carpet, United Kingdom, ca. 1810. Wool; L 208 in., W 184 in. 1967.2101 Winterthur Museum, bequest of Henry Francis du Pont.)

FIGURE 21-7. This carpet was woven with strips of fabric forming the weft. The visible seams indicate that several long lengths were sewn together to make a larger carpet. Sometimes these rugs are made of used fabrics and therefore were called "rag rugs." Textiles were expensive and were reused in as many forms as possible. (Strip carpet, United States, 1860–1920. Cotton, wool; L 196 in., W 36¼ in. 1958.146.2 Winterthur Museum, gift of Mrs. J. Watson Webb.)

and twenty Broad at about Ten guineas, one Ditto for a Room twenty feet Long and Eighteen Broad at about six Guineas" from a London merchant.[18] When he was in London in 1765, Benjamin Franklin bought "a Large Turkey carpet cost 10 guineas for the Dining Parlour."[19] An auction announcement in the *Boston News-Letter* for June 16, 1763, included "Sundry Turkey Carpets" among the "Very good Household Furniture."[20] Along with size, purchasers sometimes specified carpets whose colors and designs would harmonize with the furniture and, perhaps, the walls of rooms.[21] English, hand-knotted Axminster carpets and wire-formed loop Wilton and Brussels carpets appeared on the market in Europe in the 1750s. By the late 1780s, Axminster-type carpets were also being made in the new United States. In 1787 William Sprague of Philadelphia announced that he would receive orders

> for any figure, size, shape, of American made floor and bedside carpets after the Axminster mode, which for softness, warmth and duration, exceed anything of the kind ever attempted in this country. A few of both floor and bedside carpets are now for sale.[22]

Although neither survives, Sprague produced a carpet for the Chamber of the United States Senate, and another for the dining room of George Washington's Philadelphia house.[23]

LIVING WITH FLOOR COVERINGS

Floor coverings were not only decorative but also helped retain heat in drafty houses and softened the walking surfaces of hard floors. However, floors in most American homes did not have coverings. A few colonists used rush or straw matting on their floors; some used sand. In the eighteenth century, affluent Americans put oilcloths on floors for decorative purposes. Yarn-sewn rugs, on floors or beds, first appeared in American homes in the eighteenth century. For those fortunate few who could afford them, imported carpets were the most fashionable and desirable floor coverings.

References in letters and journals describe the use of sand as a covering on unfinished floorboards. Sand cushioned a walking surface, collected dirt and grease, protected feet from cold floors, and sometimes, if only briefly, provided decoration. Colonists sprinkled sand on floors through sieves or deposited it in piles and swept it into such decorative patterns as scrolls, feathers, or herringbones.[24] Abbé Claude Robin, who trav-

eled in this country in 1781, remarked that the floors of some wealthy Americans "are covered with handsome carpets, or painted cloths, but others sprinkle them with fine sand."[25]

Any floor—packed earth or wood, bare or covered with straw or a fine carpet—needed cleaning. Until improvements in road building, paving, personal cleanliness habits, and cleaning tools reduced interior grime, cleaning accumulated mud, dirt, and the refuse of living from floors was an important part of housekeeping. In addition to its decorative purpose, sand—preferably a fine, white variety—was a cleaning agent. An elderly Philadelphian remembered that before the war for independence, "Parlour floors of very respectable people in business used to be 'swept and garnished' every morning with sand."[26]

Straw or rush matting was a versatile and economical floor covering by the mid-eighteenth century and remained in use through the nineteenth century.[27] In the 1750s, Israel Acrelius, visiting near Philadelphia, commented that "straw carpets have lately been introduced to the towns. But the inconvenience of this is that they must soon be cleansed from flyspots, and a multitude of vermin which harbor in such things, and from kitchen smoke, which is universal."[28] Mostly imported, matting reached the colonies through England until direct American trade with China developed in the 1780s.

Matting was most common in entryways, hallways, and bedrooms. Matting and straw carpets also were protective coverings for "good carpets," padding under woven carpets, or replacements when wool carpets were cleaned and stored for summer.[29] Paint sometimes simulated expensive floor coverings.[30] Introduced from England in the early eighteenth century, painted floorcloths, also called oilcloths, probably were used as floor coverings in colonial houses earlier than carpets. Floorcloths were installed wall-to-wall or as area covers in major rooms; in entries, hallways, staircases; and temporarily under dining tables to protect floors from grease and stains.[31] For some people, floorcloths were summer floor coverings; for others, floorcloths were placed under woven carpets for additional warmth in winter.

Many painted floorcloths were imported from England and Scotland. There was risk, however, in ordering from abroad; one Virginia customer complained to his London supplier that "The cloth is inju'd by being rol'd before the paint was dry."[32] Some American artisans made floorcloths in combination with coach, house, and sign painting or with such other crafts as

upholstering and paperhanging. These craftsmen advertised that their work was in "the best" or "neatest" and "cheapest" manner and offered a choice of plain, patterned, or figured decoration.[33]

From the seventeenth until the mid-eighteenth century in colonial America, textiles, which were expensive and rare, covered tables and cupboards or upholstered furniture; colonists considered Turkey-work carpets the finest of these coverings.[34] Some surviving portraits document the practice of textiles on furniture, and the imported carpets in the few known American paintings appear to be Turkish.[35] Colonists began to put imported carpets on floors of homes in the mid-eighteenth century, and colonial inventories indicate that, with few people owning floor coverings of any kind, only a small segment of the population possessed Turkey-work carpets. Of seventy-five Boston-area inventories of household furnishings made in 1775, three included floor coverings; two were floorcloths and one, belonging to Mr. Edward Jackson, was a carpet. In 1778 four of 115 inventories listed floor coverings. Again, only one of these mentioned Turkey carpets: Joshua Winslow's house had "a Turkey carpet £9" in the downstairs front chamber and a "Turkey Carpet 42" upstairs, along with other kinds of floor coverings elsewhere in the house. The inventories that included Turkey carpets had high total valuations.[36]

In the late eighteenth century, hand-knotted Axminster-type carpets, whether made in England or America, were elegant and expensive floor coverings, especially for chambers, halls, and stairs.[37] After seeing such carpets made in England, Abigail Adams noted in her diary on July 26, 1787, "The carpets are equally durable with Turkey but surpass them in colours and figure."[38] Woven in strips of repeating pattern from twenty-seven to thirty-six inches wide, this carpeting was fitted to cover narrow spaces as well as floors of rooms. The patterns included stripes and the "newest landscape and other elegant patterns" with matching borders.[39] Professional upholsterers usually installed Wilton and Brussels carpets. After carefully mitering the corners, the installers temporarily tacked the borders into place; then they matched and stitched the strips of the field pattern. Using a tool known as a strainer, the installers stretched the carpet flat and then tacked it to the floor around the edges.[40]

In 1757 George Washington bought two Wilton carpets for use at Mount Vernon. John Cadwalader of Philadelphia had a blue Wilton carpet with a border, totaling fifty-eight yards, in his front parlor. In the back parlor, he had fifty-eight yards of yellow Wilton

carpet. Cadwalader also imported serge covers for both of these carpets, protecting them from light, dust, and wear.[41]

Brussels carpeting continued to be popular until the late nineteenth century. According to the 1801 inventory, President and Mrs. John Adams used Brussels-type carpets in the new White House during their four-month tenancy. President Thomas Jefferson's 1809 White House inventory also lists Brussels carpets in major rooms. James Madison had his agent purchase 169 yards of Brussels carpet, 30 yards of border, and a large hearth rug for the oval drawing room.[42]

By the second half of the eighteenth century, Scotch and ingrain carpets were available in most American port cities. First imported from England, ingrain carpets were manufactured in the United States, especially in New England. Although regarded as inferior to carpets with pile, Scotch and ingrain carpets provided serviceable floor coverings for parlors, chambers, stairways, and entries.[43] Designs on ingrain carpets tended to be small, closely woven, somewhat geometric patterns in the late eighteenth century and continuing into the nineteenth century. Large-scale, more curvilinear designs became possible in the second quarter of the mid-nineteenth century encouraged by the use of the Jacquard mechanism on the loom. This improvement allowed more complicated designs through variable manipulation of the warp threads.[44] The author of an article in an 1825 edition of the *New England Farmer* pointed out that "persons who are disposed to study durability more than ornament should always select a carpet, the figures of which are small; for in this case the two webs of which the carpeting consists are always much closer interwoven than in carpets where large figures upon ample grounds are represented."[45]

Yarn-sewn rugs first appeared in American homes in the eighteenth century. Made at home, these rugs were used both as bed and floor rugs. In the nineteenth century, many people also used yarn-sewn rugs in front of hearths to protect expensive imported carpets from sparks and embers.[46] By the late nineteenth century, hooked rugs were made throughout the United States.[47] Evidence suggests that hooked and braided rugs became popular as the textile industry became successful in the nineteenth century. With "store-bought" fabric and clothing available and reasonable in cost, many people used fabric scraps, either from worn clothing or bought specifically for the purpose, to make colorful rugs. With animals, houses, and flowers as popular motifs, surviving hooked rugs exhibit creativity in design and colors (fig. 21-8).[48]

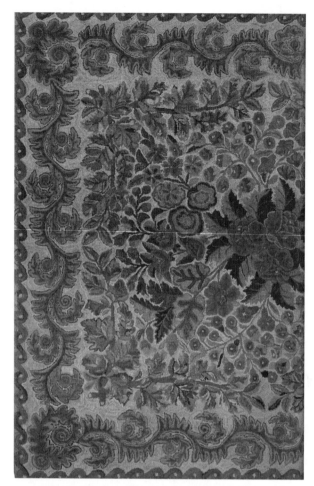

FIGURE 21-8. Like rag rugs, hooked rugs could have been made of recycled textiles. They often were made at home rather than in a shop or factory. (Hooked rug, United States or Canada, 1825–1875. Wool, burlap, cotton; L 78 in., W 71½ in. 1965.689 Winterthur Museum, bequest of Henry Francis du Pont.)

Housekeeping manuals offered advice on the care of carpets that included turning them for even wear, cleaning, and recipes to repel moths and carpet beetles.[49] Cleaning and rotating tautly stretched and tacked-down carpet was no easy task; it required a housewife to pry loose the tacks, remove, and clean the carpet by beating "well with a stick till all the dust is got out . . . wash in cold Water . . . and when thoroughly dry, rub all over with the Crumb of an hot White Loaf." Professional cleaners also promised to "clean Turkey and Wilton carpets, and make the color quite fresh."[50] *The New Family Receipt Book*, published in New Haven, Connecticut, in 1819, included directions for cleaning a floorcloth: "after sweeping and cleaning the floorcloths with a broom and damp flannel, in the usual manner, wet them over with milk and rub them till beautifully bright, with a dry cloth."[51]

By the mid-nineteenth century, inventive manufacturers developed floor coverings for various economic groups and the machinery to produce them. In 1854 Hiram Anderson, describing himself as "the Carpet Merchant of the People," boasted of his "long and successful efforts . . . to bring carpets and floor coverings . . . within the reach of the whole community."[52] For some housekeepers, the labor of carpet beating replaced the labor of floor scrubbing.

CONCLUSION

Carpets were used increasingly throughout the eighteenth and nineteenth centuries for decoration and to add warmth to a room. However, bare floors were the norm. Other floor coverings included sand, straw matting, painted floorcloths, and, in the nineteenth-century, yarn-sewn rugs, especially in front of hearths.

NOTES

1. *Oxford English Dictionary*, Compact Edition, s.vv. "rug," "carpet"; Sherrill, "Oriental Carpets," 143.
2. Denny, 23.
3. King, "Carpet Collection," 41.
4. Landreau, 45.
5. Denny, 20.
6. Roth, 5.
7. Roth, 6.
8. Denny, 32.
9. Klose, 76; King, "Carpets in the Exhibition," 25. As research continues, the understanding of weavers' products and influences on their designs is developing; see Wright and Wertime, 38–43.
10. Weeks and Treganowan, 42.
11. Roth, 42.
12. Weeks and Treganowan, 106.
13. Sherrill, *Carpets and Rugs*, 152, 175.
14. Denny, 19.
15. Gilbert, Lomax, and Wells-Cole, 61.
16. Lanier, 34–35.
17. Von Rosenstiel, 129; Roth, 6.
18. Roth, 7.
19. Von Rosenstiel, 129.
20. Roth, 6.
21. Roth, 58.
22. Anderson, 32.
23. Anderson, 34.
24. Nylander, 13; Von Rosenstiel, 10.
25. Roth, 49.
26. As quoted in Roth, 48.
27. Von Rosenstiel, 15–26; Roth, 26–29.
28. Von Rosenstiel, 19.
29. Von Rosenstiel, 20–21.

30. Von Rosenstiel, 10; Fraser, 297.
31. Roth, 23–24.
32. Roth, 12.
33. Roth, 12.
34. Von Rosenstiel, 124; Roth, 4; Sherrill, "Oriental Carpets," 145.
35. Landreau, 18.
36. Roth, 7.
37. Roth 14.
38. Roth, 10.
39. Roth, 35.
40. Michie, 28; Roth, 57.
41. Gilbert, Lomax, and Wells-Cole, 110.
42. Page, 23.
43. Nylander, 15.
44. Sherrill, *Carpets and Rugs*, 218, 246.
45. Nylander, 16.
46. Kopp and Kopp, 14.
47. Kopp and Kopp, 39–40.
48. Kopp and Kopp, 48.
49. Garrett, 172; Von Rosenstiel, 122.
50. Roth, 54.
51. Little, 24.
52. Stott, 173.

BIBLIOGRAPHY

Denny, Walter. *Oriental Rugs.* New York: Cooper-Hewitt Museum, 1979.

Sherrill, Sarah B. *Carpets and Rugs of Europe and America.* New York: Abbeville Press, 1996.

Additional Sources

Anderson, Susan H. *The Most Splendid Carpet.* Philadelphia: National Park Service, 1978.

Cochran, Thomas C. *Frontiers of Change: Early Industrialism in America.* New York: Oxford University Press, 1981.

Edwards, A. Cecil. *The Persian Carpet.* London: Gerald Duckworth and Co., 1967.

Fraser, Esther Stevens. "Some Colonial and Early American Decorative Floors." *The Magazine Antiques* 19, no. 4 (April 1931): 296–301.

Garrett, Elisabeth Donaghy. *At Home: The American Family, 1750–1870.* New York: Harry N. Abrams, 1990.

Gilbert, Christopher, James Lomax, and Anthony Wells-Cole. *Country House Floors.* Leeds, Eng.: Leeds City Art Galleries, 1987.

Hummel, Charles. "Floor Coverings Used in Eighteenth-Century America." In *Imported and Domestic Textiles in Eighteenth-Century America*, edited by Patricia Fiske, 61–92. Washington D.C.: Textile Museum, 1976.

Jacobsen, Charles W. *Oriental Rugs: A Complete Guide.* Rutland, Vt.: Charles E. Tuttle Co., 1962.

King, Donald. "The Carpet Collection of Cardinal Wolsey." In *Oriental Carpet and Textile Studies I*, edited by Robert Pinner and Walter B. Denny, 41–54. London: HALI Magazine, 1985.

———. "The Carpets in the Exhibition." In *The Eastern Carpet in the Western World*, selected and arranged by Donald Kind and David Sylvester, 24–32. London: Arts Council of Great Britain, 1983.

Klose, Christine. "Centralized Designs on Turkish Carpets." In *Oriental Carpet and Textile Studies*, edited by Robert Pinner and Walter B. Denny, 76–92. London: HALI Magazine, 1985.

Kopp, Joe, and Kate Kopp. *American Hooked and Sewn Rugs.* New York: E. P. Dutton, 1975.

Landreau, Anthony. *American Underfoot: A History of Floor Coverings from Colonial Times to the Present.* Washington, D.C.: Smithsonian Institution Press, 1976.

Lanier, Mildred B. *English and Oriental Carpets at Williamsburg.* Williamsburg, Va.: Colonial Williamsburg Foundation, 1975.

Little, Nina Fletcher. *Floor Coverings in New England before 1850.* Sturbridge, Mass.: Old Sturbridge Village, 1967.

Michie, Audrey. "The Fashion for Carpets in South Carolina, 1736–1820." *Journal of Early Southern Decorative Arts* 8, no. 1 (May 1982): 24–48.

Nylander, Jane. "The Early American Look: Floor Coverings." *Early American Life* 14, no. 2 (April 1983): 13–19.

Page, Ruth. "English Carpets and Their Use in America." *Connecticut Antiquarian* 19, no. 1 (June 1967): 16–25.

Roth, Rodris. *Floor Coverings in 18th-Century America.* Washington, D.C.: Smithsonian Institution Press, 1967.

Sherrill, Sarah. "Oriental Carpets in Seventeenth- and Eighteenth-Century America." *The Magazine Antiques* 109, no. 1 (January 1976): 142–67.

Stott, Richard. *Workers in the Metropolis.* Ithaca, N.Y.: Cornell University Press, 1990.

Von Rosenstiel, Helene. *American Rugs and Carpets from the Seventeenth Century to Modern Times.* New York: William Morrow, 1978.

Weeks, Jeanne, and Donald Treganowan. *Rugs and Carpets of Europe and the Western World.* Philadelphia: Chilton Book Company, 1969.

Wright, Richard E., and John T. Wertime. *Caucasian Carpets and Covers: The Weaving Culture.* London: HALI Publications in association with Laurence King, 1995.

Index

About the Author

Rosemary Troy Krill is senior lecturer, Academic Programs Division, at Winterthur Museum, Garden, & Library. Working toward excellent interpretation of Winterthur's collections has inspired her work in education, public programs, and academic programs since 1988. Projects have included a wide range of interpretive, visitor service, and academic activities from developing elementary school programs to re-invigorating training for Winterthur's large corps of museum interpreters. More recently, her duties include managing the Research Fellowship Program and assisting with one of Winterthur's graduate programs, in concert with the University of Delaware, the Winterthur Program in American Material culture. Since receiving a master's degree in American history and museum studies certification at the University of Delaware as a Hagley Fellow, Rosemary led education and interpretive efforts at the Monmouth County (New Jersey) Historical Association and the Hagley Museum in Wilmington, Delaware. She is a member of the American Association of Museums, (serving as cochair of its Visitor Service Professional Interest Group, 2005–2008,) the American Association for State and Local History, the Mid-Atlantic Association of Museums, and the Museum Education Roundtable. She is a board member of the Tri-State Coalition of Historic Places in the Pennsylvania–New Jersey–Delaware region. Since 2006, she has been an adjunct lecturer in the Museum Studies Program at the University of Delaware.